OTHER BOOKS BY KRIS MALKIEWICZ

Film Lighting: Talks with Hollywood's Cinematographers and Gaffers

A GUIDE FOR FILMMAKERS AND FILM TEACHERS CINERATOGRAPHY THIRD EDITION

KRIS MALKIEWICZ and M. DAVID MULLEN, ASC

LINE DRAWINGS BY JIM FLETCHER

A FIRESIDE BOOK PUBLISHED BY SIMON & SCHUSTER

NEW YORK LONDON TORONTO SYDNEY

FIRESIDE Rockefeller Center 1230 Avenue of the Americas New York, NY 10020

Copyright © 1973, 1989, 2005 by Simon & Schuster, Inc. Copyright renewed © 2001

> All rights reserved, including the right of reproduction in whole or in part in any form.

Revised Fireside Edition 2005

FIRESIDE and colophon are registered trademarks of Simon & Schuster, Inc.

For information regarding special discounts for bulk purchases, please contact Simon & Schuster Special Sales at 1-800-456-6798 or business@simonandschuster.com.

Designed by Ruth Lee Mui

Manufactured in the United States of America

11 13 15 17 19 20 18 16 14 12

Library of Congress Cataloging-in-Publication Data Malkiewicz, J. Kris. Cinematography : a guide for filmmakers and film teachers / Kris Malkiewicz and M. David Mullen ; line drawings by Jim Fletcher.

p. cm.

"A Fireside book." Includes bibliographical references and index. 1. Cinematography. I. Mullen, M. David. II. Title. TR850 .M276 2005 778.5—dc22 2005044104

ISBN 978-0-7432-6438-9

ACKNOWLEDGMENTS

We wish to thank Bob Rogers, whose collaboration was fundamental in the realization of the first edition of this book. We would also like to thank several friends whose advice and encouragement contributed to the first edition: Brian Moore, Pat O'Neill, Haskell Wexler, Don Worthen, Frank Stokes, David Smith, Roy Findlon, and Milan Chupurdija.

We are deeply grateful for the help given by several generous people in the preparation of the second edition. Our thanks go to Francisco Menendez for his editorial help, and to Benjamin Bergery, Myron Emery, Grant Loucks, Larry Roberts, and Craig Smith for their expertise in the various areas of filmmaking.

For this third edition, we would also like to thank Geoff Boyle and his Cinematography Mailing List (CML), Ed Coleman, Lisle Foote, Mitch Gross, Annette Hobday, Bill Hogan, Jeff Kreines, Mike Most, Matt Nicolay, Chip Ritter, Craig Smith, Ira Tiffen, and Mark Weingartner.

Finally, we are grateful to the manufacturers, suppliers, and laboratories that contributed photographs, charts, and information.

V

CONTENTS

	Acknowledgments	V
	Preface to the Third Edition	ix
1.	Cameras	1
2.	Film Technology	48
3.	Filters and Light	68
4.	Lighting	92
5.	Image Manipulation	150
6.	Sound Recording	159
7.	Postproduction	171
8.	Special Shooting Techniques	213
9.	Production	224
	Glossary	235
	Bibliography	251
	Index	253

PREFACE TO THE THIRD EDITION

Welcome to the Digital Age. In the decade since the last edition, we have seen radical changes to filmmaking techniques in the fields of picture and sound editing, sound recording, and visual effects. While at first only wellbudgeted studio productions could afford these new digital tools, many of them are now available to the general consumer.

With the introduction of 24 fps progressivescan video cameras in the year 2000, we finally saw digitally "captured" moving images that felt more filmlike than those that previous generations of video technology were capable of delivering. Many "experts" jumped the gun and predicted the death of film. In particular, they suggested that the 16mm format, for years the only affordable alternative to 35mm for projects traditionally shot on film, would soon be gone.

However, 16mm continues to be a popular format for a number of reasons. For one thing, advances in film emulsion technology have considerably improved the grain and sharpness of the 16mm image. Digital technology has improved how the format looks transferred to video and even allows a high-quality method of copying the image onto the 35mm format for theatrical projection. So even though some filmmakers may be using digital video instead of film these days, 16mm has established itself as an excellent format for those with a modest budget who still need to get as close as possible to the look of 35mm film.

The truth is that motion picture production, postproduction, distribution, and exhibition have been using a hybrid film-digital system for years now. Film is still the primary method of capturing moving images and showing them in theaters, yet converting that image into a digital format for editing, visual effects manipulation, color-correction, and final distribution to home video and broadcast and cable television systems is unavoidable. Therefore, film and digital are partners more than competitors.

This book concentrates on the work of the *cinematographer*—the person responsible for the photography of a motion picture. It touches briefly on techniques of sound recording, cutting, and production logistics, because some knowledge in these areas is necessary for the serious cameraperson, especially in view of the increasing trend toward personal filmmaking, where a single creative individual performs the multiple functions of a film crew.

This edition has been updated to reflect current production trends and changes due to new technologies, especially as they relate to the 16mm format. However, the heart of cinematography—and this book—continues to be traditional photographic and lighting concepts. If you want to understand how to create an image, you have to understand light and all of its properties, because there is no image without it. Therefore, many of the techniques discussed in this book are applicable to filmmakers working outside the realm of 16mm.

In the continuing quest to be more innovative and experimental, it is extremely useful to know the existing principles before one tries to break them. The only really important outcome

X

of filmmaking is what happens in the heads of the audience members. That is what counts. But the long and painstaking route to the audience begins with light and continues through the lens and film in a movie camera. This book will try to help you take that route and record your creative vision with fewer frustrating disappointments and more competency and joy.

1 Cameras

The cinematographer's most basic tool is the motion picture camera. This piece of precision machinery comprises scores of coordinated functions, each of which demands understanding and care if the camera is to produce the best and most consistent results. The beginning cinematographer's goal should be to become thoroughly familiar and comfortable with the camera's operation, so that he or she can concentrate on the more creative aspects of cinematography.

This chapter covers many isolated bits of practical information. However, once you become familiar with camera operation, you will be able to move on to the substance of the cinematographer's craft in subsequent chapters. In the meantime, you are well advised to try to absorb each operation-oriented detail presented in this chapter, because operating a camera is *all* details. If any detail is neglected, the quality of the work may be impaired.

PRINCIPLE OF INTERMITTENT MOVEMENT

The film movement mechanism is what really distinguishes a cinema camera from a still camera. The illusion of image motion is created by a rapid succession of still photographs. To arrest every frame for the time of exposure, the principle of an intermittent mechanism was borrowed from clocks and sewing machines. Almost all general-purpose motion picture cameras employ the intermittent principle.

Intermittent mechanisms vary in design. All have a pull-down claw and pressure plate. Some have a registration pin as well. The pulldown claw engages the film perforation and moves the film down one frame. It then disengages and goes back up to pull down the next frame. While the claw is disengaged, the pressure plate holds the film steady for the period of exposure. Some cameras have a registration pin that enters the film perforation for extra steadiness while the exposure is made.

Whatever mechanism is employed requires the best materials and machining possible, which is one reason good cameras are expensive. The film gate (the part of the camera where the pressure plate, pull-down claw, and registration pin engage the film) needs a good deal of attention during cleaning and threading. The film gate is never too clean. This is the area where the exposure takes place, so any particles of dirt or hair will show on the exposed film and perhaps scratch it. In addition to miscellaneous debris such as sand, hair, and dust, sometimes a small amount of emulsion comes off the passing film and collects in the gate. It must be removed. This point is essential. On feature films, some camera assistants clean the gate after every shot. They know that one grain of sand or bit of emulsion can ruin a day's work.

The gate should first be cleaned with a rub-

ber-bulb syringe or compressed air to blow foreign particles away. Cans of compressed air must be used in an upright position; otherwise they will spray a gluey substance into the camera. When blowing out the aperture, it is recommended that you spray from the open lens port side, with the mirror shutter cleared out of the way, through the aperture, rather than from inside the threading area into the aperture. This helps prevent blowing particles into the mirror area. An orangewood stick, available wherever cosmetics are sold, can then be used to remove any sticky emulsion buildup. There is also an ARRI plastic "skewer" for this job, bent at the end to allow you to get the inner edges of the aperture better. The gate and pressure plate should also be wiped with a clean chamois cloth-never with linen. Never use metal tools for cleaning the gate, or, for that matter, for cleaning any part of the film movement mechanism, because these may cause abrasions that in turn will scratch the passing film. Do not use Q-tips either, as these will leave lint behind.

The gate should be cleaned every time the camera is reloaded. At the same time, the surrounding camera interior and magazine should also be cleaned to ensure that no dirt will find its way to the gate while the camera is running.

The intermittent movement requires the film to be slack so that as it alternately stops and jerks ahead in one-frame advances, there will be no strain on it. Therefore, one or two sprocket rollers are provided to maintain two loops, one before and one after the gate. In some cameras (such as the Bolex and Canon Scoopic), a self-threading mechanism forms the loops automatically. In Super-8 cassettes and cartridges, the loops are already formed by the manufacturer. On manually threaded cameras, the film path showing loop size is usually marked.

Too small a loop will not absorb the jerks

2

of the intermittent movement, resulting in picture unsteadiness, scratched film, broken perforations, and possibly a camera jam. An oversize loop may vibrate against the camera interior and also cause an unsteady picture and scratched film. Either too large or too small a loop will also contribute to camera noise.

Camera Speeds

The speed at which the intermittent movement advances the film is expressed in frames per second (fps). Each frame exposed is a single sample of a moving subject, so the higher the sampling rate, that is, the faster the frame rate, the smoother the motion will be reproduced. To reproduce movement on the screen faithfully, the film must be projected at the *same* speed as it was shot. Standard shooting and projection speed for 16mm and 35mm is 24 fps; standard speeds for 8mm and Super-8 are 24 fps for sound and 18 fps (or 24 fps) for silent.

If both the camera and the projector are run at the *same* speeds, say 24 fps, then the action will be faithfully reproduced. However, if the camera runs *slower* than the projector, the action will appear to move *faster* on the screen than it did in real life. For example, an action takes place in four seconds (real time) and it is photographed at 12 fps. That means that the four seconds of action is recorded over forty-eight frames. If it is now projected at standard sound speed of 24 fps, it will take only two seconds to project. Therefore, the action that took four seconds in real life is sped up to two seconds on the screen because the camera ran slower than the projector.

The opposite is also true. If the camera runs *faster* than the projector, the action will be slowed down in projection. So to obtain slow motion, speed the camera up; to obtain fast motion, slow the camera down.

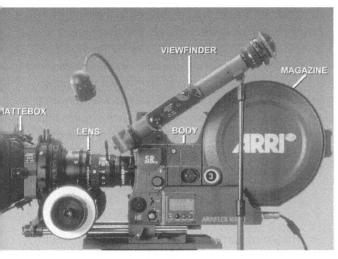

1.1 Arriflex SR3 camera. (Courtesy of ARRI Group)

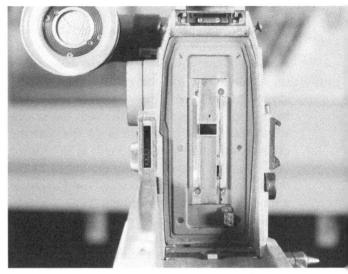

1.2 Arriflex camera gate.

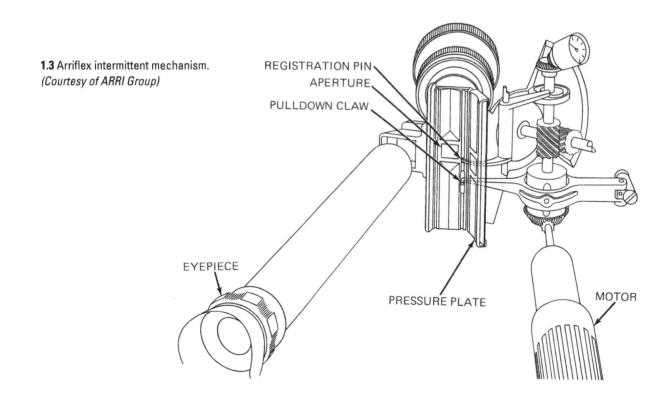

This variable speed principle has several applications. Time-lapse photography can compress time and make very slow movement visible, such as the growth of a flower or the movement of clouds across the sky. Photographing slow-moving clouds at a rate of, say, one frame every three seconds will make them appear to be rushing through the screen when the film is projected at 24 fps. On the other hand, movements filmed at 36 fps or faster acquire a slow, dreamy quality at 24 fps on the screen. Such effects can be used to create a mood or analyze a movement. A very practical use of slow motion is to smooth out a jerky camera movement such as a rough traveling shot. The jolts are less prominent in slow motion.

To protect the intermittent movement, never run the camera at high speeds when it is not loaded.

When sound movies arrived in 1927, 24 fps was firmly established as the standard shooting and projection rate, although it was a frame rate occasionally used by Silent Era filmmakers. It is not actually the ideal frame rate for the recreation of motion, as it provides barely enough individual motion samples over time to create the sensation of smooth, continuous motion when played back. However, it's become the frame rate that audiences are most accustomed to seeing in movies and has become an integral part of the "film look" that many people discuss these days as they attempt to get video technology to emulate film. The main artifacts to this fairly low frame rate are strobing and flicker. Strobing is the effect of sensing that the motion is made up of too few samples and therefore does not feel continuous. One of the ramifications is that it is sometimes necessary to minimize fast movement, such as when panning the camera across a landscape; otherwise the motion seems too staccato, too jumpy. *Flicker* happens when the series of still images are not being flashed quickly enough for the viewer to perceive the light and image as being continuously "on." The solution generally has been for film projectors to use a twin-bladed shutter to double the number of times the same film frame is flashed before the next frame is shown. So even if the movie was shot and then projected at 24 fps, the viewer is seeing forty-eight flashes per second on the screen.

SHUTTER

A change in camera speed will cause a change in shutter speed. In most cameras the shutter consists of a rotating disk with a 180° cutout (a half circle). As the disk rotates it closes over the aperture, stopping exposure and allowing the movement to advance the film to the next frame. Rotating further, the cutout portion allows the new frame to be exposed and then covers it again for the next pull-down. The shutter rotates constantly, and therefore the film is exposed half the time and covered the other half. So when the camera is running at 24 fps, the actual period of exposure for each frame is ¹/₄₈ second (half of 1/4). Varying the speed of the camera also changes the exposure time. For example, by slowing the movement by half, or to 12 fps, we increase the exposure period for each frame, from $\frac{1}{48}$ to $\frac{1}{24}$ second. Similarly, by speeding up the movement, doubling it from the normal 24 fps to 48 fps, we reduce the exposure period from 1/48 to 1/46 second. Knowing these relationships, we can adjust the f-stop to compensate for the change in exposure time when filming fast or slow motion.

A change in the speed of film movement can be useful when filming at low light levels. For example, suppose you are filming a

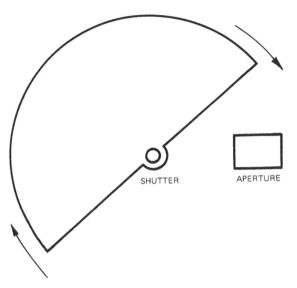

1.4 180° rotating shutter.

cityscape at dusk and there is not enough light. By reducing your speed to 12 fps, you can double the exposure period for each frame, giving you an extra stop of light that may save your shot. Of course, this technique would be unacceptable if there were any pedestrians or moving cars in view; they would be unnaturally sped up if the film were projected.

Some cameras are equipped with a *variable shutter*. By varying the angle of the cutout we can regulate the exposure. For example, a 90° shutter opening transmits half as much light as a 180° opening. Some amateurs make fade-outs and fade-ins on their original film by using the variable shutter, assuming it can be changed smoothly while the camera is running. Professionals generally have all such effects done in the lab.

Since changing the camera speed also changes the exposure, you can compensate for a speed change in midshot (called *speed ramping*) by adjusting either the f-stop or the shutter to maintain the correct exposure. For example, a speed change from 24 fps to 12 fps would cause twice as much light to reach the film by the time it was running at 12 fps, so you could simultaneously close down the shutter angle from 180° to 90° as the frame changes, thus counteracting the exposure increase. However, the rendition of motion will be different when you alter the shutter angle, not just when you alter the frame rates.

Shutter movement is directly responsible for the *stroboscopic effect*. Take the example of the spokes of a turning wheel. Our intermittent exposures may catch each succeeding spoke in the same place in the frame, making the spinning wheel appear to be motionless. The camera may even catch each spoke in a position counterclockwise to the previous spoke captured, making the wheel look like it is running in reverse. Another variation, called *skipping*, results from movement past parallel lines or objects, such as the railings of a fence. They may appear to be vibrating. These effects will increase with faster movement and with a narrower shutter angle.

Exposure time controls the amount of *motion blur* recorded on each frame; due to the low

1.5 Arriflex SR3 adjustable shutter.

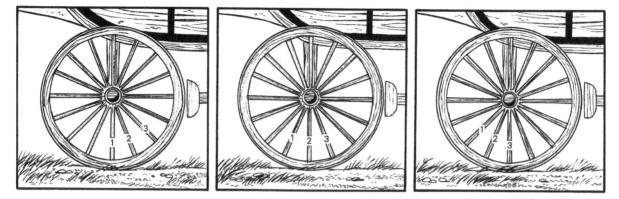

1.6 Stroboscopic effect.

sampling rate of 24 fps, a certain amount of blur is needed to make a moving object on one frame visually "blend" with the next frame. Too little blur and the motion seems too "sharp" and the viewer becomes more aware as to how few motion samples there really are; it no longer feels continuous but instead "steppy." Therefore, shooting at 24 fps with a closed-down shutter, like at a 45° or 90° angle, will cause faster motion to strobe heavily. This has been used as a creative effect by some filmmakers, since it adds a certain nervous, jittery energy to action scenes. The movie Saving Private Ryan is the most famous example of this technique; many of the battle scenes were shot handheld with a 45° shutter angle. It's also a useful technique when shooting spraying water or falling rain, if you want to see each droplet more clearly.

There are other reasons to use a shutter angle other than 180°, such as for filming TV screens or lights that pulse with their AC current. (See chapter 8.)

VIEWING SYSTEMS

In many cameras the shutter performs a vital role in the viewing system. The front of the shutter has a mirror surface that reflects the image into the viewfinder when the shutter is closed. The great advantage of this reflex system is that *all* the light goes alternately to the film and to the camera operator's eye, providing the brightest image possible. The surface of the mirror shutter should be cleaned only with an air syringe or gently with compressed air; nothing should be allowed to touch it.

Other systems (such as the Bolex Reflex) use a prism between the lens and the shutter so that a certain percentage of the light is constantly diverted to the viewfinder. The disadvantage is that it reduces the amount of light going both to the viewfinder and to the film, since the beam is split. An exposure compensation is required to allow for the light "stolen" from the film by the viewing system. It is usually very slight. For example, in the Bolex Rex-5 the loss is about a third of a stop. You should consult the operator's manual for the specific camera to learn the exact compensation.

Be aware that just as the reflex camera allows light coming through the lens to reach both the film and the camera operator, *it also allows light coming back through the eyepiece to reach the film.* Therefore, you must keep your eye pressed against the viewfinder while filming to prevent any light-leak from fogging your im-

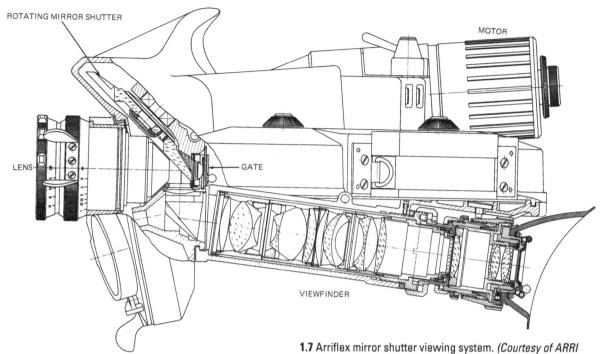

Group)

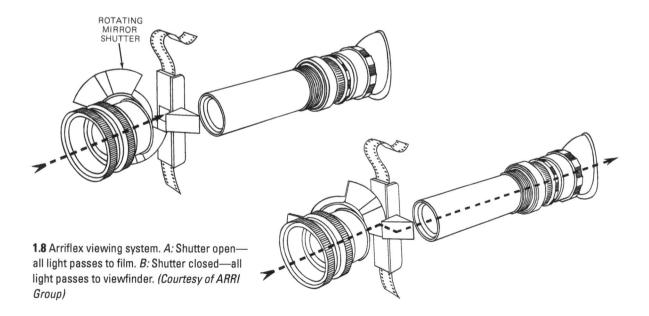

age; if you are not planning on looking through the viewfinder during the take, you must seal off the eyepiece.

The viewing systems discussed so far allow the cameraperson to look through the taking lens. Many cameras of older design do not have a reflex viewfinding system. As a result, the film in the camera may not receive exactly the same image that the separate viewfinder (usually off to one side of the camera) sees. Referred to as *parallax*, this is especially a problem when shooting close with a wide-angle lens. However, most nonreflex cameras have an adjustment that can partly correct for parallax.

Video Assist

Also referred to as a *video tap*, this is a system where some of the light going to the viewfinder

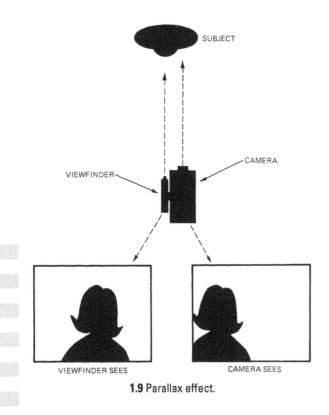

is also received by a tiny internal video camera; that image can then be sent to a TV monitor, either with cables or transmitted by UHF (by using an additional device). This signal can even be recorded to videotape for temporary playback on the set. The image quality of this video image is generally very poor, but it allows you to see the framing without actually looking through the viewfinder. This is mainly done so that people other than the camera operator can see the exact shot during the take. However, it is also useful when it is physically impossible to look through the camera viewfinder during the take, like when the camera is mounted on a moving vehicle, a Steadicam, or a remotecontrolled crane. Occasionally the camera assistant will have a small LCD monitor mounted to the camera, which enables the assistant to see what the operator is framing. This can come in handy when shooting a scene on a telephoto or macro lens in which the operator is panning from one object to another and the focus needs to be adjusted as each object comes into view. The portable LCD screen can even be used by the operator when doing a complex dolly move, perhaps with an extreme boom up or down combined with a pan, when it may be too difficult to continually keep the eye against the viewfinder.

MOTORS

The film transport mechanism, the shutter, and other moving camera parts are operated by the motor. There are two basic types of motors, spring-wound and electric. Spring-wound cameras run approximately twenty to forty feet of film per wind. The advantages include a compact design and reliable performance under difficult conditions such as cold weather.

Electric motors are available in a variety of designs. The five types that are generally

used are: (1) variable speed ("wild"); (2) interlocked; (3) stop frame (time-lapse); (4) constant speed; and (5) crystal speed, which is the most commonly used, especially for sync-sound production. Variable speed motors have an adjustable speed control that may range from 2 to 64 fps or more. (Above 64 fps are considered high-speed motors.) The interlocked motor synchronizes the camera with other devices, such as back or front projectors. The stop frame or time-lapse motor is usually connected with an intervalometer to allow the setting up of whatever exposure intervals are needed for timelapse photography (such as filming the growth of plants). The constant speed motor is designed to run at a set speed, such as 24 fps, with some precision.

The most advanced type of synchronous speed motor is designed with a *crystal control* to regulate the speed with extreme precision. When the camera motor and the tape recorder are both equipped with crystal controls, you can film "in sync" with no cables connecting the camera to the recorder. Furthermore, several crystal control cameras can be held in sync to one or more crystal recorders, allowing for multicamera coverage with no cables to restrict the distances between them. Some crystal control motors even combine several functions, allowing the operator to change from constant speed crystal-sync to variable "wild" speeds or single frame at the touch of a switch. The best controls allow a wide variety of speeds to be shot precisely at crystal-sync, necessary for filming under certain pulsing AC light sources at high frame rates for a slow-motion shot.

BATTERIES

Most 16mm camera motors operate on DC current supplied by batteries. Nickel-cadmium (NiCad) and nickel metal hydride (NiMH) are widely used; lithium ion batteries are becoming more common. Their life expectancy varies, depending on the conditions of use and maintenance, but on the average about five hundred cycles of recharging and discharging should be expected.

There are slow "overnight" chargers that require fourteen to sixteen hours, quick chargers that will charge batteries in half this time, and truly fast chargers that can do the job in one hour.

It is essential to familiarize yourself with the charger on hand. Some chargers will damage a battery when left to charge for longer than required. It is advisable to have at least four charged batteries on hand so that they can be rotated with enough time for slow charging.

Batteries come in three types: *belt, block,* and *on-board.* The battery belt, consisting of built-in nickel-cadmium cells, is a convenient power source for portable 16mm and 35mm cameras, especially when shooting handheld. In situations where mobility is less of an issue, longer-lasting but heavier block batteries may be used. Many modern 16mm cameras use small on-board batteries that clip onto the rear or side of the camera. All Super-8 cameras house the batteries (usually AAs) inside the camera body.

Make sure the voltage of the battery used matches what your camera motor uses. The 16mm Arri SR1 and SR2, and the Aaton XTRprod and A-Minima, for example, use a 12-volt battery, but the Arri SR3 uses a 24-volt battery (as do many 35mm cameras). Many battery belts and block batteries can be switched between 12V and 24V, or between 12V and 16V. Plug into the correct voltage connector on these batteries.

MAGAZINES

Most of the smaller 16mm cameras will house up to 100-foot loads (on metal *daylight spools*) in-

side the camera body. Modern 16mm cameras are usually equipped with film magazines capable of holding up to four hundred feet of film on a plastic core instead of a metal spool. Four hundred feet of film stock in a camera running at 24 fps will give you eleven minutes of footage. The Aaton A-Minima uses a unique 200-foot plastic spool design that must be loaded in darkness. There is an optional 1,200foot magazine for the 16mm Panaflex Elaine and an 800-foot magazine made for the Aaton XTRprod and Arri SR3 cameras.

Having several magazines allows for a more efficient production, particularly when more than one type of film stock is used on a given day. The camera assistant loads several magazines in advance so that the magazine change will slow down the production minimally.

Remember, when considering magazines, the two decisive factors are capacity and design. The shape and placement of the magazine is sometimes important too. For most shooting situations it doesn't matter, but when you are shooting in cramped quarters, such as from the cockpit of a plane or from under a car, the bulkiness of the camera can make a difference. Here a cameraperson may want a camera with magazines that are smaller or that mount to the back rather than the top. The operator may even want to use one of the smaller cameras that only allow the 100-foot daylight spool loads.

Most magazines have to be loaded in total darkness. The smaller loads available on daylight spools require only subdued light when loading; however, these are not generally used in modern sync-sound cameras, as they increase the noise level while the camera is running. Film not on daylight spools necessitates either a darkroom or a changing bag. The changing bag must be of adequate size and absolutely lighttight. It should be stored in a special case or cover to keep it spotlessly clean and dust free. (Don't let your dog sleep on it.) Any hairs, dirt, or dust in the changing bag can easily enter the magazine being loaded and from there travel to the gate. Even the tiniest of dust specks are visible on a 16mm frame because of the higher magnification of the image.

Before loading an unfamiliar magazine, practice loading it with a roll of waste film (called a *dummy load*) that you don't want, first in the light and then in the dark, to simulate the loading of unexposed stock.

Some magazines have their own take-up motors to wind up the film as it reenters the magazine after passing through the camera. Such motors should be tested with a waste roll before the magazine is loaded with unexposed film. Run this test with the battery to be used in filming. This test is advisable because a battery may sometimes have enough charge to run a camera with a small 100-foot internal load or an empty magazine but then fail to operate the magazine and camera when it is loaded.

Also, before loading, clean the magazine with compressed air, camera brush, and a piece of sticky paper in order to remove dust, film chips, or hair, and make sure that the rollers are moving freely. (Never wear a fuzzy or hairy sweater when cleaning camera equipment or in the darkroom.) It is a good idea to do a scratch test where you run some new film through the camera to see if the magazine or the gate is scratching the film. You examine the strip of film afterward with a light and magnifier to look for any faint abrasions in the surface of the emulsion or base. Obviously this piece of film becomes waste at this point, having been exposed to light.

After loading the magazine it is advisable to seal the lid with 1-inch camera tape. This is partly to prevent light leakage on old magazines, but mainly to prevent an accidental opening, especially if the loaded magazine is dropped. When you are loading magazines in a hurry, it is easy to confuse loaded ones and unloaded ones. Taping and labeling the loaded magazines immediately after loading will save you the annoyance of opening a supposedly empty magazine and ruining a roll of film.

It is customary to stick a piece of 1-inch white tape on the side of the magazine with the following information:

- number of that magazine
- camera roll number
- type of film stock
- emulsion and batch number
- length of the roll
- date
- title of the film
- name of the production company

This will help in the preparation of a camera report to accompany the film to the lab. Later this label is often taken right off the magazine and put onto the film can holding the exposed roll. You might also put a label on the magazine with special processing instructions, such as PUSH ONE STOP, as a reminder to everyone using the camera and to whoever later writes the camera reports and work order for the lab.

Despite the most careful cleaning and loading, even the finest camera designs will occasionally jam. The film will stop advancing somewhere along its path and the oncoming film will continue to pile up at that point, creating a "salad" of twisted and folded film. If the camera jams, remove the film from the camera interior, checking carefully to see that chips of broken film are not stuck in the gate, around the registration pin, or anywhere else. Remove the magazine to a darkroom or put it in a changing bag. You will need a spare take-up core or spool (whichever you already have in the camera) and a can with a black paper bag to unload the exposed film and rethread the magazine.

Never spool up any film with broken sprocket holes. It may jam in the processing machine in the lab and ruin a considerable amount of footage, not only yours but other customers' as well. Generally you would feel the edge of the film in the dark and snip off the part of the roll where the perforations have been broken. If you can't find the torn perf but suspect any damage inside your roll of film, write a warning clearly on the can to alert the lab technicians.

One simple procedure that helps prevent camera jams is to make sure there is no slack between the take-up roll and the sprocket roller. If there is, when the camera starts the take-up motor may snap the film taut, breaking it or causing the camera to "lose its loop" and become improperly threaded. There is usually some way of rotating the take-up roll to make it taut before you start to shoot. On the Arri SR cameras, for example, there is a button labeled "Test" that you are supposed to hit whenever you load a new magazine onto the camera. It gently engages the claw into a sprocket hole so that when you run the camera, you won't immediately damage a perf. On other cameras, you may want to manually inch the film through the movement to make sure that the loops are the correct size and that the claw is properly engaging the sprocket hole before you then trigger the camera motor.

Some magazines, instead of using a plastic core to take up the exposed film, use a metal *collapsible core*. Be sure not to send the roll to the lab with the collapsible core still in the center. When unloading a magazine, unclasp the collapsible core and gently lift up the roll with one hand on the inner edge and one on the outer edge. Do not let the center of the roll drop, which is called "coning" the roll and is very

tedious to fix: you'd have to rewind the roll by hand in total darkness. Some magazines also have a center part that covers the spindle but holds the plastic core. Don't pull this center piece off and send it to the lab along with your film. This is very important. If you send this costly little piece to the lab, you will have trouble trying to reload the magazine without it.

Super-8 film comes in cartridges and cassettes. Not much can be done if a cassette jams, but you can help prevent jamming by making sure the cassette fits easily into the camera.

LENSES

Beginners in filmmaking are quite often confused by the various aspects of camera lenses. They are intimidated by the mathematical formulas that appear in many photography books whenever lenses are under discussion. But today the filmmaker's life is easier. Readily available tables provide all the information that previously required mathematical computation. Common sense is all you need to understand lenses.

The basic function of a lens can be ex-

plained as a pinhole phenomenon. If you removed the lens from your camera and replaced it with a piece of black cardboard with a pinhole in it, you could take a picture, provided the exposure time was long enough. The picture on film would be upside down and the sides would be reversed. This is the first thing one should know about lenses: they produce images that are reversed both vertically and horizontally. The advantage of the lens over the pinhole is that while a pinhole allows only a very small amount of light to reach the film, the lens collects more light and projects it onto the film. In this way, shorter exposure times and sharper pictures are achieved.

F-stops and T-stops

The maximum amount of light a lens is capable of transmitting depends on the diameter of the lens and the focal length. By focal length we mean the distance from the optical center of the lens to the film plane when the lens is focused at infinity. The focal length divided by the diameter of the lens gives us a measure of the maximum aperture. It's quite simple. For exam-

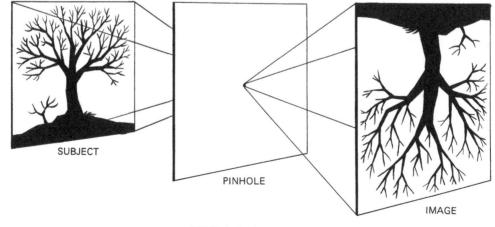

1.10 Pinhole phenomenon.

ple, a lens 1 inch in diameter with a focal length of 2 inches will pass the same amount of light as a lens 3 inches in diameter with a 6-inch focal length, because the maximum aperture, or f-stop, for both lenses is f/2 ($2 \div 1 = 2$; and $6 \div 3 = 2$ also).

We can reduce the amount of light by means of an iris placed in the lens. By closing the iris we reduce the effective diameter of the lens, thus reducing the amount of light passing through the lens. Now the f-stop equals the focal length divided by the *new* diameter created by the iris. Therefore, if a 2-inch focal-length lens has an iris adjusted to a $\frac{1}{2}$ -inch opening, the f-stop is f/16, because $2 \div \frac{1}{2} = 16$. A 4-inch lens with a $\frac{1}{2}$ -inch iris opening would also be f/16, because $4 \div \frac{1}{2} = 16$.

So the f-stop calibration is not merely a measure of the iris opening, but instead expresses the relationship between focal length and iris.

It is important to note that the smaller the iris opening, the more times it can be divided into the focal length. Therefore, as the iris opening becomes smaller, the f-stop number becomes higher. So a lower f-stop number means more light (a larger opening), and a higher f-stop number means less light (a smaller opening).

F-stops are calibrated on the lens. They are commonly 1, 1.4, 2, 2.8, 4, 5.6, 8, 11, 16, and 22. *Each higher f-stop cuts the light by exactly half.* For example, f/11 allows half as much light as f/8. Conversely, f/8 allows twice as much light as f/11. If the difference is more than one stop, remember that the light doubles between each stop. So f/4 will yield eight times as much light as f/11, because f/8 is twice f/11, f/5.6 is twice f/8, and f/4 is twice f/5.6. Therefore, f/4 is eight times more light than f/11, because 2 × 2 × 2 = 8. It doubles with each step.

Some lenses have *T-stops* as well as f-stops. The two are almost equivalent. T-stops are more precise because they are calibrated for the individual lens. Because some light can be lost as it passes through the various elements in the lens, not every lens will produce exactly the same exposure if set to the same f-stop. So the lenses are individually tested with a light meter to determine how much light is transmitted at various settings, and the f-stop mark is adjusted on the barrel of the lens to compensate for any light loss. Since f-stops are determined by a mathematical formula and are not calculated for the individual lens, the new mark is called a T-stop. Therefore, we should consider T-stops as very accurate f-stops. When calculating the exposure or consulting the tables, f-stops and T-stops can be considered equivalent.

Lens Speed

The lowest (widest) f-stop setting will vary between lenses, depending on their focal lengths and diameters. For example, one lens may start at f/1.9 and another at f/3.5. (Often, as in these cases, the starting number is in between the usual calibrations.) *Lens speed* refers to the widest setting (lowest f-stop) a lens is capable of. For example, a lens that opens to 1.9 is a relatively "fast" lens, and one that opens only as far as 3.5 is a relatively "slow" lens. Because telephoto lenses are longer, their diameter will usually divide several times into their focal length, making their lowest f-stop high. Therefore, telephoto lenses tend to be slow, while wide-angle lenses tend to be fast.

Coatings

Often, some or all of the glass elements of a lens are coated with a substance that reduces glare and internal reflections that would normally make a lens less efficient. These coatings allow modern lenses to be pointed into bright lights with a minimal amount of flaring compared to

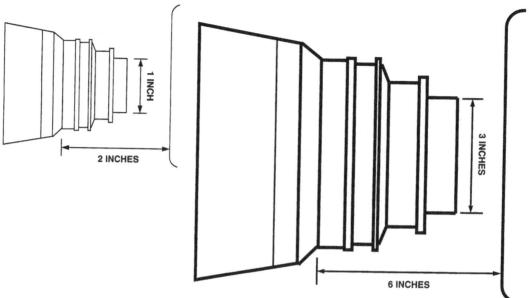

1.11 Two lenses of equal maximum aperture ("speed").

older lenses with very few elements coated, if any. Coatings also help improve the speed of the lens; without the coating, some light transmission would be lost due to internal scatter.

Optimal Range

Every lens has an optimal range of f-stops that yield the sharpest image. This usually starts about two stops from the widest opening and runs to about f/11 (in other words, the middle range of f-stops are preferred). Below and above this range the lens will tend to produce slightly less sharp images. Stopping down extends the depth of field, but beyond f/11 or f/16 the maximum resolution decreases due to diffraction around the small iris opening, thereby canceling out the increase in sharpness. This is especially true of wide-angle lenses. Most professionals when shooting indoors like to set the f-stop somewhere in the optimal range (for example, f/4) and then adjust the light levels for the proper exposure. Testing is

vital to determining the f-stops where the lens performs the best; occasionally you come across lenses that have been designed to look their best when shot nearly wide-open, for example.

Focusing

Apart from f-stops, nearly every lens has a calibrated ring representing focusing distances. The exceptions are some very wide-angle lenses, such as 10mm and shorter, that have a "fixed focus"—that is, there is no need to adjust focus. With a well-adjusted reflex viewing system we can focus quickly and accurately by rotating the focus ring while looking through the lens, especially if the camera has a large, bright, and clear viewfinder image. Another method, used particularly in older cameras without reflexive viewing systems, is to measure the distance between the subject and film plane (marked on the camera by the symbol ϕ) and set the focus ring accordingly.

The settings achieved by focusing by eye

1.12 Focal distances are measured from the subject to the film plane, sometimes indicated on the camera body by the mark.

through a reflexive viewing system and by measuring and turning the focus ring may not agree. This may be due to a slight inaccuracy in the focus ring adjustment. In such cases, *if the viewing system is accurate*, you should depend on that rather than on the focusing calibrations.

Ideally, though, your camera, viewfinder, and lenses have been tested and adjusted so that tape measurements and the focus set by eye match each other.

Zoom Lenses

The cinematographer uses a variety of focal lengths. Older camera designs accommodated three or four lenses on a rotating plate called a *turret*, which allowed for quick changing between lenses. In later cameras the turret gave way to a single-lens design, the *varifocal* or *zoom lens*. It contains a variety of focal lengths and allows you to move continuously between them as you rotate the "zoom" ring of the lens. After the zoom lens was invented, the term *prime lens* was coined to describe an ordinary fixed focal length lens.

The first thing to be considered when describing a zoom lens is its range—for example, 12mm to 120mm. We can also express it as a ratio, in this case one to ten (1:10).

The Angenieux 12–120mm achieved great popularity in the 16mm film industry in the 1960s. A 10mm prime lens became its customary companion. Lenses like the Angenieux 9.5–95mm, the Zeiss 10–100mm, and the Cooke 9–50mm followed, representing a better choice to some camerapeople who were willing to sacrifice the telephoto end of the range in order to increase the wide-angle end. New zooms like the Canon 8–64mm and the Zeiss 11–110mm were also introduced to cover the larger Super-16 aperture. (See chapter 2.)

Zooming smoothly is an art. There are many mechanical aids available. Zoom lenses can come with either zoom levers, cranks, or both to allow moderately smooth zooming by hand. For very smooth zooming, though, battery-powered motors are normally used with variable speed controls. One type is operated by two buttons (in and out) or a single rocker switch with speed controlled by separate dial, although it can be modified by the pressure you exert on the rocker switch. Another type features a "joystick." The rocker switch and the joystick design allows one-touch control over both speed and direction.

Some camera operators still prefer to zoom manually by gripping and turning the zoom ring with their hand. If you use this method, you must be careful not to move other rings on the lens, such as the f-stop and focus. If you are concerned about this, you can use a small piece of tape to prevent the f-stop ring from turning.

All zoom lenses require the same focusing procedure: you open the aperture fully to reduce depth of field, zoom all the way in on the subject, and closely examine the sharpness. After focusing, it is easy to forget to return the

f-stop to its proper setting. This is a very common mistake among beginners. The ability to magnify the subject by zooming in, and thus being able to see the focus very clearly, makes focusing by eye much more common when using zooms compared to when using prime lenses, where tape focusing is more common.

Many zoom lenses do not focus as closely as prime lenses. For example, the Zeiss 11–110mm will only focus as close as about 5 feet away, while a 12mm Zeiss Distagon prime lens focuses down to 8 inches. However, there are zooms that focus as close as 18 inches.

Zoom lenses by their nature have many more glass elements than do prime lenses. They are therefore more prone to flaring and losing contrast when light shines into them. They also can *breathe* when the focus is changed during the shot; as the glass elements move to change the focus, the focal length is altered slightly, creating a mini-zooming effect that looks like the frame is "breathing." Some zooms have been designed to minimize or eliminate that artifact. Despite these problems and their complex design, modern zoom lenses, when stopped between f/4 and f/11, are nearly as good optically as prime lenses.

Optical Attachments and Close-up Work

For close-up work, *macro lenses* focus as close as a few centimeters away without the use of special attachments.

Regular lenses require one of several types of attachments in order to focus more closely than they're designed to.

Extension tubes or bellows can be used to focus practically as close as the front element of the lens. They are introduced between the lens and camera body. But because extension tubes and bellows upset the normal optics, they cannot be used with optically complicated lenses, including all zooms and many wide-angle lenses. When the subject is closer than ten times the focal length of the lens, an exposure compensation is required and depends on the rate of extension.

The correction can be found in tables supplied with the devices or in the *American Cinematographer Manual*.

Another way to focus more closely is through the use of close-up attachments called diopters. Sometimes incorrectly referred to as filters, these are actually small single-element lenses that attach to the front of the lens in use. Their convex side faces the subject. The small arrow on the rim should point away from the camera. Diopters come in series (+1, +2, +3,etc.). Each higher number allows for closer focusing. When diopters are combined, the higher number should be closest to the camera. No exposure compensation is required. Compared to extension tubes, bellows, or macro lenses, diopters are the least satisfactory as far as optical quality. Yet unlike extension tubes or bellows, diopters can be used on zoom and wide-angle lenses. And they are a relatively low-cost alternative to renting or buying a macro lens.

A *split-field diopter* covers only half the lens (it's basically a diopter cut in half), enabling the camera to be focused very close on one side of the frame and far away on the opposite side simultaneously. It is frequently used in commercials, where, for example, the soap package may be in the foreground with a housewife using it in the far background. The one drawback is that the fuzzy line at the split of the diopter must be hidden by lighting and composition. Also, zooming becomes difficult and panning impossible.

There are other optical attachments in current use. The magnification of a telephoto or zoom lens can be increased with a telephoto *ex*-

tender. For example, a 200mm lens may be made into a 400mm. Such attachments require two stops additional exposure each time the focal length is doubled. When a telephoto extender is used, the best resolution is usually obtained when the lens is stopped down (around f/11). The usual focal lengths of some zooms can also be shortened by retro-focus wide-angle attachments, and these do not require an exposure compensation. However, camerapeople usually do not like either telephoto extenders or retrofocus attachments, as they soften the picture, decreasing the resolution.

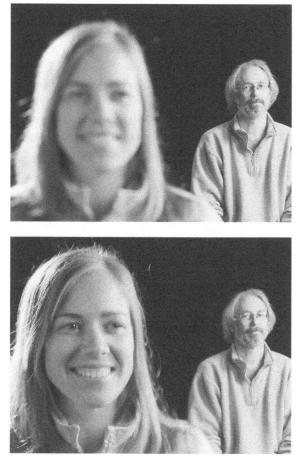

1.13 Split-diopter effect. A: no attachment. B: split-diopter attachment.

Tilt-Focus Lenses

Also called *slant-focus* lenses, these are an alternative to using split-field diopter attachments; they are built to pivot (bend) near the rear element, causing the focus to fall at a diagonal to the film plane. In other words, instead of only a single distance being in focus at a time, the focus falls on near objects at minimum focus at one end of the frame but on far objects at the opposite end of the frame. So you could put a row of objects on a receding diagonal to the camera and have them all fall into focus for a faux deep-focus look. The advantage over a split-field diopter is that there's no fuzzy line where the split occurs. You could do the same thing with a normal lens and a bellows attachment, but the single tilt-focus lens is a lot simpler to use.

Anamorphic Lenses

Although this primarily only concerns people shooting in 35mm, it is useful to understand what this type of lens is. The concept dates back to Dr. Henri Chretien and his invention of the Hypergonar lens, the precursor to CinemaScope in the 1950s. It involves using a single cylindrical lens element in the lens (in front or in the rear) to squeeze a horizontally wider image area onto the film, to be unsqueezed later by a matching anamorphic lens on a projector. For video transfers, the image can be unsqueezed electronically. After anamorphic lenses were introduced, the term *spherical* was coined to describe traditional nonanamorphic lenses.

Usually, 35mm anamorphic optics have a $2 \times$ squeeze (compression) factor. What this means in practical terms is that a 40mm anamorphic lens, for example, "sees" the same area horizontally that a 20mm spherical lens would, but vertically it sees what a 40mm

spherical lens would. While it is possible to put an anamorphic lens on a 16mm camera, especially if it has the same PL mount (see figure 1.14) common to modern 35mm cameras, the $2\times$ compression creates some nonstandard aspect ratios. (See chapter 2.)

Lenses with a front anamorphic element have some unique optical properties: (1) bright points of light shining into the lens will create a blue horizontal line across the frame; and (2) as objects in the background fall out of focus when racking to the foreground, the compression back there becomes greater than $2\times$, making the background objects look skinnier. Out-offocus points of light that would normally be a circular "blob" now appear to be vertical ovals in shape.

Lens Mounts

18

Among 16mm cameras with changeable lenses, there are four common lens mounts. The

C-mount is the smallest and therefore the least strong and most sensitive. The *Arri mount* is stronger and positively locks into the camera. As lenses got larger and heavier, the *Arri bayonet* was introduced, a subsequent improvement over the regular Arri mount. A bayonet lens attaches to the camera even more securely and accurately. The regular Arri lenses will fit into either the bayonet or the regular Arri lens sockets, but a bayonet lens requires a bayonet socket and will not fit into a regular Arri mount.

But the larger and stronger *Arri PL (positive lock) mount* used for their 35mm cameras is now commonplace on many 16mm cameras; the main advantage is that it allows the same lenses to be used on either a 35mm or 16mm camera package.

There are many other types of mounts; Aaton, Eclair, and Cinema Products cameras have their own types of mounts, although many can be adapted to use one of the Arri mounts.

1.14 Lens mounts. From left to right: Arri PL, Arri Bayonet, Regular Arri, and C-mount.

OPTICS

Depth of Field and Circles of Confusion

If we were to photograph only one distant point, such as a light, the lens would be in focus when it projects a point onto the film.

Because the lens can be focused for only one distance at a time, objects closer and farther away will be slightly out of focus. In figure 1.15 a second, closer light would have its image formed behind the film plane and be represented on the film as a circle. A third light, farther away, would form its image in front of the film plane and also appear on the film as a circle. These circles are called *circles of confusion*, and they vary in size depending on how far out of focus they are. The "confusion" is that circles smaller than $\frac{1}{1000}$ inch in diameter confuse our eye and are seen as points in focus. This allows us to see pictures of three-dimensional objects that appear in focus. We have a range in which objects will appear sharp. It runs between the closest and farthest objects represented as circles of confusion smaller than $\frac{1}{1000}$ inch. This range is called *depth of field* (and is sometimes incorrectly called depth of focus).

The depth of field varies with the effective diameter of the lens opening and hence with the f-stop. By "effective diameter" we mean the actual size of the iris opening, not the f-stop number. If you want to change lenses without changing the depth of field, you must use the same iris opening, which will be a different f-stop. For example, an 8-inch lens shooting at f/4 has a 2-inch-diameter iris opening. If you now want to change to a 4-inch lens and retain the same depth of field, you must shoot with the same 2-inch-diameter iris, which for your 4-inch lens is f/2. This is a rare problem, and if it ever comes up, consult a depth of field chart. The above example is offered to illustrate that depth of field is dependent on the iris opening.

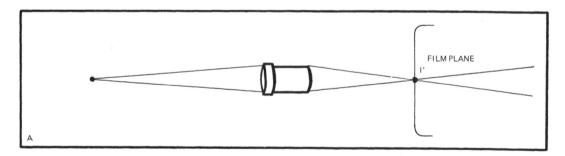

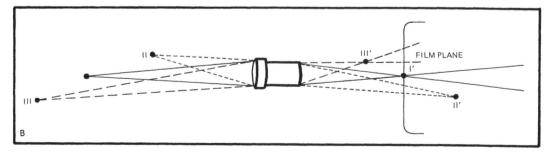

1.15 A: One point focused on the film plane. B: Lens focused on Point I. Points II and III will appear out of focus.

Greater depth of fieldLess depth of fieldWide-angle lensesTelephoto lensesHigh f-stop (smallLow f-stop (wide
aperture)aperture)aperture)Subject far away from
cameraSubject close to camera
cameraSmall film format (such
as Super-8)Large film format (such
as 35mm)

This chart shows the general principles that govern depth of field:

With greater depth of field, more elements in the picture are in sharp focus. This causes the image to appear harder. There is also an impression of higher contrast. This is because when a background is out of focus, the bright highlights and the dark shadows tend to blend into a muddle of midrange values, so when they come into sharp focus, the high and low brightness values are more prominent.

Depth of field characteristics for lenses of various focal lengths, under different f-stop and focus settings, are available in many publications, including the *American Cinematographer Manual* (see figure 1.17 for an example). Given the focal length and f-stop and the subject-to-film-plane distance, we can determine the range of the depth of field and the dimensions of the *field of view* at that distance.

For each lens and f-stop the chart also gives the *hyperfocal distance*. This is the point of greatest depth of field. It is a precalculated figure indicating that if the given lens at the given f-stop is focused at this hyperfocal distance, everything from half this distance to infinity will be in "acceptable" focus. For example, if for a given lens and f-stop the hyperfocal distance is 20 feet, by focusing at 20 feet we would obtain everything in focus from 10 feet to infinity. A similar principle is valuable when "splitting the focus" between two objects at different distances. They will both be equally sharp if we focus for a point not halfway between them but a third of the separation distance from the closer object. For example, two objects at 10 and 16 feet respectively would both be equally in focus if you were to focus for 12 feet. This is often referred to as the *one-third-distance principle*.

Depth of Focus

Not to be confused with depth of field, *depth of focus* refers to the distance in front of or behind the focal plane at which the film can be situated and still produce a sharp image.

Unlike depth of field, depth of focus actually decreases for wide-angle prime lenses or the wide-angle end of a zoom lens. Therefore, the distance between the back of the lens and the film plane, sometimes referred to as the *back focus*, becomes extremely critical. Lenses must be seated properly in their mounts. Even something like a behind-the-lens gel can be thick enough to throw the focus off on a very wide-angle lens at a wide aperture.

Focal Lengths and Perspective

Perhaps the most important physical element related to creative lens use is *perspective*. A lens that is "normal" for a given film gauge will reproduce reality with perspective similar to that seen by the human eye. In the case of 16mm film, a 25mm lens is normal. In Super-8, a normal lens is about 12mm, and in 35mm film, a normal lens is 50mm. Of course, what is "normal" is highly subjective; for example, humans have a wider field of view than what a 50mm lens provides on a 35mm camera, so for some filmmakers, a wider-angle lens seems to recreate human perception more naturally. Also,

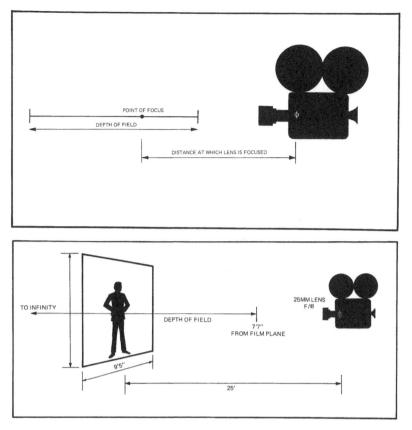

1.16 Depth of field.

16mmCAMERADEPTH-OF-FIELD,HYPERFOCALDISTANCE& FIELDOFVIEWLENSFOCALLENGTH:25mmCircle of Confusion = .001" (1/1,000")(Field of View is based on FULL 16mm Aperture: .402" x .292")											
Hyperfocal Dist.	36'8''	28'10''	20'2''	14′5″	10'1''	7'4''	5'0''	3'8''			
	f/2	f/2.8	f/4	f/5.6	f/8	f/11	f/16	f/22			
LENS FOCUS (FEET)	NEAR FAR	NEAR FAR	NEAR FAR	NEAR FAR	NEAR FAR	NEAR FAR	NEAR FAR	NEAR FAR	FIELD OF VIEW		
50	22'9'' INF.	19'6'' INF.	15'1'' INF.	11'8'' INF.	8'8'' INF.	6'6'' INF.	4'8'' INF.	3'6'' INF.	14'2"x18'9"		
25	16'6'' 161'	14'9'' INF.	12'1'' INF.	9'9'' INF.	7'7'' INF.	5'11'' INF.	4'4'' INF.	3'3'' INF.	7′1″x9′5″		
15	10'8'' 25'2''	9'11'' 30'11''	8'8'' 56'9''	7'5'' INF.	6'1'' INF.	5'0" INF.	3'10'' INF.	3'0'' INF.	4'3''x5'8''		
10	8'0'' 13'8''	7′5″ 15′2″	6′9′′ 19′6′′	5'11'' 31'6''	5'1" INF.	4'3'' INF.	3'5'' INF.	2'8'' INF.	2'10"x3'9"		
8	6'7'' 10'2''	6'3'' 11'0''	5′9″ 13′1″	5′2″ 17′6″	4'6'' 35'10''	3'10'' INF.	3'2" INF.	2'6'' INF.	2'3"x3'0"		
6	5'2'' 7'2''	5'0'' 7'6''	4'8'' 8'5''	4'3'' 10'1''	3'10'' 14'3''	3'4'' 29'4''	2'9'' INF.	2'4'' INF.	1'6"x2'0"		
5	4′5″ 5′9″	4'3'' 6'0''	4'0'' 6'7''	3′9′′ 7′6′′	3'4'' 9'7''	3'0'' 14'8''	2'7'' INF.	2'2'' INF.	1'5"x1'10"		
4	3'7" 4'5"	3'6'' 4'7''	3'4'' 4'11''	3'2'' 5'5''	2'11'' 6'5''	2′8′′ 8′5′′	2'3'' 16'9''	1'11'' INF.	1′1″x1′6″		
3	2'10'' 3'2''	2'9'' 3'4''	2'8'' 3'6''	2'6'' 3'9''	2'4'' 4'2''	2'2'' 5'0''	1'11'' 7'1''	1′9′′ 8′2′′	9"x12"		
2	1'11'' 2'1''	1'11'' 2'2''	1′10′′ 2′3″	1′9′′ 2′4′′	1′8″ 2′6″	1'7'' 2'9''	1′5″ 3′3″	1′3″ 3′10″	6"x8"		

1.17 Sample depth-of-field chart. (Courtesy of American Society of Cinematographers)

since the matted wide-screen projection format crops the 35mm frame to a smaller rectangle, a 35mm might be used instead of a 50mm for a "normal" perspective.

Lenses shorter than normal for a given film gauge are considered *wide-angle*, and those two or more times longer are *telephoto*.

Picture perspective is frequently misunderstood; it depends on the camera-to-subject distance and not on the lens. From the same distance, three different lenses—wide, normal, and telephoto—change the area of view but do not change the perspective. By using the same three lenses and changing the distances to the subject, we can retain the same field of view but with different perspectives.

One can see from figures 1.19 to 1.26 that a wide-angle lens exaggerates or elongates depth and a telephoto collapses or compresses it. For example, a person walking toward the camera will seem to approach faster with a wide-angle and slower with a telephoto. This is caused by the distance, not the lens. In a telephoto shot the person is almost always farther away than in a wide-angle shot. When similarly framed, the person walking toward the telephoto may be 25 yards away, while the person moving toward the wide-angle lens is only 5 feet away. If the

wide-angle approach is redone at 25 yards, the person (very small in the frame) will move just as slowly as with the telephoto. Therefore, remember that the degree of distortion is controlled by the distance, not the lens.

This is further illustrated in figures 1.27 to 1.34 by a comparison between the effects of zooming and dollying. When you dolly, the spatial relationship between the objects in the frame—that is, the perspective—changes because the distances change. When you zoom, the focal length changes, yet the effect is like a gradual enlargement of one part of the frame without any change in perspective. For this reason, a zoom effect has a flat look.

To make a zoom movement appear more three-dimensional, it can be combined with a slight camera movement up, down, in, out, or to one side. A panning movement also helps, in addition to zooming past or through a foreground, such as a row of trees or a picket fence, that goes out of the picture as you zoom in. Other times a flat effect may be desired. In this case the cameraperson should make a point of avoiding foreground objects and keeping the camera rigidly framed while zooming; otherwise the flat effect will be diminished.

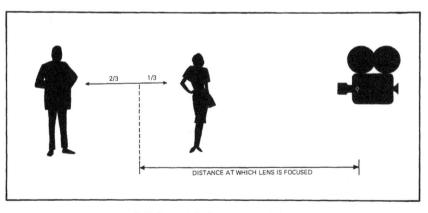

1.18 One-third-distance principle.

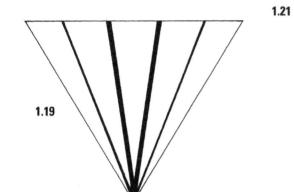

1.19–1.22 Long, medium, and wide-angle lenses used from the same position. Note that there is no change in perspective. *(Photos by Bob Rogers)*

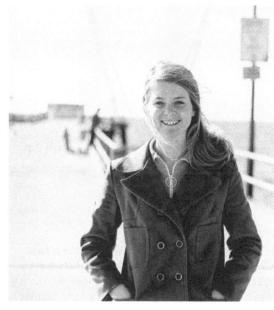

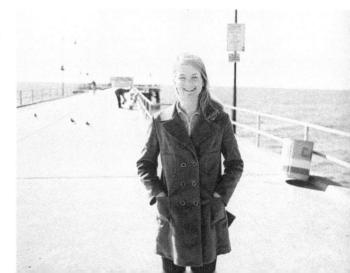

0 0

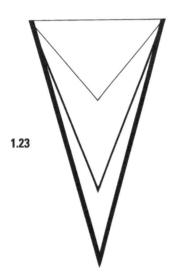

1.23–1.26 Long, medium, and wide-angle lenses used at different positions to obtain similar framing. Note the perspective changes as the distance changes. Also notice the depth of field diminishing with longer lenses. *(Photos by Bob Rogers)*

1.26

1.25

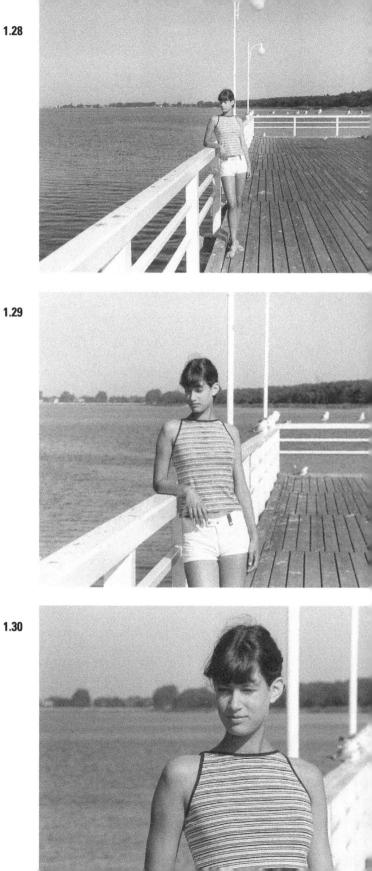

1.27–1.30 Zoom effect. Note the lack of changes in perspective. (Photos by Wojciech Plewinski)

1.30

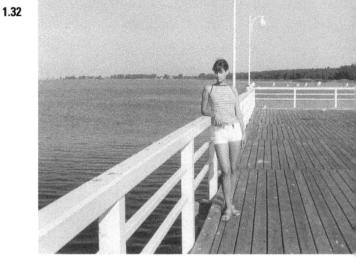

1.31–1.34 Dollying effect. Note the visible changes in perspective. Because a wide-angle lens was used, the close-up was taken at a short distance, resulting in facial distortion. *(Photos by Wojciech Plewinski)*

1.33

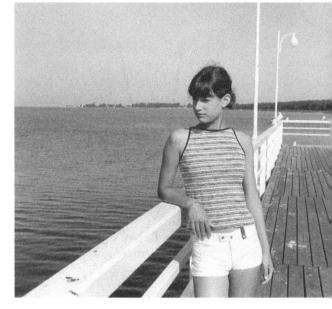

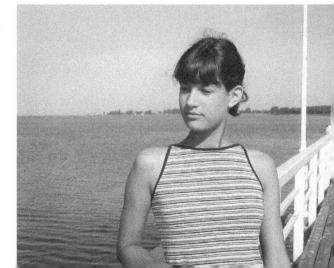

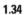

PRACTICAL LENS USE

No lens will yield high-quality results unless it is given proper care and attention.

In all cameras, lens performance depends to a great extent on the viewing system. If prisms in this system are loose or the eyepiece is not adjusted to the operator's sight, even the most excellent lenses cannot be expected to give satisfactory results. The best way to adjust the eyepiece is to remove the lens, point the camera toward a uniformly bright area (sky, wall, etc.), and after loosening the evepiece locking ring (if there is one), rotate the eyepiece adjustment until the grain of the ground glass or the engraved lines in the viewing system appear sharpest to your eye. Then tighten the locking ring to keep this setting from drifting. In cameras with nonremovable lenses, adjust the eyepiece while aiming at a distant object, focused at infinity and with the f-stop wide-open. The eyepiece is designed so that camera operators who wear glasses can usually adjust it for their eyesight and shoot without glasses. If not, a few eyepieces allow additional diopters to be added internally to increase the range they can be focused. If the eyepiece cannot be altered in this way, a special diopter with a rubber eyecup can be fitted over the end of the viewfinder.

As mentioned earlier, when using a reflexive viewing system, the eyepiece must be covered while the camera is running. Usually, camera operators cover it with their eye while shooting, but if they should take their eye away during the shot, or if the camera is mounted for a shot without an operator (such as on the bumper of a racing car), the eyepiece must be covered or light will enter it while the camera is running, travel through the system, and fog the film, ruining the shot. This is very important. Many cameras have some provision for closing off the eyepiece. The Arri S has a small door that swings shut across the eyepiece. Many cameras have an internal door that blacks out the viewing system when the operator turns a knob on the side of the viewer near the front of the camera. As an extra precaution, a piece of black tape might be used to cover the end of the viewfinder. A light, ghostlike apparition and an overexposed effect on the film are possible signs of light entering the viewfinder.

Lens Support Systems

Long and heavy lenses, such as 250mm or more (especially in C-mount), should rest on a lens support to prevent their length and weight from wrenching the mount out of alignment. A

27

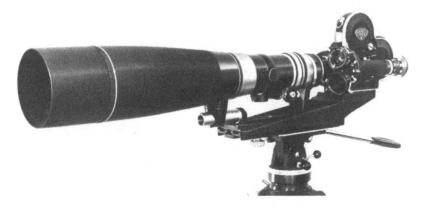

1.35 Arriflex S/B with extreme telephoto lens, supported by a cradle. (Courtesy of ARRI Group)

CINEMATOGRAPHY

support will also be required for the heavier zooms, such as the Angenieux 12–240mm, and also for some of the shorter zoom lenses when they have C-mounts.

The heavier, more sensitive lenses, such as zooms, must be stored and transported in a separate case to prevent jarring the elements. They are also more sensitive to heat. If the zoom is to be stored mounted on the camera, then the case must firmly support the lens in order to avoid straining the mount.

Front rods or *support rods*, usually two of them, are often used to support heavier lenses, the matte box, zoom motor, and follow-focus device. Some cameras have built-in slots for front rods, either at the base or on one side of the camera. Other cameras require an adapter plate with front rod slots.

Matte Boxes

A rigid *matte box* or rubber *sunshade* is mounted in front of the lens to shade it from unwanted direct light. The matte box is usually equipped with slots to hold filters. Sometimes it will have a hinged metal flap sticking out on top to further flag off the light, called an *eyebrow* or *sunshade extension*. There may even be flaps on the left and right sides that can be attached. When longer lenses are used, sometimes a rigid cover can be added in front with a cutout rectangle just large enough to not be seen inside the picture area. This is called a *hard matte* and is usually labeled to identify which focal length lenses it can be used with. Again, the point is to further limit any stray light from hitting the lens or the filters.

The most common-size rectangular glass filters used are $4" \times 4"$, $4" \times 5"$ (actually 5.65"), and $6" \times 6"$ (actually 6.6"), so there are matte boxes made to accommodate each type. These matte boxes also have a rear holder for a round filter such as a polarizer or a diopter. Some allow you to rotate the rear element and one or more of the rectangular trays. Some of the largest matte boxes allow the filter tray section

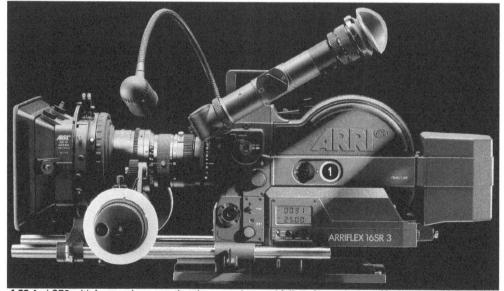

1.36 Arri SR3 with front rods supporting the matte box and follow-focus device. (Courtesy of ARRI Group)

to be tilted forward or back to remove internal glass reflection problems. The filter tray slots may also be geared so that you can smoothly raise or lower the filter by turning a knob, either manually or electronically. You can use a smaller filter in a larger matte box by using an adapter tray.

Follow-Focus

Camera operators or camera assistants have a hand on the focus adjustment all the time, ready to compensate for any subject movement. If the camera-to-subject distance changes during the shot, the operator, looking through the viewing system, can readjust the focus. This is called "following" or "pulling" focus. Industry practice is to use a camera assistant, also called a focus-puller, rather than the operator to make the focus adjustments during the shot, following tape measurements and marks made on the floor during rehearsal for the actors—and relying on experience should the actors fail to "hit their marks." A combination of fast-moving actors and a dolly or handheld camera can require a considerable amount of agility, ingenuity, and educated guessing at times on the part of the focus-puller.

The focus, zoom, and f-stop rings on most lenses have a toothed edge to allow geared devices to be attached to turn these rings without the hands having to grab the lens barrel. The most common attachment is the *follow-focus* unit, which allows the focus-puller to turn a knob that in turn rotates the focus ring. This knob is covered with a white plastic disk that may be marked by the focus-puller using an erasable marker to indicate specific focus points relevant to the shot. Or the focus-puller will mark the lens barrel directly, either with a white pencil or with a pen on a narrow strip of tape added around the barrel.

Stop Pulls

This is the practice of adjusting the f-stop position during the take to make an exposure change. It's often a last-resort solution to a lighting problem; for example, when moving from outdoors to indoors, there may be many stops of brightness difference to compensate for even after the interior has been lit. Since changing the f-stop in midshot usually causes an obvious shift in exposure, the camera assistant will try to make the pull when the camera is moving from one area to another, hoping the change in background will "hide" the pull.

Lens Maintenance

You can clean a dirty lens, but there's not much you can do with a scratched one. So it is wise to clean lenses carefully.

A stream of clean air, such as from an air syringe, is by far the safest way to clean a lens. Remember that canned compressed air must be used in an upright position; otherwise it may spray a gluey substance onto the lens.

A very soft brush, such as one made of camel's hair, is second on the list. It must be used *only* for lens cleaning. Avoid touching its bristles, as fingers are naturally greasy. Since all brushes shed, your soft lens brush should not be used on the camera, gate, or magazines: the fine, flexible hairs of a lens brush will "travel" in the camera and may end up getting wound into moving parts. A brush for camera cleaning should have stiffer bristles that are less apt to be wound into the machinery.

When using a lens brush or air, always hold the lens facing downward so that the dust does not resettle on the lens. This helps when cleaning cameras and magazines too.

Fingerprints and other stains will have to be removed with a photographic lens tissue. (*Never*

use a silicone-coated tissue such as those sold by optometrists for cleaning eyeglasses, because it may permanently discolor the lens coating.) Before using, moisten the lens tissue with a special lens-cleaning solution. Use the solution sparingly; too much may partly dissolve the cement holding the lens elements. Do not apply the cleaning solution directly to the lens. Special solutions are available from camera shops, or you can use isopropyl alcohol (91 percent or higher). Rubbing alcohol is not recommended because it contains menthol and other ingredients that will be left on the lens by the evaporating alcohol. One excellent way to use the lens tissue is to roll it like a cigarette, break it in half, and use the fuzzy end like a brush.

Lenses should be kept clean at all times, even when stored, because fingerprints and other stains left on the lens for long periods may become imbedded in the blue coating of the lens.

One of the most sensitive parts of a lens is its mounting. For proper optical alignment with the film, the lens must be precisely locked onto the camera. Much care must be taken to make sure this mounting is not wrenched out of alignment. Repairing such damage is expensive and time-consuming and may never restore perfect mounting.

Because zoom lenses and some wide-angle lenses are of retrofocal design—a complicated optical configuration—they are vulnerable to even the slightest mounting inaccuracy. A retrofocal design is desirable because it permits a larger physical lens size for more expedient handling, while retaining a short focal length. For example, a 5.7mm lens is usually about 4 inches long. If it were actually only 5.7 millimeters long, it would be a very inconvenient size. In the case of zoom lenses, the increased size is necessary to accommodate the wide-angle end of the zoom range. (Retrofocal limitations prevent us from using extension tubes or bellows with zooms and some wide-angles.)

If a zoom lens is imprecisely mounted, it may not remain in focus when zooming in or out. Incorrectly mounted wide-angle lenses will simply not be in focus.

Most Super-8 and some 16mm cameras (like the Canon Scoopic) are manufactured with a permanently mounted zoom lens. This restricts the cameraperson's choice of lenses but does mean the mounting is usually accurate.

CAMERA SUPPORTS

On the screen, any camera unsteadiness becomes very obvious because the picture is being magnified many hundreds of times. To control camera steadiness, many supporting devices and techniques have been developed.

Tripods

These are the most commonly used supports. Three-legged, as their name implies, tripods ba-

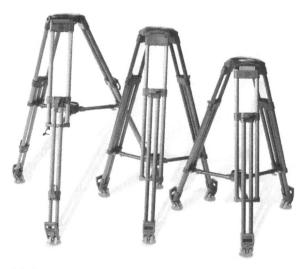

1.37 Tripods: standard legs and baby legs. *(Courtesy of Sachtler)*

1.38 High hat.

sically come in three sizes: standard legs, baby legs, and "high hat." They also come in different degrees of sturdiness for cameras of different weights.

Leg lengths are individually adjustable, so the tripod can be leveled when set up on uneven ground. For older tripods with a vertical locking ring in the center of the leg, you would tighten them by always turning the top of the lock to the outside. Though incorrect, you can tighten the tripod by turning the lock the other way, but serious bending and disfiguration will damage the tripod. Furthermore, it will not be tight and may collapse, ruining the camera as well. Other tripods use a regular locking nut ("tie-down") that tightens when turned clockwise. There are also tripods that use quickrelease clasps instead.

Some tripods are designed for heads with a *ball-joint* leveling base. They usually come in two sizes: 100mm and 150mm. There are also some smaller ball sizes normally used for video cameras that some people use for the smaller 16mm cameras. A ball-joint is very convenient and can save time by allowing the cameraperson to level just the head on top of the tripod without having to adjust the legs perfectly. This device can be dangerous, however, if it is used carelessly. There is a tendency to leave the tripod legs in a precarious imbalance and try to compensate with just the ball-joint, making the weight distribution uneven at the top of the tripod

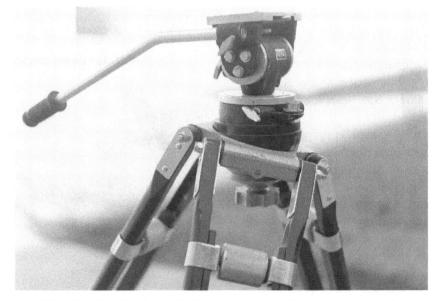

1.39 Ball-joint leveling device. Position is exaggerated for purpose of discussion.

1.40 Tripod shoe.

pod. For safety, the legs must be almost level before the final adjustment is made with the ball-joint. Heavier cameras should use the standard *Mitchell flat-base* instead, because the weight of the camera itself can loosen a balljoint.

The *spreader* is an essential part of the tripod equipment. It locks onto the "shoes" to prevent the tripod legs from slipping. In place of a spreader, you could use camera tape, a rope, or even a piece of rug or heavy cloth. Sandbags are always useful for steadying tripods or stands. Occasionally a length of chain with a turnbuckle can also be used to secure the tripod to a platform. The spreader is needed when the tripod is on a hard surface; when outdoors on grass or dirt, you might use the tripod without

1.41 Spreader.

1.42 Tape used as spreader.

1.43 String used as spreader.

1.44 Blanket used as spreader.

the spreader, with the sharp points at the end of the tripod securely pushed into the ground. Even with a spreader, a tripod might scratch a wooden or tiled floor, so use some protective cardboard or piece of carpeting under the spreader for extra protection to the location.

In situations where baby legs are not low enough or the camera is to be mounted on, say, the top of a ladder, a high hat is practical. Often, C-clamps are used to secure the high hat in such circumstances. A number of other mounts have been developed for a variety of specialized needs, such as rigging the camera to a car.

Tripod Heads

Usually between the camera and the top of the tripod legs, although it can also be used on dollies and cranes, for example, the tripod head allows the operator to smoothly move the camera. Turning the head and camera horizontally is called *panning*, while turning vertically is *tilting*.

The tripod head must be chosen with the camera in mind. Different heads are designed to support different weights. You can take the manufacturer's suggested weight as a guide, but when selecting a head it is always a good idea to test it with the camera mounted to see how it will behave. Maneuverability and smoothness when panning and tilting are important, but equally vital is the "positive lock." Locking can be tested by tilting the camera forward so that it points below the horizon, then locking it in this position. It should remain locked. If the camera is too heavy for the head, it may overpower the lock and continue tilting down until the front of the camera is resting against the tripod leg. The weight of the camera when tilted down that far may cause an imbalance that will pull the tripod over, seriously damaging the camera.

Three basic types of tripod heads are available: friction heads, gear heads, and fluid heads.

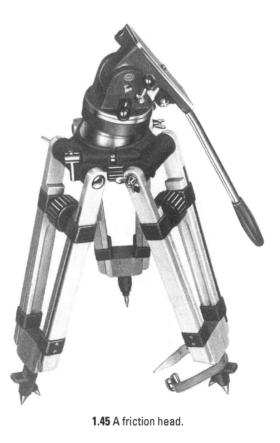

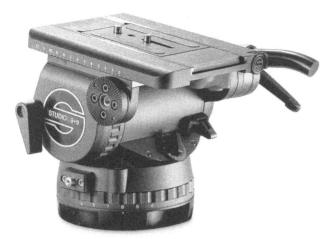

1.46 Sachtler Studio 9 + 9 fluid head. (Courtesy of Sachtler)

1.47 Mini-Worrall gear head. A hinging plate allows for further tilting forward or backward. *(Courtesy of Cinema Products)*

Friction heads, as their name implies, use surface resistance to smooth their movements. Most are made for still cameras and are not smooth enough for motion picture work, but there are some exceptions. Gear heads employ toothed gears and two sets of turning wheels to independently tilt and pan the camera. This takes a lot of skill to use properly but allows a tremendous degree of precision. Developed originally to handle the huge and heavy blimped cameras of the 1930s, they are still mainly used in 35mm. The weight of a camera creates inertia as it moves, something a gear head can easily overcome, making it possible to stop at an exact point after a fast pan or tilt. For most work in Super-8 and 16mm, *fluid heads* are the best. They use adjustable hydraulic resistance to give their movements a smooth flow. On larger productions, both a fluid and a gear head would be rented, because each is better than the other at certain types of moving shots.

Matching the two types of tripod legs, there are two types of mounts at the bottom of the heads, the Mitchell flat-base and *claw-ball* (balljoint). Adapters are available for using these two systems interchangeably.

After setting up the head on the tripod, the camera is mounted by a screw that extends from the head and goes into the bottom of the camera. On some heads, a small base plate with the screw comes off the head and is separately screwed onto the camera. Then the camera, with this mounting plate attached, is locked onto the head. It's a good idea to put a piece of cloth tape on the plate near the screw to reduce any side-to-side slippage between the plate and the camera bottom. There are two sizes of screws: quarter-inch (American) and the larger three-eighths inch (German). Some cameras have two threaded holes so that they can accept either. In addition, a small and inexpensive adapter is available that will enlarge an American screw to German size. This adapter should be a standard accessory carried by all camerapeople.

To make sure all the mounts are compatible, *always* set up the camera on the assembled tripod before leaving the equipment room or rental house. This simple practice will save you many headaches. Don't wait until you're on location to find you have different types of mounts that cannot be put together and no place to get an adapter. This applies not just to tripods but to *all* equipment.

Dollies

For traveling shots, several types of dollies are available. They differ in sophistication and expense.

The Chapman Super PeeWee and the J.L. Fisher 11 are good examples of hydraulic arm dollies that are small enough for location shooting but strong enough for most 16mm and 35mm cameras. There are also lightweight, portable, low-cost dollies that are basically wooden platforms with wheels underneath. For example, the *skateboard dolly* has small rubber skateboard wheels and will roll smoothly on standard pipe track. The *doorway dolly* usually has soft inflatable rubber tires underneath, useful for rolling on uneven or rough surfaces such as a sidewalk or asphalt road (its larger cousin is called a *Western dolly*). Shooting handheld from a wheelchair is also a popular technique for microbudget productions.

Dollies are usually run on steel or aluminum tracks, both straight and curved. Plywood sheets are sometimes laid on the floor and covered with a sheet of smooth Masonite to allow the dolly freedom to move in directions (referred to as a "dance floor" move) not possible with track. Using a wide-angle lens will

1.48 Chapman/Leonard Super Peewee IV Hydraulic Lift Camera Dolly. (Courtesy of Chapman/Leonard Studio Equipment, Inc.)

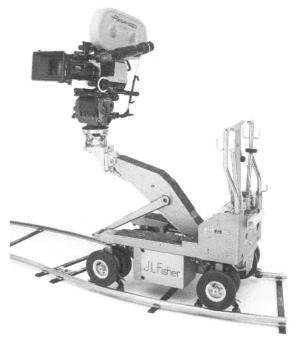

1.49 J.L. Fisher Model 11 dolly. (Courtesy of J.L. Fisher, Inc.)

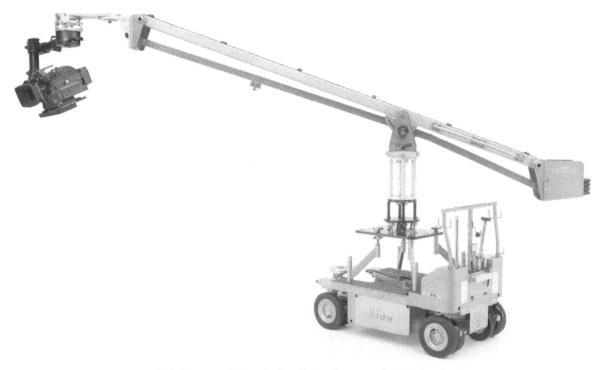

1.50 Jib arm on Fisher Jib Arm Dolly. (Courtesy of J.L. Fisher, Inc.)

1.51 Doorway dolly. (Courtesy of Matthews Studio Equipment, Inc.)

help make a camera move look smoother, which can help if you have to move over a rough surface.

Occasionally an automobile is used as a dolly. In this case, bumps can be smoothed out

by reducing the air pressure in the tires. When filming at a right angle to the direction of vehicle movement, the auto speed appears almost twice as fast as in reality. If necessary, running the camera at a slightly higher speed can smooth out the movement and compensate for the illusion of increased speed.

When shooting from a helicopter or moving car, antivibration devices like gyro stabilizers can be used to steady the camera.

Jib Arms and Cranes

A *jib arm* is essentially a miniature crane, often short enough to be mounted to a standard dolly; it allows the operator greater flexibility and speed, compared to the hydraulic boom arm of the dolly, in raising or lowering the height of the camera. However, it gets difficult to make extreme changes in height while still keeping an eye against the viewfinder, which is why it may be necessary to frame by looking at a video assist monitor instead. Cranes are usually much bigger and heavier, allowing the camera operator and the focus-puller to both sit on a platform at the end of the crane arm. Safety is absolutely essential when working with cranes; the person riding on it cannot step off the platform until the counterbalancing weight in back is adjusted. There have been so many accidents on film sets with cranes collapsing, cranes accidentally touching power lines, and so on that it is becoming more common to put the camera on a *remote-controlled head* at the end of the crane and operate it from the ground.

HANDHELD WORK

When handholding the camera, our principal concern is controlling the camera for the exact

1.52 Aaton XTR resting on operator's shoulder.

degree of steadiness we desire for the effect, whether it be smooth or jostled and vibrating.

Handheld shots can be made steadier by using most of the tricks discussed earlier, such as running the camera at a higher speed or using a wide-angle lens. Jumbled, chaotic subject action is often associated with a handheld shot, such as walking or running through a panicked crowd. Such busy activity in front of the lens will often camouflage jerky camera movements.

Steadiness is not our only consideration in handholding. Sharpness is also a problem. The 24 fps camera speed produces a ¼s-second exposure period, which is long enough to cause a relatively fast subject or camera movement to register as slightly blurred on film. Normally, this is not noticeable because each single frame is not visible long enough on the screen. However, a jerkly handheld camera will contribute to even more pronounced image blur. Thus, resolution suffers when the camera is held awkwardly.

Steady handheld work depends to a great extent on the maneuverability of the camera. Ideally, the camera operator's body and the camera should be as one, yet rough movements should be isolated from the camera. Various body mounts and rigs have been designed to transfer the camera weight from the arms and shoulders and onto the overall upper body, reducing fatigue and allowing subtler camera operating adjustments.

The highest sophistication in camera stabilizing equipment came with the invention of the *Steadicam*. It allows the operator to walk or run, climb stairs, or shoot from moving vehicles while keeping the camera steady. The camera becomes virtually an extension of the operator's body, allowing for vertical movement up or down of almost three feet and for panning a full 360°. The operator views the image on a video monitor while guiding with a gentle

1.53 Aaton XTR held at waist, machine-gun fashion.

1.54 As seen in these photographs, the rotating eyepiece adds great versatility to a handheld camera.

1.55 Aaton XTR used in ground-level shot.

1.56 Steadicam camera-stabilizing system. (Courtesy of The Tiffen Company)

hand movement a camera that seems to be floating on air. The assistant is able to adjust the focus or f-stop by a radio-operated remote control.

The only drawback to these systems is their weight. The Steadicam system with a 16mm camera weighs approximately fifty pounds. Operators need to be physically able to move in a harness supporting the whole system; a strong back is required for this job. And since the camera is perfectly balanced at the end of the support arm, it takes tremendous skill to stop it from swaying and rocking. Keeping the horizon level during a Steadicam move is an important step in mastering this device.

TIME MANIPULATIONS IN CINEMATOGRAPHY

Until now we have discussed ways of controlling the image recorded by the camera, covering the manipulation of focus, perspective, camera positions, and movements. There remains the time dimension. It has infinite possibilities and therefore allows for great ingenuity in its use.

Near the beginning of this chapter, we introduced time-lapse and slow-motion photography and described how they could expand or collapse time.

Some general-purpose cameras have speeds up to 75 fps available from a wild motor. This is adequate for some slow-motion purposes, but if higher speeds are necessary, there are two general types of cameras to be considered: intermittent movement and *rotating prism*. Intermittent cameras are the kind we have already described; they arrest each frame for the period of exposure. For this reason they are limited to a top speed of about 600 fps, but are usually slower. The rotating prism camera features a continuous film flow.

The film never stops and the prism rotates to project the image onto the passing film. Because the film does not have to stop and start for each exposure, higher speeds are possible, ranging up to 10,000 fps for 16mm film. Special scientific cameras have been designed for much higher speeds, but they are seldom of any practical use to the average filmmaker.

At high speeds many problems arise. As the exposure time becomes minimal, a great deal of light is required (and/or very fast film). There is also a *reciprocity failure*; at higher speeds the exposure time–f-stop relationship gradually changes so that computing the exposure may be difficult. Exposure tests are necessary. To further complicate matters, at very high speeds the

reciprocity failure may be different for each layer of color in the emulsion, thus distorting the color.

Film stock for extremely high-speed photography must have "long pitch" perforations. This means the distance between the sprocket holes is slightly greater. Some can only use double-perf stock (which means they can't shoot Super-16) and require that special daylight spools be used.

In addition to slowing or speeding a movement, film can be used to remove portions of it. One term cinematographers use for the creative elimination of in-between intervals of movement is *pixilation*. Pixilation is much like animation in that it is often taken one or more frames at a time, but unlike animation, its subjects are frequently moving objects, like cars or people. Whereas time-lapse cinematography seeks only to speed up action, pixilation removes specific parts of the movement, modifying the apparent nature of the action. For example, an overused pixilation effect is achieved by taking a single frame every time an actor jumps up into the air. Because he is never seen except at the height of his jump, he appears to be suspended above the ground when the footage is projected at normal speed.

Another pixilation technique involves running the camera several frames at a time. Between each interval the actor walks to a different area in the field of view. The result is that he appears for a moment in each position.

Either of these pixilated effects can be achieved by shooting single frames, shooting several frames at brief intervals, or using an optical printer to print only the selected frames from normally shot footage. If the final project is for a video-only release, you can also just edit out those frames after you've transferred the footage to video; however, if for a print, you will call attention to the fact that editing was used if you cut the negative itself, which tends to produce a little jump at every splice. The creative variations on pixilation are endless and open to experimentation.

Some cameras can run backward, providing the opportunity to invert time. Reverse action can be used to make a difficult maneuver possible or to achieve an effect. In one film, a director had the camera run in reverse while filming an actor walking backward in a crowd of normally walking pedestrians. When the film was projected forward, the actor became the only person who was walking forward in a crowd of pedestrians walking backward.

Impossible actions are made possible, such as a man effortlessly jumping straight up onto the top of a wall or low roof. The actor jumps down and walks away, all backward. The action is filmed with the camera running in reverse so that when correctly projected, the actor walks to the wall and jumps straight up onto it.

Another very important use of reverse action is in making complicated maneuvers easier. The most common example is a rapid pan to a very precise framing. If shot forward, we might spend a great deal of footage before we hit just the perfect framing the director wants at the end of the shot. However, filming in reverse, we could start on that precise framing and pan away to the first, less critical angle, achieving the shot while saving time and footage.

Reverse motion is also used to make stunts safer; for example, if you need a speeding car to come to a quick stop right in front of an infant in a baby carriage, you could start the car at the near position and have it quickly drive away in reverse gear.

Not all cameras feature an ability to run backward. But reverse action can still be achieved. In 16mm or 35mm, the action can be filmed and later reversed in an optical printer; or it can be done digitally once the footage has been transferred to video. Or reverse motion can be achieved by filming with any camera held upside down. If the image is recorded upside down, we can turn the film over in the projector and show it tail-first. It will be right side up, but the action will be reversed. In the case of single-perforated film stocks, the picture will also be turned around left to right. Doubleperforated stocks could be turned over, correcting the left-to-right position, but this would put the emulsion on the opposite side, causing focus problems in printing.

When using the upside-down reverse action method, the best way to deal with the left-to-right exchange is to avoid lettering or anything else that would give it away, or to shoot through a mirror. There is also the possibility of printing any necessary lettering backward. This was done for the movie *Titanic*; passengers had to board the ship from port side, but only the starboard side had been built by the art department, so all signs in the boarding scene were painted in mirror-image reverse and "flopped" digitally later in postproduction.

The possibilities suggested by time manipulation are endless, and we have touched on only a few. The filmmaker is limited only by his own imagination.

CHOOSING A CAMERA

Having spent the first part of this chapter covering some of the basic camera features and capabilities, we now will try to bring it all into focus. Selecting a camera is similar to choosing a car. You should consider many aspects before committing your money. There is much to be said for renting rather than buying equipment, since needs vary from one filming assignment to another. There are rapid changes in camera design and there is a constant flow of new models, which would be available at rental houses. Of-

1.57 Bolex H-16 SBM 16mm spring-wound camera with reflex viewfinder, optional electric motor, and 400-foot magazine. (*Courtesy of Bolex/Paillard*)

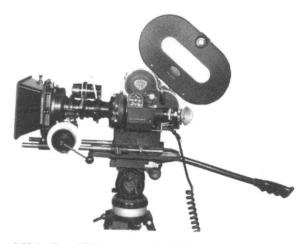

1.58 Arriflex 16S/B camera with 400-foot magazine, zoom motor, follow-focus, and 4" \times 4" matte box. (Courtesy of ARRI Group)

ten you can rent a much more expensive camera than you could ever afford to buy. The decision to rent or buy a camera also depends on how extensively you plan to use it. Professionals will purchase a piece of expensive equipment only when they have already been working on jobs where they've had to rent that item continu-

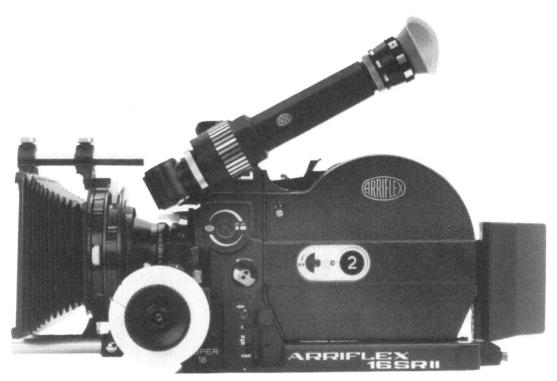

1.59 Arriflex SR2 16mm camera. (Courtesy of ARRI Group)

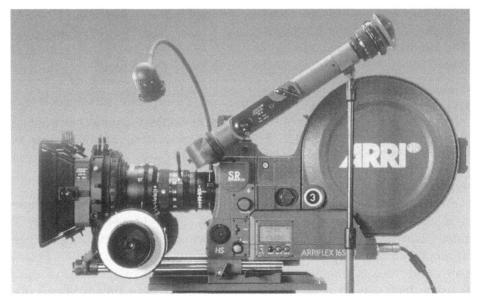

1.60 Arriflex SR3 16mm camera. (Courtesy of ARRI Group)

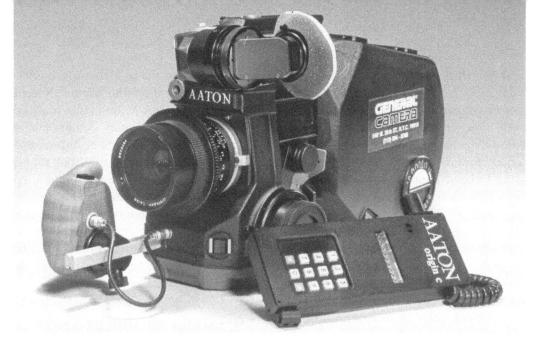

1.61 Aaton XTR camera with an Origin Cplus Masterclock used for AatonCode operation. (Courtesy of Aaton)

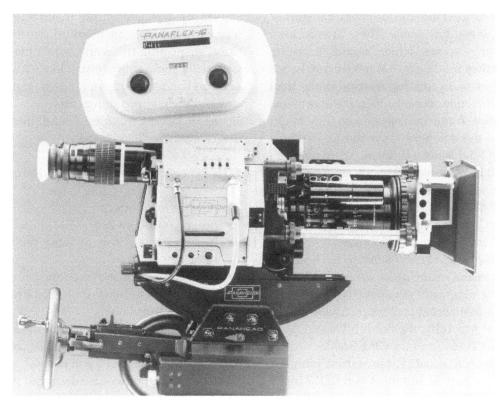

1.62 Panaflex-16 Elaine, a 16mm studio camera, similar to the 35mm Panaflex cameras. (Courtesy of Panavision)

ously, and therefore know that the purchase will pay for itself over a short time.

If you are preparing to shoot a short or feature-length film, it sometimes makes more sense to rent if it will be shot over a short but intense period of a few days or weeks. However, if it's going to be shot off and on over a very long period (like some documentaries), it might make more sense to own the equipment.

Many amateurs and professionals prefer to own their own cameras. In this way, if they take good care of their equipment, they can be confident about its dependability. Sometimes they will own a "standby" or "B-camera" and rent their main camera, such as an Arri, Aaton, or Panaflex.

Besides the reflex versus nonreflex viewfinder issue already covered, 16mm cameras can be loosely divided into the following categories:

MOS or non-sync-sound. These are too loud for shooting scenes while sound is being recorded; they might also not have crystal-sync motors (but many do for reasons other than shooting dialogue scenes). Often these cameras have multiple frame rate options, so they might be used to shoot non–24 fps material, in which case being loud is not a problem, since no syncsound will be recorded anyway. Cameras in this category include the Bolex, the Bell & Howell Filmo, the Arri-S/B, the Eclair CM3, the Beaulieu R16B, the Canon Scoopic, and high-speed cameras like the Photosonics Actionmaster.

Early sync-sound ("self-blimped"). These are the first generation of quiet sync-sound cameras. Being older and cheaper, they are often someone's first sound camera purchase. These include the Arri 16BL, the Eclair NPR and ACL, the CP-16, CP-16R, and the CP-GSMO.

Modern sync-sound. These started with the release of the Arri SR and the Aaton LTR 7 in the mid 1970s and continued with the Arri SR2 and SR3, and the Aaton LTR 54, XTR, and XTRprod.

Panavision also made a 16mm version of their Panaflex line called the Elaine. Recently the very small Aaton A-Minima was released.

Every couple of years, camera manufacturers bring out new designs or improvements on older models. Therefore, this book cannot hope to provide an up-to-date consumer's report on every current camera. You will have to investigate the features offered by the designs of leading manufacturers at the time you buy. In addition to providing promotional literature, equipment rental houses can often be very helpful as you make a decision.

CAMERA TROUBLES AND TESTS

Even the most sophisticated cameras will occasionally fail to operate properly. Usually this is caused by a rather simple malfunction. Amateur camerapeople frequently jump to conclusions, suspecting the worst, when the problem is actually some simple thing like a low battery or a bad connection. So don't panic until you've checked the obvious things first.

Most camera troubles will fall into roughly five categories:

1. *The camera will not run*. This could be caused by:

- dead or low battery
- broken on/off switch
- broken power cable or loose plug connections
- dirty connection between the camera body and the magazine take-up motor (applies to Arri and Beaulieu)
- buckle switch not reset (some cameras have this safety device, which automatically stops the camera if a jam occurs)
- burnt-out or otherwise damaged motor
- extremely cold weather (the camera should be winterized by changing the lubrication

from oil to graphite in a camera shop before shooting in very low temperatures)

2. *The projected picture is unsteady.* This could be caused by:

- film loops too small or too large
- film stock that has shrunk because of improper storage
- faulty synchronization of the shutter and pulldown claw (causes a vertical blur)
- pressure plate too tight or too loose

3. *The film is scratched*. This could be caused by:

- dirt or emulsion buildup somewhere along the film path
- rollers stuck in the camera or the magazine
- film gate scratched or damaged
- film loops too large or too small
- film not properly threaded

4. *The film is fogged.* This could be caused by:

- light leak from an improperly closed camera or magazine door
- reflexive viewfinder open to light—often because the camera operator took his or her head away from the eyepiece
- behind-the-lens filter slot that has been left open (especially on Bolex or wide-angle lenses)
- improper loading or unloading that may have exposed the film to light
- an empty lens cavity left open in the turret

5. *The picture is out of focus*. This is usually the fault of the camera operator or focus-puller, but it can also be caused by:

- lens not flush in the turret
- lens out of alignment

- viewfinder out of adjustment
- pressure plate not locked in correct position when the camera was loaded

Most of these troubles can be avoided by a thorough check. Before the day of shooting, *all* the equipment should be assembled and examined to make sure it is compatible and in working order.

CAMERA OPERATION AND CARE

Shooting a camera test is a vital step in preparation. It must be done and screened before the shooting begins so that there is ample time to deal with any problems. The main objectives of the test will be to check lens performance and picture steadiness. If two or more cameras are used, it is imperative that the frame lines be compared to make sure that footage from the two cameras can be intercut without the frame line shifting on the screen.

Lens sharpness is best checked by shooting a test chart or even a newspaper with the lens aperture wide-open (lowest f-stop). In the case of a zoom lens, the entire focal range (zoom range) must be tested.

At the same time, test the reflex viewing system and lens calibration by turning the test chart to a 45° angle.

Focus visually (or by measured distance) for a marked spot. If the viewing system or the

1.63 Lens tested with a chart at 45°.

calibrations on the lens barrel are out of alignment, the footage will be focused either closer or farther away than the marked spot.

Even the most comprehensive tests cannot eliminate human errors. Most mistakes are due to careless oversights. Camera operators have to keep track of so many small details that they are bound to eventually forget something. When they do, it will be a simple and obvious error.

The beginner is especially prone to such mistakes. Professional camerapeople develop a systemized routine of checking everything immediately before shooting. I have my own list of things to check before filming. I check that

- tripod is level;
- gate clean;
- gate closed;
- sprockets engaged;
- footage counter reset after loading;
- forward/reverse properly set on both camera and magazine motors;
- motor speed set;
- magazine take-up taut;
- viewfinder eyepiece focused for eye;
- matte box not visible in frame;
- filter slot covered or closed;
- filter in place; and, most important, I
- check frame for composition, mike boom, set limits, etc.;
- check focus; and
- check f-stop.

The last three are the most important because they are constantly being changed during the shooting day and are therefore the most likely to be wrong when you start to shoot.

The Ditty Bag

The ditty bag contains all the small items camerapeople feel it necessary to have in their immediate reach while filming. The items may vary depending on personal choices, but most ditty bags are similar in content. Mine contains:

- American Cinematographer Manual (known as the cinematographer's bible)
- air syringe and/or can of compressed air
- orangewood sticks
- pair of fine tweezers and a dental mirror (for careful removal of film chips and hairs from inaccessible places; these are the *only* metal instruments used for cleaning)
- small flashlight
- camera brush made of fairly stiff hair (not camel's hair)
- lens brush made of extra-soft hair (such as camel's hair)
- lens tissue
- cotton swabs (for cleaning lenses only!)
- lens-cleaning fluid
- compact magnifying glass (cleaning aid)
- assorted screwdrivers
- needle-nose pliers
- crescent wrench
- black camera tape
- white camera tape
- gaffer's tape
- regular and grease pencils, marker pens, and ballpoints
- camera report cards (can be simple index cards)
- chalk (kept separate because of dust)
- scissors
- spare cores
- spare daylight-load spools
- 50-foot cloth measuring tape
- assortment of spare parts and adapters (e.g., quarter-inch to three-eighths-inch tripod screw adapter, a spare core center piece), depending on the type of equipment being used
- stopwatch

 contrast-viewing glasses for black-andwhite and color

Apart from the ditty bag, these items might also be necessary on location or in the studio:

- spare light meter
- spare light meter battery
- spare changing bag
- spare film cans with black paper bags
- spare power and sync cables
- extension cables for mikes
- extension cables for lights
- all sorts of adapters for electrical supplies; most important, the common two-prong to grounded three-prong adapter
- spare bulbs and fuses
- spare batteries, such as for tape recorder
- spare camera battery with charger
- spare magazine take-up belts
- spare lens caps
- spare rubber eyecup
- spare supply of filters

- spare tape recorder take-up reel
- soldering iron
- voltmeter, or at least a voltage tester
- headache tablets (aspirin, etc.)

This list could go on forever. The point is that you should scale your equipment to your production, remembering that you *want* to be overprepared. Camera operation depends on many small details. If a camera malfunctions, all your footage may be ruined.

Lists of this sort are always of enormous value and should be made up before the day of shooting to make sure that nothing is forgotten.

Here again, as throughout this chapter, we are reminded of the great concentration and attention to detail required from the camera operator in order to maintain control in his or her work. Only after thoroughly mastering the techniques and mechanics of their craft can cinematographers develop the consistency necessary to achieve an individual stylistic approach, which is the goal of the cinematographer's art.

2 FILM TECHNOLOGY

A cinematographer must understand all the factors that affect the photographic image; besides camera-related issues like lens optics, covered in the previous chapter, these include the shooting format and the film stocks chosen, postproduction processes, and the various final delivery formats and presentation methods, both film and electronic.

In particular, the cinematographer's choice of film stock is a major factor in determining how the image will be recorded and therefore contributes greatly to the cinematographic style. The cinematographer must not only appreciate differences among stocks but be familiar with every property of the film so that he or she will know how to manipulate it to achieve the desired appearance and qualities. Therefore, in our discussion of film stocks we will be concerned with every characteristic relevant to the control of image quality, starting with the most basic.

FILM STRUCTURE

The two fundamental components of film stock are the *base* and the *emulsion*. The base is usually made of cellulose triacetate. Some stocks are also manufactured on thinner, stronger *Estar* base. In fact, it is so strong that it is more likely to damage a camera during a jam rather than break, so Estar stocks are generally relegated to laboratory intermediate and print stocks, not camera stocks. This polyester base cannot be spliced using regular film cement; either tape or fusion splices have to be used. Tape splices are not acceptable for negative preparation, as they would show up on the print. Fusion splices require special equipment that is not readily available. Therefore, the durable Estar-based stocks are more practical for film elements that will be printed from many times, such as duplicate negatives and release prints.

The emulsion consists of a thin layer of gelatin in which light-sensitive silver halide crystals are suspended. The emulsion is attached to the base with a transparent adhesive called the *subbing layer*. There is also an emulsion undercoat called the *antihalation backing*, which usually contains absorber dyes or a thin layer of silver or carbon (called *rem-jet* on color negative stocks). Without this coating, bright points of

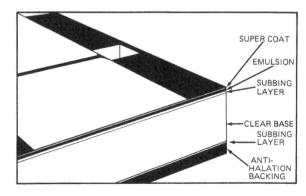

2.1 Film structure.

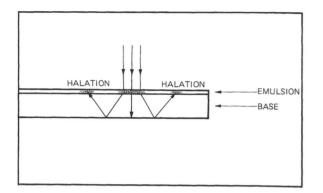

2.2 Halation effect, caused by internal reflections in the film.

light would penetrate the emulsion, reflect off the inner surface of the base, and reexpose the emulsion, creating a halo around these bright areas. The antihalation backing can also serve to reduce static buildup.

PRACTICAL SENSITOMETRY

The science of measuring an emulsion's reaction (sensitivity) to light is called *sensitometry*. The basic principles of practical sensitometry do not require an extensive knowledge of mathematics or physics. They only require common sense.

As a first step toward a study of sensitometry, we should explain roughly how a film is able to record an image. Photography is basically possible because of how certain forms of silver react to light. Any scene contains a variety of objects reflecting various amounts of light toward the camera. As the light strikes the silver halide crystals in the emulsion, it causes changes that remain invisible until the image is developed. These hidden changes make up the *latent image*. When the film is developed, the areas in which the silver halide crystals received the most light produce more metallic silver (which is black) than areas that received less exposure. After development, the unexposed silver halide is removed, leaving only the metallic silver. Consider a photograph of a man in a white shirt and black pants. The film stock is black-and-white negative. The white shirt reflects a lot of light, causing great changes of silver halide into metallic silver. Meanwhile, the black pants reflect only a small amount of light, causing a minimum amount of changes in the emulsion. The face had a light reflectance in between the two extremes and so caused a medium change in the emulsion. The developed negative will represent the white shirt as a very dense area with a lot of metallic silver appearing black. The black pants will be the opposite-less silver halide was exposed, so less metallic silver was formed, leaving that area very transparent or thin. This is why we call it a *negative*; holding the developed film up to the light, white objects appear black, while black objects appear bright (clear).

Reversal film, on the other hand, results in a positive image on the camera original. It is developed much like a negative, and at one point is in a negative form. However, the processing does not stop here. The metallic silver of the negative image is removed in a bleach bath and the remaining (unexposed) silver halides are exposed to a weak light in the processing machine. The film is then developed again. This time the image is positive. Black is black and white is clear.

Color

The structure of color films is similar to blackand-white stocks except that there are three general layers of silver halide emulsions to separately record the red, green, and blue information of the photographic subject. For every silver halide grain there is a matching *color coupler* grain.

The top layer of a color negative contains a

CINEMATOGRAPHY

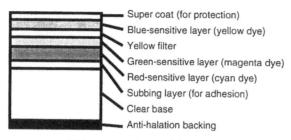

2.3 Color negative emulsion layers.

blue-sensitive silver halide emulsion. This is followed by a yellow filter to cancel blue wavelengths; after this comes a green-sensitive layer and then a red-sensitive layer.

Just as in black-and-white, the first step in color development converts exposed silver halide grains into metallic silver—except that an equal amount of color dye will be formed as well. The color couplers in the blue-sensitive layer will form yellow dye during processing, the green layer will form magenta dye, and the red layer will form cyan dye. A bleach step will convert the metallic silver back into silver halide, which is then removed along with the unexposed silver halide in the fixer and wash steps, leaving only color dyes. (See description of the bleach-bypass process in chapter 5.)

The Characteristic Curve

Many beginners have been misled into believing that for any scene there is only one proper light level and one correct exposure. This notion is reinforced by automatic exposure systems, which magically divine the correct setting for the entire scene. This unfortunate idea is misleading and will hamper the filmmaker's understanding of exposure.

Every scene contains an infinite number of reflected brightnesses. White objects reflect much light and dark objects reflect little light. The film will faithfully record only the part of the range the human eye is capable of adapting itself to. Take, for example, a scene in which the range runs from a bright sky to a black telephone in shadow. From one vantage point, the eye can probably see these extremes because it readjusts itself when looking at each one. As you glance up from the telephone, your eye closes its iris and refocuses for the brighter sky. It is difficult, however, to see both at the same time. The film has the same problem. If two such extremes are in the field of view at once, it is impossible for the film to record both faithfully. The range of light levels in many scenes is greater than the range the film can correctly record.

Therefore, in filming a scene we must decide what objects are the most important and calculate an exposure that will place the brightness level of those objects within a range the film will faithfully reproduce.

To define the optimal range of each film, we will determine how increasing amounts of light cause deeper reactions in the emulsion. We chart the levels of exposure against the resulting densities in the processed film, arriving at a graph known as the *characteristic curve*. It is not a practical on-the-set aid, yet its thorough comprehension is indispensable in helping us understand how the film emulsion interprets the subject's brightness range.

The curve is established by placing a short strip of unexposed film into an instrument called a *sensitometer*, where it is exposed to increasing levels of light. The film is then processed, and the density resulting from each light level is measured with a device known as a *densitometer*. By plotting the results on a graph we arrive at the characteristic curve, describing the relationship between light levels and densities for this particular emulsion.

Let us consider an everyday exposure problem and relate it to the characteristic curve (see

figures 2.4 through 2.7). In figure 2.4, we are confronted by a huge range of brightness in the scene. We decide that for this scene it is most important for the person in it to be represented faithfully, so we use an exposure that would bring the face within the optimal range of the curve. The blouse is brighter and the skirt is darker, but they too fall within the range and are recorded proportionately lighter and darker. However, designs on the lamp stand and the telephone in the shadow are so far un-

2.4 Graphic representation of extremes in the scene brightness range that were not distinguished in the photo. See figure 2.7.

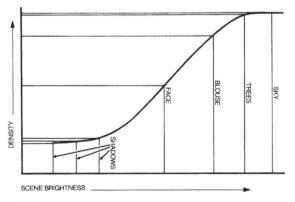

2.5 Scene brightness recorded on a characteristic curve.

derexposed that all details are lost. This is because at the low end of the curve (called the toe), where the lamp stand and telephone are, the shadow details are "squashed" or "crushed." Note in figure 2.5 how a large difference in scene brightness is represented as a minute difference in densities on the film, and thus detail is lost. The same is true of the other extreme, where the trees outside are lost because at the high end of the curve (called the shoulder) the great difference between the trees

2.6 Negative.

2.7 Positive print.

and the sky is represented on film as only a small difference in density, and therefore the two are not distinguishable from each other.

Ideally the curve might be a straight 45° line, not squashing anything, but in fact no such film exists. The nearest to this ideal is the straight-line portion of the curve (between A and B in figure 2.8). Actually, this portion between the toe and shoulder is rarely perfectly straight. However, any scene that stays under the limits of the straight portion (e.g., between A₁ and B₁ in figure 2.8) will be faithfully reproduced in correctly related densities. That is, an increase in the brightness will cause the image to be proportionately brighter, without squashing.

Some scenes, such as a foggy landscape, may be so narrow in brightness range (low contrast) that they could fit into the straight-line portion of the curve twice over. In practical terms this means that such a scene could be exposed anywhere within the straight-line portion and still yield a negative with correctly related densities. It is very common for a photographer using black-and-white negative film to give such a scene a minimal exposure, positioning the brightness range on the lower portion of the curve yet still within the straight-line portion. In this way, a fairly "thin" (not dense, more clear) negative is obtained that gives a more finely detailed reproduction of the lighter tones in the image. The lab technician will later compensate for this minimal exposure by printing it lighter. This technique is only used for black-and-white negative film. When shooting in color negative or any reversal emulsion, the important brightness range should usually be placed near the middle of the straight-line portion to obtain the best rendition.

In negative, the horizontal length of the emulsion's straight-line portion (A_1 to B_1 in figure 2.8) and the size of the scene brightness range (for example, A_1 to X_1) together deter-

mine *latitude*. In this example the latitude is from X_1 to B_1 . In negative, latitude is any range outside the scene's brightness range yet still within the straight-line portion. In the original example in figure 2.5, there was no latitude because the scene brightness range was greater than the straight-line portion.

It should be noted that we have been talking about negative film only. Latitude for reversal films is thought of differently. Reversal films are much less tolerant of overexposure and underexposure. There is not a wide range of acceptable exposures. When using reversal film, we place the most important brightness range in the center of the straight-line portion and think of latitude as the adjacent tolerance range (acceptable over- and underexposure). In other words, latitude is a measure of how far clearly separated details extend into the bright and dark areas (i.e., how large the optimal range is).

Therefore, when calculating exposure we are not exclusively interested in one reflected light level. Our real consideration is a range of brightness levels present in the subject, from which we choose one. We calculate an exposure for it that will place it and the other adjacent levels on the curve where they will be represented in correctly related densities. For example, in the situation of figure 2.7, if we had

2.8 Characteristic curve.

2.9 Exposure calculated for trees outside. Compare with figure 2.7.

decided that the view outside the window was the most important element to see clearly, we could have calculated an exposure that would have brought the trees near the center of the straight-line portion, as in figure 2.9.

There are two complications we have previously ignored in the interest of keeping things simple. First of all, the three emulsions in color film—one for each of the primary colors, blue, green, and red—will each have its own characteristic curve. Ideally they should be parallel and very close together, but this is not always the case (see figure 2.10).

The second complication is that because reversal films yield a positive image, their curves slant opposite to negatives (see figure 2.11). That is, with negative film, darker areas of the image yield a low-density (clear) area on the film, while brighter areas create a more dense area on the film. With reversal film, however, the opposite is true. A white object is recorded as bright (clear) and a dark object is recorded as dark (dense), so the curve slants in the opposite direction, from upper left down to lower right.

2.10 Characteristic curve for a hypothetical color negative.

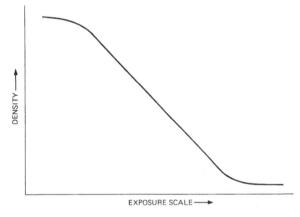

2.11 Curve for a black-and-white reversal film.

Exposure Values

It was earlier stated that the exposure value (f-stop) was selected so that the important light levels would be placed within the optimal range of the characteristic curve. To understand how this is done, it must be noted that the "scene brightness" side of the graph (see figure 2.8) represents the light actually reaching the film—that is, the amount of light allowed to pass by the f-stop. The horizontal and vertical (density) scales increase logarithmically, as do f-stops. (Logarithms are common in filmmak-

CINEMATOGRAPHY

ing; many filmmakers understand and use them without realizing it.) If a scale is logarithmic, it simply means that each succeeding step doubles the value of the previous one. Logarithms could also triple or quadruple between steps, but in filmmaking we are almost always talking about "logs" that double the value with each increasing step. Take the example of f-stops. As you remember from chapter 1, each wider f-stop setting doubles the amount of light passing through the lens. Therefore, f-stops are designed in a logarithmic progression.

Light is measured in logarithms because it naturally increases that way. Suppose we start with one lightbulb on and then turn on a second. Of course the illumination appears to increase. To make the light appear to increase again by the same amount, we must turn on two more bulbs. To increase it the next time will require four more bulbs if the increase is to appear as great as in each of the previous steps.

Step number:	1	2	3	4	5	6	7
Number of bulbs:	1	2	4	8	16	32	64

This is a logarithmic scale. The light doubles with each succeeding step. Yet the light appears to increase by the same amount between each step, making a logarithmic scale the most convenient system for discussing light.

Because f-stops and the scene brightness scale of the characteristic curve are both calibrated in logarithms, the two can be related. It happens that each stop equals 0.3 on the horizontal scale. That is, between 0.0 and 0.6 there are two stops. Between 0.0 and 2.4 there are eight stops. We could determine where the various scene brightnesses would fall on the horizontal scale. For example, a given object, such as a face, might be exposed so as to fall in the middle of the scene brightness scale. An object one stop brighter in the scene would fall one 0.3 division to the right of the face on the scene brightness scale. An object reflecting two stops less light will fall 0.6 to the left on the horizontal scale, and so on. Remember that the scene brightness scale of the characteristic curve refers to the amount of light actually reaching the film. Therefore, if we now reduce the exposure one f-stop, all the scene brightnesses will shift 0.3 to the left on the horizontal scale. Similarly, if we increase the exposure by one f-stop, all the brightness would shift 0.3 to the right.

Consider the example in figure 2.5. We decided that the face was the most important object in the scene and therefore calculated an exposure that brought the face within the straight-line portion of the characteristic curve. We could instead have used an f-stop that would have brought the trees within the straight-line portion, but the face would have been lost in the shadows (see figure 2.9). Therefore, by selecting the proper f-stop, we are able to "position" the brightness of our subject within the straight-line portion of the characteristic curve. Thus, to calculate the exposure, we need to know the brightness of the subject and the sensitivity of the film.

The overall degree of sensitivity of a film is expressed by the position of the characteristic curve in relation to the horizontal scale (scene brightness). Our goal is to find some way of arriving at an f-stop that will place the range of important scene brightnesses within the straight-line portion. Therefore, for practical purposes the sensitivity of each film is rated by an *exposure index*.

For decades, this value was called an ASA (American Standards Association); later, the ASA value was renamed either ANSI (American National Standards Institution) or ISO (International Standards Organization). Film manufacturers now just call the rating an EI (exposure index), which is what we will use in this book.

Faster films are more sensitive and have higher EI numbers. They are designed for filming under lower light levels. Because they require less light, the straight-line portion of their characteristic curve will appear slightly to the left (see figure 2.12). Slower emulsions are less sensitive and have lower EI numbers. They are designed for shooting scenes with brighter illumination levels.

The EI value doubles as the sensitivity of the film doubles. For example, an exposure index of 200 EI represents an emulsion twice as fast as one of 100 EI; 200 EI describes a film four times as fast as 50 EI.

Notice how f-stops relate to EI values. For example, let's say we have a set amount of light (say, 800 foot-candles), which will remain at that level. Then, for the following EI values we would use the following f-stops:

25 EI	50 EI	100 EI	200 EI	400 EI
f/4	f/5.6	f/8	f/11	f/16

Every time the exposure index doubles, it means the film is twice as sensitive, therefore requiring *half* as much light. As each succeeding f-stop cuts the light by half, we can see how f-stops relate to EI; every time the EI doubles, it signifies that one stop less light is required.

Therefore, we sometimes describe a film as so many "stops" faster or slower than another film. For example, a film of 200 EI is eight times faster than a film of 25 EI ($25 \times 8 = 200$). But we may also say this by stating that the film of 200 EI is three stops faster than the film of 25 EI (25 doubled three times equals 200). This tells us that a film of 25 EI requires three stops more

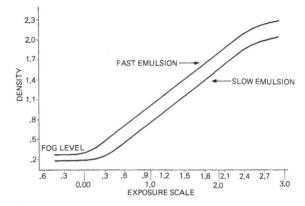

2.12 A fast and a slow emulsion. This fast emulsion starts reacting to light one stop (0.3 increment) before the slow emulsion. Notice that of these two hypothetical emulsions, the fast emulsion has a slightly longer useful portion. Notice also that the faster emulsion has a higher fog level (i.e., higher minimum density inherent to the emulsion).

light than one of 200 EI. This relationship is vital. Although it may seem puzzling at first, it will seem quite simple once you have mastered it.

Daylight Versus Tungsten Sensitivity

The exact color of light differs depending on the source. The eye compensates for the difference between the color of sunlight and the color of tungsten illumination. The film, however, is quite sensitive to variations in the color of the light, and therefore black-and-white films are given two EI values, a higher one for daylight and a slightly lower one for tungsten. This is because black-and-white stocks are more sensitive to the blue end of the color spectrum (daylight) than to the red end (tungsten).

Color film will see these variations in the spectrum; for accurate color reproduction, we must use the proper filter to modify the incoming light, tailoring it to the color sensitivity of the emulsion. This will be discussed at much greater length in chapter 3.

Push Processing

The EI number is only the manufacturer's recommended sensitivity rating to obtain a negative of normal density after normal development. Density can be changed by increasing or decreasing the period of development, usually in conjunction with changing the sensitivity rating of the stock. Increasing the developing time will have the effect of increasing density-this is called pushing or forced processing. It can allow you to obtain a negative of normal density even after underexposing it in order to film in lower light levels. It can also allow you to achieve a higher density level even though you exposed normally. While a one-stop push is the most common request, most emulsions can be pushed by two or even three stops, but pushing will result in quality losses such as:

- a color shift in the shadows
- an increase in the base fog density
- an increase in contrast
- an increase in graininess

The amount of quality loss depends on the amount of pushing and the type of emulsion being used. Because of this, to protect their reputations for quality work, most labs recommend not pushing by more than two stops. In other words, push as little as possible unless an unusual effect is desired. The effect of pushing shows up in a family of characteristic curves. In figure 2.13, for example, light level A would normally yield a density of X, but by pushing the film one stop it results in a density of Y. Note that these curves are not parallel. You can also see that the more the film is pushed, the steeper the characteristic curves become. This means that we can expect an increase in contrast with increased pushing of negative.

Pushing increases the base fog density, so

blacks in the scene are not perfectly black but are somewhat gray. This is why sometimes there is the impression of a *loss* of contrast even though the actual contrast has increased.

Excessive pushing will also desaturate some colors and give the film a "muddy" look.

Graininess is increased mainly because of the underexposure technique combined with push processing. Underexposure means that only the largest, most sensitive grains were exposed; the smaller, less sensitive grains were removed in processing because they received insufficient exposure.

For a practical example of how to use a film with the intention of pushing it, suppose you are using a film of 100 EI. You want to shoot a scene where there is not enough light. If you had a film of 200 EI you would be fine. So you decide to use the 100 EI film, underexpose it by one stop (by rating it at 200 EI), and push it one stop in the development to compensate, so that a normal density results and you don't have to print up a "thin" negative. So you set the light meter to 200 EI and expose the entire scene accordingly.

When you send this roll of film to the lab, you would clearly write on the film can, the camera report, and lab work order: PUSH ONE STOP.

The more you underexpose and pushdevelop, the more critical your exposures have to be, because you are placing so much critical information at the lower end of the film's sensitivity. You find that certain detail is acceptably rendered with two stops of underexposure but not two and a half stops, so you have less room for error. Also, extended development is not an exact science in that you don't exactly double your density when ordering a one-stop push (in fact, often you only get two-thirds of a stop more density from a one-stop push). Therefore, some people will err on the side of more exposure and rate the stock one-third of a stop slower than what they should be for the amount of pushing being ordered. For example, if you ask that a 500 EI stock be pushed two stops, you might want to rate it on your meter at 1600 EI instead of 2000 EI.

Pushing is occasionally described as "developing to a higher gamma." Gamma is a measure of the slope of the straight-line portion of the characteristic curve, which, as you can see in figure 2.13, becomes steeper with more pushing. A higher gamma indicates a steeper curve. Therefore, a higher gamma means more contrast. The gamma standard for the majority of black-andwhite camera negatives is 0.65. Black-and-white print stocks are slower and have a higher gamma of 2.50; the final gamma of the printed image is 1.60. Color negative has a slightly lower gamma than black-and-white negative, but the color print stocks have a higher gamma than their black-and-white counterparts; again, the final gamma is around 1.60.

Negative, intermediate, and print stocks are designed together so that the resulting gamma of the final image allows enough contrast to create the effect of solid blacks even though the image is projected with a powerful light onto a reflective screen. This is why reversal stocks need to be so high in contrast: they were designed for *direct* projection of the original. Therefore, when they are duplicated and printed onto stocks designed to work with camera negatives, the resulting increase in gamma gives you much more contrast than looks natural.

Pull Processing

Pull processing, usually done by shortening development time, will result in less density being formed. It lowers contrast, which in turn gives the effect of softer colors and less definition. Usually pull processing is done to emulsions

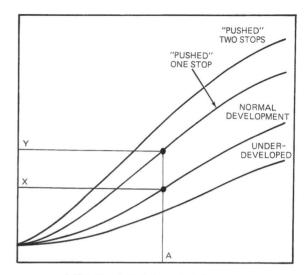

2.13 A "family" of characteristic curves.

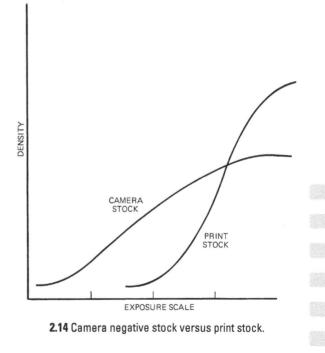

rated slower than recommended. This moderate overexposure reduces graininess in color negative (see "Grain" below). Alone, the overexposure would produce *excess* density in normal development—but in this case, it is compensated for by the reduced development time, resulting in normal density. Not all labs offer pull processing for 16mm, while all of them offer push processing.

DEFINITION

Until now we have been mainly discussing sensitometry—that is, ways of measuring a film's sensitivity. Yet when we compare film stocks we are equally interested in another aspect, the film's *definition*. It is a key factor in determining the texture of the images as they appear on screen. The photographic definition of a film depends on three contributing factors: the grain, the sharpness, and the resolving power.

Grain

When the grains of metallic silver forming the black-and-white image-or the grains of dyes that remain in processing color film-are visible, they create a random texture like boiling sand when projected. The degree to which these grains are visible will depend upon their size and their concentration (density). As explained earlier, the grains of silver halide are struck by light and then processed to yield an image formed by grains of metallic silver. It seems that the larger a silver halide crystal is, the more easily it is affected by light because it presents a larger surface area that is more efficient at collecting photons. So faster emulsions achieve their increased sensitivity partly by using generally larger crystals. Therefore, faster emulsions show more grain than slower emulsions.

Grain characteristics differ between the black-and-white and the color stocks, as well as between the negative and the reversal emulsions. Overexposure will produce more graininess in black-and-white than in color negative. Slight overexposure will actually give the illusion of less graininess in color negative-this is because you've exposed more of the smaller, slower grains between the larger grains, filling in the spaces between the bigger grains and "tightening up" the grain structure, which now looks finer-grained. On the other hand, underexposure of color negative leads in turn to increased graininess, since the smaller grains were never exposed and thus washed away in processing.

Contrast can have an effect on apparent graininess, since the grain structure is more visible in flat areas of midtones than in pure black or white (assuming that your blacks are dense enough). So a low-contrast image, like a scene shot in foggy weather, would tend to show the true graininess of the film more than a highcontrast scene with a lot of very dark and bright areas but few midtones. This is why high-speed film often doesn't look objectionably grainy in night exterior scenes but too grainy in flatter day exterior scenes with lots of midtones. Therefore, you can control apparent graininess not only with exposure and density but with how much contrast you use in lighting and with the tonal values of the setting.

In black-and-white reversal, emulsions show less grain than the negative stocks of comparable speed—again, partly because of the higher-contrast images that result from shooting on reversal stock. In discovering the grain characteristics of a given film stock, tests and practical experience are more reliable than the manufacturer's promotional literature.

Degree of enlargement is also an important

factor: the larger the image to be displayed, the more visible the grain structure. This is why smaller film formats or faster film emulsions seem acceptably fine-grained for presentation on television compared to large-screen theatrical projection.

Sharpness

This is another key factor influencing photographic definition. It represents the precision with which the emulsion records sharp edges in the scene. An *acutance* test measures sharpness by using a densitometer to determine how quickly the density drops across a sharp shadow line, such as in a picture of a knife edge. A reversal film will yield a sharper image than a negative of the same sensitivity.

Again, how "sharp" an image looks to the eye can be influenced by scene contrast. A dark edge against a bright background, or the opposite, creates a stronger illusion of sharpness than a gray edge against a slightly lighter shade of gray. This "trick" is used in electronic image manipulation to make softer images look sharper (called *edge enhancement*) by adding thin black lines around light objects and thin white lines around dark objects. There is even a chemical and optical version of this effect in film: grain particles can be mildly "sharpened" in certain developers or when rephotographed through the lens of an optical printer onto a new piece of film.

Resolution

Resolving power is the third factor contributing to the overall picture definition. It is the film's ability to record fine detail. Resolving power is measured by photographing a chart composed of fine sets of parallel lines, separated by spacings of the same width. The lines and spacings become gradually thinner from set to set. After processing, the film is examined under a microscope to determine the maximum number of lines per millimeter that the film is capable of distinguishing. For example, Plus-X B&W Negative Type (7231) can resolve 33 lines per millimeter if the contrast ratio between the lines and the background is 1.6 to 1, or 112 lines per millimeter if the ratio is 1,000 to 1. As we see in this example, the resolving power is dependent on the subject's contrast. In addition, it will be influenced by other factors. A fairly slow, fine-grain emulsion, properly exposed and processed normally, will usually deliver high resolution. However, over- or underexposure, over- or underdevelopment, or the use of a faster film would reduce the resolving power. It should further be noted that lens quality also contributes to the overall resolution of the image.

FILM STOCKS

At first glance, the list of available motion picture stock can be overwhelming to the beginner. But after becoming familiar with different film emulsions, you will be able to relate each film stock to the specific tasks or situations for which it can be used. Many practical considerations will influence the choice of a film stock, but your guiding principle should always be the artistic needs of your project.

Since Kodak and Fuji are constantly improving their camera and print stocks, adding new ones and eliminating others, it would be pointless to list their current offerings. Check their published literature or look on their Web sites for more detailed information on specific stocks. Kodak also has a newsletter called *In Camera;* Fuji publishes one called *Exposure.* Trade magazines like *American Cinematographer* and *ICG* magazine are a priceless source of information regarding current practices.

Black-and-White Versus Color

The decision of color versus black-and-white is in its nature both aesthetic and financial. To shoot a film in black-and-white becomes a visually strong graphic statement, particularly today, when the vast majority of films are shot in color. To some extent black-and-white is becoming a lost art, and fewer labs are equipped and knowledgeable enough to handle black-andwhite film stocks. And yet, once every few years we see an ambitious film shot in this medium, often to provide a nostalgic look or to create the visual mood preferred for a given story.

On a more practical level, the decision to shoot on a black-and-white stock may be the result of budgetary restrictions. Both the blackand-white camera stock and the subsequent prints are less expensive than color. When you decide to film in black-and-white, you will need to shop around for the best available lab. You will be able to find out which lab deals best with the black-and-white film, both in processing and printing, by sending short rolls of identical tests to a few different laboratories.

Distributors have had a bias against blackand-white productions, claiming that they are harder to sell to television and tend to do less well at the box office. However, with cable television increasing the number of alternate venues for feature films, an "art house" movie shot in black-and-white might still find an audience. But don't be surprised if businesspeople claim that shooting in black-and-white is "uncommercial"—despite the fact that many high-end commercials shown on television use blackand-white imagery for its striking visual effect!

Color can be thought of as an additional

layer of visual information that can either augment the emotional tone of the image or become a distraction. In black-and-white, everything is reduced to tonal values and texture. This is one reason why deep-focus photography seems to work better in black-and-white. With color, a background detail will have unwanted significance if its color directs your eye toward it and away from the main subject. Keeping the background out of focus reduces this problem. So shooting in color puts a greater burden on the filmmaker to *control* that color, which can be very difficult on a low budget and when working in real locations.

Negative Versus Reversal

Today, most professional film work is shot on color negative stocks. Negative emulsions offer a much wider exposure latitude than reversal stocks; this allows greater flexibility to make changes when printing and when doing a transfer to video.

Reversal stocks were originally designed for the purpose of direct projection of the camera original, which comes out from processing as a positive. However, to protect the original, the normal practice of only projecting prints is followed. One advantage of working with a reversal stock is the possibility of superimposing white "burned in" titles in just one printing step (see chapter 7). Reversal emulsions are also physically tougher and are less easy to scratch than the negative emulsions. Dust specks on a reversal original print as black, whereas on a negative, they print as white, which is more visible on the screen.

But the primary reason reversal is still occasionally used, especially for transfer to video, where printing is not an issue, is to create a unique look, often higher in contrast. Also, the

FILM TECHNOLOGY

high color saturation of modern E-6 35mm color reversal stocks is appealing to some filmmakers. However, the problem has been that copying the color reversal onto a duplicate negative for making projection prints lowers the intense saturation that made the stock interesting to begin with (especially if the dupe negative is flashed to reduce the buildup in contrast). One recent solution has been to use *digital intermediate* technology, where the reversal is scanned into a digital form, color-corrected electronically, and recorded out to a new negative.

At this writing, the majority of film productions shot in the United States are shot on Eastman Kodak film stocks, but Fuji films have also gained a share of the market. The technical quality differences between the two manufacturers' products have closed considerably over the past twenty years; which you choose will partly be a matter of taste as well as economics.

A recent trend has been to offer some color negative stocks with lower contrast, some fairly flat and pastel-looking, others only mildly different from the normal-contrast stocks. Some people feel that these low-contrast stocks help counteract the increase in contrast of modern print stocks; others feel that they are more flexible in video transfers and digital intermediate processes, where there is more information to work with in the color-correction stage. Generally, in the digital realm, it is easier to throw away information than it is to try to retrieve something that was never recorded to begin with—so it is easier to add contrast than to remove it.

Speed Versus Graininess

As discussed earlier, faster emulsions are generally more grainy than slower emulsions. This is especially critical when shooting in 16mm, which is inherently more grainy than 35mm. The general rule is to use the slowest-speed film stock *as is practical* for your shooting requirements. The exception would be if a grainier look is desired for creative reasons.

You would choose a faster-speed stock for situations where the light levels are naturally low—for example, when filming night exteriors on city streets with practical sources in the frame. Or when shooting by the light of a campfire or candles. These are all situations where you either want to shoot under practical illumination only or don't want your additional movie lights to be significantly brighter because you don't want to overpower the natural ambience.

Cinematographers often will rate a color negative stock slightly slower than the manufacturer's rating. For example, a 500 EI stock may be rated at 400 EI or even 320 EI. This gives the negative more density than normal, which in turn requires higher printing lights to bring the image "down" to normal brightness. The result is generally deeper blacks and richer color saturation.

Tungsten Versus Daylight

Color stocks come balanced either for tungsten or daylight illumination. This is covered more thoroughly in the next chapter. Tungstenbalanced stocks are often used in daylight with a color-correction filter. Whether it is better to use daylight-balanced stock in daylight situations or use tungsten-balanced stock with a correction filter is a matter of taste and practical considerations. For example, if you don't want to carry multiple film stocks and will be shooting under both tungsten and daylight illumination, you would probably choose a tungsten-balanced film stock.

Print Stocks

Kodak, Fuji, and Agfa all make print stocks. Recent improvements have mostly been in terms of making blacks look denser, which means that there has been some mild increase in contrast. Kodak Vision (2383) is the most popular print stock used currently. The Fuji version (3510) is slightly less contrasty.

Kodak and Fuji also offer an alternative higher-contrast color print stock with even stronger blacks. The Fuji stock is called 3513DI. Kodak's higher-contrast stock, Vision Premier (2393), has the highest contrast, deepest blacks, and strongest color saturation of any print stock. The look is similar to the old Technicolor dye transfer printing process.

Unfortunately, Vision Premier is not available for 16mm printing. However, if you make a blowup from 16mm to 35mm, these highercontrast Kodak and Fuji print stocks tend to give the 35mm projected image the appearance of improved sharpness, better blacks, and less grain—which is useful to hide some of the artifacts of the blowup process. They are also popular for printing material that went through a digital intermediate step and was transferred back to film using a laser recorder, since there can be a somewhat duller look to the blacks and colors in this process (especially for digitally captured material).

Testing

The American Cinematographer Manual has a thorough article on the ways of testing film emulsions, written by Steven Poster, ASC. The basic concept is that you need to determine the exposure latitude of the emulsion in terms of how it handles different lighting ratios and over- and underexposure. You will also be determining an optimal speed rating for the emulsion that will give you the look you want.

You should also test any unique filtration and special lab processes you plan to use. If the final product is for print projection, you should carry your tests all the way through the process to the release print stage.

Many labs also have demonstrations of the special processes they offer.

Film Storage and Handling

To prevent undesired changes in the film stock, such as changes in color, sensitivity, and fog level, and to prevent shrinkage, all films should be properly stored and handled. Color film is especially sensitive to high temperatures and extremes in humidity.

All films should be stored in a refrigerator, sealed airtight in their cans. Humidity of 70 percent or more should be avoided, as it may cause the cans to rust and damage the labels and the cartons.

For storage up to six months the recommended temperature is 55°F (13°C) or lower. For longer periods film stocks should be kept in a freezer at 0°F to -10°F (-18°C to -23°C). When the film is taken out from the refrigerator, it must be allowed to warm up to room temperature before it is opened, or moisture may condense on its cold surface. This will take a single roll of 16mm film from thirty minutes to one hour. In a place with high temperature and humidity, extend this time to one and a half hours. A carton of several cans may take twelve hours or more to warm up.

When shooting on location the film is usually preloaded into camera magazines, which should be kept in dust-proof and moisture-tight metal magazine cases. These cases must be left in a cool place. When your car is parked in the sun its trunk becomes like an oven, so never keep your film there, even for a short period.

Before filming in really hot or humid areas or extremely cold areas, familiarize yourself with the appropriate Kodak pamphlets *and* the section in the *American Cinematographer Manual* dealing with film handling in these conditions. Kodak now has this information online.

When bulk film and magnetic tape has to travel on commercial airlines, advise the airline officials that it is perishable in extreme heat and that it should not be x-rayed or submitted to strong magnetic fields. Also write these instructions and the concerns on the outside of the case in large red letters. Due to security concerns, it is getting harder to avoid x-ray examination when transporting film on commercial airlines; it may be necessary to use an air package shipping service that guarantees that your film will not be subject to x-rays. If you have to use a commercial airline, don't put the film inside your checked baggage; you should hand-carry the film and contact the airport in advance to request hand inspection. Check the Kodak motion picture film Web site (www.kodak.com/ US/en/motion) for up-to-date advice on how to ship your film by air.

Film Ordering Information

Schools and independent filmmakers can buy raw stock directly from Kodak at a discount. Eastman Kodak Company Educational Marketing Division in Rochester, New York, can give you the address of the local distribution center. Also inquire at the FujiFilm dealerships about their student discounts.

When ordering film, make sure to specify the type of perforations and "wind" that are correct for your camera. Almost all cameras

2.15 Film winds. Film wound emulsion side in.

require film wound *emulsion side in*. Singlesprocket cameras use either B-wind single-perf film or double-perf film. A few cameras will accept double-perf film only, but since so many cameras can use single-perf film, and the Super-16 format requires it, *B-wind single-perf is the most common type you'll find sold*.

Very few cameras will accept A-wind film. It is mainly for printers.

"Pitch" refers to the distance between sprocket holes. High-speed cameras and print stocks require long pitch.

Emulsion is made up in batches, which yield thousands of feet of film. When ordering raw stock for a given production, it used to be advisable to secure all the footage with the same batch number, since different emulsion batches may have had slightly different characteristics. Modern film manufacturing is consistent enough that this is not necessary; however, you should always note the emulsion batch number on the cans and camera reports in case you need to track down a problem.

Film is cheaper when bought in bulk. It is common for amateurs to buy film in rolls of 400 feet or more and then break it down into 100foot spools. This is often more trouble than it is worth. It should be pointed out, however, that when winding unexposed stock from reel to reel in a darkroom, there is a chance that spots and patterns will be caused by static electricity on the film. This can be prevented by grounding the rewind arms and winding the film slowly at an even speed.

FILM FORMATS

Although this book primarily is concerned with the 16mm format (including Super-16), it is important to understand the 35mm format because it is *the* industry standard. If a theatrical release is intended, 16mm is always blown up to 35mm. Even at film festivals, 35mm print projection is by far more common than 16mm print projection. Image and sound quality are generally higher with 35mm projection, even if you had originated on 16mm.

The standard 35mm movie frame, moving vertically through the camera and the projector, is four perforations tall ("4-perf"); in comparison, the standard 35mm frame in a still camera is eight perforations wide, with the film run-

ning horizontally. The vertical rows of *perfs*, also known as sprocket holes, run along the outer edges of the film.

Early Cinema

Originally, the maximum area possible between the two vertical rows of perfs was used by the camera and the projector for the actual picture, with only a thin line separating each frame. This is called *full aperture* photography. It may also be called the "silent aperture" to distinguish it from later sound-era apertures; it is also the basis of the Super-35 format.

The 35mm 4-perf full aperture frame is $0.980'' \times 0.735''$. Using simple math, you can determine that the ratio of width to height—called the *aspect ratio*—is 1.33:1, 1.33 units wide for every single unit tall. This proportion is also sometimes expressed mathematically as 4×3 , the same aspect ratio of television. HDTV, how-

2.16 The 4-perf 35mm frame. *A:* Full aperture. *B:* Academy aperture. *C:* Matted wide-screen aperture. *D:* Anamorphic (CinemaScope) aperture.

ever, has a wider 16×9 aspect ratio; this can also be expressed mathematically as 1.78:1.

The introduction in the late 1920s of a sound track on the 35mm print, running just along the inside of one row of perfs, reduced the aspect ratio of the projected image from 1.33:1 to the almost square 1.20:1. Many felt that this was an awkward shape to compose within, so as a compromise, the projector aperture was also reduced slightly in height to create a more rectangular shape again. This was called the *Academy aperture;* it has an aspect ratio of 1.37:1.

The Wide-screen Era

The early 1950s saw the introduction of widescreen formats like Cinerama, VistaVision, Todd-AO, and *CinemaScope*. The latter used special anamorphic lens optics to squeeze a wider image onto the squarish 4-perf 35mm negative, which was then unsqueezed by another anamorphic lens when projecting the printed image. For a number of years, the aspect ratio of CinemaScope movies was 2.35:1, although this was modified in recent decades to around 2.39:1. To add to the confusion, this is rounded up to 2.40:1 by some—but the majority still refer to the old 2.35:1 proportions.

The standard amount of compression for 35mm anamorphic photography is $2\times$, which means the image is squeezed by half horizontally by the camera lens and then later doubled in width by the projector lens; 35mm anamorphic prints are often referred to as "scope" prints.

Around this time, the term *spherical* was used to describe traditional nonanamorphic lenses and the term *flat* was used to describe nonanamorphic prints. The popularity of these wide-screen formats caused the studios in Hollywood to begin experimenting with cropping down the height of the Academy aperture

ANAMORPHIC IMAGE ON PRINT WITH 2X SQUEEZE

IMAGE ON SCREEN AFTER BEING UNCOMPRESSED

2.17 The 2X squeeze of the anamorphic image on the print is uncompressed by the anamorphic projector lens.

frame during projection (by use of a mask in the gate) to make the image appear more widescreen. This is referred to as *matted wide-screen*, as opposed to anamorphic wide-screen. The most the frame would be cropped vertically was down to 1.85:1, although there were less cropped formats used, like 1.66:1, especially by European filmmakers.

The end result fifty years later is that the two most common 35mm print projection formats are 1.85:1 matted wide-screen and 2.39:1 anamorphic wide-screen. This is important to remember because it has ramifications when shooting in 16mm for blowup to 35mm.

16mm and Super-16

In 1923, 16mm was introduced as an amateur filmmaking format by Kodak. The frame lies between two sprocket holes and is roughly the

same shape as (but obviously smaller physically than) the 35mm frame. While engineers put the sound track on the 35mm format inside of two rows of sprocket holes, when sound-onfilm was introduced in 16mm, a different solution was used. The perfs on one side of the print were eliminated and the sound track was placed in that area.

The 16mm camera aperture is $0.404" \times 0.295"$ (1.37:1). This aspect ratio is well suited for transfer to 4×3 video (1.33:1) but problematic for blowup to 35mm, since all 35mm the-

atrical projection is wide-screen. This means that while the entire 16mm image will appear on the 35mm print within the 1.37 Academy aperture area, *it will be cropped down to 1.85:1 during projection*. Therefore, if you are shooting in 16mm for eventual blowup to 35mm, it is advisable to compose your image for this eventual cropping top and bottom to 1.85:1.

There have been a few cases where the regular 16mm frame was blown up to 35mm with a "window box" so that the entire frame fit inside the 1.85:1 projected area. However, many dis-

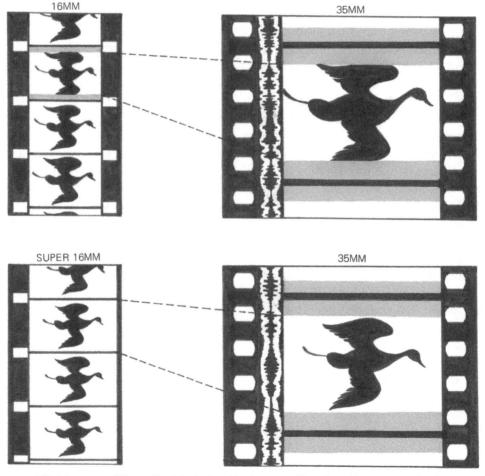

2.18 Advantage of Super-16 original when blowing up to 35mm for wide-screen projection.

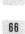

tributors and exhibitors frown on the practice for some reason. It is normally reserved for 4×3 video documentaries that are transferred to 35mm.

In the late 1960s, the Super-16 format was introduced. Using camera stock with perforations running only on one side (single-perf), the picture area was extended in the opposite direction of the perfs to the far edge of the film, creating a wider camera aperture of $0.493" \times 0.292"$ (1.69:1). Since this area is normally reserved for the optical sound track on a 16mm print, Super-16 is generally not considered a projection format, only a shooting format.

However, the combination of a larger negative area and the fact that, because of the widescreen shape, less of the image would have to be cropped during 35mm projection, means that a blowup from Super-16 to 35mm will look less grainy than a blowup from regular 16mm, all other factors being the same. So even though the Super-16 frame is only about 22 percent wider than the regular 16mm frame, when comparing a 1.85:1 area on both, the effective surface area used by Super-16 is 40 percent larger than regular 16mm.

A few filmmakers have blown up 16mm to

35mm anamorphic for 2.39:1 projection. One method is to use a regular 16mm camera with a PL-mount so you can use a $2\times$ anamorphic lens. The other method is to shoot in Super-16 and compose the 1.69:1 image for cropping later to 2.39:1.

Both techniques require that you waste some of the negative area. A $2\times$ anamorphic lens on a regular 16mm frame gets you an image with a 2.74:1 aspect ratio when unsqueezed, so it has to be cropped horizontally to become 2.39:1. Ultimately the size of the negative area used for the 2.39:1 frame is about the same whether you use a $2 \times$ anamorphic lens on a regular 16mm camera and crop horizontally or use spherical lenses on a Super-16 camera and crop vertically. Therefore, it would probably be better to just use spherical lenses on a Super-16 camera, since those will be optically superior to anamorphic lenses. Plus, spherical lenses will be more readily available. Either way, these approaches will yield a grainier image than if you shoot Super-16 for conventional 1.85:1 projection in 35mm.

See chapter 7 for more descriptions of the optical and digital methods for blowing up 16mm to 35mm.

З FILTERS AND LIGHT

A cinematographer's primary concern is the manipulation of color, contrast, and texture. These qualities can be controlled either by changing the way in which the light falls upon the subject (as we will discuss in the next chapter), or by introducing a filter between the subject and the camera. To understand how light can be manipulated by filters, we will start by exploring just a little bit of light theory. Then we can discuss specific filters and their functions. (*Note:* There are several filter manufacturers, and some have different designation systems. For the sake of simplicity we will use Kodak Wratten filter numbers, unless otherwise indicated.)

THE ELECTROMAGNETIC SPECTRUM

The electromagnetic spectrum extends from cosmic rays to telephone impulses and beyond. Within this enormous range of wavelengths there is a narrow range of visible energy, called light. The rest is darkness to our eyes. At each end of this visible spectrum there are wavelengths—ultraviolet and infrared—that are not visible to the human eye but can be recorded on film.

The most common human experience of the entire visible spectrum is the rainbow. All the colors of the rainbow are generated by the sun. *Together they appear white.* But when dispersed by the moisture in the air or refracted by a prism, the wavelengths are spread, thus creating a rainbow effect.

FILTER THEORY

The color of an object comes from the light falling on it. When white light (which contains all the visible wavelengths) falls on an object, some hues are absorbed. The other colors are reflected, giving the object an apparent color. For example, when white light strikes a "blue" object, the surface of the object reflects the blue light and absorbs all the other visible wavelengths, mainly red and green.

The color of the object will change when the light falling on it is not white. For example, when a "blue" object is illuminated by light *not* containing blue wavelengths, the object will appear black.

This brings us to the basic principle of filters. Filters modify light by absorbing certain colors and allowing others to pass. To put it more simply, filters, as their name suggests, do not *add* colors, they can only *remove* certain wavelengths.

When using filters we think of the spectrum as three primary colors: *red*, *green*, and *blue*. This is sometimes shortened to RGB. Any other color is a mixture of these three. We manipulate the primary colors by using their so-called complementaries: *yellow*, *cyan*, and *magenta* (YCM).

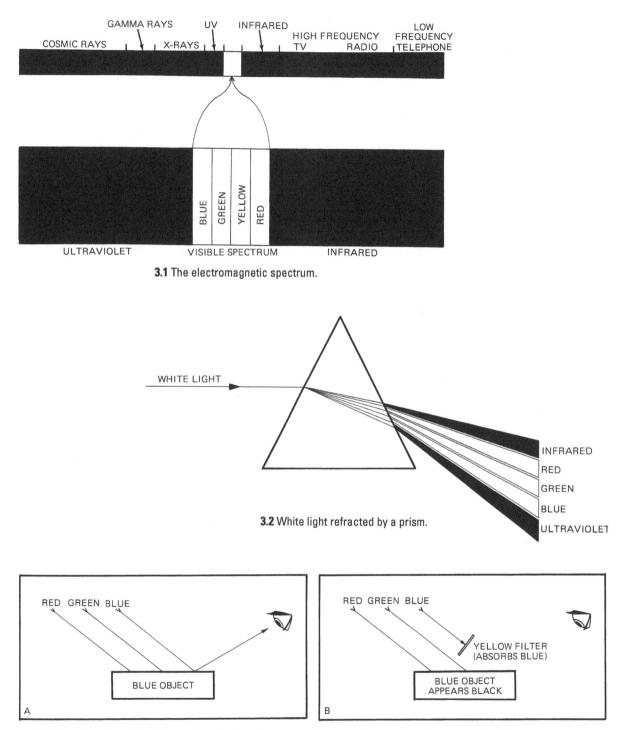

3.3 The color of an object depends on A: the color absorbed by the object; B: the color of the light falling on the object.

Yellow is called "minus blue," because a yellow filter stops blue and passes green and red, which together make yellow light. Magenta is called "minus green," because a magenta filter stops green light and passes blue and red, which together make magenta light. Cyan is called "minus red," because a cyan filter stops red light and passes blue and green, which together make cyan light.

These are the basic principles of filter formulas. In practice we do not always deal with pure primary and complementary colors, and so a wide variety of filters have been designed, each for a specific and limited job. There are three main areas of filter use: black-and-white, color, and all-purpose. But before going further we must first consider filter factors.

Filter Factors

All filters absorb a certain amount of light reaching the film. Depending on the rate of absorption, the compensation in exposure is expressed as the *filter factor*. The filter factor represents the number of times we need to increase the exposure. When the factor doubles we increase the exposure by one stop.

For example, if the exposure for a picture is f/11 with no filter and we then decide to use a filter with a factor of 2, the exposure will have to be increased one stop to f/8.

When using more than one filter, we *multiply* their factors, not add them. An alternate method is adding the required f-stop compensations for the filters.

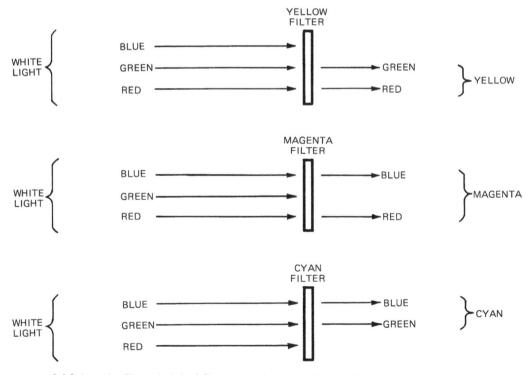

3.4 Subtractive filter principle. A filter passes its own color and subtracts its complementary.

Factor	Compensation
2	1 stop
2.5	1⅓ stops
3	1⅔ stops
4	2 stops
5	2⅓ stops
6	2⅔ stops
8	3 stops
10	3½ stops

For example, suppose we were combining two filters with factors 2 and 4, respectively. If we multiply the factors $(2 \times 4 = 8)$, a factor of 8 requires 3 stops compensation. If we add compensations, factor 2 requires 1 stop compensation, factor 4 requires 2 stops compensation, and 1 stop plus 2 stops equals 3 stops compensation. The same result is obtained by multiplying factors. Exposure compensation tables are provided in the filter manufacturer's literature and in the *American Cinematographer Manual*.

FILTERS FOR BLACK-AND-WHITE FILM

Black-and-white film reproduces color in shades of gray. The human eye is not equally sensitive to all colors, seeing some colors, such as green, as brighter than other colors, such as blue. Similarly, black-and-white films also have their own peculiarities. For example, they see blue as brighter than green and will record blue objects in a lighter shade of gray than green objects, the opposite of what the human eye does.

In black-and-white photography, filters are used to manipulate the emulsion's response to colors. You may correct the emulsion's response to match that of the human eye, or you may augment the *contrast* between two colors that would otherwise appear as the same shade of gray.

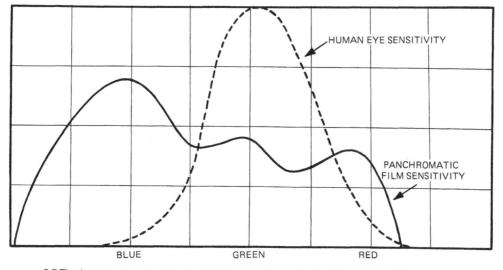

3.5 The human eye and a black-and-white panchromatic film differ in sensitivity to colors.

Because black-and-white emulsions are "oversensitive" to blue light, the most common problem is the overbright sky. In such cases the sky appears as dead white. To correct this, we use a yellow filter, which absorbs blue light, thus slightly darkening the sky. Because the shadows are illuminated by blue light from the sky, they will also be darkened, thus increasing the overall scene contrast.

The orange filter goes further in darkening the sky and shadows. If we want to make cloud formations very visible, an orange filter can be used to accentuate the clouds by overdarkening

3.6 Blue sky with clouds shot in black-and-white film with no filter.

3.7 Blue sky with clouds shot in black-and-white with a red filter.

the sky. A red filter will render the blue sky nearly black and greatly accent clouds and contrast for a night effect. Of course, these effects are based on the elimination of blue light. If the sky is overcast (that is, white and not blue), such filters will not successfully darken the sky. It should be noted that at altitudes above 3,000 feet the blue sky is much darker and often no filter is necessary to correct it. Even a light yellow filter may make it quite dark.

Another very important use of the orange filter is for penetrating haze. Normally, haze is created by tiny water and dust particles suspended in the atmosphere. It scatters the shorter wavelengths of light, most notably blue. Because it absorbs blue, the orange filter can be used to diminish the effect of haze. However, haze cutting must be done with moderation, as haze gives a picture threedimensional aerial perspective. If *all* haze were eliminated (such as with a red filter), the picture would appear flat.

When the subject is farther away from the camera, there is more atmosphere (hence potential haze) between the camera and the subject. For this reason, lenses longer than 250mm will frequently require an orange filter for outdoor use. This is because the subject is usually a considerable distance away when such a lens is used.

To *increase* haze, as when one wants to exaggerate atmospheric depth, a pale blue filter will help. It may also be used to simulate the look of old Silent Era orthochromatic films, which were insensitive to red and overly sensitive to blue, so skies often burned out to white.

For portraits, filters are often used to improve or modify skin tones. In close-ups the orange filter will darken blue eyes and eliminate all or most of the freckles and skin blemishes. A #15 (deep yellow) filter is commonly used for this purpose. A green filter, on the other hand,

would darken the skin for a suntan effect while emphasizing freckles and blemishes.

Filters can be used to improve the rendition of foliage. In nature our eyes can distinguish many shades of green. Without filters, blackand-white film emulsions tend to darken greens and eliminate tonal gradations. A green or a green-yellow filter will help to differentiate the green tones but will not lighten foliage as much as we might expect. Actually, foliage reflects much red light and infrared radiation, and therefore an orange or red filter will brighten greens. If infrared film is used with a deep red infrared filter, the foliage will appear white.

FILTERS FOR COLOR USE

In black-and-white photography, colored filters can be used to augment contrast or otherwise alter the way in which the emulsion translates colors into shades of gray. However, when filming in color the film will record the color of the filter. Therefore, in color work the principal task of filters is to keep the colors true to reality.

As we mentioned before, white light contains all the colors of the spectrum. But the *exact* color of the light depends on the *temperature* of its source. For example, if we heat up a piece of metal, it will glow red. If we heat it up even more, it will glow white. The sun is burning "white hot" and therefore glows white. The tungsten filament in a lightbulb, however, is burning at a lower temperature and therefore only emits a reddish yellow light.

Our eye adapts so easily between these color temperatures that we see them both as white unless they are placed side by side. If such a comparison were made, the outdoor light would appear to contain just a bit more blue light, and the artificial light would show more red. Color film will not adapt so easily between these different sources. Therefore, an emulsion must be designed for a specific color temperature.

To define the exact color temperature of a given light source, scientists compare it to a "black body." This laboratory instrument is dead black when cold. As it is heated, it starts glowing, changing color as the temperature rises. The temperature is measured in degrees Kelvin. Each color radiated by the black body can be described by its color temperature in degrees Kelvin. We think of red as a warm color and blue as a cold color, but the Kelvin degree ratings show them as just the opposite. Some color temperature ratings of common light sources are:

Source	Color Temperature		
Candle flame	1,500°K		
Tungsten:			
60-watt household bulb	2,800°K		
Film-studio lights	3,200°K		
Photoflood bulb	3,400°K		
Sunset in Los Angeles	3,000°K–4,500°K		
Noon summer sunlight	5,400°K		
HMI lamp	5,200°K–6,000°K		
Blue skylight	about 10,000°K		
Clear blue northern sky	up to 30,000°K		

Color emulsions are balanced either for tungsten light (3,200°K) or for photographic daylight (5,500°K). By this we mean that 3,200°K light will appear white on color film balanced for 3,200°K. Midday sunlight will appear white on film balanced for daylight.

If the light source and the emulsion balance do not match, the color reproduction will be biased. For example, if a tungsten-balanced emulsion is shot outdoors in noon daylight, the entire

scene will appear to be bluish. The opposite is also true. A daylight-balanced film shot indoors under tungsten illumination without the proper correction filter will yield an orange picture. In such situations we must use a color conversion filter to correct the color balance of the light entering the lens. The most common conversion by far occurs when indoor (3,200°K) film is being shot outdoors. This requires an orange #85B filter, which "warms up" the bluer daylight, lowering the color temperature of the incoming light from 5,500°K to 3,200°K in order to agree with the film. A #85 filter (also called #85A) is slightly "cooler." It lowers the daylight color temperature to 3,400°K, leaving the light with a little blue content. Film comes in two tungsten balances, Type A (3,400°K) for shooting under photoflood illumination and Type B (3,200°K) for movie lamp illumination. Hence, the #85A converts daylight for Type A film and the #85B converts it for Type B film. However, all motion picture color negative stocks are Type B.

74

Although rarely done, the opposite conversion—for daylight emulsion used under 3,200°K lights—can be accomplished by using the blue #80A filter. While the orange #85B filter cuts the exposure down by two-thirds stop, the #80A blue filter requires a compensation of two stops.

Color conversion filters are used for broad modifications of color. More exact corrections in color temperature are done by the lab timer in the printing process. The type of filter used during printing is called a color compensating, or CC, filter. These come in six basic colors, three primary (red, green, blue) and three complementary (cyan, magenta, yellow). They are available in seven densities. Occasionally, they may be used while shooting—for example, if a particular lens produces a slight color cast, or when the emulsion has to be color-balanced to some unusual light source, such as fluorescent or a mercury vapor light.

Some minor color changes can also be ac-

Filter Color	Filter Number	Exposure Increase in Stops*	To obtain 3200 K from:	To obtain 3400 K from:
Bluish	82C + 82C 82C + 82B 82C + 82A 82C + 82 82C 82B 82A 82A 82	$ 1 \frac{1}{3} 1 \frac{1}{3} 1 1 1 2 3$	2490 K 2570 K 2650 K 2720 K 2800 K 2900 K 3000 K 3100 K	2610 K 2700 K 2780 K 2870 K 2950 K 3060 K 3180 K 3290 K
No Filter Necessary			3200 K	3400 K
Yellowish	81 81A 81B 81C 81D 81EF	1/3 1/3 1/3 2/3 2/3 2/3	3300 K 3400 K 3500 K 3600 K 3700 K 3850 K	3510 K 3630 K 3740 K 3850 K 3970 K 4140 K

*These values are approximate. For critical work, they should be checked by practical test, especially if more than one filter is used.

3.8 Kodak light-balancing filters. (Courtesy of Eastman Kodak)

complished by using light-balancing filters. These are designed to obtain a bluer (#82 series) or more yellow (#81 series) rendition of color. For example, daylight emulsions are balanced for noon daylight. However, color temperature of daylight changes from reddish at sunrise to bluish at noon and back to reddish at sunset. From about two hours after sunrise until about two hours before sunset these changes are minor. But in the early morning and late afternoon the color changes rapidly. Some cinematographers like to correct these changes while shooting in order to avoid a discrepancy in color between shots that must later be edited together. This way, even the dailies printed from the original footage with only broad color correction will look acceptable when screened.

Besides the #81 series, there are a wide variety of "warming" filters made with different mixes of yellow, orange, red, brown, and so on. Some examples: Coral, Chocolate, Tobacco, Straw, Sepia, Tiffen Antique Suede, and the Tiffen 812 filter. The brown filters such as Chocolate or Sepia tend to have a higher filter factor because they are fairly dense.

It is sometimes undesirable to completely "correct" color temperature. For example, if we are filming a reddish sunset, it is better to leave it uncorrected than to change it into white daylight. Sometimes a partial correction is desirable by replacing a #85B filter with a yellowish lightbalancing filter (#81EF).

The key question to ask is whether the nonwhite light is motivated, either by the situation or the story needs. If two actors are standing near an open fire, it is entirely reasonable that their faces should be illuminated by reddish light. In fact, at times we may use color filters to distort the existing color, to make the image more logical or more poetic. For example, if an actor is outside at night, supposedly illuminated by moonlight, a light blue filter gel may be used on the light for psychological realism. We may want soft dusk light outdoors to have a bluer cast than the warm sunset light that preceded it. It is also not uncommon to let snow scenes look a little more blue to create a stronger feeling of coldness. Some filmmakers will even allow fluorescent-lit scenes go greenish for a disturbing effect.

One unusual filter made for color photography that should be mentioned is the *Color Enhancer*. It uses a combination of rare earth elements called didymium dissolved in glass and completely removes a narrow portion of the spectrum in the orange region. The effect is to increase the intensity of certain brown, orange, and reddish colors in objects by eliminating the muddier tones and maximizing the red saturation. Its most frequent use is for shooting fall foliage. The only danger is that some skin tones might become overly warm, almost plum colored, and be difficult to correct later. It has a filter factor of 2 (one stop).

Measuring Color Temperature

To determine the proper light-balancing filter for converting a given light to the correct color temperature required for a given film, we use a color temperature meter. This meter will determine the exact color temperature of the light falling on the subject. It should be pointed directly into the light source being measured. The less expensive color temperature meters measure only two colors-red and blue-and indicate which filter is required to achieve the proper color balance. These meters cannot handle fluorescent light, in which green content will affect the image substantially. For measuring lights that have unusual spectral characteristics, such as fluorescent and mercury vapor, there are three-color meters designed to measure red, green, and blue.

3.9 Minolta Color Meter III-F. A three-color temperature meter that indicates appropriate correction filters. *(Courtesy of Minolta Corporation)*

Many cinematographers consider the color temperature meter a luxury that they can survive without. Others see it as an important tool in controlling the color standards of their lighting.

Every filmmaker should, as a standard, enforce the uniformity of color temperature among all the light units that he or she is using. A conscientious cinematographer or gaffer will find, for example, that a new HMI light may be close to 6,000°K, while an old one can be down to 4,800°K. Smaller HMI units (750-watt, 1,200watt, 2,500-watt) are often too green. Checking the globes with a color temperature meter will allow the cinematographer to balance them out with color lighting gels. It is advisable to mark the recommended corrections on a piece of tape placed on the yoke of each light. If the cinematographer decides that the light from all the HMIs should be a bit "warmer," he may balance them to a lower color temperature, say, 5,200°K, with proper lighting gels *on top of* the previously discussed individual lamp corrections made to match each other.

The MIRED System

MIRED (micro reciprocal degrees) is another way of describing changes in color temperature. The problem with the Kelvin system is that the amount of blue needed to change a light from 2,800°K to 3,200°K, for example, is not the same as the amount needed to convert 5,100°K to 5,500°K, even though both describe a change in 400°K. Or to put it another way, the same lighting gel, such as a #¼ CTB (color temperature blue), will not increase a tungsten light source by the same degrees Kelvin as an HMI.

To determine the MIRED value, you divide 1,000,000 by the color temperature, so 3,200°K has a MIRED value of 313 (312.5 to be precise), and 2,800°K has a MIRED value of 357. Therefore, the difference is 44 MIREDs. Since higher color temperatures have lower MIRED values, gels that are bluer (and thus lower the MIRED value) have negative numbers, while gels that are redder will have positive numbers. So to increase 2,800°K to 3,200°K, you would use a blue gel with a MIRED shift of -44.

Tiffen makes a line of color-correction filters that work in terms of MIRED values, called *Decamireds* (a Decamired is a MIRED divided by 10). If 3,200°K has a value of 313 and 5,500°K has a value of 182, the difference is 131. So the closest filter to make that correction is a #12 Red Decamired filter to convert 5,500°K to 3,200°K and a #12 Blue Decamired to convert in the other direction. However, keep in mind that a #12 Red Decamired filter doesn't have the same degree of UV protection as #85B. Also, the dyes in the #85B filter are specifically designed to correct colors under daylight illumination for tungsten-balanced film stock.

Manufacturers of lighting gels list their MIRED shift value. This can be cross-referenced with the LB number that your color temperature meter tells you is needed to correct the light.

MIXED LIGHT SOURCES (DAYLIGHT, FLUORESCENT, AND TUNGSTEN LIGHT)

Fluorescent light is an odd light source that rates a discussion of its own. Its peculiar characteristics make it somewhat of a headache when filming in color.

As we mentioned at the beginning of this chapter, white light contains all the colors of the rainbow. Tungsten light also contains all the colors but in a different proportion—more red and less blue. The majority of fluorescent tubes and industrial gas discharge lamps (like streetlamps), on the other hand, do not contain the entire spectrum and thus are called *partial spectrum* lights. The electrified gas inside these lights emits only a few distinct wavelengths. This light is often rich in green but deficient in red and contains "gaps" in other colors.

This statement holds true when dealing with the most often encountered varieties of fluorescent tubes with names like Cool White and Warm White. There are, though, a number of newer fluorescent lamps characterized by so-called continuous spectrum light, which emits a light comparable to tungsten or daylight. Optima 32 (made by Duro-Test) is an example of a fluorescent tube closely matching 3,200°K tungsten light, as opposed to Vita-Lite (Duro-Test), which matches daylight. Also not far from matching daylight is Chroma 50 (GE). A number of other companies make Chroma 50 tubes but with other names, such as Colortone 50 (Philips).

Color Rendering Index

All of these tubes still have a certain amount of excess green that may need to be filtered out. Even closer to regular movie lamp colors are tubes made for Kino Flo fluorescent units, the Kino 55 (5,500°K) and the Kino 32 (3,200°K). There is also a Kino 29 tube (2,900°K).

The *color rendering index* (CRI) is a method of judging how different lights affect color reproduction compared to a reference source of the same color temperature. The numbers are not absolute. A "perfect" score is 100, and any light between 90 to 100 is considered to have good color reproduction properties. A Cool White fluorescent, because of the excess green, has a CRI rating of only 62, while a Vita-Lite is rated 91 and a Kino Flo K55 tube is 95. But note that there are many variable factors (such as overheating) that alter how much green these lights may put out.

When budget and time allows, such fluorescent tubes can be rented and installed to meet production needs. The Optima 32 and Chroma 50 / Vita-Lite tubes are cheaper than the ones by Kino Flo, which have better color. So your choice between them will probably be determined by the number of tubes you need to get. Unfortunately, in the majority of cases the filmmaker is faced with locations where replacing the existing tubes would be prohibitive both financially and time-wise.

Handling Mixed Lighting

Let's look at a hypothetical scene and three lighting situations. For the sake of simplicity we will use the color designations of two gel manufacturers, Lee Filters and Rosco.

Scene 1

The first scene, shown in figure 3.10, takes place in an interior illuminated by the most commonly encountered Cool White fluorescent tubes and by daylight coming through the windows of the location. We are planning to use HMI lamps as additional sources *inside* the room.

We are shooting this scene on color negative balanced for tungsten light (3,200°K). We can call this our first lighting scheme, a daylight-plus-green plot. Our goal is to match the amount of green in the fluorescents to every light source and then to correct the entire image for the tungsten-balanced film stock. The windows, tungsten lights, and HMIs will be gelled with Full Plus-Green (Rosco #3304 / Lee #244). The tungsten lights will also be gelled with Full Blue (Rosco #3202 / Lee #201) to match the daylight. Or instead of Full Plus-Green and Full Blue, the tungsten lights could gelled with Cal-Color 60 Cyan (Rosco #4360).

The only light source that will be without a gel is the fluorescent light. We could also use additional fluorescent tubes as fill light. Technically, if the tubes are Cool Whites, we should add at least a Quarter Blue (Rosco #3208 / Lee #203) to them to match the blueness of the HMIs and daylight windows. Cool Whites are around 4,200°K.

With all sources matched to fluorescent Cool White, all that remains to be done on the camera is to use a fluorescent-to-tungsten converting filter known as the Tiffen FL-B. This has a MIRED shift of about +100, which would convert 4,700°K to 3,200°K. This corrects most of the blue-green fluorescent tubes like the Cool Whites; therefore, when our color temperature is more like 5,500°K, as in this case, we would still have a slight coolness in the filtered image that can be adjusted later in color timing. Should our film stock be daylight balanced, the camera filter to use would be the FL-D. The FL-B looks magenta (minus green) plus orange, while the FL-D just looks magenta. These filters require an exposure compensation of one stop. If we cannot afford this one stop loss due to low light levels, we could make a partial correction using a #CC20M (magenta) filter to remove most of the green, leaving the rest for the lab to correct in postproduction. You should always remember that printing from a negative allows greater latitude in color corrections than does the use of reversal. Some filmmakers opt to have the lab do all fluorescent correction on prints from a negative. At worst, there might be some slight loss of red saturation in skin tones. Prior consultation with the particular lab, however, is a good idea in such a case.

Scene 2

Our lighting scheme for scene 2 is shown in figure 3.11. This time the windows will be left unfiltered and all the other light sources will be matched to daylight. The Cool White fluorescent tubes will now be covered with Full Minus-Green gels (Rosco #3308 / Lee #247) to filter out the excessive green. HMI lamps will remain unfiltered as they are matching daylight, and tungsten lights will be gelled with Full Blue (Rosco #3202 / Lee #201) to convert their color temperature to daylight. Again, we could add Quarter Blue (Rosco #3208 / Lee #203) to the Cool Whites if we wanted to get closer to 5,500°K.

If the camera is loaded with tungsten balanced film, a #85B filter will have to be used on the lens, since all the light sources will be converted to daylight. In this scheme, covering all the fluorescent tubes with Full Minus-Green gel may become a logistical problem. We could try to avoid doing this by overpowering the scene

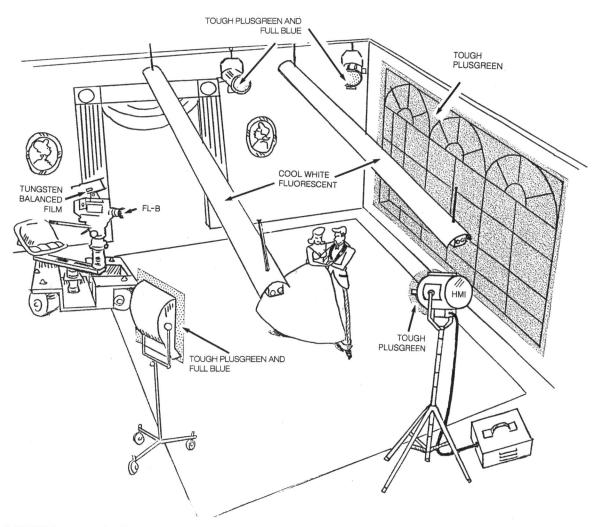

3.10 All light sources in this scene are balanced with proper gels to match the color of the fluorescent tubes. Lens is equipped with a Tiffen FL-B filter to convert the light entering the lens to the 3,200°K required for the tungsten-balanced film stock. (Drawing by Robert Doucette)

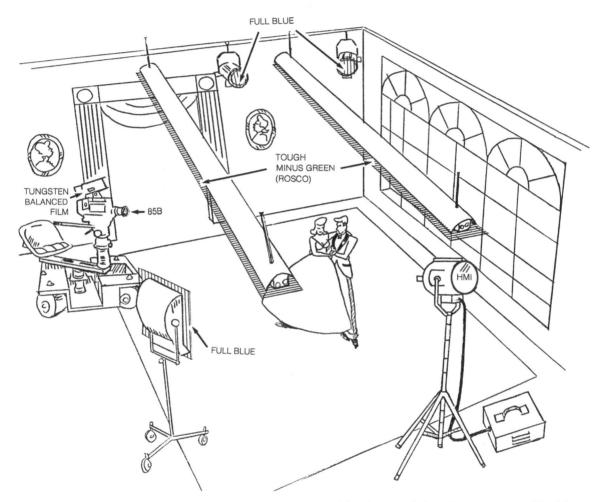

3.11 Both the fluorescent tubes and the tungsten lamps are balanced with gels to match the color temperature of daylight. HMI lamp produces a daylight-matching light without any correction. Lens is equipped with a #85B filter to convert the daylight entering the lens to the 3,200°K required for the tungsten-balanced film stock. (Drawing by Robert Doucette)

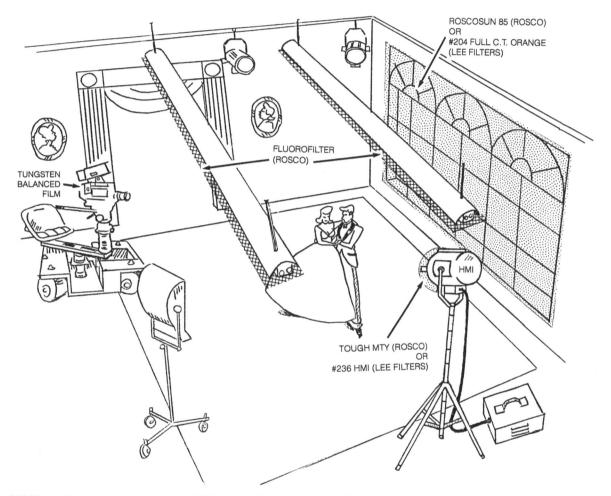

3.12 The daylight sources (window and HMI lamp in this scene) and the fluorescent tubes are all converted to 3,200°K with proper gels to balance them to tungsten light. With all the lights matching tungsten, and tungsten-balanced film stock being used, there is no need for a color conversion filter. (*Drawing by Robert Doucette*)

with our daylight-balanced lights and leaving the fluorescent tubes ungelled. This works particularly well when the scene is covered in shots that do not reveal large spaces and when the fluorescent fixtures are not visible in the frame. A color temperature meter that measures red, green, and blue colors will prove handy in such an operation.

Scene 3

Our third scheme of color balancing, the scene in figure 3.12, will aim at having all the sources converted to 3,200°K.

The windows will be gelled with RoscoSun 85 (#3401) or with Lee Full CT Orange (#204), and the Cool White fluorescent tubes will be covered with Rosco Fluorofilter gel (#3310). This is similar in color to the Tiffen FL-B filter. The tungsten lights will remain unfiltered and the HMI lamps will be gelled with Tough MTY (Rosco #3106) or Lee HMI (#236). You can also use RoscoSun ¾ CTO (#3411) or RoscoSun 85 (#3401) on the HMI depending on its exact color temperature. With all the light sources converted to 3,200°K, no filter is needed on the camera lens.

ALL-PURPOSE FILTERS

Some filters are suitable for use with either black-and-white or color films.

Ultraviolet Filters

These are sometimes referred to as "haze" filters because ultraviolet (UV) light is scattered by atmospheric haze. When unfiltered it will cause distant landscapes to appear flat, and open shade will show a bluish cast. The effects of ultraviolet radiation are particularly pronounced in the mountains. The filter most often used for cutting haze and slightly warming the scene is the Sky 1-A. If you don't want the extra warmth of a Skylight filter, Haze 1 and 2A can be used. Fog is different from haze and will not be penetrated by this filter. It is important to bear in mind that all filters in the yellow, orange, and green series also stop ultraviolet radiation. Therefore, if you are employing a #85B filter, the ultraviolet light is already taken care of. Also, most manufacturers add additional UV protection to the #85 series filters. This is important to know, because if you remove the #85B filter—for example, to gain two-thirds of a stop more light when it gets darker outsideyou have also removed your UV protection. It may be a good idea to then add a UV filter. Or use the Tiffen LL-D (low-light daylight) filter, which is a UV filter combined with some correction to remove excess blue.

Neutral Density Filters

These are designed to cut down overall brightness and reduce all colors equally, hence they look gray in color. They are often used when the light intensity is too high for the given emulsion (for example, when shooting on a fast emulsion outdoors in bright sunlight). Neutral density (ND) filters are also used to avoid having to stop the lens down too far. There are two reasons for doing this. Lens optics are better at f/11 than at f/16 or f/22. Furthermore, stopping down increases the depth of field, which may not be desirable if, for example, we want to separate the subject from the background.

Neutral density filters are calibrated by their density. The most frequently used are ND 0.30, ND 0.60, and ND 0.90, representing exposure reductions of one, two, and three stops, respectively. Some other filters are manufactured in combination with neutral density filters. For

Neutral Density	Percentage Transmittance	Filter Factor	Increase in Exposure (Stops)	
0.1	80	1 1/4	1/3	
0.2	63	1 1/2	2/3	
0.3	50	2	1	
0.4	40	2 1/2	1 1/3	
0.5	32	3	1 2/3	
0.6	25	4	2	
0.7	20	5	2 1/3	
0.8	16	6	2 2/3	
0.9	13	8	3	
1.0	10	10	3 1/3	
2.0	1	100	6 2/3	
3.0	0.1	1,000	10	
4.0	0.01	10,000	13 1/3	

KODAK WRATTEN Neutral Density Filter No. 96

3.13 Kodak Wratten neutral density filters. (Courtesy of Eastman Kodak)

example, a #85N3 is a single filter combining a #85B with an ND 0.30 filter.

A neutral density filter that does not cover the whole frame comes as a graduated or grad filter. There are three varieties: hard-edge, softedge, and attenuator. The *hard-edge* grad is not really graduated at all but has an abrupt transition from a clear area to the ND area on the glass. It tends to be used on longer lenses where the sharp transition is blurred, since the filter is completely out of focus. A *soft-edge* grad has a soft bleed line that separates the ND part of the filter from the clear area; it is the most commonly used type of grad filter. The *attenuator* just gradually darkens throughout the whole filter from the clear area to the ND area; it's useful on wideangle lenses where even the soft-edge grad is too obvious because of the deeper focus. Grads also come in a wide variety of colors. Customdesigned filters may have the dividing line at different levels and angles to fit a particular horizon line, or the line may even be uneven (wavy). The ND grad filter is most often used to darken the

sky. Used vertically, a grad can be used to darken the sunny side of the street, a particularly bright building, or a bright window on one side of a room. To augment the colors of a sunset, you can use one of the color grad filters. There is no exposure compensation required with grad filters, unless you do something unusual like use a color grad from below and another from above, with no clear area left in between.

Unfortunately, panning and other camera movements may betray the presence of this filter, so the camera should generally remain stationary when it is being used. There are some matte boxes, though, that allow the filter tray to be mechanically raised or lowered; this allows you to keep the transition line of the filter over the same background even as the camera tilts or booms up or down.

Diffusion and Contrast Reduction

Neutral density filters absorb light. On the other hand, *diffusion filters* and their cousins,

contrast-reduction filters, scatter light and reduce definition. Some are designed to do more of the first, and others more of the second.

Diffusion filters are often used in two ways, what could be called "invisible" and "visible" techniques, although there is some overlap. With the invisible approach, the idea is to simply soften definition without any visible artifacts to give away the fact that a filter was used. Often this invisibly (or at least subtly) filtered shot will be intercut with undiffused material. The reduction in definition is usually done to hide some flaw in the actor's face that day or to make a prosthetic makeup effect more convincing. The ideal invisible diffusion filter would be one that created none of the common artifacts, like halation (a glow around bright areas) or contrast reduction (a result of halation), but simply reduced fine details. The lighter strengths of the Tiffen Soft/FX and the Schneider Classic Soft filters are often used for lightly softening detail in close-ups with a minimal amount of halation or contrast loss. The Tiffen Black Diffusion/FX has even fewer artifacts.

With visible diffusion, you are using a filter to impart a distinct look to the scene, whether to create a soft and hazy "period" feeling to a movie that's set in the past or a more romantic, dreamlike mood for a fantasy film. In such cases, you often cannot intercut filtered and unfiltered material because the mismatch in tone and texture will be very obvious.

The 16mm format does not have as much resolution as 35mm, and therefore diffusion in 16mm is not as necessary for, say, reducing definition in a close-up. It is rather used, if at all, to create a visibly diffused look. However, it is still advisable to use a lower-strength version of the same filter you might use if you were shooting in 35mm. Remember that there are methods to soften the image later in postproduction, but it is harder to sharpen overly soft images—so err on the side of less diffusion.

Most diffusion filtration works on the principle of using a "screen" or pattern of some sort that allows some areas to pass through the filter unaltered and sharp but other areas to be thrown out of focus. The soft image is therefore superimposed over the sharp one. The filter may also have suspended "mist" particles that serve to scatter light, allowing it to bleed into dark areas and thus lower contrast. There may even be black particles added to counteract the contrast loss from the mist particles. What all of this means is that there are situations where the pattern of the filter may come into focus if there is too much depth of field, and some diffusion filter designs have this problem more than others.

In addition to commercially made filters, many materials have been used for diffusing the image, such as a black net, white gauze, panty hose, and a piece of optical glass smeared with petroleum jelly or glycerin. Some cinematographers have used a smudged thumbprint on a piece of glass to soften a specific part of the frame.

Some diffusion filters are mainly used to scatter light and cause halation, rather than to simply soften the image. *Fog filters* are one example; they were originally designed to simulate the look of shooting in fog. From that concept evolved *Double Fog filters*. These create the effect of fog without reducing definition as much as regular fog filters; they are essentially a combination of a fog filter and a low-contrast filter. At their lower density range the fog effect is minimal, but they help to cut down contrast and desaturate harsh colors. Neither fog nor double fog filters create a very convincing effect of actual fog, which in nature progressively hides objects as they recede in depth. To help

FILTERS AND LIGHT

this problem, Harrison & Harrison designed the Scenic Fog Filter, which could be described as a fog grad filter. When the less dense half of the filter covers the lower section, the foreground objects are less affected. If this position is reversed, however, the lower part is foggier, creating the effect of low-lying fog. Tiffen also makes a filter called Smoque, which simulates the effect of smoke in the air.

Low-contrast filters are useful for dealing with heavy contrast on an exterior, particularly when the shots may have to be matched with previously shot footage of the same area on a smoggy day. They produce less halation and less softening than a fog filter but are otherwise similar. The Tiffen Ultra Contrast filter, however. is even better than a low-contrast filter at lifting shadow detail without causing halation or softening. The tiny light-scattering particles in this filter are so finely dispersed that you get an even haze more akin to flashing the film. The filter relies on ambient light hitting the glass, so it should be the filter farthest away from the lens in the matte box and should not be overly shaded from ambient light (just hard light).

Frost filters such as the Tiffen Pro-Mist, the Wilson SupaFrost, and the Schneider White Frost are also like fog filters, but they soften the image more with less blooming around light sources and less overall haziness. There are versions of these frost filters that use a random pattern of black specks in the glass to improve blacks normally lost by the diffusion effect. The Tiffen Black Pro-Mist is one example. The use of a black screen to restore contrast is the principle behind a black net or panty hose or the pattern of black dots in the Tiffen Black Diffusion/FX.

Most of these diffusing or contrast-cutting filters do not require more exposure. On the contrary, lowered contrast, especially in already low-contrast subjects, may appear as overex-

3.14 No filter.

3.15 Tiffen #1 Pro-Mist filter.

posed images and therefore some minor exposure reduction is sometimes needed to prevent slight flaring. On the other hand, the lightdiminishing characteristics of homemade diffusion devices—such as clear glass smeared or sprayed with glycerin, or nets such as panty hose—should be tested by holding the "filter" in front of an exposure meter. Filters like the Tiffen Black Pro-Mist also might require a minor adjustment in exposure to compensate for the light loss due to the black specks.

The effectiveness of all these diffusion filters depends on the f-stop, the focal length of the lens, and the subject's size in the frame. Stopping down decreases the effect of the diffusion but risks causing some filter patterns to come into focus. On the other hand, the wider the lens opening, the more the "blooming" effect something like the fog filter will produce as the depth of field drops. Also, at very wide apertures there will be a loss of optical resolution, so it might be necessary to reduce the strength of the diffusion to compensate.

Sometimes you get two seemingly contradictory views about diffusion: (1) since diffusion looks heavier on longer lenses, you need to use lighter diffusion to match shots made on wider-angle lenses; and (2) wider shots need less diffusion than closer shots. So when you need to do a wide shot with a wide-angle lens and a close shot with a longer lens, do you decrease or increase the amount of diffusion on the closer shot? In theory, to match the two shots in terms of optical resolution, you probably would use lighter diffusion on the longerlensed closer shot. However, since a close shot often enlarges details, which also stand out more because the background is out of focus, you often need to use a heavier diffusion. In other words, we can psychologically handle the closer shots being diffused more, where as our eyes want to see more fine detail in the wide shots.

When viewed through a reflex camera, the diffusion effect usually looks heavier than the final result. More accurate evaluation is possible when looking through a combination of the viewing glass (to be discussed in the next chapter) and a given filter. Familiarizing yourself with the effects of different filters by shooting extensive tests is highly recommended.

Polarizers

Unlike fog and diffusion filters, which scatter light rays, the *polarizing filter* "straightens" the light into parallel planes in which the light vibrates in the same direction. The basic principles are:

- 1. Light vibrates in all directions along its axis (path). See figure 3.16.
- 2. When light reflects from surfaces like glass or water, it becomes polarized (i.e., vibrates in only one direction).
- 3. A polarizing filter correctly positioned can stop polarized light.
- 4. This filter will *pass* previously unpolarized light, *polarizing it in the process*.
- 5. This light will be the image that reaches the film.

A polarizer (pola for short) can be used to minimize the reflections in glass (such as in shop windows) and is most effective when the angle between the optical axis and the glass surface is about 34° (see figures 3.17, 3.18, and 3.19). If the surface is being photographed "straight on" (about 90°) the filter will have little or no effect (see figures 3.20 and 3.21). This filter must be used in moderation, however. Complete elimination of all glare and reflections dulls the picture, giving it a flat look. If overdone, it could even make the surface disappear. For example, if you are photographing a beautiful clear pond and use a polarizing filter to make the bottom more visible, the pond might appear not to have any water in it.

Unlike glass or water, metal surfaces do not polarize light, so to eliminate glare from metal surfaces, polarizing filters must be put on both the camera lens and on the light sources. When setting a polarizing filter, you rotate it to obtain the desired degree of effect. It may have either

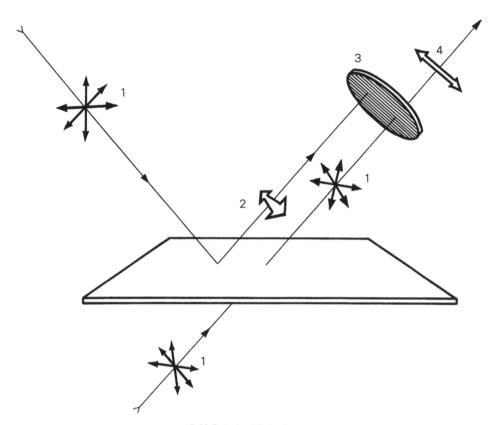

3.16 Polarized light theory.

a dot or a handle that when pointed toward the source of light (such as the sun) gives maximum glare elimination. This effect is most pronounced when the sun is at 90° to the lenssubject axis (see figure 3.22).

In color photography, polarizing filters (of the colorless variety) have several important functions. Blue sky can be effectively darkened if the sun is 90° from the optical axis (see figure 3.23). If we are shooting either toward the sun or 180° away from it ("down sun"), the effect is minimal. The white clouds against a blue sky will be accentuated when the sky is darkened. However, if the sky is white, as it often is down near the horizon or on overcast days, the polarizer will have little or no darkening effect. In color photography a polarizing filter is also used for haze penetration. A version is also made in combination with the #85B colorcorrection into one filter to reduce the number of glass elements in front of the lens.

Because a polarizer will eliminate glare from the surface of objects that normally would have a certain amount of it, such as leaves, flowers, and certain textiles, the color saturation will often increase. Some cinematographers who want to get the maximum color saturation when shooting outdoors will combine the polarizer, which can intensify the blue in the sky and improve the green color in plants by removing glare, with a Color Enhancer filter, which intensifies the reds. However, this filter

3.17 34° *without* pola filter.

3.18 34° with pola filter.

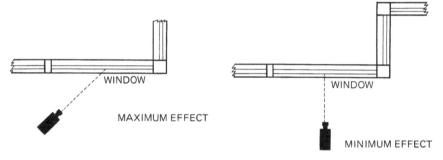

3.19 When the window is photographed "straight on," the pola filter will have minimal effect.

3.20 90° without pola filter.

3.21 90° with pola filter.

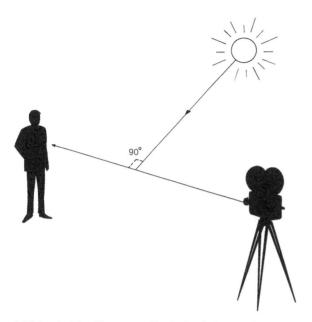

3.22 A polarizing filter most effectively eliminates glare when the sun (or other light source) is 90° to the lens-subject axis.

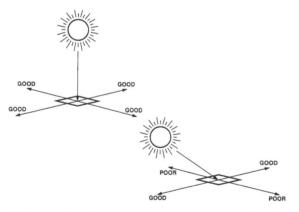

3.23 A polarizing filter most successfully darkens a blue sky when the lens-subject axis is 90° to the sun.

combination loses almost three stops of light, so the technique tends to only be useful in sunny conditions.

A *fader device* for amateur cameras can be made from two polarizing filters. The two filters are placed on the lens and counterrotated for a gradual elimination of light. This is not a professional practice, however, and serious filmmakers have such effects done in the lab.

The filter factors for polarizing filters are not constant. The basic factor is about 2.5 (i.e., 1½ stops), regardless of the filter's position. An additional factor of up to 2 (i.e., one more stop) may be needed, depending on the rotation and light angle. The total factor can be measured by placing the filter in front of the light meter at the same angle of rotation it will be on the lens. When taken from the camera position, such a reading is fairly accurate. A "spot meter" (to be discussed in the next chapter) is ideal for this purpose, as it allows you to take the reading while you are looking through the meter to see the degree of glare reduction.

Beginners frequently make the mistake of overcompensating for a polarizing filter. Therefore, remember to use caution to avoid overexposing the picture and thereby losing color saturation and washing out detail.

PHYSICAL CHARACTERISTICS AND MAINTENANCE OF FILTERS

Camera filters come in two types: gel and glass (although there are cheaper plastic versions of the glass filters).

Filter *gels* (short for gelatin) are the best optically because they are thin. Unfortunately, they are soft and easily scratched. Once damaged, they cannot be repaired and must be replaced. Fortunately, gels are the least expensive type of filter. To prevent damage, they should be handled by their edges. Fingerprints on the surface cannot be removed. A soft camel's hair brush or an air syringe might be used to remove dust, but not much else can be done. Gels are also sensitive to moisture or prolonged direct sunlight, and should therefore be stored flat in a dry place.

When a gel is cut to fit a particular filter holder, it should be placed between two pieces of paper and cut with sharp scissors. A filter slot inside the camera gives the advantage of having the gel more protected from dust and the possibility of scratching. At the same time, if the slot is very close to the film plane, there is a danger: any filter imperfection will register on the film. There is also concern about the back focus, which will shift by about one-third the thickness of the gel. This could affect the focusing of wide-angle lenses, particularly at the wide end of a zoom range. When using a fixed focal lens on a reflex camera, this small focal shift can be compensated for when focusing by eye. Stopping down the lens will also improve its performance.

One big advantage to using colorcorrection and ND gels behind the lens, between the mirror shutter and the gate, is that the camera operator does not have to look through them. This allows a much brighter image in the viewfinder; when using fast film stock and a heavy ND filtration in front of the lens, it can be very hard to see anything. But again, it is absolutely critical that the gel be free from dust or imperfections. Also, don't use a gel filter in the slot that is inside the film gate of some cameras. These slots are really used to add "hard mattes," not filters. They are right up against the film to allow the hard matte to be sharpedged, so if you use a gel filter in there, even the slightest filter imperfection would be photographed into the image.

Glass filters are much easier to handle. They come in three designs. One type consists of a colored gel cemented between two sheets of optical glass. This filter should never be washed or exposed to moisture. This may result in the swelling of the gelatin and the ruining of the filter. An excellent type of glass filter is made by laminating two pieces of optical glass together, with organic dyes mixed in the cement.

The cheapest and least satisfactory filters are made by adding the dye directly to the glass during the manufacturing. In this process it is difficult to control the exact color rendition given by these filters.

When shooting footage that is to be edited together, it is a good idea to stick to one brand and design of filter. Different brands may have slightly different colors.

Above all, the quality of the filter is most important. It is ridiculous to spend several thousand dollars on an excellent lens and camera and then save money by getting a poor filter or by using a gel that is slightly damaged and should be replaced.

There are some filters that are made in *acrylic plastic* instead of glass; these tend to be cheaper to buy. While the optical quality might be acceptable, it is important to protect these filters against damage, since they scratch much more easily than glass filters.

Another filter not mentioned, because it falls into its own category, is called an *optical flat*—a fancy term for a clear glass filter. Relatively cheap to replace, these are often used to protect the lens (which is not cheap) when shooting situations in which something may hit the camera during the shot, like fake blood from a body squib or dirt from a car passing close to the camera. Some people always try to have some piece of glass in front of the camera to protect the lens, although this should not be necessary if you are diligent while working on a film production. There's no reason to have extra glass in front of the lens if it's not serving a purpose for the shot.

Remember that gels manufactured for use on light sources are not good enough optically to be used on camera lenses. To make sure that filters are of the highest quality, cinematographers should be well informed about the leading manufacturers in this field. The catalogs of such companies as Harrison & Harrison, Lee, Tiffen, Formatt, and Schneider are a great source of information about the range of available filters and their characteristics.

Filter Sizes

Glass filters come in a wide variety of sizes, usually in round or rectangular shapes. If you are renting or buying a matte box, make sure that it takes filters that are large enough not to *vignette* (intrude into) the image created by your widest focal-length prime lens or the widest end of your zoom. Conversely, make sure that you get filters that are the correct size for your matte box stages.

If you are using an especially wide-angle prime lens, it may be necessary to forgo the matte box for those shots and use a clamp-on sunshade. In this case, it may be necessary to carry additional round filters just for this lens and sunshade combination.

Originally made just for Panavision cameras, $4" \times 5"$ has become the most common size for filters and matte boxes used on Super-16 cameras; for regular 16mm, which is less wide, the $4" \times 4"$ size is common, although of course you can always use a bigger-size filter for a smaller frame. Polarizers, although they are made in squares or rectangles, are usually round and used in the rotating rear stage of the matte box.

4 LIGHTING

ighting is the most important element in cinematography. It is the task on which a cinematographer primarily focuses, studying the characteristics of the film stock in order to predict what effect it will have in translating the scene onto the screen. The cinematographer then manipulates the lights accordingly. Filters are an aid in modifying that translation. But it is lighting that shapes the reality in front of the lens, giving it depth or flatness, excitement or boredom, reality or artificiality. Cinematography attempts to create and sustain a mood captured on the screen. In this respect, lighting is at the heart of cinematography.

LIGHTING CONCEPTS

Characteristics of Light

As discussed earlier, a certain overall *quantity* of light is necessary to register the picture on film. However, the way in which the scene will be portrayed on screen depends on the *quality* and *distribution* of the light. There are three distinct aspects to be considered:

- whether the light source is "hard" or "soft"
- the angle of the "throw" relative to the camera position
- the color of the light

A source can be described as hard or soft, depending on the type of shadows it creates.

Light that travels directly from the filament of the bulb to the subject with only a lens in between will usually cause shadows with sharply defined edges. This is referred to as a "point" source. If the light is bounced off some diffusing reflecting surface or softened and spread out by passing through some translucent substance, the shadows will be weaker and less sharp. This is called a "broad" source. The diffusing surface acts as a multitude of small sources, all washing out one another's shadows.

The hardness or softness of light depends on the size and distance of the *effective* source relative to the subject. For example, if the effective source is a large surface from which the light is bounced, it creates a softer illumination than would be obtained if the light came directly from the filament of the bulb. The most extreme example of a soft light is blue skylight or an overcast sky. As for distance, the sun—by no means a small source-creates sharp shadows because it is so far away that its rays are almost parallel when they reach the earth. On the moon, where there is no atmosphere to scatter and diffuse the sunlight, this hard quality is most pronounced. The sky is black, shadows are dramatically dark, and contrasts are extreme. On earth the atmosphere scatters the sunlight. Our sky acts as an enormous soft source that fills in the shadows left by the sun. If the sun is completely diffused by the atmosphere, as on an overcast day, the gray sky is the

only source and the soft light creates a nearly shadowless effect.

The second aspect of light quality is the angle of the throw. The direction from which the light comes will suggest the mood of the scene, the time of day, and the type of location. It will also model the objects in the scene, bringing out their shape and texture, or perhaps intentionally not revealing shape and texture. Of course, the camera position relative to the light is important; a single source coming from the side may seem very moody until the camera dollies around and that side light becomes a frontal light.

The third aspect of a light source is its color. Often the story may allow color to be used in ways that go beyond strict realism, or the situation logically justifies a colored lighting effect. In such cases, gelatin filters might be used on the light sources.

Studying the light around us in every type of location, time, weather, and season is the best way of learning about these light characteristics. It's also a good idea to watch films with lighting in mind (preferably without sound) and study the lighting in paintings and photography.

Lighting Styles

In the traditions of motion picture lighting, it is possible to distinguish various stylizations, just as in the work of the great masters of painting. The three most pronounced styles used by cinematographers are high-key (such as in the paintings of Turner, Whistler, and some of Degas), low-key (such as in the paintings of Rembrandt and Caravaggio), and graduated tonality (such as in the paintings of Ingres).

A *high-key* scene is one that appears generally bright with few areas of underexposure. It is best achieved in cooperation with the art di-

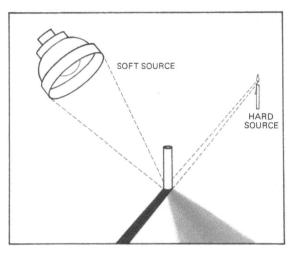

4.1 Hard light versus soft light.

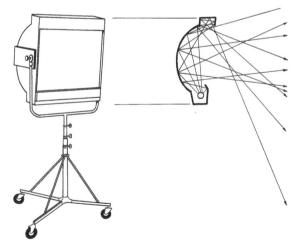

4.2 A soft light. Light from the bulb reflects from the large inner back surface, creating soft illumination.

rector, as the sets and costumes should be in light tones. The lighting for a high-key effect will often employ much soft, diffused illumination with relatively few shadows. Or it may be hard-lit from more frontal angles with additional light filling in the few shadows. It is important to include at least a few dark areas to indicate that the highlights are not simply overexposed.

If, on the other hand, only a few areas of the frame are well lit and there are many deep shadows, the effect is *low-key*. There is a popular fallacy that to achieve a low-key effect one has merely to underexpose. In fact, it is the *ratio* of dark shadow areas to adequately lit areas that creates a low-key effect. The majority of the low-key image is made up of dim or black areas—but some small areas might not only be at full exposure but even overexposed. Here again the art director can help, this time by providing darker sets and costumes.

Graduated tonality is intended to produce a tonal effect of gradated grays. It is often achieved by soft light evenly illuminating the scene, creating weak shadows with the tonal gradations often painted onto the sets or created in the actor's costumes and makeup. Sometimes artificial shadows are painted on.

These three stylizations by no means cover all the approaches to lighting the film.

Long before shooting, the director and the cinematographer should discuss the style or approach to be taken in the film. This will depend to a great extent on the mood and character of the story, or perhaps of each scene. For example, a drama is most often done in a low key while a comedy is usually more effective in a high key. All sorts of films *could* be done in gradated tonality. There are no set rules about what style should be used with what type of film. It is all up to the director and cinematographer.

Functions of a Light

In creating and maintaining a style, the haphazard approach is bad. We have to know exactly what each lamp is doing and why we are putting it in a given spot. To simplify things, a terminology was developed, naming the functions of the lights.

The *key light* is the main source of light for a given character while at a certain place in the scene. (If the character moves about, he may have several key lights, one for each of his locations.) You can also think of it as the dominant source for the scene. There are no set rules on the placement of the key light. A traditional starting place is 45° from the camera and 45° off the floor, but the mood or location of the scene usually leads the cinematographer to put it elsewhere. Another rule of thumb suggests that the key should come from "outside the actor's look." That is, if the actor is looking off-camera, which is usually the case, the key should come from the other side of his line of sight so that he is looking between the camera and the key

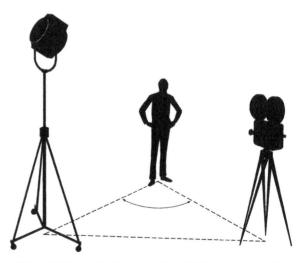

4.3 Key light "outside the actor's look." The actor's sight line runs between the camera and the light.

light. This means the downstage side of his head will be in shadow, giving his features a pleasant three-dimensionality, but this rule, like the 45° rule, is very frequently ignored. It is very interesting to note that many of the masters of classical painting often used a "key light" coming from the left side of the canvas. A cinematographer rarely has so much freedom. The final position of the key light will depend on the mood, the actor's features, the set topography, the supposed time of day, and so on. The key's position will determine the shadow pattern on the face.

A *fill light* is used to fill in the shadows created by the key light. It should not create additional shadows and therefore usually comes from fairly near the camera. Classic Hollywood studio techniques for fill light included using a frame of bulbs around the lens. This practically eliminated the possibility of creating shadows visible through the lens. Or they would put a slightly diffused lamp right under the lens, since often the key was coming from an overhead grid and thus a lower light would fill in more shadows. Unfortunately, you can sometimes see in old movies a shadow on the wall above the actor's head, which results from this low fill.

Today, soft-light sources are often used for fill. The shadowless quality of soft light allows for greater freedom in placing the fill and is especially useful in television studios, where all lights are hung from above and the action must be properly lit for several cameras at a time. When trying to achieve dramatic low-key effects, the cinematographer will frequently omit or greatly reduce the intensity of the fill light.

The third principal light is the *backlight*, which is designed to separate the actors from the background. This adds three-dimensionality to the picture. The back light is positioned above

and behind the actor. It illuminates the top of his shoulders and head. Some cinematographers, preferring greater realism in lighting, only use a backlight when it is logically motivated.

Similar in function but different in placement is the *kicker light*. It works from a threequarter-back position, usually on the opposite side of the key light, and is often placed lower to the floor than the backlight. It is sometimes referred to as an *edge light* or *rim light*. The use of backlights and kickers depends entirely on the situation. Sometimes one, both, or neither will be used. They are introduced at the discretion of the director of photography.

The use of separate key, fill, and backlights for portrait shooting is often called *three-point lighting*. However, it is more of a general concept to work from than a rule to follow. The fill or backlight may also be at such a low intensity as to be hardly visible; in fact, a subtle backlight is also called a *hair light*, since it mainly just creates a nice shine to the hair. A shot may only have a very strong backlight with a little fill, so whether the backlight is the key (because it is the most prominent light) or the fill light (because it illuminates the actor's face) is a question of semantics.

The lighting may also require effects or "accent" lights. For example, there may be a clothes light to bring up the texture of a costume or a "special" to create a glint off a knife, a glow to a bottle of wine, or to see the steam rise off a plate of hot food. As you can imagine, the world of commercials uses these lights all the time. Another effect light, the *eye light*, is usually a small hard-light source either positioned near or mounted right onto the camera. It acts as a weak fill light that mainly fills in the actor's eye sockets. Its reflection provides a lively sparkle in the actor's eye. It is recommended when photographing an actor with dull or

4.4 Key light only.

4.6 Backlight only.

4.8 Set light only.

4.5 Fill light only.

4.7 Kicker and backlight only.

4.9 Portrait illuminated by key, fill, back, kicker, and set lights.

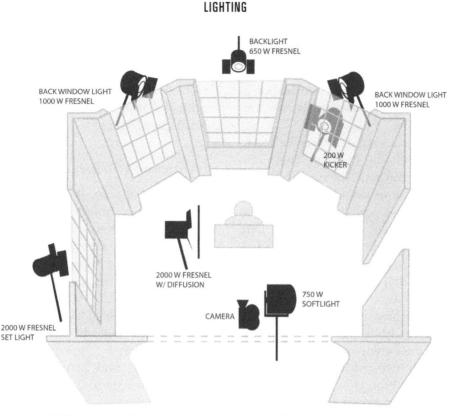

4.10 Placement of lights for figures 4.4 through 4.9. (Illustration by Scott Cook)

deeply set eyes. Some cinematographers mount the eye light on the camera, just above the lens, and use it in every shot because they like its effect. The eye light may also be referred to as a *catch light*, which is a light that gets "caught" in a reflection, creating a glint—for example, you might use a catch light to get a diamond to sparkle.

As you can see, with lighting there is a fuzzy line between official technical terms and mere nicknames. This holds true for lighting equipment as well. The most important thing is that the people doing the lighting work on the set use these terms in the same manner as the cinematographer.

Set lights illuminate the walls and furniture. There may also be *practical lamps* (lamps that are part of the scene), *backdrop lights* illuminating painted or photographed backdrops seen through a window or doorway, and other special light sources simulating fire, passing car headlights, lightning, and so on.

Achieving Depth

Most of the time the cinematographer is trying to re-create a three-dimensional reality on a two-dimensional screen. This depth can be controlled through the manipulation of many variables: shapes and volumes, scales and distances, color and light, movement (subject and camera), and lenses (perspective). An understanding of these variables is essential to all involved in visual arts. Most of them are the

direct responsibility of other members of the production team, such as the art director, set designer, makeup artist, and film director. The cinematographer is involved in the coordination of all of them, but he concentrates on his own contribution, the lighting.

For individual subjects, depth can be accentuated by back and side lighting. This highlights prominent features, leaving the rest in shadow. The three-dimensionality of the set can be augmented by using pools of light separated by dark objects or areas. For example, a long hallway has more apparent depth if only a few parts of it are lit, with many shadow areas in between. When shooting color, the depth will be further expressed as chromatic separations, thus adding to the three-dimensionality. Blackand-white lacks this advantage and therefore is harder to light than color because more time and care must be invested to obtain a threedimensional image. With color film, color gels can sometimes be used over light sources to enhance the depth. For example, the actors can be lit with warm tones and the background with slightly cooler colors.

Some techniques can increase depth just as easily as they can flatten out the image. For example, the use of smoke can increase the sense of depth by exaggerating atmospheric perspective, especially if you use a wide-angle lens, so that the foreground is seen through very little smoke compared to the background. However, if you use a telephoto lens, which compresses the perspective, you'll tend to see everything through a veil of smoke, lowering contrast and flattening the image out.

Another example is depth of field. In some cases, shallow focus can create more depth because the subject will stand out more, as it is in focus while the background is not. If everything is in focus, the image might seem flatter. But other times, the opposite effect seems to happen: in the shallow focus shot, the background is so fuzzy that it just becomes like "wallpaper" with a flat pattern of blurred shapes; in the deep focus shot, background objects create a sense of scale and look like they recede in threedimensional space.

Textures and Shapes

The texture of a rough surface is best accentuated by lighting from the side or back. Texture is revealed through many small shadows created by the raking light. Because sharp shadows will be more effective for this purpose, a hard-light source is used. Conversely, if we wish to smooth out a surface (such as a face), a soft frontal lighting would prove most advantageous. Frontal lighting also brings out color while it diminishes texture.

As shape and texture are expressed by shadows, designers sometimes have shadows painted on their sets to create a desired physical appearance, such as in *The Cabinet of Dr. Caligari*. The early Disney animation films, such as *Snow White and the Seven Dwarfs*, gained much depth and realism through the use of dramatic lighting, achieved by meticulously painted shadows that moved with the characters.

Often the "texture" is not a surface but a substance suspended in the air. Rain, fog, dust particles, steam, and other such elements can be seen best when backlit. For the effect of an aura or halo, one might suspend gauze in that area of the scene. If the background is dark, the gauze can be backlit for the desired effect. Barn doors or flags, for example, may be used to limit the area illuminated by this particular backlight.

MEASURING LIGHT

To be in control of your lighting, you must learn how to judge its intensity. Light meters allow

you to match light levels to a particular film stock and to get consistent results from scene to scene.

There are two distinct types of light measurements: incident and reflected.

Incident light meters measure the intensity of the illumination coming from the lamp and express the reading in f-stops, based on the sensitivity of the film and the shutter speed input. Some will also display the amount of light falling on the subject in foot-candles.

Reflected light meters measure the light reflected from the subject and yield a reading in lumens per square foot, or footlamberts. Or they also display the suggested f-stop at which to expose the subject.

The more widely used incident meters, like the Spectra, Minolta, or Sekonic, have a hemispherical "light collector" in front of the lightsensitive cell. This plastic device is designed to represent the general curvature of a human

4.11 Spectra-Pro "Classic" incident light meter. (Courtesy of Spectra Cine, Inc.)

4.12 Sekonic L-558 DualMaster combination incident and spot meter. (Courtesy of Sekonic/MAC Group USA)

face. When pointed from the subject directly toward the camera, it registers the amount of light falling on the face. In addition to the hemispherical collector, these meters may be used with a flat disk, preferred by some camera people for measuring individual lights. The incident light meter gives a very objective measurement, unaffected by the skin or background color, and therefore it is constant from scene to scene. An incident light reading is extremely convenient when working to a given illumination level, setting the f-stop, and when manipulating the lights to arrive at the proper foot-candle values. We can quickly check those values while walking about the scene with the sphere of the meter pointed toward the camera.

One thing to remember when using an incident light meter is that the reading will not be influenced by the background. Especially when filming outdoors in the shade, an overbright background may spoil the shot, and therefore

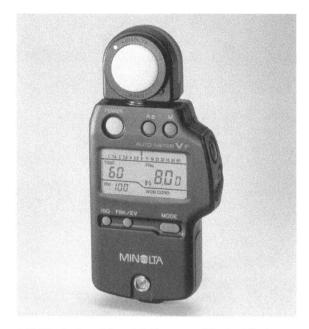

4.13 Minolta Auto Meter VF. (Courtesy of Konica Minolta Photo Imaging USA, Inc.)

an incident light reading must be intelligently interpreted. For example, it may be desirable to modify the reading by a half to three-quarters of a stop to allow for an overbright or overdark background.

For reasons such as these, many cinematographers prefer reflected light meters for outdoor work, while depending on incident light meters when in the studio, although they usually carry one of each.

There are two types of reflected light meters. The first has a rather wide angle of acceptance and therefore measures *and* averages the brightness levels in a wide area. Although satisfactory for determining the average brightness range, this meter must be used with special alertness. Such things as a very light or very dark background, light sources in its view, or any other extremes in scene brightness will influence the reading and possibly lead to exposure errors. For example, a close-up is taken against a setting sun. When measuring the face, some light from the bright sunset could very easily enter the meter and drastically affect the reading. As a result, the face would be underexposed.

The second type of reflected light meter is the *spot meter*. It overcomes the problems mentioned above by featuring a very narrow angle of acceptance (such as 1°). It permits scanning the entire scene so that individual brightnesses can be measured and compared. This becomes particularly useful when there are translucent surfaces or self-luminous objects in the scene, such as stained-glass windows, neon signs, practical lamps, TV sets, or sunsets. Looking through the meter, the cameraperson can see the exact spot he or she is measuring. The calibration on some digital spot meters is equal to one-tenth of one stop, making it quite easy to measure the brightness ratio between parts of the scene.

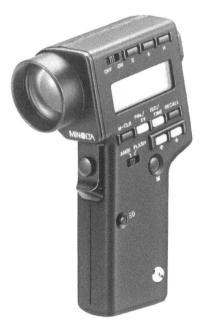

4.14 Minolta Spotmeter F. A reflective light meter with a 1° acceptance angle. *(Courtesy of Konica Minolta Photo Imaging USA, Inc.)*

If different light meters are to be used, they should be tested against one another. The light meters should also be serviced periodically by a qualified technician. Fast films and lenses allow for shooting in lower light levels than can register at the lowest end of the scale on older meters. You can have the meter recalibrated for a new scale, reading low light values only. For example, a certain Spectra may be calibrated to measure from 0 to 50 foot-candles only. This would make it easier to read the different light values in this range.

Eighteen Percent Gray Card

It is very important to keep in mind that reflected light meters are calibrated for so-called medium gray (18 percent reflectance). A reflected light meter always indicates the exposure required in order to have the measured subject represented as medium gray on the film (or its equivalent in terms of color brightness). Therefore, cinematographers using a reflected light meter must ask themselves if they want the subject to be represented as medium gray. Obviously, the answer is quite often no.

For example, a Caucasian face generally has a reflectance of around 35 percent. On the other hand, a black face might reflect less than 18 percent. If the reflected light readings are blindly followed, both faces will be represented as similar shades of gray (on black-and-white film). The Caucasian face will appear a bit dark and the black face a bit light. For a more faithful representation, the Caucasian face should be given a half-stop to one stop more exposure than the reflected meter reading. This is actually not over- or underexposing, but intelligently interpreting the readings so that the subjects will be correctly represented relative to medium gray.

One way to avoid guesswork is to use an 18

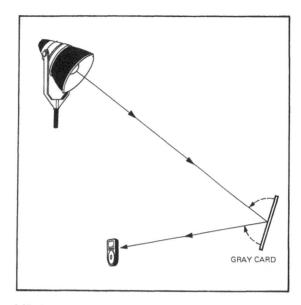

4.15 18 percent gray card angled halfway between the light and a reflected light meter.

percent gray card, measuring it instead of the subject. This guarantees that objects that are medium gray in the scene will be medium gray on film. Thus the reading is not biased by the tonal value of the objects in the scene. When using a reflected light meter with an 18 percent gray card, the readings will be as objective as those taken with an incident meter. An incident meter, as you remember, reads the light coming from the source. Its spherical light collector approximates a medium gray readout.

When using an 18 percent gray card and reflected light meter, the card should be angled halfway between the light angle and the camera to get the most accurate reading. Watch out for any glare over the surface of the card.

Contrast-Viewing Glasses

When looking through a viewing glass, a cinematographer can see approximately how the contrast ratio will appear on film. For an inexperienced cameraperson this is invaluable in setting the relative values of the key, fill, back, and kicker lights.

There are three types of contrast-viewing glasses: one for black-and-white film (panchromatic) and two for color film (tungsten and daylight). The cinematographer should not keep the glass to the eye for long periods, because if the eye is given time to adapt to the filter the judgment will be less accurate.

Balancing Light Levels

Indoors, when all light sources are under control, cinematographers like to use one f-stop for an entire scene. This dictates the number of foot-candles of light required. Considerations for choosing the f-stop-foot-candle combination include the depth of field required, the actor's comfort, and economy of electric power.

Suppose a cinematographer chooses f/2.8, which requires 100 foot-candles with a 100 EI film stock like Kodak EXR 100T (7248). For this hypothetical example, the cinematographer will use an exposure of f/2.8 for the entire scene and light with key-plus-fill sources of 100 foot-candles for the areas he wants to keep at a key level. In order to keep the lighting interesting, he uses a range of exposure values. Some areas in the frame will receive higher light levels, while others will be kept darker.

Because of the need for setting the exact light levels, the incident light meter, which is calibrated in f-stops and/or foot-candles, has become the basic tool for studio lighting. Sometimes an additional reflected light meter (especially a spot meter) is helpful in evaluating highlights and some special problems, such as translucent and self-luminous objects.

It should be noted that light meters are merely a tool for measuring light; the mood of

the lighting is principally established by the eye and the sensibility of the cinematographer.

The traditional *lighting ratios* of fill light to key-plus-fill light are actually measured mainly when shooting tests and in basic school lighting courses that acquaint students with the moods created by varying light contrast on the human face. A good percentage of the lighting today is done with soft, diffused light that "wraps around" the face, making the distinction between the key and fill more blurred.

Testing for lighting and exposure is important when familiarizing yourself with the film stock to be used in the production. From a welldesigned test you can learn how much overand underexposure the film can handle in terms of reproducing highlights and shadows, grain structure, and color. Such tests can also include lighting ratios that will help you to discover how much darker one side of a face can be before details start disappearing into shadows. Lighting ratios should include four setups: 2:1, 4:1, 8:1, and 16:1. For the actual exposure test the cinematographer should use a 4:1 ratio. This means that the brighter side of the face, lit by key-plus-fill, should measure (in foot-candles) four times higher than the darker side that is lit by the fill light alone; for example, 100:25. This indicates that the one side is two stops brighter than the other. To make the difference between the sides of the face easy to watch in these tests, the key light should come from the side. The fill light should be near the camera.

Also, when shooting the test, make sure that the model is not affected by light reflected from the wall or coming from the windows or house lights.

It is customary to position subjects against a white background and have them wear black cloth to see the extremes of the brightness range. Or have them wear gray and put them against a background that is half black and half white. A gray scale and color chart should also be included in the frame. The cinematographer should start the test with a correctly exposed image. After ten or more seconds of normal exposure, he should stop the camera and reset the f-stop to underexposure one half-stop. He should continue shooting these series to cover three stops underexposure and three stops overexposure in half-stop increments. Each setup should have a sign in the frame or a slate at the head indicating the exposure used.

At the end of the test, the cinematographer should shoot with the correct exposure once again. When this film is developed, the lab should be instructed to make two prints from the same camera roll. The first print should be made at a one-light printer setting, set for normal exposure. The second print should be timed by changing printer lights to correct the over- and underexposed shots back to normal. Lab reports should indicate the printing lights (levels of light intensity) used on the printer for the three primary colors (red, green, and blue).

To evaluate the results of this test, you need to make certain that the projector provides the required screen brightness, which has been established at 16 footlamberts. Most cinematographers do not own a footlambert meter, but there is a way to use a regular reflected meter as a substitute. The meter should be set at 100 EI and $\frac{1}{20}$ second. The meter then is pointed at the screen, which is illuminated by a projector running without the film in the gate. The reading of f/3.2 will represent 16 footlamberts.

Analyzing these tests will give several indications. The one light print will show how much latitude the film possesses before its quality starts to deteriorate. The timed print, on the other hand, shows how much of over- and underexposure can be corrected in printing. It is essential to shoot tests and discuss them with your lab. After getting familiar with the emulsion characteristics, a cinematographer can feel more comfortable in interpreting the light readings.

Practical Light Meter Use

A question often asked by film students is: What is the proper way to aim an incident light meter when measuring a key light that comes from a three-quarter-back angle? When describing an incident meter, I mentioned that the light-collecting dome represents the shape of a human face, and therefore, when pointed directly at the camera it should register the amount of light falling on the actor's face. And yet if you rigorously follow this rule in the case of a three-quarter-back key light, you will be reading mainly the fill light. As a result, the face will be correctly exposed where there is fill light and grossly overexposed where it is lit by the key. This, most likely, will not have been your intention.

We can still opt to read the fill light but not necessarily follow the meter's recommendation concerning the f-stop used. We may decide that the shady side of the face will be two stops darker than the medium gray and adjust the f-stop accordingly (i.e., underexpose two stops).

On the other hand, if the key light hits only a small portion of the face, we may want to expose for the fill light. Despite the fact that the key light is still quite hot, we may find the "blooming out" effect acceptable.

Oftentimes when the key light comes from the side or from three-quarters back, a cinematographer will not point the incident meter's dome directly toward the camera but will instead angle it halfway between the key and the optical axis. This allows a midpoint reading be-

CINEMATOGRAPHY

tween the key and the fill. Some cinematographers like to read the lights individually by pointing at them with an incident meter equipped with a flat disk instead of the lightcollecting dome. Or they will shade the dome from the other lights with their hand.

Landscapes with brightnesses ranging from white snow to dark forest will influence our light readings tremendously. Snow, for instance, generates so much reflected light that the light meter usually indicates stopping down the lens too much, which would result in underexposure. A close-up reading of a face with a reflected light meter (a spot meter particularly) will give a more accurate reading.

For outdoor scenes with large vistas in long shots, a triple light measuring technique is sometimes used. It consists of the following steps:

- 1. Read with the incident light meter pointed toward the camera.
- Read with the incident light meter pointed first to the sky and then to the ground, averaging the exposure.
- 3. Evaluate selectively the scene with a spot meter.
- On the basis of these readings and of your desired emphasis on particular subjects, decide the exposure.

Establishing exposure becomes a process of interpretation. The light meter is merely a technical device, and a cinematographer has to decide what's to be exposed more and what less. It may even be that for dramatic reasons the wall behind the actor needs to be the brightest spot and the face has to be underexposed altogether.

Therefore, how to expose different parts of a scene becomes a creative decision. For instance, when two actors are facing each other in a scene and one of them is a stop darker, who can say which is "correctly" exposed? After all, in real life four people in a room can have four different levels of illumination on their faces. One of them standing near the window in a shaft of strong sunlight will be, according to the meter reading, overexposed, yet this is an accurate representation of reality. Another actor in a dark corner will be two stops underexposed and still the whole scene may be perfectly acceptable.

While the keys are set with the help of a meter, the levels for the backlight and kicker will depend entirely on the subject and the situation. The color and texture of the actor's hair and costume are sometimes the factors that influence the amount of backlight reflected toward the camera.

For example, in color photography you could use color gels over the lights to give a blonde an amber backlight or a brunette a blue backlight to further increase the feeling of depth. Actors seen against a dark space may require a backlight to separate them better from the background. On the other hand, an actor standing in front of a well-lit wall may be sufficiently separated without a backlight.

With a full brightness range in the frame, we may have a difference of seven stops between the whitest white and the blackest black. Sometimes it is desirable to have such a range of tones, because without something bright in the frame we cannot have rich blacks. Without this contrast, black looks gray. Color negative is better suited for this brightness range. Color reversal film will lose some details in highlights and shadows.

When appraising the brightness ratio of face to background, the incident meter is not much help because it does not take the subject's color brightness into consideration. Here a spot meter can be very useful. Depending on the mood of the scene, the face may be lighter or

4.16 Practical lamp 3 stops brighter than the face.

darker than the background, but in most cases it should not be the same. You would also use the spot meter when determining the brightness of so-called practical lamps. Take, for example, a man sitting at a table on which there is a practical lamp with a translucent cloth shade. As a rule of thumb, this lamp will look convincing if it is approximately two to three stops brighter than the face. (The exposure is set for the face.)

Practical lamps are very difficult to judge by eye. They usually photograph at least a hundred percent brighter than they look on the set. With practice, a cinematographer learns to depend more on his eye and less and less on his meter. Fast emulsions allow you to shoot in lower light levels, which makes a visual evaluation easier.

Yet, after many hours of work the eyes will get tired and less reliable. This is the time when a contrast viewing glass will help the most. Some cinematographers substitute gray sunglasses that they put on for a few seconds to evaluate the light balance. Some also take Polaroid pictures to evaluate the contrast ratio. With experience, a black-and-white Polaroid photo can indicate how the contrast will be rendered on the film. A recent development is the use of digital still cameras to judge the lighting.

LIGHTING EQUIPMENT

Today there are enough types of lighting equipment available to fill volumes. We will try to cover the most important types. You should pay particular attention to the practical working characteristics of each light, namely, the *quality* of the light produced by the given instrument and its physical capabilities in the way of mounting, controlling beam size, and so on.

The first thing to understand about the lighting instrument (also referred to as the fixture or luminaire) is the type of light source it employs. The two principal sources used in film lighting are the tungsten incandescent globe and the daylight-balanced arc light. Fluorescents, a third category, are also becoming very commonplace.

Arc Lights

Arc lamps can be categorized as carbon arc and mercury arc. The *carbon arc* works on the principle of a gaseous arc that is formed between two carbon rods connected to a direct current (DC) supply such as a generator or a powerful battery. These were used more in the classic studio era when powerful spotlights were needed because of the extremely slow speed of film stocks of the day. They are still in use and produce a beautiful, sharp daylight-balanced light but require a trained lamp operator to periodically

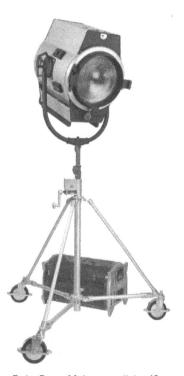

4.17 225-amp Baby Brute Molarc spotlight. (Courtesy of Mole-Richardson Co.)

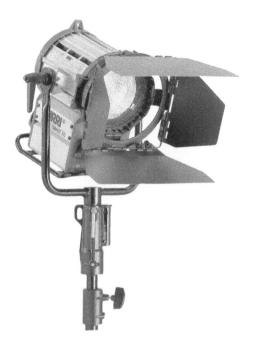

4.18 575-watt ARRI HMI Fresnel. (Courtesy of ARRI Group)

"trim" the rods, since they burn down over time, causing the light to sputter if not adjusted. They have been replaced for the most part by the easier to use *HMI* lamp.

A mercury arc enclosed in a glass envelope with metal halide additives is a gas discharge metal halide light. The HMI (hydragyrum medium arc-length iodide) is a widely used lamp of this type. It produces daylight-matching light of approximately 5,600°K–6,000°K. It is five times more efficient than a carbon arc. A 12,000watt (12K) HMI actually will outperform a Brute arc in terms of its power. But many cinematographers believe that the quality of the carbon arc light still remains the most sunlike.

HMI lamps work on alternate current (AC) that has to be locked up at an exact number of cycles (60 cycles per second in the United States but 50 in Europe) to prevent the lights from flickering. Therefore, a crystal-controlled AC generator or the local power supply is used to

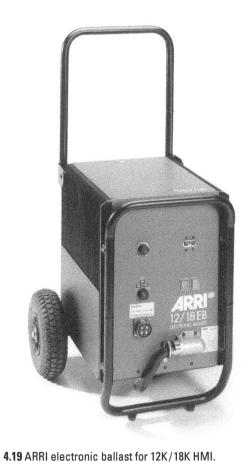

(Courtesy of ARRI Group)

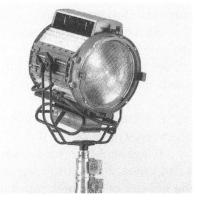

4.20 12K/18K ARRI HMI Fresnel. (Courtesy of ARRI Group)

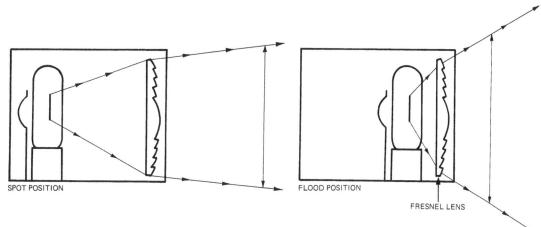

4.21 Fresnel lens lamp with adjustable beam width.

CINEMATOGRAPHY

run the HMIs. Between the AC power supply and the HMI light a "ballast" unit is required. This serves several functions, such as providing very high voltage for the initial start-up and for adjusting voltage while the light is still burning. The older magnetic ballasts are rather heavy and can make HMI lights less portable than incandescent luminaires. However, modern electronic ballasts are much lighter. They square off the curves in the sine wave of an AC light; in "flicker-free" mode the valleys between the peaks are reduced, making the light more or less continuous.

"HMI flicker" is not really visible to the eye. If you are seeing the light occasionally flicker, it is more likely a voltage spike or some other problem, like a bad connection. HMI flicker occurs because the pulsing of the light is not in sync with the camera as it captures frames, causing each frame to receive slightly more or less of the pulsing HMI light. This frame-toframe exposure variation shows up as a pulsing on the moving image. To avoid flicker, a camera with a crystal-sync motor should be used, and high speed is ruled out unless: (1) your camera can run crystal-sync at HMI "safe" speeds; or (2) you use an electronic ballast on the light in flicker-free mode. The main problem with the flicker-free mode is that the noise level of the ballast and lamp increases, to the annoyance of your sound recordist. If you don't use a flickerfree ballast, note that "safe" frame rates and optimal shutter angles to avoid flicker depend on whether you are filming under 50 Hz or 60 Hz lighting.

HMI lamps have the additional advantage of producing very little heat, compared to tungsten lamp gelled with Full Blue to correct it to daylight. However, unlike an incandescent lamp, HMIs cannot be used on a dimmer.

Xenons are another form of daylightbalanced arc lighting. Their parabolic reflector dish design creates a very narrow beam of great intensity, like a projected ray of sunlight. They are somewhat expensive and problematic, though; there can be a dark center to the beam, creating an annoying "doughnut" pattern, and they have cooling fans that make them too noisy for use in enclosed spaces.

Incandescent Spotlights

This group takes its name from the tungsten filament made incandescent by electric current. Tungsten globes of the quartz halogen type are the ones mostly used in film lighting. They are generally known as *quartz lights*. They retain a steady color temperature of 3,200°K and are smaller in size than the household-type incandescent. A quartz bulb should never be touched with bare fingers, as the acids of the skin weaken the quartz glass. Any fingerprints should be removed immediately with alcohol.

TYPES OF FIXTURES

Fresnels

Fresnels are the most widely used studio instruments. They are available in many sizes, ranging from 50-watt to 20,000-watt, with either traditional heavy-duty housing or lightweight aluminum construction. HMIs and tungsten lamps both come in Fresnel designs. A Fresnel is recognizable by the circular ridges or rings in the glass lens in front of the bulb. These rings act to reflect and refract rays of light so that they all travel in parallel lines, increasing the efficiency of the light and producing cleaneredged shadows. The Fresnel lens remains stationary while the bulb and spherical mirror are moved together, allowing you to control the beam of light. When the bulb and mirror are farthest away from the lens, the light rays are

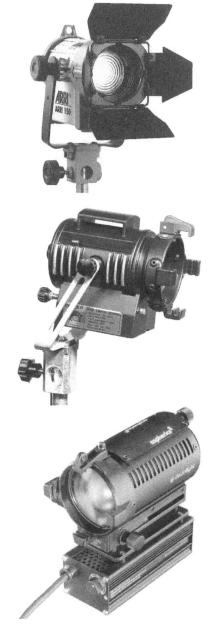

4.22 Very small tungsten instruments ranging from 100 watts to 650 watts are convenient for shooting on small locations with fast emulsions. *A:* ARRI 150-watt tungsten fresnel light. *(Courtesy of ARRI Group) B:* 100-watt LTM Pepper 100. *(Courtesy of LTM Corporation of America) C:* 100-watt Dedolight. *(Courtesy of Dedotec USA, Inc.)*

4.23 The smaller 2,000-watt Molequartz Baby Junior Solarspot. *(Courtesy of Mole-Richardson Co.)*

4.24 The larger 2,000-watt Junior Solarspot. *(Courtesy of Mole-Richardson Co.)*

more converged. This is the *spot* position, and it narrows the beam to a smaller area of coverage. In the *flood* position, the bulb and mirror are moved to the front of the housing, near the lens. In this position the lamp throws a wider beam, illuminating a broader area. When working in a hurry, the spot/flood adjustment can be used to set the intensity of the light. Flooding spreads the light over a greater area, therefore making it less intense than when spotted into a small area. It is quite common for the cameraperson or gaffer to stand in the actor's position, reading a meter while an electrician follows orders to spot or flood the lamp until the desired level is obtained.

When you point a Fresnel at a subject, you spot it first. This narrows the beam so you can clearly see exactly where the center of the beam falls. Then turn the lamp until the beam is hitting the center of the area to be illuminated. The Fresnel is then flooded to the desired degree.

Strangely enough, when the lamp is flooded, the shadows are sharper than when it is focused. The reason is that when the lamp is focused (spotted), the entire lens acts as a light source. When flooded, the bulb is in the front of the lamp and almost visible, thus constituting a smaller light source and creating sharper shadows. If the spotted position seems sharper, it is only that the greater intensity makes the shadows more prominent. To obtain the sharpest shadow from a Fresnel lamp, you can remove the lens altogether. However, it will not be as bright. Also, it is dangerous to do this with an HMI because the Fresnel helps reduce intense UV radiation coming from the HMI globe. Without any glass in front of the globe, anyone looking at the lamp can burn the retina in the eye. Therefore, if it is necessary to remove the Fresnel from an HMI, you must replace it with a clear glass shield.

Tungsten Fresnels made by the Mole-Richardson Company come in two sizes. The larger versions were introduced first, designed for soundstage work, with names like Tener (10,000-watt), Senior (5,000-watt), Junior (2,000watt), and Baby (1,000-watt). Later, smaller, more portable quartz-halogen versions, called Babies, were made for location work. So the 2,000-watt version, for example, is called a Baby Junior and the 1,000-watt version is called a Baby Baby.

Ellipsoidals

Another type of lighting instrument is called an *ellipsoidal reflector spotlight (ERS)*. The unit contains a light source, an elliptical reflector, and one or two plano-convex lenses. It casts a sharpedged pattern that can be shaped by irises or shutters or by inserting a cutout pattern. Lights of this design originated in the theater, and so their rating is generally low, ranging from 250 to 2,000 watts. The classic *Leko* is the most famil-

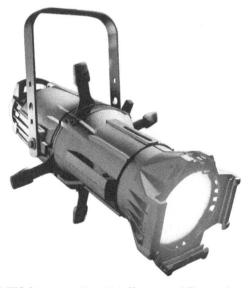

4.25 ETC Source-4 ellipsoidal. *(Courtesy of Electronic Theatre Controls, Inc.)*

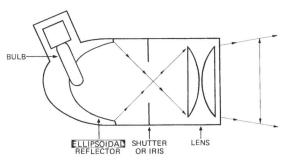

4.26 An ellipsoidal-reflector spotlight.

iar type found in theaters, but there is also the more efficient *ETC Source-4* series, which have found their way onto film shoots. *Dedolights* (100-, 150-, and 400-watt) are another example; the 100- and 150-watt versions are extremely small and lightweight, they produce a very sharp gobo pattern when a projector lens is attached, and they have a tremendous spot-to-flood range.

Most ellipsoidals are tungsten, but there are a few HMI versions.

Open Lights

Open lights—also known as open face lights, open reflector lights, or open bulb lights-are those instruments that do not have lenses. They are generally more light-efficient and less heavy than Fresnel spotlights of the same wattage, but they are far less controllable. Open lights come in many variations. The oldest type used in cinematography is the scoop, which has been employed for many years as a source of soft light. Scoops range from 500 watts to 2,000 watts. Even larger are sky-pans or sky lights (5,000watt) used for soft lighting of large backdrops. Small "nook" lights and banks of "cyc" lights are also types of open lights. All of these are tungsten units, since HMIs do not come in open light designs.

Compact open lights are designed to meet

4.27 2,000-watt Molequartz Scoop. Note the frame for adding diffuser scrim to soften the light. *(Courtesy of Mole-Richardson Co.)*

4.28 5,000-watt Skylite. (Courtesy of Mole-Richardson Co.)

the varied demands of location work. The 2,000-watt Mighty Mole (Mole-Richardson) is a favorite of many gaffers for bouncing. In a cramped location, from a distance of a few feet, a Mighty Mole will cover a $4' \times 4'$ sheet of reflective material, such as foam core or a Styrofoam board ("beadboard"). It has a tremendous light output for its size. The 1,000-watt version by Mole-Richardson is called a Mickey Mole. Ianiro makes an even simpler, lighter version called a Redhead (2K) and a Blonde (1K), named for the color they are painted.

Soft lights, as their name implies, are open reflector lights that create a semibroad source. The quartz bulbs are not visible. The light is dif-

4.31 The smaller 2,000-watt Molequartz Baby "Zip" Softlite. *(Courtesy of Mole-Richardson Co.)*

4.29 6,000-watt Six-Light Overhead Cluster (chicken coop). *(Courtesy of Mole-Richardson Co.)*

4.30 The larger 2,000-watt Molequartz Super-Softlite. *(Courtesy of Mole-Richardson Co.)*

4.32 Molequartz Five-Light Overhead strip (cyclight). *(Courtesy of Mole-Richardson Co.)*

fused by being bounced off the curved, white surface at the back of the housing. None of the light reaches the subject directly. Most are rigid and large; they are confined to soundstage use, where daily storage and transport on location trucks are not problems. The smaller ones, like the 2K "zip" light, do not produce as soft a light, being a smaller-size source. Some modern designs can be collapsed into suitcase size. Soft lights are available in sizes from 750 to 8,000 watts. Some use more than one bulb, allowing you to control the intensity by switching the bulbs on or off individually. To maintain a constant color temperature, the white reflecting surface must be kept clean and periodically repainted.

A soft lighting style sometimes requires an even overhead illumination. This can be provided by what is called a "chicken coop," an open metal box that houses a six-lamp cluster of 1,000-watt silver bowl globes. The light can be further diffused by stretching bleached muslin or silk beneath the fixture.

PARs

Sealed-beam lights provide focused illumination and are compact and lightweight like open reflector lights. These globes are officially coded as PAR, which stands for parabolic aluminized reflector. Both the lens and reflector are built into the globe as a sealed unit. To change the beam angle, you must change to a different globe. The globes are available in wide flood, medium flood, spot, and narrow spot variations. Or the PAR globe has a clear glass front and requires separate "lenses" to be placed in front for wide, medium, and narrow beam configurations. A car headlamp is a familiar type of PAR unit. There are both HMI and tungsten PARs, although the tungsten versions have the lens built in, while most of the HMI versions

4.33 1,000-watt tungsten MoleParCan (PAR 64). *(Courtesy of Mole-Richardson Co.)*

4.34 1,200-watt ArriSun 12 Plus HMI PAR. *(Courtesy of ARRI Group)*

CINEMATOGRAPHY

4.37 Nine-light Molequartz Molefay (PAR 36). Daylight color temperature. *(Courtesy of Mole-Richardson Co.)*

4.35 1,000-watt Molequartz Molepar (PAR 64). *(Courtesy of Mole-Richardson Co.)*

4.36 6,000-watt six-bulb PAR cluster Molequartz Molepar (PAR 64). *(Courtesy of Mole-Richardson Co.)*

use separate lenses. What this means practically is that you have to specify the beam configuration you want (flood, medium, spot, narrow spot, etc.) when you rent or purchase tungsten PAR units.

Within the PAR grouping there are many subtypes, each described by a three-letter designation that specifies the variable characteristics, such as beam width, voltage, wattage, and color temperature. For example, a FAY bulb is one type within the tungsten PAR group. A FAY bulb is 650 watts with a color temperature of 5,000°K, making it useful as an outdoor fill light. It's actually a 3,200°K tungsten PAR 36 bulb, but a dichroic coating on the lens allows it to achieve a higher color temperature. However, HMIs have become more popular than

4.38 1,200-watt LTM HMI Cinepar with a set of lenses to adjust beam spread. *(Courtesy of LTM Corporation of America)*

4.39 Lowel Tota-light. (Courtesy of Lowel-Light Mfg., Inc.)

4.40 A family of open reflector quartz lights: 650-watt, 1,000-watt, and 2,000-watt. (*Courtesy of Mole-Richardson Co.*)

FAY units because they are more powerefficient and cooler.

The terms for the instruments themselves and for the bulbs seem somewhat confused in popular usage. The larger 1,000-watt PAR 64 instruments are commonly referred to as Par lights, while the instruments accepting the smaller 650-watt PAR 36 lamps are often called Fay lights. In the Mole-Richardson line, the lights are designated as Molepars and Molefays, while the Colortran nomenclature is Maxi-Brutes and Mini-Brutes.

The spot and narrow-spot versions of the 1,000-watt PAR 64 (3,200°K) are good choices for situations that require a far-reaching beam-for instance, if you want to rake a building or alleyway or hide lights in trees to give more depth to a forest at night. Individual PAR lamps are usually too hard a source for lighting faces, unless their light is bounced or diffused. And the shadow patterns produced are less sharp and clean than those created by a Fresnel lamp, unless the PAR unit is very far away and thus a small point source. A multibank PAR unit, if softened, is often used as powerful key or general fill light. However, if undiffused, these multibank lights should be kept at a distance from the subject in order to avoid multiple shadows.

The 1,000-watt PAR 64 bulb is also used in a light called a *PAR Can*, a fixture with an elongated front tube that acts like a "snoot," creating a spotlight effect. They are often painted black or are chrome-plated because they are used in nightclubs and for rock concerts. Therefore, in the right environment, they can be visible in the shot as a form of practical set dressing.

Fluorescents

The traditional problem with fluorescents was poor color reproduction: the tubes produced a partial spectrum light with a heavy green spike. There were also flicker problems, since they are "pulsing" AC lamps. And multitube fluorescent units built for filmmaking were often too heavy.

The color problem has been solved with full-spectrum tubes that have almost no green at all in them. The flicker problem was reduced with the rise of crystal-sync motors for cameras and high-frequency ballasts for the lights,

CINEMATOGRAPHY

which allow them to "pulse" at incredibly high rates, making them practically continuous. Innovative companies like Kino Flo have created lightweight housings, color-correct fullspectrum tubes, and flicker-free ballasts that allow you to dim the tubes, making fluorescents increasingly popular for film production. They have several advantages:

- They have low power consumption compared to light output, making them very practical for location work.
- They have low heat generation, allowing sets to remain cool.
- Units can be switched to either tungsten or daylight-balance just by swapping the tubes.
- Units can be fitted with tubes to exactly match a location's existing fluorescents.
- They produce a naturally soft light.

Besides the wide array of household, industrial, color-corrected, and party-colored tubes available, there are also some specialty items like tubes for lighting green or blue back-

4.41 Kino Flo Foto-Flo 400 4-bank (4-foot tubes). (Courtesy of Kino Flo Inc.)

grounds for chroma key work. These have a very narrow spectrum with a heavy green or blue spike, allowing them to light a screen in a very deep and pure shade of green or blue.

When shooting under ordinary fluorescents encountered on location, the same issues regarding flicker apply as when shooting under any AC gas discharge light source, including HMIs with magnetic ballasts, nontungsten streetlamps, and stadium lighting. For example, for a 60 Hz line frequency and a 180° shutter angle, you should use the following "safe" crystalsync camera speeds (in fps): 1, 2, 3, 4, 5, 6, 8, 10, 12, 15, 20, 24, 30, 40, 60, 120.

OTHER LIGHTING PRODUCTS

Lighting Kits

Several companies offer location lighting kits. Very innovative location lighting systems are made by Lowel-Light Manufacturing, brainchild of cinematographer Ross Lowell. This company's lighting instruments and accessories constitute very efficient systems with interchangeable modular parts. Many lights can be adapted to 30- or 12-volt battery power. Taking advantage of today's fast films and lenses, Lowell has designed low-wattage, small units that are combined into several functional, portable kits.

A simpler but enormously efficient kit for location shooting is the Lowel-Light System. It makes use of the R-type reflector bulbs, which are available in a wide range of sizes. Of these, the R-40 bulb is recommended.

A lightweight barn door attaches directly on this reflector lamp and the ingenious base plate can be easily mounted on walls, pipes, and furniture.

The small-size bulbs, like the R-14 (25 watts) and R-20 (30 or 50 watts), are small and

LIGHTING

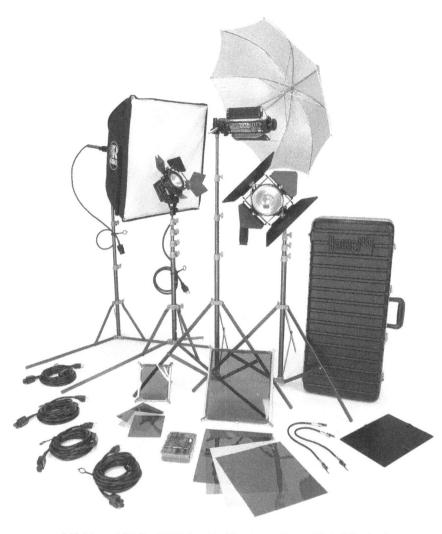

4.42 A Lowel DV Pro 55 lighting kit. (Courtesy of Lowel-Light Mfg., Inc.)

easy to hide. Even smaller, the so-called peanut bulbs are often used in practical lamps or inside cars. They can be 1% inches long (6-watt bulb #6S6), or 2% inches long (10-watt bulb #10C7).

A number of other companies besides Lowel-Light, including Arri, LTM and Dedolight, make lighting kits containing various units that fit into a portable suitcase. They are extremely popular for shoots with very small crews, such as documentaries, industrials, or news programs. In these situations, a lighting setup has to be created quickly and then disassembled just as quickly by one or two people, with all of the camera and lighting equipment having to fit inside a small vehicle.

One kit that should be mentioned in particular is the *Kino Flo Mini-Flo Kit* and *Kino Flo Micro-Flo Kit*. These consist of two Kino Flo

4.43 A Lowel-Light and barn doors affixed to a wall with gaffer tape. (*Courtesy of Lowel-Light Mfg., Inc.*)

4.44 A Lowel-Light attached to chair. (Courtesy of Lowel-Light Mfg., Inc.)

4.45 LTM Cinespace 125/200W Sun Gun. (Courtesy of LTM Corporation of America)

4.46 Ultracompact 125-watt GAM Stik-Up light. *(Courtesy of Great American Market)*

4.47 Kino Flo Mini-Flo Kit. (Courtesy of Kino Flo Inc.)

Mini-Flo or Micro-Flo tubes in small reflective housings that can be taped anywhere inside of a car and powered by the cigarette lighter. Dedolights can also be powered with an adapter through the cigarette lighter.

Sun Guns

Certain situations require a battery-operated light. Besides the incandescent units, there are also battery-powered HMI heads available. Because of their efficiency, a 200-watt HMI provides an equivalent of close to 1,000 watts of light, balanced to daylight.

Lightbulbs

Ordinary household bulbs can be used in cinematography, but these are generally below 3,200°K and will render a warmer look even on tungsten-balanced film. There are lightbulbs made for photography called *photofloods* and *photo enlarger bulbs* that are around 3,200°K and even higher. Some are painted blue to increase the color temperature to 4,800°K.

Photofloods

ECA 250-watt / 3,200°K ECT 500-watt / 3,200°K BBA 250-watt / 3,400°K EBV 500-watt / 3,400°K

Photofloods ("blue-dipped")

BCA 250-watt / 4,800°K EBW 500-watt / 4,800°K

Photo Enlarger Bulbs

G.E. PH-211 (75-watt) G.E. PH-212 (150-watt) G.E. PH-213 (250-watt)

CONTROLLING THE LIGHT

Just as the gaffer, being the head of the electrical department, is a cinematographer's chief collaborator in terms of lighting a set, the *key grip*, along with the entire grip department, also plays a vital role in rigging and controlling that lighting. Much of the equipment discussed below is part of the grip department's package.

Mounting Accessories

A studio light usually can be ordered as either a hanging model or a standing model. The hanging model comes with a shorter cable and *without* an on/off switch. It should be ordered with a pipe clamp that is the proper size for the grid. The standing model comes with a 25-foot cable and an on/off switch.

Stands vary in size from heavy-duty to lightweight. Some are equipped with casters. They are adjustable for different heights and can be equipped with many types of side extenders or boom arms. Some are power-operated for elevating large, heavy lights. Other available mounting instruments include trombones, wall plates, and base plates. In studios equipped with a grid of fixed height, you may have to use lamp hangers of various designs, such as telescoping anti-G hangers or ordinary adjustable rod hangers in various heights.

Lights generally come two different ways in terms of their mounting point. Smaller lights have a hole in the base of the yoke; the light stand has a "spud" or pin that fits into this hole. This type of mount is called a *baby*, and thus a stand with this spud is called a baby stand.

Heavier lights and wooden reflectors have a large pin instead of a hole at the end of the yoke, and the stand has the hole to receive it. This type of mount is called a *junior*; the stands are called junior stands or reflector stands, alLIGHTING

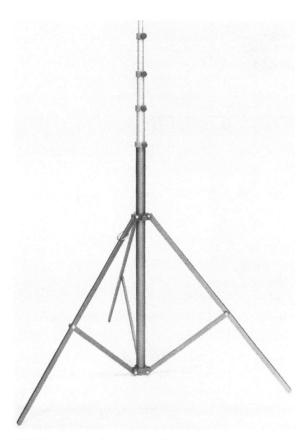

4.48 A lightweight Baby stand. (Courtesy of Mole-Richardson Co.)

though often they also have a little baby spud that can be popped up. Those stands are therefore called combo stands.

Scaffolding (called *parallels*) is often used for mounting lights, both in the studio and at outdoor locations.

Polecats are extremely useful as compact portable grids for indoor locations, although they cannot take too much weight. Wall spreaders, which use a piece of lumber to span the gap across a ceiling, with metal vises at the ends to put pressure against the walls, can take more weight but can also damage a delicate wall.

There are a wide variety of clamping and gripping devices, with names like Cardellini

4.49 A rolling Junior (reflector) stand. (Courtesy of Mole-Richardson Co.)

clamps, Mayfer clamps, furniture clamps, ordinary C-clamps, and so on. Spring-loaded metal "grip" clips of various sizes are also used.

Safety Rigging

Every overhead lamp, every barn door and snoot must be secured with a safety chain or cable. The bases of lightweight lamp stands especially on location-should be steadied with sandbags. Stands can also be lashed to almost any supporting structure, such as a wall, furniture, or a window frame. Light stands are pulled over most frequently by people tripping on badly secured cables left lying loose on the

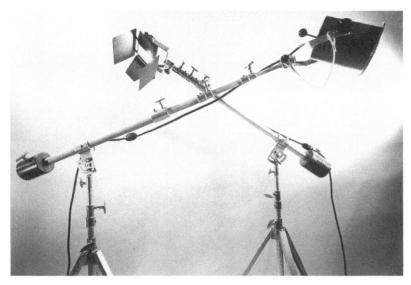

4.50 Boom arms. (Courtesy of Berkey Colortran, Inc.)

4.52 Wall plate with baby spud. *(Courtesy of Mole-Richardson Co.)*

4.51 A trombone. The arms hook over the top of the set wall and the light mounts on the spud at the bottom. *(Courtesy of Mole-Richardson Co.)*

4.53 Telescoping anti-G hanger. (*Courtesy of Berkey Colortran, Inc.*)

floor. All cables, especially those in areas where people will be walking, should be taped to the floor with 2-inch cloth or paper tape, sold in film-supply houses. Or they can also be covered with slip-resistant rubber mattes. Sometimes a ring is provided at the base of the stand and the cable is put through it, so that if someone trips on the cable, the lamp is less likely to be pulled over. For extra stability, one leg of the stand should point in the direction of the light—that is, it should be directly under the lamp. All cables should be long enough to reach the ground so as to not "clothesline" and thus possibly trip someone.

Any C-stand arm that sticks out could potentially poke someone, especially on a dark

4.54 Adjustable rod-type hanger. (Courtesy of Mole-Richardson Co.)

set. There should be a brightly colored piece of tape hanging off the end of the point, or the end should be covered with a tennis ball.

Accessories for Controlling Light

An ability to control and manipulate light is necessary for its creative use. There are five objectives in controlling a light beam: changing the intensity, changing the effective size of the source (diffusing), manipulating the pattern, adjusting the color, and, in special circumstances, eliminating heat.

To cut down light intensity, scrims can be introduced between the light and the subject. These are usually made of metal wire mesh and

4.55 Colortran Pole Kings. *(Courtesy of Berkey Colortran)*

4.56 Sandbags steadying a stand.

4.57 Wire scrims. *Left to right:* a single, a double, a half single, a half double scrim. The physical size varies according to the size of the light instrument. *(Courtesy of Mole-Richardson Co.)*

LIGHTING

4.58 Two-leaf barn doors. (Courtesy of Mole-Richardson Co.)

4.59 Four-leaf barn doors are preferable. (Courtesy of Mole-Richardson Co.)

may come in round or square shapes to fit in the holder on the front of the light. There are also larger sizes of black nets built as flags for positioning at some distance in front of the light. Nets can also be stretched on large frames.

There are two common densities for these scrims and nets. A single scrim or net cuts the light by half a stop. A double scrim or net reduces the light by one stop. Wire scrims are available in different shapes, such as halfscrims, which cover only half the light. Often, several scrims are used at once. Singles are identified by a green edge, while doubles have a red edge.

By placing a diffusing material in front of the light source, we are able to change the effective size of the source, making the light softer. Like scrims, diffusers are often made of a mesh material, but a mesh will only diffuse if the gaps between the threads are narrower than the thickness of the threads themselves. Common diffuser materials are silk, Dacron, bleached muslin, heat-resistant plastics, and tracing paper. The density of the diffusing material affects how well the light will be evenly spread, eliminating any hot spot from the original point source. Therefore, heavier diffusion materials tend to make the light softer but also to lose more intensity—but ultimately the amount of softness is limited by the *size* of the diffusion frame. Once the light has evenly filled the frame from edge to edge, it cannot get any softer even if you increase the layers of diffusion material used.

Barn doors are the most versatile instruments for controlling the light pattern. Almost any light (all Fresnels and most types of open reflector quartz lights) should always be equipped with barn doors, preferably of the rotating four-leaf variety. Fitted over the front of each light, they can be used to keep lighted areas from overlapping. By restricting the light pattern they can prevent unwanted shadows, such as from the sound boom, and they can keep light off shiny surfaces and protect the camera lens from direct light. They can also be used to create desirable shadows such as the "fall-off" at the top of an interior wall. Barn doors are the simplest way to shadow or "cut" the edges of a light; they are tried first before more complicated methods of flagging are attempted.

CINEMATOGRAPHY

4.60 Snoots. (Courtesy of Mole-Richardson Co.)

Snoots are similar in function and also fit over the front of a lamp. These funnel-like devices of different diameters are even more restricting, casting circles of light. "Flags," "dots," "fingers," and "cookies" differ in size and shape, yet they are all used for introducing shadow patterns. Unlike barn doors or snoots, they are usually on *C-stands* (century stands) that hold them between the light and the subject. One very important use of a flag is shading the camera lens from direct light (called a lenser).

4.61 Flags (black solids) and scrims (nets). (Bardwell & McAlister, courtesy of F & B Ceco of California, Inc.)

4.62 Assortment of dots and targets. (Bardwell & McAlister, courtesy of F & B Ceco of California, Inc.)

4.63 A cucaloris (cookie).

The *cookie* (or "cucaloris") can be used to create the random shadow pattern usually associated with foliage. Some are made of frosted plastic material and give a very soft shadow pattern. Some are cut from wood and create a sharper pattern. To make the pattern more subtle, you can put a silk between the light and the cucaloris.

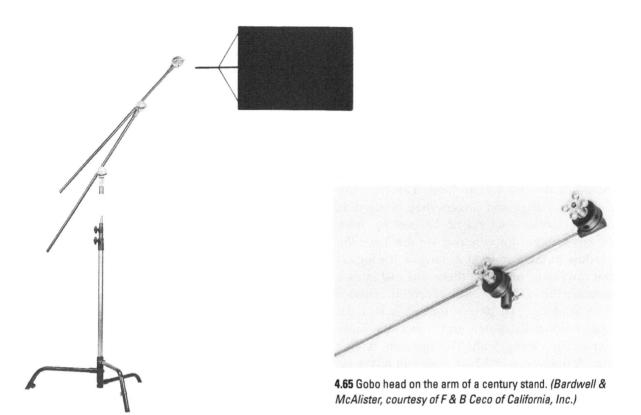

4.64 A flag, gobo arm, and a C-stand. (*Bardwell & McAlister, courtesy of F & B Ceco of California, Inc.*)

4.66 A "gooseneck"—a hinged arm that holds a flag. *(Courtesy of Berkey Colortran, Inc.)*

These shadow-making devices serve many functions, not the least of which is the breaking up of evenly illuminated areas. Large flat surfaces like a blank wall can look very uninteresting when evenly lit. A few random shadows here and there will break up the monotony, making the background seem more alive and three-dimensional. The shadows do not need an established reason for being there, yet they shouldn't directly violate logic. For example, a couple of flags and fingers may be used to create shadows that might be coming from the crosspieces of a window. We don't see the window in the scene, yet as long as it's logical that a window might be there and cast such a shadow, the audience will accept it without even thinking. The darker the set is and the more random its design and colors, the more you can get away with. The opposite is also true. A lightly colored bare wall will advertise the shadows thrown onto it, so they have to be especially logical to prevent the audience from being distracted. In all such cases, subtlety is advisable. Remember too that by using shadow patterns to make a set more alive, its visual appearance becomes more pleasing. Therefore, be sure that an attractive appearance is not in conflict with the mood the director is trying to create.

In placing any shadow-making device, the shadows will be more distinct if the light is from a hard source such as a Fresnel, and they will also be sharper the farther the device is from the lamp.

For adjusting the color, a gelatin filter can be mounted on the front of most lights in a special holder that positions it some distance from the lens. Gels that are not heat-resistant will have to be mounted on a stand and held farther away from the lamp.

Glass heat-removing filters can be used to prevent excess heat in special applications, such

as in filming an ice cream commercial *or* in close-up zoological work. These filters cause a slight loss in color temperature and reduce the amount of light by about a third of a stop.

LIGHTING PRACTICES

Creating Soft Light

Much on this subject has already been covered, but it bears some repeating because modern cinematography mainly involves soft lighting techniques. Why? Because many of the natural light sources in the real world are not sharp and projected, but diffused or reflected off surfaces. Also, soft lighting is less specific to a single area, allowing actors greater freedom to move about without "missing" their light.

Light can be softened by bouncing it or by shining it through a diffusing medium. It can also come from a naturally broad source (like a cluster of fluorescent tubes, which cannot create a sharp shadow). Whether to bounce the light off a white surface or use a frame of diffusion depends on a number of physical factors, including the space allotted for the light and the angle it needs to come from. For example, if the soft light needs to come from above and there is a low ceiling, it may be simpler just to bounce the light off the ceiling (if it is white) or off a white card taped to the ceiling.

The size of the soft light relative to the subject determines its softness. Therefore, a smaller frame of diffusion up close to the subject and a very large frame of diffusion very far from the subject may create the same degree of softness. The difference will be more in terms of fall-off. The larger soft light that is farther away will allow the subject to move a few feet closer or farther from the light and not change much in exposure. If the subject is very close to a soft light, then simply leaning away from the light can produce a rapid drop in exposure on the subject.

We've already mentioned the professional soft lights made by various manufacturers. There is also a wide variety of diffusion material made in a wide variety of sizes that can be used on frames. A few other techniques worth mentioning:

Companies like Chimera and Photoflex make nylon fabric soft boxes that fit over standard lights using adapter rings. Lowel-Light makes a similar system called the Rifa-Light that contains both a soft box and the lighting unit. These soft boxes are easily collapsible and fit into small bags for easy transport. Homemade soft boxes can be constructed out of strips of wood with porcelain sockets holding ordinary household bulbs, photofloods, or enlarger bulbs. The sides are usually made out of foam core, with light diffusion gel underneath to diffuse the light and black cloth hanging on the sides to control the spill.

A paper Chinese or Japanese lantern is also another cheap and simple method of creating a soft light. Lightweight, these lanterns can be easily hung just outside the frame line as a source of soft light. Depending on the size of the lantern and the lighting need, various bulbs can be used. A 500-watt or 250-watt photoflood is often employed. Be sure to use a porcelain socket; a plastic socket will melt. To control the spread of light the lantern can be sprayed on one side with black paint. An added feature of the lantern is that its visible reflection in any glass surface on the set will not cause problems because it will appear to be a practical. The larger lanterns will naturally produce a softer light so carry a variety of sizes to fit your space requirements.

4.67 Bouncing a light off a 4' \times 4' white beadboard.

4.68 Shining a light through a 4' \times 4' frame of diffusion gel.

4.69 A large paper Chinese lantern.

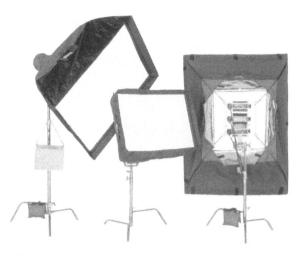

4.70 Medium Quartz Chimera Lightbank on light. *(Courtesy of Chimera Photographic Lighting)*

Lighting the Close-up

Of all the shapes in nature, the human face is the one that interests us most in cinematography. Every face is different and may require a different treatment. The shape and size of the nose and depth of the eye sockets are perhaps the most challenging elements of a subject's face. A long nose shadow can be ugly, and to diminish it we move the key light to a more frontal, medium-height position. To prevent deeply seated eyes from appearing as dark cavities we can lower the key light or use a soft fill light positioned close to the camera lens. An eye light will fill in the eye sockets and give the eyes a sparkle. Similar procedures may be needed to eliminate shadows created by a wide-brimmed hat.

Through placement of lights we can also control the contours of the face. To elongate a round face we will move the key light higher. This will accentuate the cheekbones and diminish the chin. Some slim faces also benefit from this treatment. Josef von Sternberg, who created lighting for Marlene Dietrich, used high and frontal lighting to bring out Marlene's cheekbones and to create a butterfly shadow under her nose. A very round face can be lit from the side to make it seem narrower.

Wrinkles are sometimes thought to add character to an older man's face, but they are usually considered unattractive on a woman's face. Since these are just another form of texture, we know from the last section that we can minimize texture by eliminating shadows that these uneven surfaces create. To do this, the lighting has to be more frontal and usually softer. This is often a more effective technique at age reduction than using diffusion filters.

A backlight, which usually serves to define the shape of the head and make the hair shine, should be avoided with a bald head. Or, if it's needed for separation, it should be kept soft and low in intensity. Large protruding ears are better left in the dark.

Usually the lit side of the face will be positioned against the darker background to define the shape and to create separation and depth. And instead of using a backlight for separation, you could position the dark side of the head against a brighter area in the background.

When setting up kickers and backlights, be careful not to hit the tip of a nose, creating a hot spot in the middle of the face. Moving the key light more to the side of the face leaves the opposite half dark, solving the problem of unpleasant nose shadows. When a side key light is used, you have to watch out for long and thick eyelashes, which will cast a heavy shadow on the nose. Soft lighting helps a lot in softening these shadows.

Facial proportions can be changed by various camera angles as well. Experienced older actresses often object to being filmed from below, knowing that the low camera accentuates jowls and the double chin. A longer lens (50mm–100mm for 16mm film) is usually used for close-ups because it does not exaggerate the nose. On the other hand, a wide-angle lens is useful if the exaggeration of facial proportions is desired.

Cheating

This is a term used to describe the act of "improving" the lighting as you change camera position while making it look consistent with the master angle. Often the challenge in setting up a wide shot is hiding the lighting instruments, which gets harder as the rigging gets larger, like when diffusion frames are used.

But once you've managed to light the wide shot to your satisfaction, there is no reason to not make adjustments once you move in tighter and have more off-camera space to take advantage of. The goal, though, is to not change the character of the master shot lighting, which you accomplish by keeping the contrast and direction of the lights similar.

This may mean softening the key light for the close-up and moving it to a lower position, if high before, to reduce shadows under the eyes. It may mean adding a subtle eye light.

It takes years of experience to know just how much cheating you can get away with. When setting up a wide master shot, you should already be planning how to make changes for the tighter angles so that any special equipment (like a diffusion frame) is standing by, ready to move in. Often there is less time allotted for lighting the tighter angles than on the wide master, so your adjustments should be simple to execute.

Also note that the bigger the change in camera angle and screen size, the more you can cheat the lighting, because the viewer is presented with an obviously different view of the scene. So a straight "punch in" from a wide shot to a close-up, without changing the angle,

4.71 The scene begins with a wide shot of person lit with hard key light coming from the right side of frame, from a high position. A hard backlight and a soft fill light also come from a higher position.

4.72 "Cheating" the lighting for the close-up. The actor's key light still comes from the right side of the frame but has been lowered and softened. The hard backlight from above has been replaced by a lower, softer edge light coming from the left side of the frame. The fill light has been lowered and brought closer to the camera to create an eye light.

means that a lighting alteration will be more noticeable. However, a camera position that is, say, 90° over from the master angle is such a change in view on the subject and background that there is more freedom to change the lighting as well.

Handling Reflective Surfaces

When dealing with a *flat* shiny surface, it is essential to remember the high school physics principle that the angle of incidence equals the angle of reflection. In situations where it is impractical to change the light, perhaps the flat surface can be tilted or moved. In the case of a hanging mirror or picture on a wall, a "tape ball" (a large wadded-up piece of tape) can be placed under one corner to alter its plane.

Curved shiny surfaces such as car bumpers or bathroom fixtures represent a greater problem. The curved surface is like the view of a super wide-angle lens, reflecting a large area all around, including lights and cameras. Turning or tilting the curved subject does little to remove the reflection. Like any shiny surface, it can be toned down with *dulling spray* that is available from most photographic and artsupply shops. In emergencies, soap, fuller's earth (dust), and other substances may be used.

There are many examples where you are attempting to get a reflection of the light in the

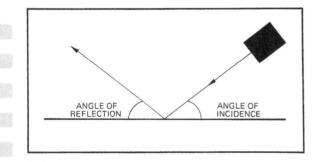

4.73 The angle of incidence equals the angle of reflection.

surface of the subject, not remove it. The classic example is shooting a polished black car. You don't shine a light at such a large mirrored object so much as reflect a light off it to reveal its shape. Since using a hard light simply creates a hot spot on the car, usually a very large soft light is positioned so that it is reflected over all the curved surfaces of the car.

Another example is a wall paneled with dark wood. You can either light it for its texture, with directional light coming from one side, or you can reflect a large diffused light source in the paneling.

In the case of water surfaces, a backlit reflection is usually desirable. Without a light sparkling over the surface of a lake, for example, you might not even see the water at night.

Sometimes a large, soft glare from a soft light is less distracting than a small but bright glare from a hard light. On the other hand, it may be easier to use a black flag to remove the reflection altogether with a small point source.

Reflections from eyeglasses may betray the presence of film studio lights. It is most objectionable when the glaring reflections hide the actor's eyes, interfering with the audience's ability to see the full performance. Using empty frames with the glass removed is an easy but unrealistic solution. Normally the glass should have some shine. Some camerapeople prefer the actors to wear flat surface glasses in place of normal convex lenses. The flat surface will not reflect as many light sources, but at certain angles the full surface will capture the reflection. This may be used to advantage as an interesting effect. For example, you may want the object that the person is looking at to be reflected in the glasses, over the eyes.

Sometimes moving the glasses forward, pushing them up, or lifting them a bit off the ear will help. You can hire specialists in film eyeglasses who will bring with them boxes full of glasses, flat and curved, with matching frames set at different angles. Moving the key light high and as far around the subject as possible minimizes the reflection problems, although it may not be the best position for the face. On the other hand, big soft sources positioned low and frontal will easily be reflected in the glasses.

Antireflection coatings for the glasses can help a lot but will not eliminate all reflections. Also, the reflection of the light, though reduced in intensity, may have a green color cast.

You should discuss choice of eyeglasses before production, remembering that they restrict actors in relation to the lighting.

Planning and Executing the Lighting

It goes without saying that the cinematographer must be familiar with the script. He or she will talk it over with the director, determining such elements as the mood and time of day of each scene. At this stage, close cooperation with the art director and set designer is invaluable. Before doing anything, the cinematographer must know the size and shape of the sets, the number of actors and extras, and all the color schemes of the sets and costumes.

Although it may cost more money at first, the most efficient thing to do next is *prerig* the set or location before the main production arrives. The gaffer (or his "rigging gaffer") will set up the power distribution and main lights in advance according to the cinematographer's direction. The set walls and backdrops can be lit before the actors arrive. Practical lights, since they are props as well as light sources, will also be prepared. The key lights, fill lights, backlights, and kickers can be hung in likely places, but they will not be focused in their final settings until the actors arrive and the director blocks the scene.

During the blocking, the cinematographer

collaborates with the director in lining up the shot; camera and actor positions are marked. When the blocking is over, the real lighting starts. In professional studios the actors usually take this opportunity to go off and either rest, finish their makeup, or practice their lines, leaving the cinematographer to light the scene with stand-ins. This is why it is important to mark each actor's position on the floor. The incident meter is especially useful when lighting without stand-ins, since there are no photographic subjects to point a spot meter at.

First the key lights are positioned and adjusted to the proper levels; all other lights (fill, back, kickers, etc.) are balanced to those. It often happens that one light may serve several functions. For example, one actor's key light may be another's kicker.

The AD (assistant director) is informed when the lighting is nearly completed and the cast are invited to come to the set; the first full "camera" rehearsal follows for cast, camera crew, sound crew, and special effects. After this rehearsal any necessary changes (called "tweaking the lights") will be made before more runthroughs and the actual shooting.

Simulating Natural Lighting Effects

Unless the production is intended to be unrealistic, the lighting will generally follow the logical scheme of the natural light sources within the scene—such as windows, practical lamps, candle flames, or fireplaces.

The most common of these is the window. If a window is visible in a daylight scene, you might have strongly backlit curtains or an illuminated backdrop, either painted or photographic. (For a realistic effect of bright daylight, these backdrops should be about two stops brighter than the faces in the key light.) Because this window is the logical source of light, the

CINEMATOGRAPHY

general direction of most of the key lights will therefore come from the direction of this window. You may also want to introduce the window-pattern shadow on the opposite wall by using a cutout in an ellipsoidal spotlight, or by using a shadow-forming device such as a flag in the path of a Fresnel.

Practical lamps in the scene look best if they are two to four stops brighter than the face. Here a dimmer is useful in obtaining the right level. The practical lamp can even be used as the key light, in which case you will need a strong bulb. Photo enlarger bulbs are often used in practical lamps because they are closer to 3,200°K than household bulbs.

The camera side of the lampshade may have to be shaded in order to maintain a two- or three-stop difference between the face and the lampshade. To do this you could place a scrim between the bulb and the lampshade, or use a neutral density gel cut to fit the inside of the lampshade. Still another method would be to cut out the back of the lampshade and allow the bulb to shine directly upon the actor's face. When incandescent filaments are visible, as in ornamental chandeliers with bulbs in the shapes of candle flames, stick on small pieces of paper tape to cover the hot spots. The density of tape can be built up by additional layering. If it is necessary to darken a whole bulb, it is customary to spray it with Streaks 'N Tips, a brown or black hair spray. The spray is applied until the bulb looks right. Afterward, the spray can easily be washed off with water. Overly bright neon signs can be covered or wrapped up with black netting or ND gel to bring down their intensity.

A flashlight used in a scene can also be regarded as a practical light. A prop flashlight can be rigged with a brighter bulb such as an MR-16 halogen. But now there are also very powerful xenon-halogen flashlights by companies like Surefire that use lithium batteries. The flashlight beam will be better utilized if white surfaces are positioned in areas where the light is aimed. This will allow the light to bounce back and illuminate other areas of the scene.

With practicals or flashlights, it may be necessary to use supplemental lighting in the room that seems to be coming from these sources. For example, a Chinese lantern may be positioned just above a practical lamp to create a soft key light coming from the practical's general direction.

To further illustrate this, let us consider the similar example of a candle flame. The candle flame is a very weak source, and therefore it is usually supplemented with artificial light.

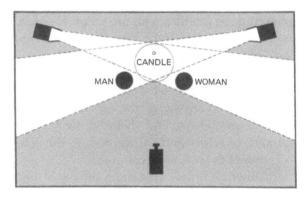

4.74 A "back-cross" of key lights.

4.75 The bottom barn door of each key light is raised until the key no longer illuminates the top of the table, thus eliminating the candle shadow.

LIGHTING

When faced with candles or other weak sources, some cinematographers will use low illumination so that the candle exposes as brightly as possible. For example, if the key is 100 foot-candles, the candle appears very dim in comparison. If the key is reduced to 25 footcandles, the candle will seem brighter in relation to the key light. Keeping the flame against a dark background will help.

In lighting the scene in figures 4.76 to 4.79, our key lights must appear to be coming from the candle. To maintain a realistic effect, very little or no fill light is used in this scene. The circle of candlelight on the table can be simulated by a Fresnel with a snoot pointing directly down from above (figure 4.76). Two 650-watt Fresnels ("Tweenies") are used as key lights. This is called a "back-cross" because the paths of the key lights cross behind the actors (figure 4.74).

The two key lights are angled so that the shadows of the candle do not fall upon the actors. Barn doors are used to keep the woman's key light off the man's back and vice versa. For a realistic effect, these two key lights are positioned at about the same level as the candle flame. The candle should not cast a shadow across the table because it supposedly is the only source of light. Therefore, the bottom barn door of each key light is raised until the key no longer illuminates the top of the table, thus removing the candle shadow (figure 4.75).

In this particular scene there is no logical reason for backlights, but we may use them with great discretion to separate the actors slightly from the background (figure 4.78). These minor violations of logic are acceptable as long as they remain subtle.

Now, in looking at the scene as we have lighted it so far, we notice the large black void behind the actors. It would be nice to break up the area and perhaps see the back wall. To illuminate it flatly might be uninteresting and would certainly be in conflict with the shadowy depth created by the rest of the lighting. By simulating a window pattern cast on the back wall by moonlight, we can break up the monotony of the large black area and show the back wall (figure 4.79). The effect is created by using flags to shape a square some distance from a Fresnel. A Fresnel is chosen for its distinct shadows. A scrim is placed on a century stand near the flags and crisscrossed with gaffer's tape to obtain the shadows of the window's crosspieces. You could also use an actual window frame, perhaps with venetian blinds, mounted on a century stand.

If you're shooting color film, it might be effective to put amber gels over all sources that are supposed to be coming from the candle and a pale blue one over the source of the moonlight window pattern.

Thus we finish lighting the candle situation. This is just one of many ways we could have approached it. Probably no two cinematographers would have lit it the same way. However, the one thing most of their techniques would have in common is logic. Each light performs specific tasks. If a given effect is not realistic yet is still needed (in this case the backlights), it is very subtle. But each light has a reason for being used.

Another difficult variation of this is an actor *walking* with a candle. In this case the actor may be illuminated by a handheld Fresnel (such as a Tweenie) with a snoot. A dimmer could be used to achieve the flicker effect.

When working with a large candle or a lantern, there is the possibility of hiding a small bulb in it (operated by battery or a hidden cable), or using a special candle with a double wick.

When discussing the need to simulate the light from a candle to gain sufficient exposure,

4.76 The circle of candlelight on the table can be simulated by a Fresnel light with a snoot pointing straight down from above.

4.77 The candlelight on the faces is created by two key lights in the back-cross fashion.

4.78 A bit of backlight is added to separate the actors slightly from the background.

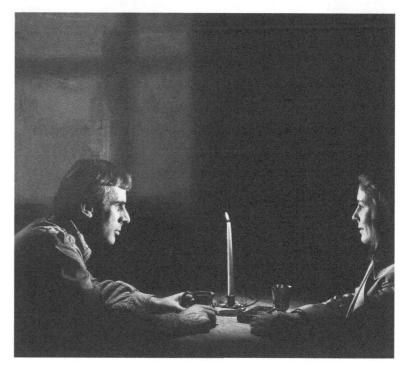

4.79 A window pattern (supposedly coming from the moon or a streetlamp) is used to show the back wall slightly. *(Photo series by Roger Conrad)*

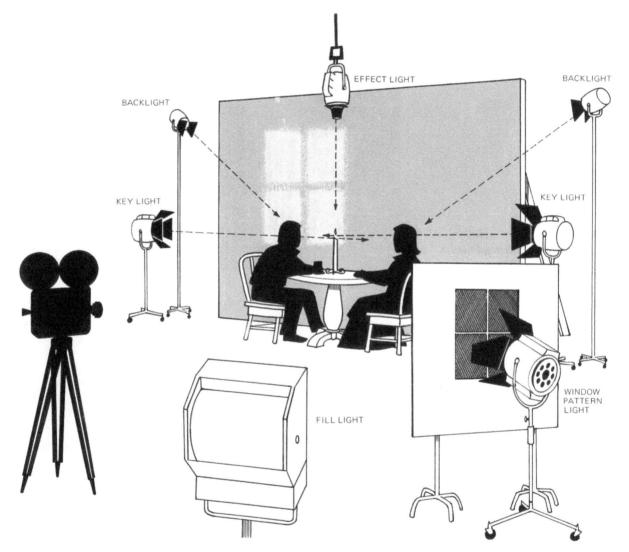

4.80 Lighting scheme for the candle effect. Fill, from the soft light, would be used if less contrast is preferred. Lights simulating the candlelight could be gelled orange, and the light simulating the moonlight could be gelled pale blue if desired.

the case of *Barry Lyndon* is often mentioned, a film famous for shooting under real candlelight. For that movie, triple-wicked candles were used and thus were three times brighter. A special f/0.7 Zeiss lens was discovered by Kubrick and adapted to fit on a nonreflex Mitchell. His 100 EI film stock (Kodak 5254) was pushed one stop, to 200 ASA. To get the same exposure on a Zeiss Super-Speed lens (f/1.4), we would need an 800 ASA film stock, something that now exists. However, in 16mm photography, this would create a somewhat grainy image, and the depth of field at f/1.4 would be extremely low. It is an option to consider, though, assuming you can find triple-wicked candles.

For imitating larger fire sources, such as fireplaces, a flickering effect can be cast on the subjects by moving a fringed flag in the light beam or by reflecting the light from a rotating drum covered with wrinkled orange tinfoil. You can also put a couple of orange-gelled lights through a single diffusion frame, to blend them into one source, but have some of the lights on a *flicker box*, a device that allows you to randomly flicker and dim the lights at different rates. You can also just wave something, even your hands, in front of the diffused light. Another technique is to shine an orange light through a real fire, which projects the flames and rising smoke patterns over the subject.

When an actor is switching a practical lamp on or off, your lighting must react simultaneously. The practical switch can be connected to the lighting circuit, or the electrician can rehearse the movement with the actor. In the latter case it helps if the actor partly covers the switch with his or her hand and turns it with a smooth movement.

Frequently, sets create problems that the cinematographer must overcome in order to obtain the best visual result. For example, a medium shot of a person in bed may create a lighting problem if the linen is white. Here, you don't want the white sheets to be too much brighter than the face. Therefore, the light should be controlled so that the face is illuminated but the light on the sheets is reduced. There are several ways to do this. When using small Fresnels, such as inky-dinks, it may be sufficient to spot the lamp and use the barn doors to limit the beam width. With larger instruments you may need other shadow-creating accessories, such as flags and fingers. If only a slight reduction is necessary, you can use a large scrim on a flag stand, some distance from the lamp, with a cutout portion in the shape of the face. This problem should be at least partly remedied in advance through cooperation with the art director, who can order less reflective material for the sheets. However, when using borrowed locations and props, the cinematographer must make do with what's available.

There are many less obvious situations that require such control. For example, the upper portions of interior walls should be softly shadowed for more realism and better composition. This is easily done with a barn door or a flag.

One of the most common lighting problems arises when the scene requires an actor to move toward or away from the key light. If we wish the light levels to remain the same throughout the scene, we use half-scrims on the front of the

4.81 A half-scrim is used to equalize the illumination as the actor moves closer to the light.

light. Because the intensity of the lower part of the beam is reduced by the half-scrim, the illumination level will remain the same as the actor moves throughout the area.

Another difficulty is that your lights may create unwanted shadows, the most common of these being multiple shadows of people and objects and the shadow of the sound boom. Generally, try to keep the actors several feet away from the walls, especially if the walls are lightcolored, which makes the shadows more visible. Shadows on the floor are generally less noticeable. Sometimes two shadows from a single person are unavoidable, but three shadows becomes distracting and unrealistic. The crossing sound boom casts moving shadows and is most objectionable. We can try to position our lights so that the boom shadows fall outside the frame. If the key light is causing a boom shadow on the back wall, it can be eliminated by using a flag or barn door to remove the key light from the wall without removing it from the actor. The wall is then illuminated by another light. The cinematographer needs a lot of cooperation and understanding from the sound man, who may be able to help by changing the boom position or using some method other than a boom mike.

STUDIO LIGHTING

Some filmmakers are shooting on location rather than in the studio. Location shooting saves money on studio rental and set materials and gives greater authenticity and realism. Nevertheless, the film studio still offers some very real advantages: full control of the environment and weather, an overhead lighting grid, extensive electrical power, ideal sound quality control, a smooth and level floor, set construction (flexible ceiling heights and removable walls and floors), and so on.

Cycloramas

One advantage that is unique to the studio is the possibility of attaining the abstract situation called the "limbo effect." To create the limbo effect (apparent infinite space), the studio must be equipped with a *cyclorama*. The "cyc" can be a permanent installation—such as those made out of wood and plaster—or temporarily made out of plastic or cloth material stretched from the floor to the grid. A wedge-shaped "foot" is used to merge the cyc walls invisibly into the floor. This wedge may be positioned away from the curtain in order to hide the cyc strip lights. Other cyc strips will be hung from the grid. The object is to illuminate the floor and wall evenly, creating the illusion of infinite space. Therefore,

4.82 A cyclorama.

4.83 A quartz cycstrip. (*Bardwell & McAlister, courtesy of F & B Ceco of California, Inc.*)

for smooth lighting the cyc strips should not be too close to the cyclorama.

To obtain the full limbo effect of the subject suspended in a white void, the cinematographer doesn't want any shadows on the floor. To achieve this, use all diffused light, such as several large soft lights, on the subject. Another excellent diffused source is a large lightweight Dacron screen stretched above the scene and illuminated from above by several powerful lamps. Whatever type of instruments are used, the light should come from all sides in order to achieve the shadowless quality.

The studio can also provide a black limbo effect. In this case the cyclorama and floor will be black and you will not have to light the cyc. Black surfaces still may reflect a certain amount of light. To keep the light off the back wall, use a controllable light, such as a Fresnel spotlight or ellipsoidal spotlight. The lamp is equipped with barn doors and placed in either a threequarter-back or side position. This keeps shadows off the back wall and the back stage floor. If fill light is necessary, it should be weak enough so as not to illuminate the background. These three things should be remembered when trying to eliminate shadows from a dark-colored floor and walls of a set: (1) the fewer the lights, the fewer the shadows; (2) softer lights create less distinct shadows but need larger flags to control the spread; and (3) shooting from a low angle eliminates the floor from the frame.

When lighting a black limbo effect, your eye may mislead you into thinking the background is too visible. A spot meter is invaluable in giving the number of stops difference between the faces and the cyc, enabling you to determine whether the latter will be visible on the film. In most cases, six stops difference should be enough to render the background black.

Cycs may also be painted green or blue for chroma key work.

Creating a Small Soundstage

The requirements of television have stimulated the development of many highly efficient lighting systems with elaborate dimmer boards equipped with preset electronic memories. For film schools and small production companies, the most economical grid system consists of ordinary 11/2-inch steel pipes suspended from the ceiling, with outlet boxes along the pipes, spaced about one every four feet. A simple breaker box can serve as the switchboard. Each outlet should be on its own 20-amp circuit and have its own switch in the breaker box. Convenient spacing of the pipes is about four feet apart. When building a grid and buying lights, much time will be saved by making sure to order all compatible plugs.

A variety of portable dimmers are available in many sizes and capacities, some with remote-control devices. You must be careful when using dimmers with color film productions, as varying the voltage will change the color temperature of the light. If a midscene dimming is required when using color film, it can be done with a purely mechanical shutter that operates like a venetian blind.

SHOOTING ON LOCATION

The studio provides the ideal lighting situation, but the director may see greater advantages in location shooting. There, limited working space and insufficient power make the cinematographer's job more difficult, but the results are often more interesting.

Household Power

Most modern houses in the United States have a total power supply of 100 amps. This power is distributed into several circuits, each with its

CINEMATOGRAPHY

4.84 A simple grid system constructed from 1½-inch pipe.

4.85 A shutter. This can also be used for creating a lightning effect on a powerful light. *(Courtesy of Mole-Richardson Co.)*

own amperage limit, which is usually 15 or 20 amps. Each circuit may go to a different part of the house. Suppose the bedroom is on a circuit with a 20-amp fuse. From the multiple wall sockets on this circuit we can use a maximum of 20 amps total (not per socket). It is wise to remember the equation: Watts = Amps \times Volts. Therefore, Amps = Watts \div Volts. For example, say we are using two 1,000-watt lamps. Added together they make a total of 2,000 watts. To find out how many amps are required, we divide 110 volts into our 2,000 watts. This yields approximately 18 amps.

Therefore, we can use up to 2,000 watts in this 20-amp circuit. A 2-amp margin is allowed for safety. There is also a shortcut method useful when the voltage is 110. Total watts divided by 100 gives the approximate amps, with a margin of safety. In general, you'll find that a 2K tungsten lamp or a 1,200-watt HMI are the

biggest lamps you'll be able to plug into a common household outlet, assuming you have a 20amp circuit.

In Great Britain and European countries, the voltage is usually 220 to 240 volts. In this case, our 2,000 watts divided by 240 volts would equal a little more than 8 amps. So when the voltage is greater, the same lamps will require less amperage. However, European houses generally have a lower total amperage and the fuses are also of lower denominations. For example, 13 amps is a common circuit. The exact electrical situation varies from country to country and from district to district and will also depend on the age of the house.

The first step in scouting a location where house power is to be used—with permission, of course—is to find the circuit breaker box and see how much power is available in how many circuits and how many amps per circuit. Later you'll need to determine which outlets belong to which circuit. If the breaker box uses fuses instead of switches, be sure to bring extra fuses along for the shoot.

Trying to get more than 20 amps out of the 20-amp circuit will cause fuses or breakers to blow. The wires in the wall are not designed for a higher amperage, and if the circuit is overloaded, the wiring may overheat and start a fire. Fuses and breakers are safety devices designed to turn the circuit off if it becomes overloaded. *Therefore, simply installing a larger-capacity fuse or bypassing the breaker switch is dangerous.*

If you need more than the maximum amperage of the circuit, you can use extension cables to bring power in from another circuit, possibly in a different part of the house. We can find what outlets belong to which circuits by turning the breaker switches on and off or unscrewing the fuses. Such extension cables should be heavy enough to carry the expected amperage load. A #12 cable will carry up to 2,000 watts and is therefore a standard cable for such a location. A #8 cable should be used for the same load if the distance is longer than 100 feet.

A cable with an inadequate gauge will heat up due to overloading and eventually will melt or crack the insulation, the plug, or the switch.

Working with lights, especially on location, requires constant alertness and common sense. All the light instruments should be grounded as required. On wet locations cable connections should be sealed with a silicon gel. For your personal safety, avoid holding a light fixture in each hand. Faulty wiring inside the light may cause the current to travel across your body. It would be particularly dangerous if these lights were drawing power from two separate phases. The potential voltage between them would read 240 volts instead of 120 (or 480 volts instead of 240 in Europe). It is therefore an essential rule of safety that in a situation where the original three-phase, 240-volt electric supply is divided into two 120-volt legs, the cable distribution is arranged in such a way that lights on one phase are at a safe distance from the lamps powered by the other phase.

Also, be aware of what other devices are using the same power in the location; forgetting about the refrigerator is a common mistake. Another problem is having someone in another room turn on a hair dryer or Xerox machine, especially if those devices share the same circuit as your lights.

Tie-Ins

To help overcome power limitations, film crews might employ the services of an electrician trained and licensed to do a tie-in to the city's main power. The circuit breaker box will be bypassed and a separate distribution box will be used. Extension cables of the proper capacity

CINEMATOGRAPHY

run from the distribution box to the lights. This eliminates the hassle of crisscrossing cables from room to room and the worry about blowing fuses. Bypassing the breakers without the aid of a qualified electrician is dangerous and illegal. Permission from the owner and sometimes the city has to be obtained.

Generators

For larger lighting jobs, the power usually comes from a generator. They come in all shapes and sizes, some towed, some part of a large equipment truck, some built into a van. Typically, they need to be of the "silent" variety for film shooting purposes and also have to be crystal-controlled. These generators are often in the 250-amp to 1,000-amp range.

There are also smaller, portable generators called "putt-putts" (for the noise they make) that may provide 90 amps or so. They are generally only used for nondialogue shooting because of the noise.

Rigging Lights on Location

Another limitation encountered when filming on location, besides power, is space. The amount of available working space will dictate the size and placement of the lighting instruments. The low ceiling and lack of a grid forces the cameraperson to place lights closer to the subjects. This creates two problems: hiding the lights and achieving an even illumination. First, the lights must be kept out of the field of view. Therefore, smaller instruments and ingenious mounting devices are required. Because of their higher output and smaller size, quartz lights (especially the open reflector types) will be used more often than they were in the studio. Inky-dinks, Tweenies, Peppers, and Babies will be the most useful Fresnel lights on location. Dedolights and

fluorescent units like Kino Flos are also popular now.

The main mounting devices will be compact, lightweight lamp stands and C-stands. In addition, a temporary gridlike structure (such as a polecat) will permit mounting small lights very close to the ceiling without using a floor stand that might otherwise be visible in the picture. A temporary grid could be of stronger construction for supporting larger instruments. Various clamps and gripping devices are useful in attaching lamps to doors, fixtures, and furniture.

The other space problem is that the close positioning of lights will create an uneven illumination and will be uncomfortable for the actors. Whenever space permits, it is preferable to use a more powerful light from farther away in order to even out the light. This is not always

4.86 Gaffer grip. (Courtesy of Berkey Colortran, Inc.)

4.87 A Cardellini clamp. (Courtesy of Steve Cardellini)

possible. A very even illumination can be achieved by using bounced light. If a light is pointed at the wall or ceiling, the reflected illumination will be evenly distributed, resembling a daytime interior effect.

A wall that is not pure white is not always the best surface for bouncing a light. White show cards, foam core, or Styrofoam boards ("beadboard") may be used. For higher reflection but also harder light, silver surfaces are employed. One of the cheapest and most easily available silver sheets is the so-called space blanket sold in many sporting-goods and surplus stores. Space blankets are not only highly efficient reflectors but also protect the walls and ceilings from the hot lights. However, even with a space blanket the lamps should be positioned at least a few feet away from the reflecting surface.

When trying to create a night interior effect, the cameraperson uses only a little bit of bounced light for overall fill and depends more heavily on practicals and directional lights such as Fresnels.

Aside from the limitations of power and space, the third major interior location problem is dealing with the mixed color temperatures of light sources (daylight, tungsten, fluorescent) and the exterior-interior lighting situation. We have already discussed the filtration solutions for mixed color temperatures. Let's now look at scenes where the outside world is visible through the window and the exterior light level

4.88 A "space blanket" used as a reflective surface for bouncing light.

will most likely be several stops higher than the interior.

This situation creates the problem of a brightness range wider than the emulsion latitude is able to handle. There are a few ways to solve this problem. If you are already applying color-correcting gels on the windows, and still more light attenuation is needed, neutral density gels may be added. Unfortunately, multiplying the gels will augment the problem of light reflection, wrinkles, and rustling noise. Happily, not all is lost, because combination gels, composed of the orange #85 color plus neutral density, are available in different densities (#85N3, #85N6, and #85N9). These gels are also available in large panels of hard acrylic sheets, which solves the problems of wrinkles and rattling. But they are rather expensive.

Another way to darken the windows utilizes Rosco BlackScrim, a perforated plastic that works like a net. When the windows are seen in a long shot, this scrim appears invisible, but close-ups shot next to the window will unfortunately reveal the texture. Regular double-net scrims may be used on large frames, but this only cuts the light by one stop. They also tend to make the background look diffused, which can be a romantic effect.

It is often desirable to have the exteriors slightly overexposed for a sunny, hot feeling, or actually bluish for a rather cold effect. But a difference larger than three stops between the interior and exterior may, on color negative, completely "wash out" the recognizable exterior by overexposure. Replacing a #85 gel with a lesser color-correction, such as Rosco #3408, Roscosun Half CTO, or Lee #205 Half CTO, will leave the windows slightly blue. Overly hot sky can sometimes be helped by "dressing" the outside with green plants.

Night-for-Day Interiors

Sometimes you have to keep shooting a day interior scene into the night. If you plan ahead for this, it may be possible to shoot all angles looking at the windows before the sun goes down. If that's not possible, you should plan on lighting the windows in such a way that it looks as if the sun is still up. One technique is to simply "white out" the view by covering the window with tracing paper and backlighting it, or by putting a big frame of white material outside and lighting that up. This can look a little unreal unless you break up the whiteness by covering the window with curtain sheers, lace, or venetian blinds. It also helps not to stage your action too close to the windows, or do those angles while there is still sunlight.

Day-for-Night Interiors

For the sake of the schedule, or to see a "moonlit" landscape out the windows, night scenes are sometimes shot during the day. We'll cover classic day-for-night techniques for exteriors in chapter 8.

The first issues are whether a view is needed out of the windows and if you still need to light through the windows. In other words, can the background be simply blacked out, and if so, do you need to build a black "tent" (as opposed to just covering the outside of the windows) to allow room for exterior lights?

For some night interiors where there are practical room lights on, it may be unnecessary and unrealistic to have blue "moonlight" pouring in the windows. Therefore, you can get away with just covering the outside of the windows with heavy black cloth to shut out the daylight. It is still recommended, though, to cover the windows with curtain sheers, lace, or blinds to break up the blackness.

Tenting a house to allow lights to be placed outside the windows but underneath the blacks can be very time-consuming and manpowerheavy, so it should be worth doing it instead of simply shooting at night. Sometimes, however, a location is only available during the day or you may be shooting during the summer, when you do not have a full twelve hours of true night.

You can also shoot "day-for-night" in the house in order to have a bluish background that looks moonlit. This may be necessary, for example, if you have a large landscape, or the ocean or a lake outside the window that would be impossible to light at night. Just as with exterior day-for-night, you should avoid framing in the daytime sky, which is hard to darken realistically. By using heavy ND filters on the windows and shooting on tungsten-balanced film with tungsten practicals in the frame, you can have a background outside the windows that is dim and blue while the room itself is naturally lit by lamps. Be sure to smooth out the ND gels used on the windows, or use hard acrylic ND sheets, because if the windows are very dark in a lit room, they will act like mirrors and reflect the room. Any wrinkles in the gel will be very obvious.

Daytime Exterior Shooting

When planning to shoot an exterior location scene, scouting the location is essential. On such occasions a magnetic compass should be on hand so that it can be used to predict the sun's position at different times during the day. With this knowledge the order of shooting can be planned.

All the long shots will need to be photographed in close succession to create the same lighting angles. They should be scheduled for mornings or afternoons, to avoid flat midday light. When the sun is higher, shots can be staged under a "butterfly" scrim or silk, and an HMI or reflector can be used to create sunlight that comes from a more attractive angle. Butterflies or larger overhead textile materials have exchangeable screens, such as white silk, black

4.89 A reflector board kit. (Courtesy of Berkey Colortran, Inc.)

4.90 Butterfly scrim. (Courtesy of Mole-Richardson Co.)

CINEMATOGRAPHY

net, and solid black, depending on the character of light required. Certain plastic diffusion materials are also available, welded into very large sheets. They can be tied to metal frames of various sizes, such as $12' \times 12'$ or $20' \times 20'$. These large frames of materials can act like sails in windy conditions, however, so secure them with ropes and sandbags. It is not safe to use them if the wind becomes too strong.

Direct sunlight is generally too harsh for the human face. If we wish to use it without any diffusion, then it is best used as three-quarter cross light or direct backlight. Such an angle of light makes the background appear more interesting. One can, for example, introduce a smoke effect that will lend a marvelous threedimensionality to the scene.

With the sun as a backlight or a threequarter cross light, we need to provide adequate fill, either from the reflector boards or from daylight balanced lamps. Traditional, silver-coated wooden reflectors known as "shiny boards" reflect light that is generally too harsh for faces but serves well when pointed at bushes or buildings. They can also be used to create back or edge lights. Much softer is light reflected from white surfaces such as foam core or large white plastic screens made of Griflon. There is also a softer cloth material used on large frames called Ultra-Bounce.

Small HMIs, maybe used as an eye light or for overall fill, can sometimes be powered from a nearby building or by batteries.

There are times when the weather is so overcast that the problem is a lack of contrast. Strong HMI lights may be used to create a backlight on the actors that resembles sunlight. You can also use large black flags to reduce some of the light coming from one direction—this technique is called *negative fill*.

When shooting in mixed weather conditions where it may become overcast at some point yet be sunny at other times, the best technique might be to average out the look by softening the hard sunlight and then adding some artificial back or edge lights. Then use the same back or edge lights to the overcast shots. Also, use ND filters to maintain a consistent stop and thus a similar depth of field.

NIGHT EXTERIOR LIGHTING

A night effect is not achieved by simple underexposure. Most of the objects will be dark, but given objects will be correctly exposed and some points may in fact be quite bright. The feeling of night is really achieved by creating many dark shadow areas in an otherwise correctly exposed scene.

The most convincing night scenes are shot at night. As usual, the logic of the lighting will have to follow the practical light sources in the scene, such as streetlamps, campfires, or the moon. In addition, we must consider the audience's preconceived notions about the appearance of night light. In an urban setting, night light looks best if the key light sources come from the side or back and, usually, from a low angle, creating many long shadows. However, at other times it may be necessary to rig a powerful light onto a crane in order to raise it high in the air, above the frame, to stimulate the moon or a high streetlamp.

Lights can be gelled various colors to simulate different sources such as sodium-vapor or mercury-vapor streetlamps. There is also a popular notion that moonlight is pale blue, and therefore, when shooting color, pale blue gels would be put over any sources supposedly coming from the moon. If a daylight-balanced light like an HMI is used for the moonlight, and the film stock is tungsten-balanced, you may want to use pale orange gels like CTOs to reduce some of the blue to a realistic level. We can suggest depth by lighting selected separated areas, to obtain pools of light with shadow in between. Another technique, especially useful with buildings and city streets, is to wet down the area with water, obtaining high-contrast textures that reflect the lights. When shooting night exterior scenes, using medium-to-light tones in the actors' costumes could help separate them from the dark sets. However, a costume should not be *so* light that it calls attention away from the actor's face in a dark scene.

5 IMAGE MANIPULATION

Up to now we have been analyzing the different aspects of cinematography as separately as possible. Yet the final aim is the total coordination of these many elements to create the image on the screen as it first existed in the filmmaker's mind.

The photographic style of a film has a broad range of possibilities, from the naturalistic to the highly theatrical, from documentary realism to poetic abstraction. By manipulating the color, composition, image quality, and lighting, we are able to evoke the atmosphere of a given period, place, or time or suggest a state of mind or impression. Cinematographers may imitate the paintings or etchings of a given period and culture or perhaps constantly introduce a visual effect that will complement the mood of the film. A classic example of such an application is John Huston's 1952 film Moulin Rouge, in which cinematographer Oswald Morris used the color schemes and compositions typically found in paintings by Toulouse-Lautrec to create the atmosphere of the Parisian cabarets of the late nineteenth century. To accomplish this technically, he used smoke on the sets, Fog filters, and colored key lights, which was a radical approach at the time and caused much concern with executives at Technicolor, who supplied both the cameras and the printing technology used.

All of the artistic decisions that affect the cinematography are based on the needs of the story and are made in collaboration with the director. A cinematographer will read a script and find ways of expressing that story with colors, light and shadow, and composition. For example, in *Apocalypse Now*, Vittorio Storaro interpreted the script as a conflict between natural and artificial energies, between an ancient culture and an invading modern one; whenever possible, Storaro made visual choices that clarified this concept for the viewer. He juxtaposed the natural light of the jungle and illumination by firelight with the harsh electrical lighting that the American army used to penetrate the darkness.

Whatever artistic concept is employed, the cinematographer must be in full control of the technology in order to ensure success. This chapter will explore techniques of image manipulation, using the basics introduced in previous chapters.

COLOR AND CONTRAST

There are three stages at which color and contrast can be controlled:

- in front of the camera
- in the camera
- in postproduction

Production Design and Lighting

It starts with the cooperation between the cinematographer and the art department. Primary colors can draw attention and should be used carefully to direct the eye to different parts of the frame; otherwise they need to be reduced in saturation in order not to be distracting. Make sure that the walls are not too bright (or too dark), because those are harder to control with lighting. Also, there is an old rule that "bright areas advance and dark areas recede." This was a guiding principle for the painter Caravaggio, who knew that his work would be displayed in dark churches and compensated by placing his figures in dramatic side lighting that made them seem more three-dimensional and helped them stand out against the background.

Some paint colors may clash with the actor's wardrobe, create an unpleasant cast in the skin tone, or simply be too similar to the color of the face, causing everything to blend together too much. White fabrics can be "teched" down, which means rinsing them in special solutions to make them off-white. Sometimes a weak tea rinse will do the job. The idea is that it is easier to get an off-white wall or costume to render on film as pure white while still retaining texture; a pure white object can sometimes overexpose too easily, losing surface detail in an unnatural way. This will therefore require that more care be spent with lighting to control the brightnesses of these objects; this time could be better spent elsewhere if the production designer and wardrobe person work with you to minimize these problems.

When special film stocks or processing is planned, the art direction may need to be adjusted to take this visual effect into account. For example, if the process will create an extremely desaturated effect, certain colors may actually have to be exaggerated in intensity so that they still show up after the process. For example, in Tim Burton's *Sleepy Hollow*, the fake blood used on the set was a bright orange-red; after the entire image was desaturated in postproduction, the blood became a realistic brownish-red color.

When a color scheme is created for sets, costumes, and makeup, the cinematographer's input is mainly advisory. But once the scheme is set, the cinematographer can still affect the final outcome by using color gels on lights, color filters on the lens, and color changes in postproduction. All these corrections can change hues.

Mixing cool and warm lights in a scene is often a desirable visual and psychological effect. For instance, using an orange key light with a bluish fill resembles a warm sunset with its cooler light in the shadows. At night in a room lit with tungsten lamps, a blue rim of light could indicate moonlight coming through the window. The colors may also be symbolic: red may suggest passion, energy, or anger; green may represent the forces of nature or suggest insanity, envy, or illness; blue may create a reflective, passive tone or represent the coldness of technology-or physical coldness. There is an old rule that if something happens twice, it's a coincidence; if it happens three times, it's a motif. Therefore, a specific color may come to represent anything you wish through visual repetition; the audience will begin to associate it with a certain character or poetic concept as it's repeated. Keep in mind, however, that some colors have certain traditional associations, although they can mean different things for different cultures.

Aside from color gels, reflective materials are also available in colder or warmer tones. In the Rosco line of products there is the golden Roscoflex G material. Gold reflectors are useful for "warming up" black skin tones, which can sometimes become too blue, particularly when the light comes from a back angle.

Controlling the Sky

During daylight exterior shooting, the main concern can be the color of the sky. The blueness of the sky differs vastly depending on the direction of the sunlight, the time of day, and the atmospheric conditions. These changes are very noticeable when different shots are edited together. There are a few ways to deal with this problem. In the Oscar-winning film *Butch Cassidy and the Sundance Kid*, cinematographer Conrad Hall consistently overexposed the sky to wash it out. He felt that shots with different shades of blue would not intercut well and that blue was also too strong as a background, drawing attention from the remaining colors.

The sky can be darkened by a graduated filter, either neutral density or color. Such filters are quite popular now. They can warm up the sky (as with a Coral or Tobacco Grad) or make it a deeper blue. Polarizers can also affect the saturation and brightness of a blue sky. In blackand-white photography, yellow, orange, and red filters will darken the blue in the sky.

Controlling Contrast

After working with the art department to select colors for sets and wardrobe that work in conjunction with the photographic plan, it may be necessary to alter the contrast of the image, especially when filming in less controllable daytime exterior situations.

Techniques to *reduce* contrast include:

- using more fill light
- using a low-contrast negative stock
- overexposing the negative, combined with pull-processing
- using contrast-lowering filters

- flashing the negative or the positive
- using smoke
- using digital manipulation

Techniques to add contrast include:

- using less fill light
- using "negative fill"
- push-processing
- using a reversal stock
- using a higher-contrast print stock
- using special processing techniques such as silver retention
- duplicating the negative onto reversal as an intermediate step (this will involve an optical printer)
- using digital manipulation

Desaturation

Some cinematographers find it desirable to reduce the normal color saturation in a projected print of material shot conventionally on color negative stock. This may be because they think that these products give an unrealistic or distracting level of saturation in the final image, or because they are trying to achieve a stylized look with softer colors. In general, there is a connection between perceived color saturation, contrast, sharpness, and black levels; often, methods of lowering contrast or "lifting" (lightening) black levels, for example, produces softer colors and the impression of less definition. Therefore, some of the techniques listed here are similar to the ones listed as methods of lowering contrast.

Increased contrast and deeper black levels tend to give the impression of better color saturation and sharpness. Therefore, it is easier to create an image with softer, more pastel colors if you also want less contrast, softer blacks, and lower definition—but it is harder to achieve less color saturation if you also want more contrast, deeper blacks, and greater definition.

The various methods used to desaturate color in motion picture photography are:

- *Art direction.* The best way to control color is by using less color in costumes, set dressing, wall painting, and so on.
- *Film stocks.* The lower-contrast color negative products sold also have less saturated colors, since contrast and saturation are directly connected.
- *Filters.* Light-scattering filters that allow bright highlights to "halate" (glow) and thus fog the nearby shadow areas not only lower contrast but soften colors. Examples include Fog, Low Contrast, Frost, or Mist filters.
- *Smoke*. Smoke has an effect similar to filters in that contrast and color are lowered because light is allowed to scatter and wash over everything. However, smoke is dimensional and affects objects in the background more than objects in the foreground, due to the increasing density of the smoke through which you view objects as they recede from the camera position.
- *Lighting*. The general rule is that frontal lighting emphasizes color; back or cross lighting emphasizes texture.
- *Film exposure and development*. Mild overexposure and pull-process developing of color negative can lower saturation and contrast. Printing an underexposed negative back up to a normal density will give you weaker colors, but also weaker blacks and more grain, so this approach is not recommended unless you want that effect. Extreme overexposure puts more information on the flatter shoulder of the film stock's

characteristic curve, producing a somewhat washed-out look with a loss of detail in bright areas. There are also limits on the feasibility of printing down the image to a normal brightness level.

- *Flashing*. Again, like filters and smoke, flashing lowers color saturation by adding a wash of white light over the image, also lowering the contrast by lifting the blacks. The advantage of flashing over diffusion filters is that it doesn't soften definition as much, nor does it produce artifacts like halos around light sources. See page 156 for an explanation of flashing.
- *Silver-retention processes.* One of the few methods that decrease color saturation while *increasing* contrast, the retention of black silver grains normally removed in processing "pollutes" the colors with mono-chromatic silver. When done to the print, many colors will become darker than normal, as well as look less saturated. See page 154 for an explanation of silver retention.
- Optical printing. From the original color negative, both a color IP (interpositive) and a black-and-white "fine grain" positive are struck and then both elements are combined to create a new, desaturated duplicate negative (internegative). How desaturated the final image is depends on what percentage of the total exposure onto the new negative came from the black-and-white or the color positive. You could, for example, have 90 percent of the exposure come from the black-and-white element and only 10 percent from the color element, creating a new image that has very little color in it. Optical printing is explained further in chapter 7.
- Digital color-correction. Color is easily manipulated in the electronic realm. In particular, reducing chroma levels in a digital

CINEMATOGRAPHY

image is very simple. This can easily be done to film material transferred to video for television presentation; it can also be done for film that is scanned to a digital data format, color-corrected, and then recorded back to film again (i.e., a "digital intermediate" process; see chapter 7).

All of these techniques can be combined in various ways-and usually are. Most productions trying to create a softer color palette always begin with the art direction and costuming. The main reason is that it is always better to use the simplest means to achieve a goal. Another is that primary colors tend to desaturate less noticeably than pastel colors when you use some sort of desaturation technique. Since skin tones are generally pastel, they will lose their color much faster than a primary color in the frame. So controlling those colors in front of the camera is very important and allows you more options to alter the color with special techniques or processing without affecting the skin tones too much.

One popular technique is to first lower saturation by using a method that also lowers contrast on the negative, and then counteract the loss of contrast by using a silver retention process on the print. Both steps separately lower the color, but each has the *opposite* effect on contrast, thus creating a final image with more or less normal contrast.

SPECIAL TECHNIQUES

Silver Retention

In normal processing of color negative and positive films, color dye is formed in equal proportion to the amount of metallic silver formed, but then this silver is converted back to silver halide during the bleach step so that it can be completely removed in the following fixer and wash steps.

The *skip-bleach* or *bleach-bypass* process involves, as the name suggests, skipping the bleach step and leaving all the metallic silver in the film. The effect on the image is an increase in contrast, a decrease in color saturation (as each color is "polluted" by black silver), and an increase in graininess, since now you have silver grains combined with the color dye grains.

When this process is done to the negative, you increase the density of highlight information tremendously, similar to overexposing the image more than a stop. Most people compensate by underexposing by a stop to bring the final density down to something closer to a normal range of printer lights. Visually, the effect is that bright highlights burn up faster than normal. You also get a greater increase in graininess than when this processing technique is done to a print stock (or a lab intermediate stock) because camera negative stocks have to be much more sensitive to light and therefore have larger silver grains. Just remember that if you underexpose to compensate for a skipbleach process to the negative and then change your mind and develop normally, you will end up with a thin negative.

When this process is done to the *print*, you increase the density of the blacks and lose some detail in the shadow areas. You don't, however, have to adjust the exposure of the negative to compensate for this increase in black density in the print. In fact, the deeper blacks that result will often mask any variations in blacks due to accidental underexposure.

Most people find that the increase in contrast is *so* strong with a skip-bleach process that they have to compensate in some way during the original photography, using one of the contrast-lowering techniques already discussed.

In fact, if the main reason for using the skip-

bleach process is to lower color saturation more than increase contrast, then using one or more of the listed methods of lowering contrast is a very effective technique.

Some labs offer *partial* silver-retention processes where only a percentage of the total silver is left in the film. This allows a more subtle effect on contrast and saturation. ENR (Technicolor Labs) and ACE (Deluxe Labs) are the most famous examples; however, they are only used on prints. Only a few labs can successfully do partial or total silver retention processing to an interpositive or internegative. This is very hard to do without streaking or unevenness problems.

A warning: Most labs charge a setup fee (often \$500) for these processes, since it requires making changes to their processing line. They also normally make some money back on the reclaimed silver from standard processing, so they compensate by increasing the per-foot processing fee when you request any form of silver retention.

Therefore, daily silver retention processing of the negative on a long-term project could get quite expensive. It is by far more common to do these processes to the positive print, since you are paying the setup fee less often and you have more control over the effect if it's not built into the negative. However, it's necessary to do the process to the negative if

- the original negative is going to be transferred directly to video with no plans to strike a print; or
- the skip-bleach material is going to be intercut with normally processed material to create two distinctive looks.

However, you can come up with a reasonable skip-bleach look using normal digital color-correction tools when transferring the normally processed negative. The silvery graininess would be missing, but often it is hard to see this effect on the average-size television screen anyway.

Cross-Processing

This most commonly refers to developing a color reversal stock in a color negative developer so that a negative image results. You end up with a somewhat grainy image with extreme color saturation, very high contrast, and some odd color shifts. Sometimes a greenish tone tends to dominate. Note that the color negative that results will be missing the orange color mask and therefore will require some extreme printer light adjustments to get close to a correct image. And this image will still have some built-in color biases that can't be corrected out. However, most people use this technique to get these odd colors anyway.

It is recommended that if you plan on intercutting cross-processed reversal footage with normal color negative photography, you place those shots on their own printing roll (often a C-roll if the rest of the conformed negative exists on A-B rolls).

Modern E-6 reversal stocks like Fuji Velvia and Kodak Ektachrome 100D will produce incredibly intense color saturation effects when cross-processed, with less of an increase in graininess compared to the older VNF Ektachrome reversal stocks.

However, Kodachrome cannot be crossprocessed successfully, since it has no color dye couplers in its emulsion. Normally the color dyes get added during the Kodachrome processing. Therefore, if you run Kodachrome through a color negative bath, no color will appear, and the silver image that forms on the film will be removed by the bleach, fixer, and wash steps. The latitude of reversal stocks is normally limited and the contrast becomes even higher with cross-processing, so careful exposing is important. It may be necessary to rate the stock differently as well in order to obtain a correct density, so testing is vital. Because of these difficulties, some people have resorted to shooting normal color negative and creating the crossprocessed look with digital color-correction techniques.

Flashing

This refers to exposing the film element (negative or positive) to an overall weak amount of light, deliberately fogging the image. When done to the *negative* (or internegative), dark areas will receive more exposure, lowering contrast and bringing out some detail that before was on the verge of being visible. Blacks will also be lightened and no longer be purely black.

If you flash the *positive* (print or interpositive), contrast is also lowered but in the opposite manner: whites are darkened, bringing out more detail in bright areas. It is less common to flash the positive because it can make white objects look "dirty" and dull.

While it is usual to employ a "white" light for the flash (the color temperature of the light adjusted for the color balance of the film stock), you can also use colored light to tint the shadows and blacks.

The level of flashing used is often expressed as a percentage, but it is actually a measurement of the density increase over the normal "D-min" of the film; for example, an increase by 0.10 density units is often called a 10 percent flash level. The percentage numbers don't really mean much from a practical standpoint in that the actual flash level to be used has to be determined by shooting tests and looking at the results printed and projected. Some labs offer flashing as a service, but with reservations, since it involves handling the exposed negative in total darkness, running it through a printer to add the flash and then developing it. You could also flash the film yourself before you shoot the scene, by marking the frame in the gate, filming an underexposed, out-of-focus gray card, and then rewinding the film in a darkroom. This approach was used for some of the earliest movies that were flashed, such as *Picnic* and *Camelot*. But it's rather awkward, risky, and time-consuming.

The more common approach is to do it in-camera using either a Panaflasher or an Arri Varicon device. The Panaflasher fits over the unused alternate magazine port on the 35mm Panaflex camera. It is basically a little light box with a built-in light meter to measure the flash level and a knob to control the intensity of the light inside, which can also be filtered for a colored flash effect. But since this unit is limited to 35mm Panaflex cameras, the Arri Varicon device is a more practical choice for someone shooting in 16mm. It's basically a $6" \times 6"$ glass filter that "glows" internally when a light strip along the top edge is turned on. The advantage here is that you can see the effect of the flash in the viewfinder of a reflex camera and set the level by eye if you want. The disadvantage is that it requires you to use a $6" \times 6"$ matte box, which is rather large for a typical 16mm camera setup, especially if you plan on doing any handheld or Steadicam shots. Some people will compromise in these circumstances and create a pseudoflash effect with a Tiffen UltraCon filter instead, fogging the blacks and lowering contrast enough to intercut with material shot using the Varicon.

OPTICAL PRINTING

Besides the normal uses of an optical printer covered in chapter 7, this device can also be

used to manipulate the look of the image. For example, the early scenes in The Natural, photographed by Caleb Deschanel, were desaturated optically, by combining a color IP and a black-and-white positive made off the same negative. However, an additional twist to this approach was that the color IP image was rephotographed slightly out of focus onto the new negative while the black-and-white version was kept sharp. This created a unique diffusion effect in the final image with the colors "smearing" and halating over a sharp monochromatic image. And since black areas were represented in the color IP as well as in the black-and-white copy, blacks in the final image were also "glowing." These foggy blacks are very striking in the scene where Barbara Hershey's character is standing in a black nightgown against a white window.

Optical printing was also used in 2001: A Space Odyssey to create the alien landscapes that the camera flies over after the Stargate Sequence. The color negative of these images shot from a helicopter of real landscapes was separated into three black-and-white positives using color filters. These were then recombined onto a new color negative—except that the "wrong" filters were used for each color separation, so the final surreal image was made up of bizarre color combinations.

DIGITAL TECHNIQUES

Over the past decade, optical printing has more and more been replaced by digital technology, which involves scanning the original film negative into a digital format, manipulating it or combining it with other elements in a computer, and then "recording" the final results back onto film. This is referred to as a *digital intermediate* (*DI*) process; in the past few years, entire feature films have been put through this process, whereas before it was only affordable for a few shots.

It's a powerful tool for creative image manipulation, to the point where almost anything that can be visualized can be put onto film, limited "only" by time, budget-and imagination. A striking example is the movie Pleasantville, shot by John Lindley, one of the earliest examples of digital color-correction being used on large portions of a feature film. This technology allowed portions of the frame, and select characters, to contain color within a mostly black-and-white image. A few years later, cinematographer Roger Deakins used a digital intermediate process for O Brother, Where Art Thou? to turn the lush green landscapes shot in summer into the dry, brown-toned autumn setting that the story required.

See chapter 7 for more information on the digital intermediate process, where it is discussed more as a replacement for the traditional methods of color-correcting a movie and for blowing up 16mm to 35mm.

SHOOTING A REFERENCE CHART

No matter how you choose to manipulate the image, whether in front of the camera, in the camera itself, or later in postproduction, it is a good idea to shoot a neutral image at the head of the camera roll as a frame of reference. Usually a gray scale is used, although it can be a gray card or a color chart. Often a face is included in the frame as well for a flesh-tone reference. The reason a gray scale or gray card is preferred over a color chart is that color can be too subjective; we all see shades of red, green, blue, and other colors slightly differently and may not agree on what their "correct" rendition should be. However, we can all usually agree on when a gray subject is not neutral but has picked up a color cast.

Ideally, the gray scale and human subject would be shot in frontal lighting with the chart slightly angled if necessary to prevent any surface glare. In a sense, you want the lighting to be *so* flat and boring that there is no creative interpretation involved in determining the correct color and density adjustments needed. Normally the gray scale would be shot in "white" light so that any colored effects using camera filters or lighting gels in the actual scene would be preserved. Otherwise, if the first thing a colorist or timer sees on a roll is a scene shot intentionally in orange lighting, for example, it might be interpreted as a mistake and "corrected" to look neutral. An exception would be if you *wanted* a correction to be made—for example, if you wanted the green cast from overhead fluorescents to be removed. In this case you'd shoot the chart under the greenish fluorescents so that the color would be corrected in the print or transfer to video.

6 Sound recording

B eginning filmmakers frequently underrate the importance of obtaining good original sound. They think that if the original recording is at least audible, it's good enough. They forget that the original recording will be rerecorded many times and put through many generations, each slightly deteriorating in quality before it reaches the screen. If the original recording was poor, the film sound track will suffer greatly. For this reason, the original recording should strive for excellence. Only the best professional equipment and techniques should be used if the final sound track is to be of high quality.

SYNCHRONOUS SOUND

There are basically two methods of maintaining synchronous sound—mechanically and electronically. The old *single-system sound recording* method employed a single-perf 16mm film stock with a narrow magnetic track on the edge of the film. The camera recorded the sound onto the magnetic strip while it was filming. Today, single-system sound is more or less obsolete for film cameras; the term is now only applied to shooting on a video camera that is also being used to record the audio, with no other sound recorder being used.

Double-system sound recording offers higher quality and greater flexibility. It electronically interlocks the camera with a separate audio recorder. The most popular systems of coordinating these two machines are either by way of sync "pulses" or by using a time code.

Crystal Sync

The sync pulse is really a 60-Hz sync tone. "Hertz" describes the cycles of electricity per second. Sixty Hertz is a measurement that applies to North America, where the power is sixty cycles per second. In Europe, where the power is fifty cycles per second, the sync tone is 50 Hz.

The best sync pulse system utilizes highly accurate crystal speed controls for the camera and the sound recorder. Through the use of crystal-sync, the camera speed is held constant at exactly 24 fps by one crystal control, while the other regulates the sync tone device built into the tape recorder. This sync tone generator provides pulses that are recorded sixty times per second on a magnetic tape. They can be considered as "electronic sprocket holes" that allow for an accurate sound transfer to 16mm magnetic film at exactly the same speed at which the sound was originally recorded.

Time Code

A *time code* is a sequence of numeric codes generated at regular intervals by a timing system. Professional audio recorders are usually equipped with time code generators. SMPTE time code is most commonly used.

The Aaton camera is equipped to expose a data track called *AatonCode* on the film edge using a set of light-emitting diodes (LEDs). These clear figures indicate (once every second) the following data: year, month, day, hour, minute, and second. The camera can be additionally programmed to indicate production number and equipment number, as well as the scene, the take, and the roll numbers. These are the man-readable communications. Next to them, the same information is being exposed in machine-readable code on every frame and transferred into electronic time code used in video and audio postproduction.

Time code is input into the Aaton camera by "jam-syncing" from any sound recorder that generates SMPTE time code or by using the Origin Cplus Masterclock. Once initialized, each device on set counts time independently, yet in sync with one another, with no cables or other ties between each unit. Slating is not even a requirement anymore, as synchronization can easily be done in postproduction thanks to the matching real-time address recorded on both the image and sound.

A device in the telecine suite called *Keylink* reads AatonCode off the negative and sound rolls during video dailies transfer and can perform nonstop automatic syncing during the transfer. *ArriCode* is a similar system used in some Arriflex cameras.

Clapper Board/Slate

When the time code is not used, we must provide sync marks on both picture and sound so that the two can be matched up. This is traditionally achieved through that well-known symbol of filmmaking, the *clapper board*, or *slate board*. The scene and take numbers are written on the slate and voiced by the assistant, who then claps the board hinged to the slate. This provides identification marks on both the sound track and the film, telling which scene and take is being shot. Later, the "clap" on the track is aligned with the frame on which the slate closes and the film is in sync.

Slating at the end of a take instead of the beginning, called a *tail slate*, is used when: (1) the subject would be disturbed by a clap at the head, such as when filming wildlife, children, or nervous actors; or (2) the camera begins at a position too difficult to read a slate, like when it is high in the air on a crane or zoomed in on an extreme close-up. At the end of the take, the camera and the sound recorder are left running and the assistant "slates" the take as before. The only difference is that the clapper board is held upside down to inform the editor that it is a tail slate. The assistant should say "tail slate" and then give the scene and take numbers.

There is also a very small slate with no clapper board called an *insert slate*, used at the head of extreme close-ups or macro shots.

Time Code Slate

Often called a *smart slate*, this device has a large LED readout displaying the same time code running on the sound recorder. Even though the smart slate is still clapped at the head of a take, it is merely a backup, because sound and picture can be synchronized by matching any frame displaying the time code on the slate with the same time code point on the audio.

Transfer people generally prefer that the smart slate not be held upside down for tail slating because it's hard to read the upside-down numbers on the LED display in the image.

The ordinary slate is sometimes called the "dummy slate" on the set to distinguish it from the smart slate. Periodically, the smart slate will

6.1 Denecke TS-3 Time Code Slate (smart slate). (Courtesy of Denecke, Inc.)

need to have its time code rejammed with the sound recorder's.

RECORDERS

Audio recording can be either *analog* or *digital*. An analog signal is continuously variable, while a digital one represents the original sound as a series of numerical digits. Among the professional quarter-inch reel-to-reel analog recorders for sync sound operation, the longtime favorites have been the Nagra 4.2 and Nagra IV-S models. However, most sound is being recorded digitally on film productions these days.

DAT recorders like the Fostex PD4 have become the current industry standard for digital recording on location. A 120-minute tape is typically used in order to reload less often. DAT format can record two tracks of 16-bit audio (CD quality).

Digital tape recorders, though, are rapidly

being replaced by devices that record to internal hard drives or disks. The Fostex PD6, for example, can record six tracks of 24-bit audio to DVD-RAM. The Fostex FR-2, also capable of 24-bit audio, records to a hard disk or compact flash card.

MICROPHONES

Microphones are classified in two ways, first by structure and second by reception pattern. In motion picture application most microphones fall into two structural categories: dynamic and condenser.

Dynamic microphones are the most durable and reliable type. Because they employ a strong magnet, it is advisable to keep them away from magnetic tapes and recorder heads. They don't require a power supply. *Condenser microphones* have consistent and extended frequency response with a clarity lacking in most dynamic microphones. They can be miniaturized, as with clip-on microphones, and are also more sensitive to sound than the dynamic ones.

However, they require power from a microphone battery, an external power supply, or directly from the recorder in order to operate. The preamplifier ("preamp") of condenser microphones usually receives *phantom power* (48V) from the mixer or a separate power supply. *T-power* (12V) is another type of power for condenser microphones, although it is becoming less common. Be sure to use the right microphone with the right type of power. Some recorders and mixers can be switched between T-power and phantom power.

The most sophisticated of the condenser mics are the *RF condensers*, such as the Sennheiser 416/816 and the Audio-Technica 4073. Mics in this category are rather expensive.

6.2 Nagra IV-S TC ¼-inch recorder (analog). (Courtesy of Nagra Magnetic Recorders, Inc.)

6.3 Fostex FR-2 field memory recorder. (Courtesy of Fostex Co.)

Electret condenser microphones are simpler in their construction than the RF mics, and subsequently less expensive. They are very small and require a miniature battery. Lapel mics, such as Sony ECM 55B or ECM 44, are good examples of this type.

Microphones are classified by reception patterns as unidirectional or omnidirectional. The directional (cardioid) mic favors sound coming from a particular direction, approximately within a 160° angle. As a sound source moves outside of this angle, the high frequencies are the first to vanish.

A minishotgun (hypercardioid), such as the Sennheiser 416, has a narrower reception pattern (approximately 120°), and its design is particularly favored in film production.

An ultradirectional shotgun (supercardioid), such as the Sennheiser 816, has a narrow reception pattern (approximately 60°), which makes it especially suitable for outdoor shooting, where the background noise has to be avoided.

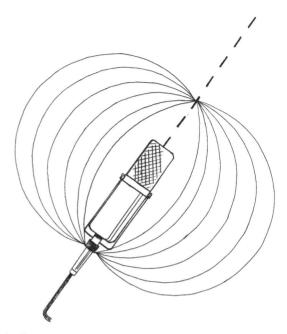

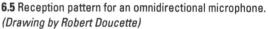

6.4 Sennheiser K3-U modular condenser microphone. *(Courtesy of Sennheiser Electronic Corporation, USA)*

6.6 Reception pattern for a unidirectional microphone. (Drawing by Robert Doucette)

CINEMATOGRAPHY

6.7 Reception pattern for a supercardioid microphone. (Drawing by Robert Doucette)

6.8 Reception pattern for an ultracardioid microphone. (Drawing by Robert Doucette)

An omnidirectional mic accepts sound coming from all directions. It is useful for background effects or group discussions where the mic must remain stationary. Unfortunately, it picks up so much background noise that it is very rarely used in film work.

The lapel lavalier microphone is clipped or taped to the subject's garments. Lavaliers are designed to favor high frequencies in order to compensate for the overabundance of low frequencies originating from the chest area. For this reason they should be placed against the chest. These microphones are generally omnidirectional in their reception pattern. They eliminate the need for a sound boom and keep the mouth-to-mic distance constant. The localized pickup tends to eliminate ambient noise. Unfortunately, some designs may be susceptible to cable noise caused by the cable rubbing against the actor's clothing. Lapel lavalier mics are often connected to radio transmitters for wireless operation.

Not all microphones are compatible with all recorders. All parts of the sound system have some resistance to alternating current (AC), which is known as impedance and measured in ohms (Ω). The different parts of the system should roughly match. Microphones with a higher impedance than the recorder should never be used. In film work, low-impedance equipment is preferred (not more than 600 ohms). It allows for very long microphone cables and reduces the danger of electromagnetic interference.

Other Equipment

Because the best microphone position is generally above and in front of the speaker, there is usually a need for some sort of *boom*. Depending on the production needs and the budget, the boom could vary from a handheld telescopic "fish pole" to a sophisticated studio boom (such as those made by Fisher or Mole-Richardson). In any case, the microphone must be mounted so that it is mechanically isolated from any hard surfaces. It is attached to the boom by a *rubber shock mount*.

For outdoor filming, *windscreens* are a necessity. They can range from an acoustic foam cover to a "zeppelin" made of plastic fiber mesh and foam. Sound recordists will often use windscreens for indoor shooting as well. Windscreens protect the microphone from the rustle of air caused by the swinging of the boom and from accidental impact.

Microphone *cables* are designed to protect the sound system from picking up electromagnetic hum. The balanced cable is best suited because the signals travel through two isolated conductors inside a shield. In an unbalanced cable, only one conductor is used, with the shield performing as the second. A balanced cable can be recognized as having three contacts. *XLR cables* are the most common; since they can get damaged, you should always have some backups.

Microphone cables require considerable attention and care. They should be protected from being run over by equipment on wheels or having heavy objects pin them to the ground. There is a set way of coiling them to avoid the constant twisting of the delicate wires (see figure 6.9). Kinks must *never* be pulled out. They should always be carefully untwisted.

Some recordists will use a *portable mixer* between the microphone and the recorder, making audio level adjustments easier and giving them more control if multiple mics are used. Popular brands include Cooper, Mackie, and Shure.

Maintenance of the Recorder

Like all other equipment, the tape recorder must be checked and tested before use. The first thing to check is the batteries. If some batteries are weak, always replace the full set. If they are chargeable, make sure they have been charged. Make sure that the recorder is compatible with your microphones (impedance) and with your tape (bias). *Bias* is a high-frequency signal generated by the recorder and added to the incoming signal to linearize the magnetic information, thereby reducing distortion. High-frequency bias is set by a qualified technician for any type of tape.

On the recording deck you should pay particular attention to the heads. The most common problem is the magnetizing of the heads. The recording and playback heads of the Nagra should be demagnetized regularly with a small band degausser. You should make sure that the recorder is switched off before demagnetizing. Demagnetizing has to be done properly or the heads will end up more magnetized than before. So read the instructions provided with your degausser carefully. It is advisable to demagnetize the heads after every ten to twenty hours of use or after the head has come within the proximity of any magnetic tools.

Dirt is frequently left on the head by the passing tape. It should be removed by using a video head-cleaning chamois stick, chamois cloth, or clean-room cloth moistened with liquid head cleaner or isopropyl alcohol (95 percent or better). When cleaning, never touch the head with any hard instrument. Heads need to be cleaned after every couple of tapes. The rollers and guides should be cleaned as well. DAT recorders can be cleaned by running a special cleaning tape.

Troubles with recording equipment are often evident on the sound track. Sound distor-

6.9 The proper method of coiling sound cables. *A:* The first loop is normal. *B & C:* The second loop is given an inside twist. *D:* The third loop is normal. And so on, alternating a twisted loop with a normal loop.

tions known as *wow and flutter* are usually caused by a faulty transport mechanism that advances the tape at an uneven speed. Hums and hisses can be caused by a faulty amplifier or low batteries, but these could also have their source in electromagnetic interference, as discussed in the section on microphone cables. Interference may also be received through the tape recorder's AC power supply. For this reason it is always a good idea to have batteries on hand when using AC power to run the recorder. Keep in mind that the hum may be acoustical, possibly generated by some audible source nearby. Fluorescent lights and refrigerators are notorious for this.

The sound recordist who hears a hum via the microphone and his earphones may not realize its true origin. Crackling noises are usually due to faulty connections. If the tape recorder is left in the hot sun, it may overheat, causing it to hum or in some other way operate improperly. Therefore, whenever filming in extremely hot conditions, try to keep the recording equipment cool.

Care of Tapes

For professional recording, use only new, highquality tapes. Cheap tapes have rougher surfaces and may be wearing out the sound heads at a quicker rate.

Tapes and recorders should be protected from dust. Although it isn't visible on tape as it is on film, dust will cause high-frequency dropouts. When not in use, tapes should be placed in their boxes. During recording, the Nagra's plastic lid should be closed.

Before recording on a Nagra, some sound recordists degauss (bulk erase) all their tapes, just in case they were partially magnetized during storage or transport. Otherwise, the erase head at the start of the tape path in "Record" mode should remove any residual recording. After recording, reel-to-reel tape should be left tail-out because fast rewinding leaves the tape unevenly wound on the reel and increases the likelihood of print-through. An unevenly wound tape is not suited for long-term storage. Room temperature and humidity of about 30 to 70 percent is acceptable for storage. Never store tapes in places where they could be exposed to extremes in temperature and humidity.

OPERATION OF TAPE RECORDERS

Nagras use quarter-inch reel-to-reel tapes and allow a choice of tape speeds. The standard in the film industry is 7½ ips (inches per second) for dialogue. At this speed a 5-inch reel runs for about 16 minutes, which comfortably matches the 400-foot magazine of most 16mm cameras. A 7-inch reel, though, allows you to reload less often. You can record 30 minutes on a 7-inch reel at 7½ ips. You can also record at 15 ips if needed; generally that's reserved for recording music.

Digital recorders and their time code generators use video frame rates like 30 fps, 29.97 fps, 25 fps, as well as 24 fps. If you are shooting at 24 fps and will be editing from NTSC video transfers, you normally would use 30 fps non-drop frame time code. If you are shooting at 25 fps for a PAL transfer, use 25 fps on the recorder. If you are shooting at 24 fps for a PAL transfer, it depends on how you are going to handle the 24-to-25 fps conversion. The most common sampling frequency used for digital sound is 48 kHz. Because 24 fps film is slowed down to 23.976 fps when transferred to NTSC video, one technique to sync the image on the NTSC transfer to the 30 fps digital sound is to record at 48.048 kHz instead of 48 kHz. When the recording is resolved in postproduction back to 48 kHz, the sound is slowed down by 0.1 percent, matching the video transfer. However, you could also

record normally at 48 kHz and do the 0.1 percent slowdown in postproduction using other techniques.

When beginning a new tape, the first thing to do is to put a voice identification at the head. Include the following: production title, production number, recordist, tape roll number, and date. This same information will also appear on the sound report sheet and on the tape box, in addition to the recorder number, the type of tape, and the speed at which the tape was recorded. After the voice identification, a *reference tone* is recorded onto the tape for about ten seconds. This reference tone generator is built into many professional sound recorders or mixers. The tone is used by the sound technicians in setting the volume for the transfer.

The level of an incoming sound signal is displayed on a meter. The most common is the *VU/meter (volume unit),* but for much more accurate reading a *peak meter* is used. The Nagra uses a *modulometer.* It is essential to familiarize yourself with the meter by recording different types of sound at various levels. The goal in recording is to obtain sound at the highest possible recording level but below the threshold of distortion.

Recording levels are set ahead of time during rehearsal. A gentle adjustment can be made during recording, but significant "pot riding" would cause noticeable changes in background noise. Many recorders are equipped with an *automatic gain control* (AGC). This is used mainly in documentaries, when there is no time to worry about sudden volume changes. Normally, sound recordists prefer the manual volume control. Some recorders prevent *overmodulation* by the use of limiters, which will cut drastic volume peaks.

For an analog recording, the louder sounds should be in the -7 dB to -1 dB range on the VU meter. A very loud sound may go a little be-

yond 0 dB without overmodulating. However, with digital recordings, anything above 0 dB will be "clipped" (cut off), so you need to keep *all* your sounds below 0 dB.

BASIC ACOUSTICS AND MICROPHONE PLACEMENT

The basic goal of a sound recordist is to get "clean" dialogue—in other words, the voice of the actor should be isolated from other sounds. To this end, the room should be as quiet as possible: refrigerators, fans, air conditioners, and motors in general should be shut off; off-camera windows and doors closed; hard floors covered with rugs or blankets to dampen footsteps; and so on. Pieces of foam or cloth should be used under cups and plates to reduce rattling and clanking when they are moved by actors.

Generally, the microphone should be placed as close to the subject as possible, depending on the design of the mic. If the microphone is farther away, the recording level has to be set higher, and a higher recording volume raises the background noise. To avoid this, try to place the mic closer so that a lower volume level can be used. Perhaps ask the director to have the actor speak up.

The best microphone placement for voice recording is traditionally slightly above and in front of the performer's face, within arm's reach. The mic should usually be pointed directly toward the actor's mouth. One exception might be in the case of an actor with a sibilant voice, which can be favorably modified by pointing the microphone slightly to one side; in doing so you will lose the high frequencies. A sound boom is used to hold the microphone just out of the frame, in proper position. If the actor turns or another person starts speaking, the mic must be rotated to keep it pointing directly into the speaker's mouth. Otherwise

there will be a considerable change in voice quality.

Room acoustics are of vital importance for the sound recordist. A room with hard, smooth surfaces will cause the sound waves to reverberate for a long time, creating live ("boomy") acoustics. An interior with different textures, such as soft furniture, carpets, and wall hangings, may be acoustically dead. Some degree of reverberation may be needed to enrich the sound and create the sense of space.

On interior locations the sound conditions are generally too live ("echoey"). A quick solution is the use of blankets and rugs. Spread them on the floor, under the microphone, hang them on the walls, and drape them over any hard surface, such as tabletops. Avoid smooth, parallel walls in front of and behind the microphone. They may create a standing wave effect in which the sound waves bounce, sometimes canceling, sometimes complementing each other, making even recording difficult. Whenever possible, the mic should be positioned so that its axis runs at a diagonal through the room.

In some scenes, more than one microphone is used to cover the action. In such instances the sound recordist must pay particular attention to the distance between them. When they are too close together, the sound waves will be reaching the microphones out of phase, and phase cancellation will result. To avoid this, the distance from a sound source to the farthest microphone should be three times longer than to the closest one. For example, when actor A speaks to a microphone two feet away, the microphone for actor B should be six feet from actor A. The phase cancellation phenomenon takes place only when signals from both microphones are recorded on the same track. In the case of two microphones connected to a stereo track recorder that offers two-track recording, each microphone provides a signal that is unaffected by the other. Another advantage of recording on separate tracks is the ability to control the voice levels of two actors independently.

When filming an announcer or recording narration, a few simple steps should be followed. If the mic is on a table, cover the table with a blanket. If the mic is on a stand or handheld, the announcer must not cover it with his script or the high frequencies will be lost. The announcer should try to keep his or her mouth at a constant distance from the mic and not turn away, for example, to glance down at notes. Similarly, if the mic is not directly in front of the mouth, the announcer must not turn suddenly *toward* it or the unexpected rise in volume may cause distortion.

Dialogue that is recorded without the camera running is referred to as *wild lines* and should be identified as such at the head of the take.

Sound Perspective and Presence

The sound and picture perspectives should match. For realism, if appearing far away in the picture, an actor must not sound as though close. Similarly, the sound quality must fit the location. For example, a huge cathedral should have a rather live, "echoey" sound. It should not have the relatively dull presence of a carpeted living room. These rules, like any others, are often broken for creative reasons.

To preserve the same atmosphere throughout an entire scene, the soundperson will record a length of *room tone* to be used on the sound track over any silent footage, or to back up dialogue replaced after shooting. Even if silent footage is not to be used, the room tone should be recorded, as it is often invaluable to the sound editing and mixing technicians who may use it, for example, to fill in for some unwanted noise occurring between lines. The room tone should always be recorded for every location, with actors, props, and equipment all positioned exactly the same as during the scene.

Other "presence" tracks may also be recorded, such as street sounds that will later supposedly be coming from a set window.

Camera Noise

The sound recordist is frequently fighting a noisy camera. Many self-blimped cameras are not quiet enough for close-up work, especially in confined areas. There are also nonblimped cameras available with sync pulse, but these are not used for shots where dialogue will be recorded. Padded covers, called barneys, are available for these cameras, and they reduce the sound somewhat but should never be expected to render these cameras as perfectly quietly as, say, a wellmaintained Arri SR3. There is no way of filtering out camera noise during mixing. Therefore, when using a noisy camera, steps should be taken to reduce the noise while shooting. Noise can be decreased by using a blimp, shooting through a window, or, when filming outdoors, using a

longer lens and shooting from farther away. The soundperson can also help to avoid camera noise by using a shotgun mic, or perhaps a localized mic such as a lapel lavalier mic.

Dialogue Replacement

Often because of poor recording conditions, such as airplanes, traffic noise, interferences, or partial equipment failure, it is impossible to get a high-quality track on location. In such cases the producer may save time by going ahead with the shooting, recording an unusable track. This "guide track" will be recorded in sync and will later be used in a mixing-and-dubbing theater when those lines of dialogue are "dubbed" by the actors. The guide track is played with the picture while the actors watch and listen to recall their exact delivery. The film is run again and the actors deliver their lines in sync with the picture. This process is expensive, so everyone always hopes all will go well on location and that dialogue replacement will not be necessary.

7 Postproduction

fter the film is shot and taken out of the cam-Aera, it goes to the lab; if film dailies are ordered, the camera rolls are printed and a screening time is arranged for the cinematographer and director to see them projected at the lab. After that, this work print goes to the editorial department for syncing to the audio recorded on the set, and then editing begins. If video dailies are ordered instead, the camera rolls are transferred to videotape using a telecine and videotape copies are made to be sent back to the set; the editor gets the master tape. Sound usually has already been synced at this point, when the footage was transferred to video. The camera rolls are normally vaulted at the lab at this point until needed near the end of postproduction.

Along the way to the release print there are many different processes, procedures, and optional routes available. To take best advantage of them, the competent editor is thoroughly familiar with laboratory services and capabilities. Because the technical cutting and lab work must be so coordinated, the two subjects are treated here in the same chapter.

SUBMITTING MATERIALS TO THE LAB

Labs require information sheets with *all* submitted materials. The information must be as explicit as possible. Time and care must be taken

to fill out the form completely to ensure that the material receives *exactly* the work intended for it. The information should usually include:

- 1. Name of the company or individual
- 2. Purchase order number
- 3. Account number at the lab
- 4. Production title
- 5. Roll number
- 6. Type of film being submitted
- 7. The estimated length of the roll
- 8. The job to be done:
 - a. If the raw footage is to be postflashed, indicate this *first* in a very visible manner. You should have already established whether the lab offers this service and have done some tests.
 - b. If test footage was shot on this roll, indicate where and how much.
 - c. Indicate whether it is to be developed. When submitting *already developed* material, indicate it as such to avoid a second development.
 - d. If the film is to be pushed in processing, give the number of stops it should be pushed.
 - e. Write SAVE TAILS if important footage occurs at the end of a roll.
 - f. If it is to be printed (as with film dailies), state whether the print is to be:
 - i) Black-and-white or color
 - ii) One light, "best light," or corrected

- iii) Single- or double-perf (not applicable to 35mm)
- iv) On any special stock (labs usually have a default stock unless you specify something)
- v) Made to allow the original edge numbers to print through; write PRINT W/KEYS
- g. If it is to be transferred to video, write PREP FOR TELECINE.
- h. Usually a *camera report* is also submitted, stating which takes are to be printed and giving their location by footage. Any special notes to the timer or video colorist, such as indicating a scene was shot day-for-night, could be here.
- i. If the rolls have a gray scale, gray card, or color chart at the head to be used as the basis for the color timing of the print or the color-correction of the video transfer, indicate this and also say whether it covers any following camera rolls that do not have a gray scale, gray cards, or color chart on them.
- 9. Indication of any suspected breaks or sprocket damage
- 10. Instructions on where to send the print (Perhaps it is to be held for a pickup. Also indicate whether the original is to be held in the lab vault or returned.)
- 11. Indication of whether the print is to be put on a core or a reel with can or case

Finally, if you are working with one particular lab technician who is familiar with you and your project, send the order to that technician's attention. This is a lot of information, but each item is vital to the fast and efficient execution of the work.

Whether you choose film dailies or video dailies generally depends on whether you choose to edit using work print or edit on a computer. However, even for projects to be edited electronically, if the end goal is a film print for projection, there will be some need to occasionally print portions of your footage to check for problems and keep an eye on the look of the project.

VIDEO TRANSFERS

It has become necessary in this day and age to transfer your film to video at some point in its lifetime, whether for electronic editing or for final mastering for the purposes of home video distribution. It should, therefore, become the responsibility of a conscientious cinematographer to supervise this process.

The most common moment of transfer occurs right after the film is processed. The original is ultrasonically cleaned ("prepped for telecine") and transferred to videotape. How much time and money you want to spend on the transfer at this point depends on its purpose.

If it is only for electronic editing in order to generate an *EDL* (edit decision list) that will guide a negative cutter, then the transfer can be considered temporary. The original camera rolls will be conformed to the edit list and prints will be struck. Later, a more sophisticated final transfer to video using a color-timed lowcon print or interpositive will be done.

If the transfer will be used to edit a video master of the project, never returning to the original film elements, then the quality of the equipment and videotape format used becomes more critical.

Considering that the telecine operator, called a *colorist*, has an impressive range of control over the outcome of the transfer, you should not relegate the responsibility of supervision to anyone who doesn't intimately understand the visual concept of the film. For

example, a dusk-for-night scene may end up looking like day if left to an uninformed colorist. Therefore, if you are not able to attend the transfer session, communication with the colorist as to your visual intent is vital.

Telecines

A *CRT flying spot scanner* telecine (like the Cintel) scans the film line by line, by a raster of white light projected through the film. A series of color photocell receptors (red, green, blue) positioned behind the film react to changes in color and density encountered by the scanning light. There is also the *line-array CCD* telecine (like the Thomson Spirit DataCine) which uses a detector to build a picture one scan line at a time by moving the film past a slit. There is also now a *fixed-array CCD* telecine (the Sony Vialta), which captures the entire frame at once.

A CRT flying spot scanner uses a point source behind the film element, while the linearray CCD uses a diffuse light source. This is one reason why the Thomson Spirit DataCine, although expensive, has become popular for transferring 16mm footage. The diffuse light source minimizes scratches and keeps grain from being overly sharpened.

Transfer Sessions

A telecine suite will come with a colorcorrection device, often a DaVinci or a Pogle. These allow sophisticated manipulations of color not possible in traditional film printing. For example, you can increase or decrease the contrast and chroma (color) levels with digital color-correction, something not possible just by changing the three color lights in a film printer. Some of the more expensive suites will have additional software features like "power windows," the ability to draw a box or circle around a point in the frame and color-correct that area independently of the rest of the frame. This will allow you to add a grad effect to the sky in an image, for example, or darken the view through a daytime window while keeping the surrounding room the same brightness. Some suites even allow you to create "keys," either luminence or chroma, to separate specific elements in the frame and correct them independently. See the end of this chapter for more about keys.

Transfer sessions come in two types: supervised and unsupervised. Supervised means that the client (you) will attend the session and sit next to and instruct the colorist as to what you want. Unsupervised sessions, which are cheaper, means that the colorist works alone. This is usually reserved for video dailies, where fast turnaround is important and the transfer will probably not be used to make a final video master. However, if the transfer will be used in an online session to create a final video master, it will have to be of a higher quality. The colorist may correct the image to be rather flat and lowcontrast (a "one-light" transfer) with the intent to later color-correct it in a tape-to-tape session. In this case, the idea is that the transfer should contain all the information stored on the original film, sort of a "digital negative." Contrast will be added later in the final color-correction session.

Telecine sessions are usually billed by time spent, not by length of footage. Therefore, you should budget more time to color-correct an original film element, like a negative, which has no corrections built in, versus a color-timed film element, like a print, low-con print, interpositive, or internegative.

Projection prints are too high in contrast to make good transfers to video and should only be used as a last resort. The transfer will suffer from a lack of shadow and bright highlight detail. After answer printing is completed, you should order either a "low-con" print (Kodak Vision 2395) or an interpositive (Kodak Vision 5242 / 7242). Even though making an interpositive is more expensive, it is recommended over the low-con print because: (1) it has even more information on it; and (2) it will serve as a protection master should your negative become damaged.

The more picture information you can work with in a telecine, like when using a negative or IP, the more flexibility you'll have in making corrections and the more detail you will be able to bring out, especially in very dark night scenes. However, with greater flexibility comes the need to book more time in the telecine.

Video Formats

You will be asked which video format you want to transfer your film to. This can be a somewhat bewildering question due to the large numbers of formats now available. They break down roughly into two categories: standarddefinition video and high-definition video.

In the past, you mainly just had to deal with the standard-definition NTSC and PAL video formats—but now you have the original 4×3 (1.33:1) and the newer wide-screen 16×9 (1.78:1) options in those systems. You also have the emerging HDTV formats, which are 16×9 . Which you choose depends on what you need to do with the transfer.

For example, a 16×9 NTSC master would probably be destined for the DVD market in the United States, since a DVD player can display the wide-screen image on a 16×9 monitor or convert it for letterboxed display on a 4×3 monitor if necessary. For release on VHS and for TV broadcast, however, you'd use a 4×3 NTSC master, either full frame or letterboxed. On the other hand, PAL television broadcast in the UK has switched to wide-screen and you will be asked to deliver a 16×9 PAL master for that market.

Compared to regular 16mm, the widescreen Super-16 format is not only better suited for a blowup to 35mm for 1.85:1 projection, it also is better for a transfer to 16×9 video. The regular 16mm format requires that the top and bottom of the frame be cropped in order to fill a 16×9 screen. On the other hand, if you crop a Super-16 frame to 1.33:1 for 4×3 television, you are essentially using the same negative area as regular 16mm.

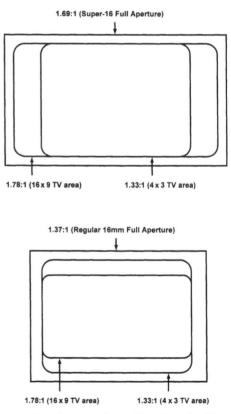

7.1 A comparison between Super-16 and regular 16mm when transferred to 16×9 and 4×3 video. Note that the Super-16 aspect ratio is a close match to 16×9 , so very little negative area is wasted.

In standard-definition video, there are a number of tape formats, both analog and digital. VHS and Beta-SP are common analog tape formats. DV (Mini-DV, DVCAM, DVCPRO, DVCPRO-50), Digital Betacam, and D-1 are common digital tape formats. These all vary in terms of how much they compress data and subsample the color space. D-1, for example, is an uncompressed digital format; Digital Betacam and DVCPRO-50 use very little compression, and DV is highly compressed with less color information. In general, you will want to make any final video masters on a format that uses very little compression and reproduces color information well. Various methods of distributing that information (such as DVD and digital broadcast) can get away with higher levels of compression.

This rule applies to the HDTV as well. Tape

formats originally designed for high-definition video camcorders, like DVCPRO-HD or HD-CAM, use quite a high compression level. A less compressed format like HD-D5 or HDCAM-SR would be better for mastering purposes.

EDITING ON FILM

Editing Room Equipment

Basic editing equipment:

- rewind arms
- reels
- synchronizer
- sound reader
- viewer
- tape splicer
- editing table with a light well
- plastic reels for sound

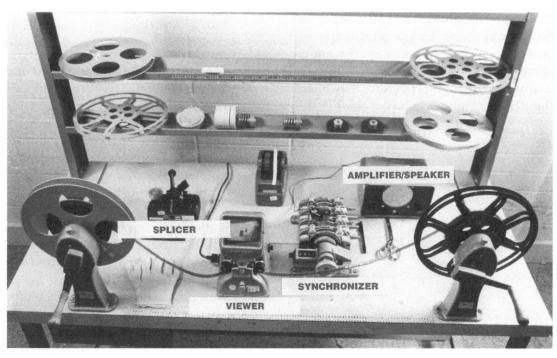

7.2 An editing table with basic equipment.

CINEMATOGRAPHY

When film is stored, to economize on reels the film is wound onto a plastic core. A metal *split reel* comes apart, allowing the core to be seated in the center, and then each side of the reel is screwed on. Another indispensable piece of equipment is the *film bin*, where the footage being worked on can be separated and each shot conveniently hung on a separate peg. Film bins can easily be homemade.

It is not a recommended practice, but if necessary an action viewer may be used for very careful viewing of originals. It must not be permitted to scratch the film. The Zeiss Ikon Moviscop is one of the safest viewers available.

The synchronizer and rewinds should be of the four-gang type (capable of running up to four rolls of film in sync at once). All reels must have centers of equal size, in order to keep a constant tension on all rolls when winding two or more strips through the synchronizer at once.

Tape splicers are always used for editing the work print and sound. Unlike cement splices, tape splices can easily be taken apart without losing a frame. This allows the editor to make a mistake or make changes. The editor may intercut the film in many ways before finding the

7.3 Split reel.

176

7.4 Film bin.

best version. There are two basic types of professional tape splicers. The Parliament Guillotine splicer uses clear, very thin tape without sprocket holes. The splicer punches the holes after the tape is applied. The second type (such as the Revisquick Tapesplicer) uses sprocketed tapes to provide a cleaner splice. Both types are available in either straight-cut or diagonal-cut models, straight for picture and diagonal for sound cutting. Splicing tape is applied to both sides of the film to facilitate movement through projectors and editing machines. For sound, it is applied only to the base side.

A work print with tape splices is reprinted when a guide print for a composer is needed or when too much tape splicing prevents the work print from running smoothly through the projector. Since the work print is a positive image,

7.5 Revisquick Tapesplicers. Straight-cut (right) for picture and diagonal-cut (left) for sound.

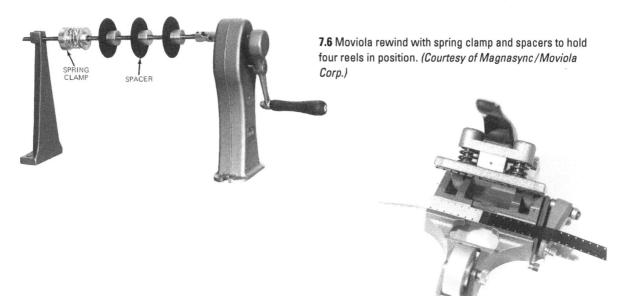

7.7 Paramount Guillotine tape splicer.

the copy is usually made onto black-and-white reversal stock (to create a new positive) and is called a *dirty dupe*.

For splicing the reversal original or negative, *cement splicers* are used. They are usually "hot splicers" that warm the cement as it dries, producing a fast, strong join. A small scraper is provided to remove the emulsion from one of the pieces of film so that the base of one piece can be glued directly to the base of the other without the emulsion in between. The fastest and best hot splicers are foot operated. They are usually too large and expensive for individuals or small organizations, but the laboratories often use them. When operated by a professional, these large machines make excellent splices. For this reason many filmmakers allow the lab to do the final splicing of the original.

Hot splicers can be either "positive" or "negative," depending on the width of the overlap. The positive type is used mainly for repair jobs on release prints, as it has a wide ‰-inch overlap. The negative type has a nar-

7.8 Moviola Console Editor ("flatbed"), horizontal editing table with one composite sound-picture and two sound heads. (*Courtesy of Magnasync/Moviola Corp.*)

rower $\frac{1}{2}$ -inch overlap and is the kind used for splicing original.

For serious filmmaking this equipment must be supplemented with an editing machine. There are many designs, all of which fall into two categories: vertical and horizontal. The *Moviola* is the best-known brand of vertical machine, and other machines are often called Moviolas. It can be equipped with extra sound or picture heads. The advantages of the horizontal design include a large bright screen and quiet operation. Some models have facilities to project the picture onto an even larger screen. The horizontal design is called a *flatbed*.

Entire editing rooms, including equipment, can be rented from some laboratories or studios. When reserving such a place, it is wise to make certain the room is equipped with everything that will be needed and that the facilities are clean and in good repair.

Apart from editing equipment, there are many small items that are needed: grease pencils (usually red and yellow), felt pens, scribes, spools, cores, a can of film cleaning fluid, empty film cans and blank labels, quarter-inch masking tape, log books and paper, rubber bands, white gloves, tissue paper, a demagnetized film punch and scissors, a demagnetizer, white leader, black leader, academy leader, and "fill" leader for the sound track, which could be of any color.

Film Dailies

The camera original, whether negative or reversal, should always be given utmost protection and care. Before the advent of electronic news recording, television crews had been shooting on 16mm reversal film. For the sake of time, the camera original was used for projection. In regular film production the original is never projected under any circumstances, in order

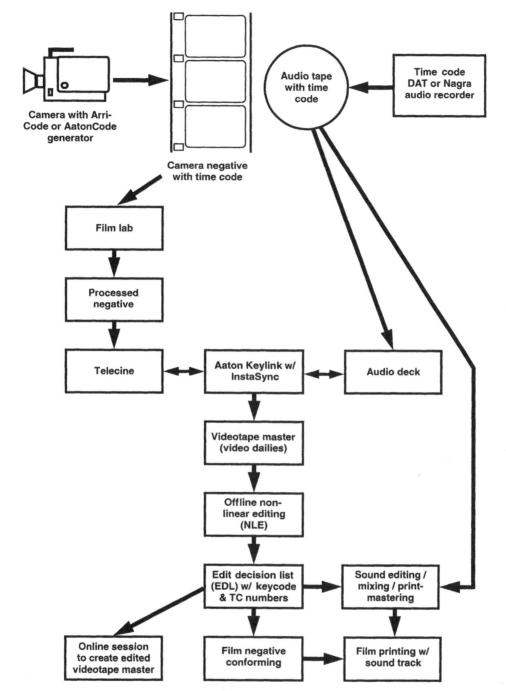

7.9 One possible nonlinear editing work-flow scenario. Film is transferred to video for dailies. AatonCode/ArriCode time code is recorded on the film by camera, matching time code on production audio and allowing easy syncing of sound and picture during transfer to video. Video transfer also includes keycode (edge code) and time code information burned into "windows" on the image. Final EDL (edit decision list) containing keycode and time code information aids negative cutter in conforming the original to the video edit. EDL can also be used for online session for video-only finish.

to avoid causing irreparable scratches. To protect it, a lab makes work prints called *dailies* or *rushes*.

Dailies are printed in contact, emulsion to emulsion, from the original. They are viewed by the cinematographer and director, usually the next day. The lab should be required to print through from original the edge (key) numbers appearing every twenty frames on 16mm film. These numbers serve the purpose of matching the edited work print to the original.

Dailies can be ordered as one-light, bestlight, or timed, each more expensive than the last. *One-light* means that one set of printer lights will be used to time the entire roll, if not every roll. *Best-light* means that a timer will make a few corrections in the roll to ensure a generally good-looking image. *Timed* means that a timer will correct every shot on the roll to look its best; this is also called scene-to-scene correction. Cinematographers should understand this process well and keep in close contact with the timer, since the concept of the "best look" can be rather subjective.

The printer machine at the lab has a range of fifty or more light intensities to choose from. On most printers, every eight "lights" equal approximately a one-stop change in exposure. In black-and-white, exposure for a given shot is indicated by one light number. In color, every exposure has to be set for the three primary colors: red, green, and blue. Some printers may work with complementary colors: cyan, magenta, and yellow.

On a scale of 1 to 50, 25 would be considered the correct light value for normally exposed footage. However, a lab can make the printer light used for a correctly exposed image anywhere from 1 to 50; the idea is to allow the most number of corrections one way or the other, so the middle of the scale corresponds to normal exposure. Often 27 to 30 are more commonly used than 25. Asking, therefore, for onelight dailies could mean that the color negative will be printed at 27, 27, 27 across the board for all three colors. However, it is not uncommon for one of the three numbers to be lower than the other two, so that the color balances out correctly.

In practice, one-light sometimes really means three or four printer light settings. A cinematographer may shoot tests and establish with the timer that all the day exteriors will be printed on a certain light, night exteriors on another, and all interiors on yet another. Day and night interiors could even have different lights. Different film stocks may require their own set of numbers. In 35mm dailies, this "multi-onelight" system is well-accepted practice.

Cinematographers like to "lock" the printing lights, which gives them a yardstick against which to measure their lighting and exposure. This way, if the dailies show exposure or color problems, the cinematographer sees it right away and is able to adjust the exposures. When watching dailies, the production team knows what is a one-light print, and minor color exposure shifts can be corrected later when the edited film will be timed for the answer print.

Finally, a cinematographer should take a keen interest in the screening conditions of the dailies. If the screen brightness varies from the 16-footlambert standard, the screening will not do justice to all the shooting and timing efforts. Before the screening, ask the lab projectionist if a check was done for projection brightness.

Syncing Up Dailies

After receiving the dailies from the lab and the magnetic film from the transfer service, the sound takes are "synced up." This is usually done on a film viewer and synchronizer with magnetic sound head, but it can also be done on

an editing machine with picture and sound heads, such as a Moviola. The clap on the sound track is located and marked. Then, on the picture, the place where the clapper board closed is located and marked. If the picture has time code numbers on the edge and the same numbers are transferred as ink printings on the 16mm magnetic film, these numbers will serve as syncing points. The picture and sound are locked into the synchronizer and aligned with their slate markings or time codes, opposite each other. Picture and sound should now be in sync.

After winding ahead to the next take, there will often be more magnetic film than picture film. This is because the tape recorder is usually started before and stopped after the camera. This excess of sound film should be removed, and the cinematographer should make sure that the identification of the next sound take, before the clap, is left intact. Whenever editing picture and sound, professional editors do all their splicing on the *left* side of the synchronizer. In this way, as the film is wound from left to right through the synchronizer, the editor knows that everything on the *right* of the synchronizer (the finished side) will always be in sync and that only the left side is of concern.

After syncing up, you should order the lab to print corresponding *ink edge numbers* on both the picture and magnetic film. This is because when the intercutting starts, the frames with the slate visible will be removed. The corresponding numbers printed every twenty to forty frames along the edge of the picture and sound track are a convenient method of maintaining sync.

Logging

All footage (sound, silent, and library) should be logged. This involves writing down the original edge numbers with a short description of the action. As edge numbers appear every half foot, frames will usually have to be counted in order to establish the exact beginning and ending of each shot. Although logging is a very tedious job, in the long run it usually saves time and often money as well. For example, an accurate logbook enables you to look up the exact length of a given shot when planning overlaps for dissolves. Without it, you would have to look at your original, thus exposing it to unnecessary hazards. (See figure 7.10.)

Assembly

Once the logging is completed, the next step is to assemble the scenes into the order indicated in the script. The first step is to break up the rolls into individual shots. After removing the slates and clearly labeling the picture and sound takes, hang them in the film bin or store them on cores.

Now splice them together in sequential order. If the best takes were not yet chosen at this time, leave the alternative takes in, to see them in the context of the whole scene. Some editors may prefer to build up the assemblage by looking for the necessary takes in the synced-up (synchronized) dailies, and they may then incorporate them, in scripted order, directly into the assembly roll without using the film bins as intermediary storage.

The assembled rolls will be fitted with head and tail leaders.

Picture leader will depend on the sprocket characteristics of the work print. Most often picture leader is a double-sprocket stock. It is essential to use single-sprocket leader for sound film. Editors like to use white leader for the picture and yellow or red for sound. If you use the same color for both, at least the writing to identify the rolls should be done in different inks.

LOG SHEET

PAGE NUMBER 7015

COMPANY Natalia Productions producer Anzelm Porfition prod. TITLE "A MOUSE & DAY...." prod. NO. 2005 LOCATIONS Lindley house garage

CAMERA ROLL NO. 7 PREFIX $\frac{JI}{2G}$ 19×20 LAB ROLL NO. 412 BW 10 LAB ORDER NO. 212619

CODE NO.	EDGE NO.	NOTES	SC/TK	DESCRIPTION
B0004-030	JI 19739-		22-1	The catenters garagea looks up. Cat moves too fast Same, Cat moves slower (Good) Mary enters from the Kitcha
800031-050			22-2	Same', Cat moves slower (Good)
800051-080			23-1	Mary enters from the Kitcha
B00081-089	19969-200	2	24-1	C.U. Mary gives Lines
B000 99-165			25-1	The cat brushes against Mary's leg C.U. Mary reacts to sound x looks up
800 166-228			26-1	C.U. Mary reacts to sound
B00229-285	2 0470-51	e mos	25A-1	C.U. Cat looks up
1300 286 - 299	20513-532	NO SLAT	E 27-1	A mouse moves along the upper shelve L-R(som The cat jumps up the shelve
B00300-314	20533-54	3 TAIL SLATE	28-1	
B00315-325	20544-56	0	29-1	Paint coms sheking on the shelves
B00326-350	20561-57	9 MOS	26A-1	C.U. Mary reacts - poor
B00351-375	20580-5	98 MOS	26A-2	C.U. Mary reads- Very good
BOO 376-390		17	29A-1	Paint caus falling down
	Endof			
		-		
	-	L	4	

7.10 Sample log sheet.

Any marking on the magnetic film itself should be done with an indelible marking pen, but not with a grease pencil. If grease pencils were used on sound film, they would smear and clog the magnetic heads. Another precaution that will protect the heads is to splice the sound leader in such a configuration that it is running with its base (shiny side) against the head. This way, the emulsion will not flake and clog the magnetic heads.

Rough Cut and Fine Cut

During the next step, called the *rough cut*, the shots will be intercut closely together. Close-ups will be inserted into master shots, but the work print will still be much longer than intended for the final print. As editors work on films, they may change their minds many times, and so they don't throw any footage away. All "outtakes" and "trims" must be saved and filed according to their scene and take and their edge numbers.

The *fine cutting* is the next step in editing. The editor strives to say more with less, making the film structure more meaningful in a shorter period of time. It is very helpful to be editing to music as early as possible, as the music will influence the cutting rhythm of the picture. In documentary films, the narration might dictate the structure of picture editing.

Fine cutting is also the time to build up the various sound tracks. Most dialogue will be broken up to accommodate different voice levels on separate tracks. Music may require several tracks as well to facilitate gradual fades and dissolves. Finally, sound effects can be quite complex and may even demand premixing to reduce the number of tracks before the final mix. Different sounds should never be laid next to each other on the same track. A five-second pause between them allows the mixer to control them effectively. Sometimes sound effects are purchased from an effects library. When ordering them, you must be very specific. For example, if a motorcycle sound effect is needed, every possible bit of information should be included, such as the manufacturer of the cycle; its size, displacement, and horsepower; a description of its age and condition of repair; and what it is doing, whether starting, accelerating, or cruising, and at what speed. Of course, whenever possible it is good to record your own sound effects at the location where the footage was shot.

Even if you decide to edit picture and dialogue using work print, it is common practice to finish editing the sound, including effects, foley, and music, using a computer-based system running software like Digidesign ProTools. It will be necessary to transfer your edited work print to video in order to edit all of your sound tracks on a computer, matching them to your picture edit.

NONLINEAR EDITING

The field of computer-based editing is changing all the time, so there are many scenarios to consider, some still evolving, some quite established. The term nonlinear editing suggests that you don't have to make each edit in the same order that they appear in the final cut; you can work out of sequence, you can go back and lengthen or shorten a shot without affecting the surround cuts. Early videotape editing (linear editing) involved dubbing each selected portion of a shot onto a new tape, one after the other, so any editorial changes required doing the whole process over again. If the goal is ultimately to be able to conform the camera originals to allow printing, the result of your nonlinear editing efforts will be an edit decision list containing accurate key code information that will guide the negative cutter.

Video Dailies

For film material that will eventually be printed, the current approach is to transfer the original camera rolls to a standard-definition video format (NTSC or PAL) using a mediumquality tape format like Beta-SP, which uses decks that are affordable enough for many professional editing rooms. However, people on a tight budget, editing at home on their personal computers, are more likely to want to transfer to a cheaper consumer tape format like DV (Mini-DV/DVCAM) because that's the only type of deck they will be able to afford. Or they might transfer to Digital Betacam but make dubs off that down to DV videotape or to DVDs and work with those in the editing room.

In this scenario, the transfer to video will usually be used *only* for editing, with the goal to generate an edit decision list that will guide the negative cutter when conforming the original footage to the edited version. Therefore, unless your project is well budgeted, the video dailies will be transferred in an unsupervised session using older telecine equipment and averagequality tape formats-all in order to save money. Since you will not be supervising the transfer, hopefully your gray scales and color charts at the head of the rolls, and your camera report notes, will be enough to give the dailies colorist an idea of the correct look. Usually you will just ask for a 4×3 transfer, letterboxed if you are shooting in the wide-screen Super-16 format. The regular 16mm format has the same aspect ratio as 4×3 TV, so letterboxing is not necessary. At this point, there isn't much need to transfer to a 16×9 wide-screen video format because you'll probably want dubs of the transfer to VHS for screening dailies on the film set.

There is a danger in accepting really poor video dailies at rock-bottom prices to save money; you may be misled or confused as to the actual quality of your image and miss certain problems in the photography (like with focus) that will show up when you make the print and project it on a large screen. Or you may even come to believe there are problems with the footage when it actually is fine.

The other common frustration with video dailies is that they are often too flat-looking. This is partly because the negative is such a low-contrast film element to work from, but the main reason is that a colorist will always shy away from throwing out any information on the negative, playing it safe. So if you want the colorist to keep the shadows dark and the blacks really black, you need to make that clear. Besides the gray scales and color charts, it is a good idea to make some signs to shoot at the head of the scene that quickly explain the overall look. For example, you may shoot a sign that says: SLIGHTLY GOLDEN TONE, DEEP BLUE MOON-LIGHT, OT GREENISH FLUORESCENTS INTENTIONAL.

If you have time in preproduction, you can sometimes sit with your colorist and transfer some tests to familiarize him or her with the visual intent of your cinematography.

Computer Editing Room Setup

For nonlinear editing, you will be using a computer loaded with one of the many editing programs out there, plus an external deck to play your video dailies and external hard drives (as many as needed to hold all of the footage you digitize into the computer). The details of how to operate a nonlinear editing system are specific to the software you choose, so they will not be covered here.

Editing Concerns

One issue you will face immediately is the difference in frame rates between your original 24 fps film footage and the video transfer. NTSC is 30 fps, but since each video frame is made up of two fields, it is also sixty fields per second. In order to convert twenty-four film frames in sixty video fields, a method called *3:2 pull-down* is employed, which repeats certain fields. Basically, there will be five video frames for every four film frames. The first film frame will be represented by two fields, but the second film frame will be represented by three fields. You'll note in the chart below that every third frame of video will contain one field from one film frame, but the other field is from a different film frame:

Film		Film		Film			Film			
Frame		Frame		Frame			Frame			
A		B		C			D			
Field	Field	Field	d Field	Field	Field	Field	Field		Field	Field
A1	A2	B1	B2	B3	C1	C2	D1		D2	D3
Video Frame 1			deo Vid ame Fra 2 3						Video Frame 5	

What this chart shows is that you have to make your edits in video on the fields that correspond to real film frames if you want to generate an accurate edit list that can be used to conform the camera original. Your telecine transfer should have a keycode "window" burned into the image that shows which video frames correspond to real film frames. There is one film frame represented exactly by the two fields of one video frame—this is called the *A-frame*. The pulldown sequence should begin on an A-frame, so be sure to remind the telecine facility that you want an A-frame transfer.

One way to simplify these issues is to use software that edits in true 24 fps (such as Avid Film Composer or Final Cut Pro). These programs use a process called *reverse telecine* to remove the 3:2 pull-down from the video transfer and work with whole film frames in editing.

Usually the transfer house will supply a *FlexFile*, a log stored on a floppy disk that shows the relationship between the keycode numbers and your video transfer's time code. If you decide to cut in a 30 fps environment, your final EDL will have to be converted at that point to a 24 fps keycode decision list that will allow frame-accurate cutting.

Also note that NTSC video is actually 29.97 fps, not 30 fps. Therefore, 24 fps material transferred to NTSC will actually be running at 23.976 fps; 24 fps editing software will correct this back to 24 fps after the pull-down is removed. However, if you choose to cut in 29.97 fps editing systems, it may affect certain audio sync issues later. Consult your specific sound editing software manual.

It is also important to remember that some types of video edits that are easy to make may require extensive optical printing or digital work later to enable the cut negative to match what was done in the computer. A common example is when you reuse the same shot more than once, which will require you to make dupes of that shot to be cut into the final conformed negative. Even more complex is when you alter the speed of the material in editing. Generally, you should only make the sorts of edits that would traditionally be made in filmbased editing so that you know you can easily create an edited negative with all of these effects. For example, if you ultimately want to do your fades and dissolves using A-B roll printing, the length of your fades or dissolves in the nonlinear edit must be in standard lab lengths.

Conforming

The process of cutting the original camera rolls to match the edited work print or EDL generated by a nonlinear editing system is called *conforming*.

The *A-B roll* technique involves creating two separate printing rolls (the A-roll and B-roll) for the *same* reel; these rolls will essentially be printed in two passes onto the same print stock. The "checkerboard" technique (see figures 7.11 to 7.13) of A-B roll conforming is used only in 16mm film; *every* edited shot in a sequence alternates between being on the A-roll and then the B-roll. A-B rolls may be used in conforming 35mm negative as well, but mainly to provide the overlaps required for dissolves and superimpositions. In this case, most of the material will exist on the A-roll, cut into a single strand, except for the other side of a dissolve or

superimposition, which will be on the B-roll. The splices in 35mm fall entirely between frames and therefore don't show in the projected area. In 16mm film, however, the splices overlap part of one frame and are therefore visible when projected. So, in 16mm, the checkerboard technique used with the A-B rolls serves the primary purpose of achieving invisible splices.

Basic Printing Effects

When making contact prints from a negative conformed in A-B rolls, there are four basic optical effects normally offered by the labs at no extra charge: fade-outs, fade-ins, dissolves, and superimpositions.

A *fade-out* is a gradual darkening of the image until it becomes black. The printer light is gradually diminished as the film is being

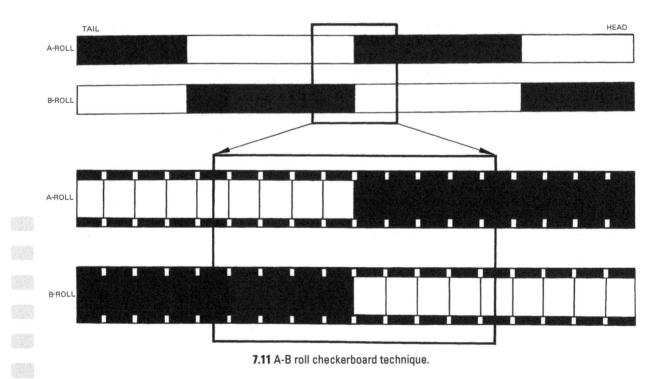

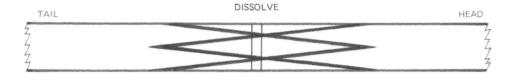

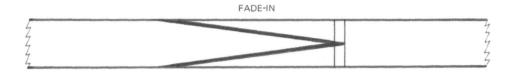

DOUBLE EXPOSURE

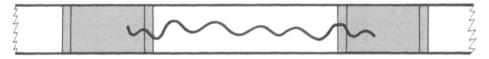

EXTENDED SCENE

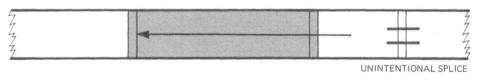

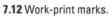

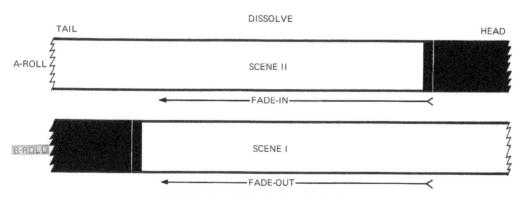

NAME W. VOLO	COMPANY GABLOTA FILMS				
TITLE " STICKY BUILD-UP"	PROD. NO. 52/	TYPE OF ORIGINAL COLOR NEG.			
ADDRESS 3 SANTA ANNA ST.	PHONE 555-1405				
VALENCIA, CA 91355	B. BACON				
	EDITOR'S PHONE	0789			

FT	FR	A ROLL	B ROLL	C ROLL	SOUND
00	00	Print Start	Print Start		Edit Sync
08	02	F.I 24			
09	24		F.I 24		
13	31		F.O 24		
16	18		F. L 24		
22	09		F.O 24		
27	39	F.O 48	F.I 48		
32	21	F.T24	F.o 24		
41	36		F.T48		
106	30		F.O 12		
113	16	F.O48			

7.14 Sample cue sheet showing location and lengths of effects.

POSTPRODUCTION

printed. A *fade-in* is just the opposite, a gradual lightening of the scene from black to normal. For this the light is gradually increased while printing. When these two effects occur simultaneously they make a *dissolve*, where one scene gradually disappears as another scene appears in its place. This is sometimes called a "crossdissolve" or "lap-dissolve." It is done in two printer operations. The first scene on the A-roll is printed until the beginning of the dissolve and then faded out. The raw stock is then rewound and run a second time. The printer light is out until the beginning of the dissolve, and then the second scene on the B-roll is faded in over the same place that the first one was faded out. Fades and dissolves can differ in length depending on the type of printer being used at the lab. Therefore, the standard lengths vary. The lab should be consulted for their specific capabilities.

Superimposition is achieved by printing two scenes over the same piece of film. This usually starts by fading a second picture in over the first. The two are then seen together for a period and one of them is faded out. It is much like an extended dissolve.

Creating Titles

The title cards are not always shot on the same stock as the rest of the film. When the titles are black or white, you will find that High Contrast Positive 7363 (which can be developed as negative or reversal) offers the crispest letters. It has a very low exposure index, and tests should be made to determine the best exposure. When you need white titles on black background, they can be prepared as black letters on white background and shot on 7363 to be processed as negative.

Titles over moving pictures can be "burned in" using A-B roll printing. The B-roll containing the titles would be black with clear lettering; this would get exposed over the background image on the A-roll. If you had shot your movie in reversal, then your titles would end up as white lettering over the picture. If you had shot your movie in negative, the titles would end up being black over picture. However, burned-in titles generally do not have enough density for the lettering to really stand out against a background of various tones. To make consistently solid letters against a background, you need to use holdout mattes in an optical printer or composite the titles over the picture digitally and have the finished result recorded to film.

Preparing Your Original

Before the conforming can begin, the work print must be "locked down." That is, all shots must be cut to the exact final length that will appear in the finished film, with all anticipated optical effects marked with a grease pencil. Dissolves and superimpositions require the two adjacent shots to overlap each other in the A-B rolls. Therefore, to maintain sync, the full lengths of the original shots will not appear in the work print. Remember that the length of the dissolve represents the two scenes overlapped. You cannot physically overlap the two shots of the work print, as they would jam in the equipment. Therefore, the two scenes are cut and spliced together in the middle of the dissolve and it is understood that each scene extends into the other. For example, a forty-eight-frame dissolve in a work print will show twenty-four frames of each shot. When planning the lengths of dissolves, we must be sure that the original is long enough by checking in the logbook.

A cue sheet should be made, indicating the location and length of each effect. The location is given as the distance from the "printer start"

7.15 Example of typical leader arrangements for the A-B rolls.

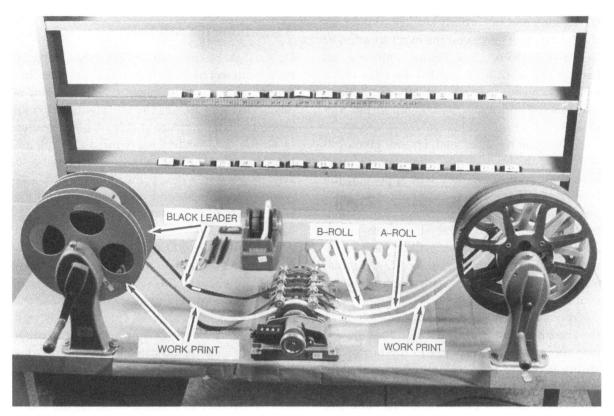

7.16 The editing table, prepared for assembling the original into A-B rolls. Note the originals broken down by "takes" and numbered according to their order in the work print. Numbers appear on the bend strips of double-weight paper (usually index cards), holding in place the outside coil of each film roll. Masking tape is not used, as it could leave residue marks on the negative.

frame on the head leader to the beginning of the effect.

If the budget permits, you can submit the untouched originals along with the finished work print and cue sheet to a professional negative cutter, who can then do the actual conforming. Otherwise, the editor will conform the originals, but even if this is the case, the editor will usually not make the actual splices. He or she will mark where they should come and leave them for the negative cutter to do. Stronger, cleaner splices offered by the professional service are worth the expense.

Before beginning to conform the original,

the leaders are set up. They should correspond exactly to the work-print leader, which was prepared for the sound mix. Tail leaders will later be prepared for the end of each roll.

When marking A-B rolls, all information must be written with an indelible marker never a grease pencil. Anything other than an indelible marker may come off or be smeared all over the picture. Also, the lab will often clean the film with high-frequency sound waves before printing. India ink does not come off in this process.

As you begin to assemble the A-B rolls, you will appreciate the meticulous preparation of

CINEMATOGRAPHY

the logbook and the orderly storage of the rolls of original. This gives you the exact location of each shot in the original. Before beginning, go through the work print and list the edge numbers of each shot that was actually used. Next, take this list and mark these shots in the logbook.

When you have finished, for any given roll of original the logbook will show which takes were used and where they will appear in the finished film. For example, original roll number two might contain the shots appearing first, ninth, thirteenth, and twenty-first in the work print. Using the logbook, it will be easy to remove just those shots from the roll of original and place them in order with a minimum of wear on the original.

You are now ready to begin conforming.

The first thing to do is to "sterilize" the editing room. Tape clean paper to the top of the editing table and the floor around it, especially at each end of the table. Remove all tools from underneath the film path. "Scrub up" and put on white editing gloves.

Breaking Down the Original

Take the first roll of original, *tail out*. Look in your logbook to see what takes were used from this roll. Carefully remove each such take, *in its entirety*. Keep everything from camera start to camera stop. You will trim or divide it later. Wind it *tail first* onto a clean core. This way it will be *head out* on the core, ready to be wound directly onto your A- or B-roll. Now label it, assigning its number according to its appearance in the work print. Place it on the shelf. Continue this process until all the *chosen* takes have been removed and arranged *in consecutive order*.

Assembling the A-B Rolls

On the right rewind you will need three take-up reels with equal hub diameters. On the first "gang" of the synchronizer, the work print is positioned *base up*. On the left rewind, or on a separate "horse," place a roll of black leader. Next, the head leaders for A-roll and B-roll are placed in the synchronizer, *emulsion up* and in sync with the work print. Their heads are wound onto the second and third reels on the right rewind. Now you are ready (see figure 7.16).

Although some budget-minded filmmakers perform the original cement splicing themselves, we suggest you scribe and temporarily tape the originals, allowing the lab to make the permanent cement splices. This service is well worth the usually reasonable price. The location of a future splice is indicated by two marks, one on either side of the nearest sprocket hole (see figure 7.17). These marks are scribed (scratched) with the corner of a razor blade on the film's edge outside of the picture area. Now the excess is trimmed away, leaving at least a one-and-ahalf-frame margin. When trimming this excess be extra alert and make certain to trim it on the correct side of the scribe mark or you will destroy something you need to use. Once trimmed, the two pieces to be joined are exactly overlapped and taped so that the future splice lines exactly coincide. The sprocket holes must be aligned so that the overlap will move easily through the synchronizer. You must always use the masking paper tape, which when pulled off will leave no trace on your original. When using such tape it is customary to tape picture over the black leader.

Let us say your first shot is an A-roll. We will leave the black leader extending from B-roll. Take Scene 1 from the shelf and match its edge numbers to those on the work print. Lock

POSTPRODUCTION

7.17 When the actual splices are left to be done by the lab, the splice line is indicated by scribe marks scratched into the emulsion on the edge of the film, as seen here. The excess is then trimmed away, leaving a 1½-frame margin.

them into the synchronizer so that they are in sync. Scribe the Scene 1 original on either side of the sprocket hole opposite the first splice in the work print. Cut off the unwanted portion before the first frame, leaving one and a half frames before the future splice line. Next, on the A-roll leader, scribe the sprocket hole opposite the first splice and trim it, leaving the one-anda-half-frame margin (see figure 7.18). Tape the two pieces of film (the first scene overlapping the A-roll leader) so that their scribe marks exactly overlap each other and their sprocket holes are aligned (see figure 7.19).

At this point we have the first scene scribed and taped to A-roll. Its edge numbers are in sync with those of the work print (see figure 7.20). We have black leader opposite this on B-roll. Now we wind in sync ahead (film moves to the right) until we come to the end of the first scene in the work print. Here the second scene will be placed on B-roll and the black leader will be joined to A-roll. To do this, find the splice between Scenes 1 and 2 in the work print. Opposite this splice put scribe marks on the end of Scene 1 (on A-roll). Trim the excess from A-roll, leaving the one-and-a-half-frame margin. Also scribe the black leader on B-roll opposite this splice. This leader is coming from a large supply roll on your left. You cut it from B-roll and scribe and tape it to A-roll at the end of Scene 1 (see figure 7.21).

Now take down Scene 2. Match its edge numbers to those of the work print. Scribe the sprocket hole on the original that coincides with the splice in the work print (see figure 7.22). Overlap and tape it to B-roll. Scene 2 is now on B-roll. Black leader is opposite it on A-roll (see figure 7.23). You are now ready to wind ahead, in sync, to the end of Scene 2, where you will put in Scene 3. As you work, be constantly checking to make certain your edge numbers are always in sync. Keep repeating this cycle, except when dealing with dissolves or supers (to be discussed next). When cutting

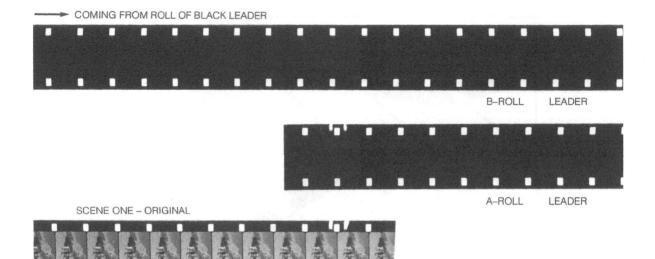

7.18 The first scene (original) is aligned with the work print so that the original edge numbers are in sync. Scribe marks are made to indicate the splice line.

COMING FROM ROLL OF BLACK LEADER

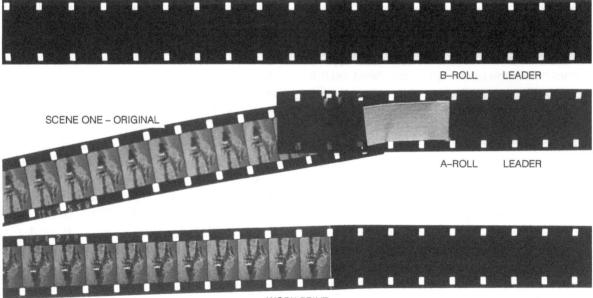

WORK PRINT

7.19 Scene 1 is taped to the end of the A-roll leader so that the scribe marks overlap. Notice that the tape does not extend into the picture area to be used. It is kept on the black leader side of the splice line so that it touches only the black leader and the 1½-frame margin.

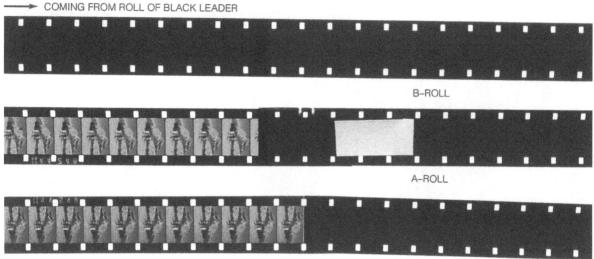

WORK PRINT

7.20 The first shot, scribed and taped to the A-roll.

B-ROLL

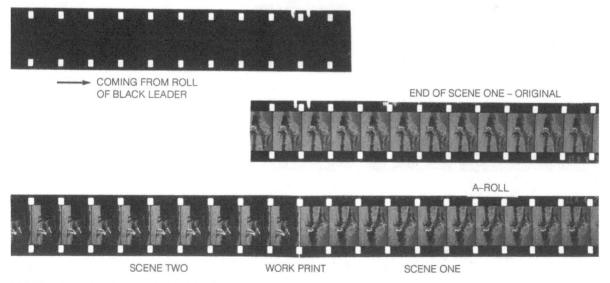

7.21 After the end of Scene 1, the black leader is removed from the B-roll and scribed before taping to the end of Scene 1 on the A-roll.

SCENE TWO - ORIGINAL

B-ROLL

SCENE ONE – ORIGINAL

---- COMING FROM ROLL OF BLACK LEADER

A-ROLL

SCENE TWO

WORK PRINT

SCENE ONE

SCENE ONE - ORIGINAL

7.22 Scene 2 is aligned (via edge numbers) to the work print and the splice line is scribed.

SCENE TWO - ORIGINAL

B-ROLL

COMING FROM ROLL OF BLACK LEADER

A-ROLL

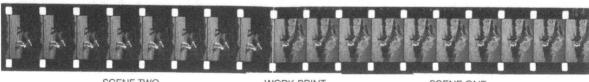

SCENE TWO

WORK PRINT

SCENE ONE

7.23 The end of Scene 1 and the start of Scene 2 have been scribed and taped in checkerboard technique.

negative original, fades must also be handled differently.

In passing, we should note that single-perf original will *only* fit *base up* on a normal synchronizer. Therefore, when conforming, you are forced to back the film out of the synchronizer and turn it over in order to scribe the *emulsion side*. This is somewhat awkward.

- **Dissolves.** Dissolves must be very clearly indicated on the work print so that you don't forget one of them and A-B roll it like a straight cut. Some labs require that the center of the dissolve be scribed (see figure 7.13).
- Superimpositions. Supers are cut much like dissolves. The important thing is to give good timing instructions, especially indicating which image you want to be more visible. To indicate the super in the work print, small sections of the shot to be supered are cut into the work print at the beginning and end of the area over which it will be superimposed. When possible, these sections should contain edge numbers to help the editor find the original before conforming.
- Fades. With reversal originals, fade-outs and fade-ins will be indicated on the work print and cue sheet but do not require any other special treatment. However, in the case of negative original, the fade-out and fade-in sections must have transparent leader (in the case of color made from the same negative stock) on the opposite roll. When a fade-out is followed by a fade-in on a negative original, *both* of the original shots should appear on one roll with the clear leader on the other (see figure 7.24).
- Lengths of Effects. For fades and dissolves, some labs require a few frames of extra overlap. For example, a thirty-frame overlap might be advisable for a twenty-fourframe dissolve. Similarly, different labs will offer their effects in different lengths. For example, the shortest dissolve possible might be sixteen frames, with other specific limited lengths available, such as twentyfour, forty-eight, sixty-four, and ninety-six. Other labs may offer different lengths in between. Before even the work print is edited, the editor should have consulted with the lab to find out what lengths are available.

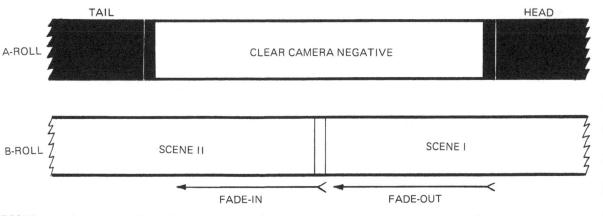

7.24 When conforming *negative* original, a clear leader (or clear camera negative, in the case of color) must be placed opposite any fade-ins or fade-outs. (This does not apply to dissolves made in negative.)

• Minimum Spacings. The minimum distance between effects is dictated by the length of the effect and the printer used. If the printer fades out in twenty-four frames, it will require twenty-four additional frames to open back up. Usually a few more frames are required as a safety margin. Therefore, if A-roll fades out in twenty-four frames, there must be at least twenty-four frames before the next shot on A-roll. If the shot on B-roll is less than twenty-four frames, the next shot on A-roll will start dark and lighten as the fader finishes opening. There are two common ways of dealing with this. You could use a C-roll-an additional roll like the A-roll and B-roll. The extra expense of running the third roll is often not desirable unless the C-roll has more than one purpose. For example, if you had a black-and-white shot cut into a color movie, it would be better to have the blackand-white material on a C-roll. Additional rolls are always possible, and some films (frequently experimental) use A-, B-, C-, D-, and E-rolls, although there could be even more. If money is not plentiful and the problem only occurs once, the solution is frequently just to splice the shot onto the same roll as the shot before, so that in the above example, A-roll fades out and then the next two shots are on B-roll. The splice will be visible, but it saves the expense of a C-roll.

THE SOUND MIX

The whole purpose of editing the various sound components of the film onto separate tracks is to enable the mixer to record them onto one master track called a *print master*.

Nowadays the final sound mix is usually recorded onto a hard drive or to a digital tape

format, most likely a DA-88. A common track setup for the print master is:

- Ch. 1 & 2: Composite Stereo Mix
- Ch. 3 & 4: Stereo Dialogue
- Ch. 5 & 6: Stereo Music Mix
- Ch. 7 & 8: Stereo Sound Effects Mix

This method of separating music and effects (M&E) from dialogue allows more flexibility when remixing the sound for foreign-language versions.

Precise *mixing cue sheets* will indicate what various tracks are, where they are to come in and out, the changes of relative levels, and a description of particular sound effects. Mixing sessions are very expensive, so the better prepared the sound tracks and the mixing cue sheets are, the faster and the more economical mixing will be. Always consult the sound mixing lab about their particular requirements regarding cue sheets, leader lengths, cue marks, and anything else that could save time during the session.

There are various software options for creating cue sheets for sound tracks edited using programs like ProTools. Some general effects, such as room tone, traffic, or birds, may be provided on CDs, which can be fed directly to the mixing console. Or you can create essentially a ten-minute track of these ambient sounds and bring that to the mix.

A punched sync mark indicates the start of the film. It is usually placed six feet from the head. Farther down, a *sync pop* (also called "sync beep" or "blip tone") is usually placed forty-eight frames before the start of the sound track.

The work print must have good, doublesided tape splices to allow it to run smoothly through the projector during the mix. Sometimes the work print is in such poor shape that

POSTPRODUCTION

7.25 Computer-generated mixing cue sheet. (Courtesy of Dane Davis)

instead of risking it on the projector, it is sent to the lab to make a dirty dupe to be used during the mix. It is quite advisable to use a dirty dupe even when a work print is in good shape. After all, the work print constitutes your edited image, and the original camera footage will be matched (conformed) to it during the formation of the A-B rolls.

If you edit your picture digitally using an NLE system, you can use a videotape copy of your edit during the mix session. However, as soon as you get your first silent answer print, it's not a bad idea to take it over to the mix stage to make sure it runs in sync with your print master before you make the optical negative.

Usually, at least some *premixes* are recommended. First to be done is a dialogue premix that allows the mixer to mix all the dialogue down to a few tracks. A large number of effect tracks may dictate the need for a premix as well. The various audio tracks are brought to the premix and the final mix, often on hard drives, and then fed through a *digital dubber* that sends the tracks to the mixing console.

When music tracks are not too numerous, it is generally better to mix them all during the final mix. This way the mixer has a better feel

for balancing music to the rest of the sound and to the picture.

Well-prepared sound tracks are the first step to a successful mix. A good sound editor will make a tremendous difference in this respect.

SOUND ON RELEASE PRINTS

From the print master that resulted from your sound mix, a high-quality *sound-release negative* or *optical negative* is created. It is essentially a negative image of your sound as an optical track. It is printed onto the edge of each release print.

Be sure to order the sound negative with the same emulsion position (A-wind or B-wind) as your picture negative. That is, when printing from an A-wind internegative, order an A-wind sound negative.

SUBMITTING MATERIALS TO THE LAB FOR PRINTING

The A-B rolls should be submitted to the lab on cores, inside a protective plastic bag, and placed in a can or box. A precise cue sheet and the finished work print should be included. The lab will again require the same information as listed at the beginning of this chapter.

Answer Printing

The first print made from the finished A-B rolls is called the *answer print* or *first trial* print. It is like a regular projection print, except that its

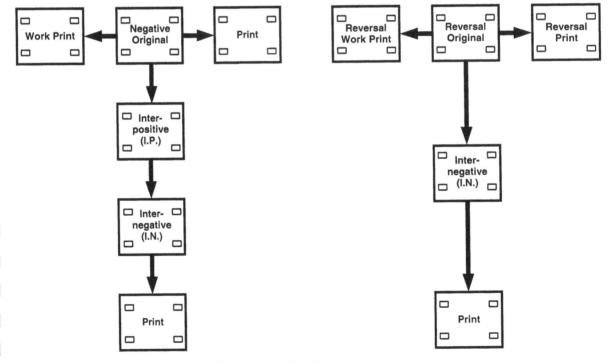

7.26 Flow chart of 16mm prints from 16mm camera originals.

POSTPRODUCTION

primary purpose is to look for errors and get the colors and exposures corrected before running off the release prints destined for theaters and wherever else. The first answer print is usually silent; the second one will be a *composite* (*"married"*) *print*—that is, one with a sound track.

The first answer print is more expensive than later release prints, because all the effects, timing, and color corrections must be set up for the first time. At the lab the timer views the conformed original on a video analyzer called a *hazeltine* to evaluate the color balance and density (brightness), noting color and density corrections that need to be made for each shot.

A few labs will make a proof print before the first answer print. This is a technique where one key frame from each cut is printed onto a roll and presented to you as a slide show. It is one method of getting closer to the correct set of printer lights even before the first answer print. When describing the printing of the film dailies, we already looked at the printer with its fifty levels of printing lights. Printer lights increase in intensity as their numbers increase. However, because we are talking about making a positive print, the greater the intensity of the light we shine through the negative onto the print stock, the darker it gets. Therefore, an underexposed, thinner (more transparent) negative allows more light to pass through and will thus require lower number lights, although this is referred to as "printing up." On the other hand, an overexposed, dense negative requires higher lights, and this is called "printing down."

"Printing up" means printing lighter; "printing down" means printing darker.

Remember, negative emulsions will offer greater latitude for timing corrections than reversal films, but even a negative cannot be saved if an exposure error exceeds the emulsion-printer combination range. The color and density (brightness) modifications, along with the fades, dissolves, and supers, will all be programmed onto tapes that will control the printer while the print is made.

When the first answer print is ready, it is projected at the lab with the filmmakers and the timer present. Some corrections are usually necessary. The timer notes the point on the displayed footage counter where the correction is needed and another print is then ordered. This could be repeated as many times as necessary, although usually after the second or third answer print any changes are usually confined to just one or two of the reels. Most people do not go beyond three answer prints. If the print is unsatisfactory because of mistakes or oversights made by the lab, then the customer can usually insist on and get a replacement print, free of charge.

When submitting your A-B rolls to the lab, be sure to specify what kind of print stock you want. Most labs will have a default stock if one is not indicated on the work order (such as Kodak Vision 2383). Most answer prints are color-balanced for xenon-lamp projection. However, smaller 16mm projectors use tungsten lamps, so you should order your print balanced for that if necessary. But generally, it is usually better to get a print balanced for xenon projection and let it look a little warm with tungsten projection than the other way around.

Master and Dupes

Having at last obtained a satisfactory print, we are now ready for release printing. If only a few prints are desired, they can be made directly from the A-B rolls. However, for more than, say, ten prints, it is normal practice to make them off a duplicate negative, or *dupe negative* for short. It is also called *internegative* (*IN*). This protects the precious original from being worn out and

damaged. If large numbers of prints are needed, it is actually *cheaper* to print them from a dupe negative because it is a single-strand element (not on separate A-B rolls) that can be printed at one light.

If the originals are negative to begin with, an *interpositive* (*IP*) will first have to be made. Then the internegative is printed from the interpositive. If the originals are reversal, an internegative can be made right from the A-B rolls; however, you would need to use an optical printer to accomplish this in order to have the emulsion on the dupe negative end up on the "correct" side for printing.

In other words, since camera original is almost always B-wind, any positive like a print will end up A-wind when contact printed (emulsion to emulsion). Any duplicate negatives need to be B-wind just like the original. If you try making an internegative off a reversal original using a contact printer, it will end up A-wind, which is incorrect (see figure 7.27).

As mentioned before, the IP or IN will also serve as a protection master of the original for long-term archiving. The IP is also a good lowcontrast film element for making a final transfer to video. However, if you have no plans on making an IP, you will probably need to make a print onto a special low-contrast stock (Kodak Vision Teleprint film 2395) for your final video transfer.

One question that students often ask is why they can't just transfer their cut original to video instead of making a low-contrast duplicate. The reason is that because the original has been "checkerboarded" onto A-B rolls, you'd have to do an extensive video editing session to cut the shots transferred to video from the A-roll with the shots transferred separately from the B-roll. Plus, there is always a danger in running spliced material through a telecine,

Construction of the second of the second	1st Generation B-wind	2nd Generation A-wind		3rd Generation B-wind		4th Generation A-wind	
	Reversal A-B rolls	Answer Print Release Prints (Reversal Print Stock)					
	Negative A-B rolls	Answer Print Release Prints Inter- positive (I.P.)		Inter- negative (I.N.)		Release Prints	
	1st Generation B-wind		Gene	nd ration /ind	3nd Generation A-wind		
	Reversal A-B rolls		nega (I. (opti	ter- ative N.) <i>cally-</i> ated)	Release Prints		

7.27 When contact printing multiple generations, emulsion to emulsion, the "wind" alternates between B-wind (negatives) and A-wind (positives). Since a reversal camera original is B-wind, a reversal print will correctly become A-wind, but any internegative made from it must be done in an optical printer to become B-wind as well.

which stops and starts the film over and over again while you color-correct each shot.

It is the norm to make the internegative on Estar stock; the advantage here is that hundreds of prints can be made off a single dupe negative due to the strength of the polyester base.

Note that with each generation, the contrast

of the image is increased as well as the graininess. With modern lab duplication stocks, this problem has been greatly reduced, but it is still a factor to consider.

CONTACT PRINTING

Most lab work involves *contact printing*. That is, the original and print stock come together, emulsion to emulsion, while the print is made. Because of this, with each succeeding generation the film will alternate its wind and the emulsion will flip to the opposite side of the base for the correct picture orientation.

If for some reason you wish to make a print with the same wind as the material it was printed from (A-wind from A-wind or B-wind from B-wind), it will have to be optically printed instead of contact printed. Optical printing is less common and more expensive than contact printing.

It should be restated that A-wind and B-wind depend only on emulsion position. Do not confuse them with A-B rolls. On B-wind film, the lettering reads correctly when the observer is looking through the base; that is, the emulsion is on the side facing away from the viewer. A-wind, on the other hand, reads correctly when looking at the emulsion side. Whether a film is single- or double-sprocket is irrelevant at this stage.

OPTICAL PRINTING

The most basic function of the *optical printer* involves rephotographing an image onto a new piece of film. It differs from contact printing in that a lens is introduced between the image being photographed and the raw stock. Imagine, if you wish, a camera that is pointed at a projector. Usually the projector side of the optical printer is loaded with a positive image. If the material was shot with reversal stock, then the resulting film can be used directly in the optical printer. But in most cases, the original footage is a negative form.

Therefore, a color-timed interpositive has to be created from the negative. If it is a small amount of material to be duped, a series of *wedge tests* will be shot from the negative in a wide variety of colors and densities. One of these wedges is selected as the desired correction and the negative is then printed onto an interpositive. If there is a large amount of footage to be duped to an interpositive, then the negative will be answer printed to determine the correct set of printer lights needed. The colortimed interpositive is then rephotographed onto an internegative (dupe negative) with the desired printing effect.

The basic optical printer functions are:

- *Fade-outs, fade-ins, lap dissolves, and super-impositions (multiple exposures),* similar in effect to the normal optical transitions performed by the lab during contact printing from A-B rolls. However, the optical printer offers much greater control over the lengths and rates of these effects.
- *Freeze-frame (the action stops and remains on one frame).* The selected frame is arrested in the printer gate and continuously printed onto consecutive frames of the receiving film stock. The problem with this technique is that the grain becomes frozen as well as the motion.
- *Stretch printing /skip printing*. By reprinting each original frame multiple times onto the new film element, the action is slowed down. Of course, by skipping frames of the original as we rephotograph it, we can speed up the action.

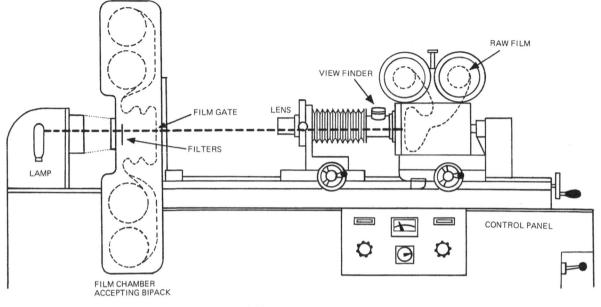

7.28 An optical printer.

- *Film format conversion.* The image on one film format can be rephotographed onto a new film format. This is how a 16mm image is usually blown up to 35mm.
- *Change in composition.* New frame limits can be established within the limits of the old frame—for example, obtaining a close-up from a medium shot. However, the grains in the image will be enlarged.
- *Zoom effect.* A *gradual* change of the frame limits will create a zoom effect that did not exist in the original footage. Again, a change in grain size will result.
- *Printing without changing the emulsion position,* such as obtaining a B-wind print from a B-wind original. This is necessary when making an internegative for printing from a reversal original.
- *Reverse-motion printing.* The original frames are reprinted in the reverse order to create backward motion.

- *Flipping a shot.* The shot is reversed left to right to become a mirror image. This is sometimes done to fix a shot made in the wrong screen direction.
- *Transition between black-and-white and color.* Gray tones can be introduced into a color picture. If a fine-grain black-and-white positive is made from the color negative, as well as a normal color interpositive, the two positive elements can be superimposed onto a new internegative. The amount of desaturation can be controlled or the image can be made to transition from full color to black-and-white, or vice versa.
- *Optical transitions.* The limitless varieties of optical transitions, such as "wipes," "pushoffs," and many others are too numerous to be described here.
- *Bipacking.* We have already discussed double exposures in which two pieces of film are individually printed one at a time onto

a third. Instead of printing them one at a time, we could instead *bipack* them. That is, we could overlap them and hold them together in the printer gate while they are exposed onto a piece of raw stock. The effect of bipacking is quite different from that of double exposure. When bipacking, the densities (shadow areas) will add up, whereas when double-exposing, the light (clear) areas will add up. The effect of bipacking can be judged by looking at two pieces of film overlapped against the light. Because dark areas will dominate, reversal materials shot especially for bipacking should be as light as possible. Otherwise, the image resulting from the bipack may turn out to be almost black. The opposite is true about film shot for superimposing. In double-exposing ("supering"), the transparent areas add up, and therefore when shooting film for superimposition, the two images should be shot so that light areas do not overlap, washing each other out.

• Matting and compositing. Matting or masking means blocking out a certain area of the frame by bipacking the original film with a piece having a high-contrast silhouette image that blocks out an area in the shape of that silhouette. This blocked-out area can be filled in with another image in the second run. Many optical printer operations depend on this two-part process, which usually involves many additional intermediate steps. Adding multiple picture elements from different pieces of film onto a single piece of film is called *com*positing. For the most part, other than for the simple addition of a black hard matte to the picture, most complex compositing jobs are done using digital technologies these days.

Combining Dupes into the Original

The effects (sometimes called "dupes") generated on the optical printer have various applications. Most often they are incorporated into a film printed on a conventional contact printer.

Optical printer effects to be cut into a conformed film original for printing must end up in the *same* format as the original, whether negative or positive.

Optical Printer Blowups

If you shoot in 16mm (regular 16mm or Super-16), at some point you will probably consider making a blowup to 35mm, a worldwide standard, for projection while 16mm print projection is on the decline. Most blowups from 16mm to 35mm are done using intermediate elements in an optical printer; however, more of this work will be done digitally as the costs come down (see the next section).

For the sake of simplicity, let's assume that you shot in 16mm using color negative. You have basically three options for an optical printer blowup:

- 16mm A-B neg \rightarrow 35mm print
- 16mm A-B neg → 35mm IP → 35mm IN → 35mm print
- 16mm A-B neg → 16mm IP → 35mm IN → 35mm print

In all three examples, the step between the 16mm and 35mm generation requires the optical printer; the other steps use a contact printer.

Very few labs have the ability to blow up directly from 16mm A-B negative rolls to a 35mm IP or print. If they do, they will require that your negative be *zero cut*, meaning that there are a couple of extra frames at the head

CINEMATOGRAPHY

and tail of *every* cut. This means that you would have had to edit the movie with these "frame handles" in mind. It also means that the original A-B rolls are being used in the optical printer and the image is being color-timed in the same step as the blowup. However, this method does produce better results, because you are getting the image into the 35mm format at the earliest possible duplicating stage. And the highest quality of all is obtained if you go directly from the 16mm negative to a 35mm print.

However, this is only affordable for one print, maybe two; any more than that and it becomes cheaper to make intermediate dupes and use those for printing. It is also a bit risky to use the optical printer to go directly from your originals to a print, so it is still recommended that you make a protection copy first, just in case the original is damaged.

Most labs can only blow up from a singlestrand element, so you will have to make colortimed 16mm interpositive from your 16mm A-B roll negative. This will be used in the optical printer to make a blowup to a 35mm internegative.

DIGITAL INTERMEDIATE TECHNOLOGY

A recent development in filmmaking, *digital intermediate* (*DI*) basically describes a technique of shooting on film, scanning the film into a digital format for various reasons, and "recording" the final digital master back to film for printing. So you begin and end on film with an intermediate stage that is digital. Initially, this technology was reserved for when it was needed the most, when the shot required extensive computer manipulation, often to composite various elements (including computer animation) together for visual effects shots. Chroma key composites, being much easier to accomplish digitally, were one of the first types of effects moved from the realm of optical printing. Eventually, as costs dropped and the process became more streamlined, more common optical effects could be done digitally instead—for example, putting titles over picture, and resizing and reframing the image.

Finally, some filmmakers started using digital intermediate technology for changing the colors in a shot, giving them access to far more powerful color-correction tools than available with simple three-color printing. With standard printing, you could simply make a shot redder or bluer, for example, or brighter or darker. However, with digital color-correction, you could change the contrast and black levels of a shot, you could do midshot corrections, you could manipulate the colors of some areas of the frame but not others. At first, only select scenes received the digital intermediate treatment, but after a while entire films were being color-corrected this way.

One big advantage with using a digital intermediate technique instead of working with dupes in an optical printer is that it is possible to record the digitally altered shot back to film with the *same* grain structure and contrast of the original film element.

For this reason, digital intermediate technology may prove to be a real boon to the 16mm market, since blowups to 35mm can be accomplished with better results. It also solves the age-old problem of incorporating optical printer effect shots into the finished 16mm film and then blowing this up to 35mm.

For example, let's say that you created a freeze-frame effect using an optical printer. The original piece of 16mm negative that was used for the freeze-frame effect had to be duped to a 16mm interpositive. This was duped again to a 16mm internegative using an optical printer to

repeat the same frame off the IP many times to "freeze" the action on the new negative. This dupe negative containing the completed effect is now treated like original negative and incorporated into your 16mm A-B rolls when you conform the project. From these A-B rolls you create a 16mm interpositive, and this gets blown up in an optical printer to a 35mm internegative. From this, a 35mm print is made.

From this long description, you can see how many generations that piece of film used for the freeze-frame effect went through: 16mm neg \rightarrow 16mm IP \rightarrow 16mm IN \rightarrow 16mm IP \rightarrow 35mm IN \rightarrow 35mm print. And most of those generations were in the 16mm format.

To minimize the loss of quality, some people will do these optical effects in 35mm and cut the results into the 35mm blowup internegative (see figure 7.29).

All of this is to say that doing the work digitally is *much* simpler. With digital technology, effects like traveling matte composites, titles over picture, fades, dissolves, freeze frames, step printing, and stretch printing can be done in the computer and incorporated into the film at the *same* quality level as the surrounding original footage.

The basic steps are:

- *Scanning.* The original film is scanned into a digital format. If the rolls are uncut, the EDL can be used to find the sections used in editing and transfer just those parts.
- *Digital conforming.* The digital files are conformed to match the EDL from your nonlinear editing, creating a digital master.
- *Color-correction*. Similar to the process of color-correcting a video transfer.
- *Dust removal.* The color-corrected master is checked for scratches and dust specks; these are then digitally painted out.

- *Recording*. The digital master is transferred to film, usually to a 35mm internegative.
- *Down conversions.* The digital master is converted to other video formats for duplication (HDTV, NTSC, PAL, etc.).

In theory, any digital format can be used as an intermediate step—for example, if you transfer your 16mm footage to consumer DV tape and then have your video recorded back to film, that would qualify as a digital intermediate.

However, the point of using a digital intermediate is to retain as much of the quality of the original film as possible throughout the process. Therefore, standard-definition video is not considered acceptable as a digital intermediate format. It lacks the resolution and color depth of 16mm or 35mm film, and you would therefore be throwing away a lot of information by using it as an intermediate step.

A minimum scanning resolution of 4,000 pixels horizontally (the number of pixels vertically depends on the aspect ratio) is considered necessary to capture all the information on a 35mm motion picture frame. This is referred to as a "4K" resolution in the industry. However, a half-resolution scan of 2,000 pixels across ("2K") is considered adequate for a number of practical purposes; 2K scans are faster and more affordable, although that will change as technology keeps improving. At this time, the majority of digital intermediate work has been done at 2K resolution. While this is somewhat a compromise for the 35mm frame, it is completely adequate for the 16mm frame.

When Thomson Spirit DataCine was introduced a number of years ago, it was unique in offering the ability to transfer film into both a high-definition video format and a 2K "data file" format, greatly reducing the costs and increasing the speed of digitizing large amounts of footage. While there have been newer 35mm

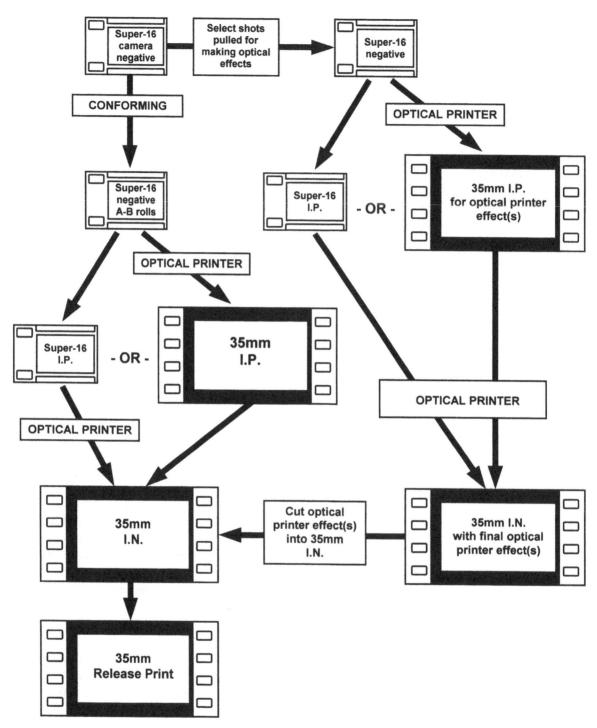

7.29 Flow chart showing Super-16 negative blowup to 35mm using an optical printer, including addition of separate optical printer effects into the 35mm internegative stage. These optical printer effects would include titles over picture, freeze-frames, step printing, etc.

film scanners released to the market since then, the Spirit remains popular for scanning 16mm projects into a 2K format for digital intermediate work.

A few 16mm projects have used 24P highdefinition video (24P/HD) instead of 2K data as an intermediate format. The Brazilian film *City of God* did this. 24P HD is a slightly cheaper format; the resolution is similar to 2K data, but since the color space is "subsampled" and the video signal is compressed for recording to tape, you won't have as much flexibility in color-correcting the image without picking up digital artifacts. Some people feel that using high-definition video instead of 2K data as an intermediate step adds a slight "video look" to the final film image. Of course, using 24P HD is preferable to using any standard-definition, interlaced-scan video format as an intermediate step.

There are a number of film recorders used for the final transfer to 35mm, but the two most common types are *CRT recorders* and *laser recorders*. CRT recorders generally are not bright enough to record to intermediate stock and use a finegrained camera negative film like Kodak EXR 50D or Fuji F-64D. Laser recorders (the Arrilaser being the most common on the market) usually go to lab intermediate stock and thus can record either an interpositive or internegative. CRT transfers can look slightly softer and more grainy than laser recorder transfers.

Don't be surprised at the sticker shock when you make inquiries about doing a digital intermediate at various facilities. Also, the prices can vary quite a bit depending on how much time they recommend for colorcorrection and dust removal. To be fair, you should be comparing these costs to: (1) the normal costs of optically blowing up a 16mm project to 35mm through dupes; and (2) the costs of mastering the project to HDTV for home video deliverables.

Digitally Composited Effects

As mentioned before, a composite effect is when multiple film elements are combined into one image. The most common example is a *traveling matte* composite, where you place a moving subject, like an actor, against a new background shot on another piece of film. The actor has to be separated from the original background behind him so that a new background can be inserted.

In the past when this work was done using an optical printer, the actor was shot against a blue screen and multiple film elements were made from that original negative using various filters and film stocks. These were all necessary for pasting the subject over the new background with none of the "ghosting" that would result in a simple double exposure of the two elements.

All of this work is now much easier using digital technology to create a "key" that allows the background behind an object to be replaced by another background.

There are two types of keys. The simplest to understand is a *luminance key*. Everything in the image above (or below) a certain brightness level can be separated ("keyed out") and removed; that area can then be filled in by another image. Imagine a black silhouette against a white background. That background can be used to create a key around the object, allowing the white background to be replaced while leaving the subject unaffected.

Unfortunately, luminance keys are fine for graphic shapes like black-and-white lettering, but they don't work as well for keying people, since they will also have bright areas that are similar in luminance (brightness) to a white background. The same goes for using a black background; somewhere in the foreground subject will be a black area that is the same luminance as the black background.

CINEMATOGRAPHY

Therefore, *chroma keys* are used instead. In this case, the subject is placed against a background of a solid primary color that does not exist on the subject itself. Then the compositing software can isolate that area of color and allow a different background to be added around the subject. Usually blue or green screens are used for the background, since human flesh tone has very little of those two primary colors compared to red, the third primary color.

Digital Projection

Since the cost of recording your digital master to 35mm is quite high, more and more film festivals are offering decent-quality digital projection using high-definition masters as sources. You will need to contact the film festival to see what specific format they need the project delivered on. You can even find some screening rooms to rent in the major cities equipped with high-definition digital projectors. Currently, the high-end systems are using DLP Cinema technology, made by Texas Instruments, built into lamp houses made by companies like Barco and Christie.

When talking to a film festival, find out the details of the type of projection system being used. You may find out that what they are calling a "digital projector" is just a poor-quality standard-definition video projector.

PRINT DAMAGE

Some labs offer services designed to conceal scratches. When "wet gate" prints are made, both films are submerged in a liquid during the exposure. The liquid fills in scratches in the base so that the light is not refracted and the scratches are less visible. This will only diminish scratches in the base. There is no way to repair deep scratches in the emulsion. If old or damaged footage is to be given to the lab for printing, the lab should be notified that it may be in poor condition. There are many precautions that can be taken to ensure its gentle treatment. For example, it can be "waxed" so that it will move more easily through the projector gate. If the footage is to be printed, the lab might advise the technician to run the printer somewhat slower than normal and to be especially alert, ready to stop the printer should a break occur.

Torn sprocket holes can be repaired with many techniques. One method that seems to work well is to use sprocketed tape over only the area of the torn sprockets. The picture area is left as clear as possible. If the tape is applied so that the *right* side of the tape fits over the sprocket holes on the *left* side of the film, the ex-

7.30 Film with torn sprocket holes.

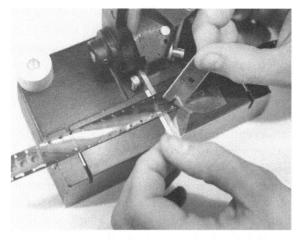

7.31 Repairing torn sprocket holes. Perforated splicing tape is applied to both sides of the sprocket-hole area, without overlapping into the picture. The excess tape is then trimmed away with a razor blade.

cess tape can be trimmed away with a razor blade, leaving the sprockets reinforced. The overlap into the picture area is minimal. Special film-repair tapes and tools are also available.

Some laboratories specialize in salvaging damaged prints. Consult a reputable lab for their recommendations.

WHY SHOOT FILM?

This is a question that comes up more and more these days, especially from beginners who are daunted by the costs of shooting even in 16mm, let alone 35mm. Most people vaguely understand why a typical video camera might not produce images of sufficient quality for presentation on a giant theatrical screen, but what about smaller projects destined for film festivals, cable television, and home video? Let's look at television, an industry you might assume hardly uses any film these days.

What we discover is that most dramatic television programs are *still* being originated on film.

The introduction of 24 fps progressive-scan high-definition (24P HD) video cameras was a big step in digital moviemaking toward the traditional look of film shot at 24 fps. Resolution finally became comparable to film and motion rendition was similar. Television sitcoms, having switched from shooting on regular interlaced-scan video to 35mm in order to be prepared for a transition to HDTV broadcasting, then switched again to video origination, but now they are using 24P HD video cameras. It made sense in a number of ways.

But some dramatic narrative TV shows, trying to reduce costs, switched from shooting in 35mm to shooting in Super-16, rather than use 24P HD video technology. Why? Simply put, Super-16 is a film format and therefore *always* looks like film, while 24P HD looks like some sort of hybrid between video and film. And the producers of these television dramas want their product to have a classic "film look," not a "pseudofilm look."

Resolution and motion rendition are only two elements of the look of film. There are many other equally important factors. Other important elements are better rendition of bright highlights, greater overall exposure range, and better color depth. There is also a natural lack of various digital artifacts, often due to signal compression and artificial image sharpening.

And while current high-definition video has a resolution similar to Super-16, 35mm color negative has even *more* resolution; this can even be seen when 35mm is transferred to HDTV and compared to something shot in HD video.

However, the high-definition image is *perceived* as having more resolution than Super-16 even in a transfer to 35mm for projection. One theory is that we have traditionally used grain size as a visual clue to tell us how much an im-

age has been enlarged; the lack of film grain in the 24P HD image fools the viewer into thinking that the originating format must be closer to 35mm in terms of resolution.

The 35mm format also has a more selective (i.e., generally more shallow) depth of field. Critics of material shot on video cameras point to the excessively deep-focus look, which doesn't allow for directing the viewer's attention to important areas by selective focusing. This is a particularly acute problem with consumer video cameras with small *CCDs*. The %-inch CCD in a professional video camera is slightly smaller than a Super-16 frame, and therefore depth-of-field characteristics are similar. However, there continues to be a push among filmmakers for video camera manufacturers to come up with a 35mm-size CCD.

Standard-definition video cameras try to get around their lack of resolution by using a process called *edge enhancement* to artificially sharpen the image. Special circuits produce a fine white or black line along the transition between sharply defined areas. This is a particularly ugly artifact when the video image is transferred to film and projected on a large screen. High-definition video cameras have just enough resolution to get away with turning off the sharpening circuitry for material to be transferred to film, creating a more pleasing look.

Another advantage of shooting on film has to do with the universal acceptance of film standards. Video technology changes constantly, so mastering on film allows you to have a highquality original that can be transferred to any emerging digital format that comes along. Television shows shot on 35mm film in the 1950s and 1960s now allow for beautiful transfers to video for TV broadcasting and release on home video. Imagine if they had used the video camera technology of their day instead.

Film also has a well-documented archival quality, and if stored in proper conditions, it can last a century, if not more. Even today, the original negative of The Great Train Robbery (1903) exists in excellent condition at the Library of Congress and prints can still be made from it. Most of the films lost over time were due to improper storage conditions and a lack of care in general. Digital camera technology continues to improve at a rapid pace and already has taken a share of the marketplace originally reserved for film technology. However, the cutting edge of high-quality digital imaging systems, starting to rival the quality of the 35mm film image, are years away from being as practical, affordable, and flexible as film. And as long as 35mm continues to be the industry standard, 16mm will continue to be a popular alternative to 35mm for people who want to shoot film but can't afford 35mm.

However, we live in a time of transition when the film and digital worlds are hopelessly intertwined. All movies shot on film, at some point, will end up in a digital form. Any digitally shot project that wants to be seen theatrically, worldwide, has to be transferred to film. The safest thing for any beginning filmmaker is to keep up with both technologies, film and digital, and use them appropriately as tools to achieve an artistic vision.

8 SPECIAL SHOOTING TECHNIQUES

This chapter covers a wide variety of reoccurring challenges that face a film production.

FILMING TV AND COMPUTER SCREENS

A lot of problems when filming TV and computer screens are based on the different frame rates involved. The standard for film projection is 24 fps. In countries like the United States that use the NTSC system for television broadcast, the frame rate is 30 fps (actually 29.97 fps). Each video frame is made up of two fields; thus every ½ second, a new field is being displayed on the TV monitor.

When the camera's shutter is not in sync with the NTSC monitor, thick, dark horizontal bands will appear and drift across the screen. These are called *roll bars*. You need a *film-video sync box* with a *phase control* to get rid of them.

With these devices to adjust the camera, if you shoot at 29.97 fps with a 180° shutter on your camera, you will have no roll bars in the image. However, when the resulting footage is projected at 24 fps, the image on the TV display will appear to be somewhat in slow motion.

If you shoot at 24 fps with a 144° shutter, your shutter angle will reduce the size of the roll bars to very thin lines. Since no sync box is required, this can be the simplest solution if the TV set is in the background, where some thin rolling lines won't be too distracting. With this shutter angle, if you then use the sync box to set your camera to 23.976 fps, you can stop the thin roll bars from moving. With the phase control, you can place them in the frame where you want. Generally your choices are either two lines, one at the top third and one at the bottom third of the display, or only one line right across the center. The *CE Signal Pick-Up* device can also be used to lock your camera to the monitor's frame rate.

There are also companies that specialize in "24-frame video playback." They bring in their own TV monitors that run at 23.976 fps, connected to their own special decks. Any source tapes you need to play on the TV are converted to 23.976 fps in advance by the company. Using the sync box, you can then run your camera at 23.976 fps with a 180° shutter and not get any roll bars.

When shooting in countries that use the 25 fps PAL system, the solution is a lot easier: you just shoot at 25 fps. When you project later at 24 fps, there is a slight slowdown.

Computer CRT monitors are a lot more problematic because they run at a variety of frame rates. Shooting them at 24 fps without getting display artifacts is very difficult. The most popular solution is to avoid the problem altogether by using an LCD screen. Their "active matrix" technology means that the image on display is more or less continuous. Otherwise, you will need to match your camera's frame rate to the refresh rate of the computer monitor. You can use the CE Signal Pick-Up or use an *optical frequency meter* to measure the monitor's frame rate. TV sets and computer monitors have a color temperature near daylight or higher and therefore will render very blue on tungsten-balanced film stock. If you are just filming the display only, you can use daylight-balanced stock or the #85B correction filter. If the TV is seen in a tungsten-lit room, you may have to either carefully (and invisibly) gel the TV monitor or shoot the material that will be displayed on it with a strong orange cast to bring the color temperature down to 3,200°K.

DAY-FOR-NIGHT

This technique of shooting a night scene in daylight "playing" for moonlight has become less popular and less necessary since the introduction of high-speed film stocks. However, it still has a use, especially when you're faced with shooting a large landscape that cannot be lit with a single lighting unit to simulate moonlight and there are no artificial "practical" light sources allowed by the story.

The main objective is to create the preponderance of dark areas in the frame. The shadows can be increased by staging the scene so that the sun comes either as a backlight or a three-quarter cross light.

The morning or the late afternoon on a clear day is the best time to shoot day-for-night, because the low angle of the sun creates longer shadows. A strong key light may be needed to balance the sunny backlight. HMI lights are a likely choice, but shiny boards (silver reflectors) can at times be very effective. The powerful amount of sunlight reflected on the foreground allows the cinematographer to underexpose the background and still have the area of action at a desirable level of illumination. However, you don't want to achieve underexposure by stopping down the lens, as this would give more depth of field, undesirable for night effect. In real night-for-night photography, you would rarely be shooting with such a high lighting level that you would be stopping down on your lens. So instead of closing down the iris to underexpose, use neutral density filters. It all comes down to having the back- or crosslit foreground against a dark background, and a shallow depth of field. Together, all these elements give the illusion of night.

After the direction of light, next comes the problem of the sky. For all practical purposes it is much better when the sky is not visible in the frame. Therefore, the best results are achieved by elevating the camera or shooting against hills whenever possible. If the sky cannot be avoided, it can be darkened with filters. In black-and-white photography, red filters are used, such as #23A or #25. These darken the sky considerably but also render the faces chalk-white. A combination of a #23A (red) with #56 (green) will correct the flesh tones. Of course, in order for a red filter to darken the sky, the sky must be blue. Wherever smog or an overcast day occurs, a red filter will have no effect.

When shooting color day-for-night, the sky may be darkened with polarizers and/or graduated filters. Polarizers will darken the sky when the sun is 90° from the optical axis. Unfortunately, white clouds or pale whitish sky near the horizon will not be affected. A neutral density graduated filter should be carefully positioned so that the soft border dividing the dense and the clear areas matches the horizon line. For wide-angle shots, an attenuator is even better, as it does not have a dividing zone.

Unfortunately, using these filters limits the movement of the camera. Polarization changes when the optical axis shifts in relation to the sun, and graduated filters allow for panoramic

8.1 Normal daytime exterior shot.

movement only when the horizon line is straight.

Whether or not it is realistic, blue has been a visual symbol for movie moonlight since the Silent Era, when night scenes were tinted blue on the black-and-white prints. To obtain the effect of blue moonlight, many cinematographers use a tungsten-balanced emulsion without the #85B filter. If that seems too blue, the #85B can be replaced by the #81EF, which functions as half the color-correction.

Whether the sky is included in the frame or not, a day-for-night effect requires controlled underexposure. Cinematographers generally agree that the best results are achieved when underexposing two stops for long shots and one and a quarter stops to one and a half stops for close-ups, if more details in faces are desired. ND.60 filter cuts down the light by two stops, so it is convenient to use it without changing the f-stop.

You should generally pay more attention to the overall character of the night than to the clarity of faces. Unless the facial details are very crucial, a shadowed look better conveys the re-

8.2 Day-for-night version. ND filters are used to reduce depth of field and create underexposure. A reflector is used to add more light to the subject's face.

ality of night. While in night-for-night shooting, lighter costumes are preferred; in day-for-night the opposite is true. Bright colors tend to give away the illusion of night.

Digital effects, which are becoming more affordable over time, can be used to great effect to augment day-for-night footage. In wide shots, skies can be further darkened; the moon and/or stars can be added. Existing practical sources can be brightened to a realistic level or added to the shot. For example, in the movie *Cast Away*, a nighttime beach scene was shot day-for-night in order to see the ocean and a distant ship in the background. Digital techniques were used to add a realistic night sky as well as create a bright glow from a flashlight that the actor was waving at a passing ship.

Dusk-for-Night

Another day-for-night technique involves shooting during the "magic hour" of dusk. During this period there is still enough light to see

8.3 Dusk-for-night effect.

the shadowed details and the horizon, yet the windows, neon signs, and other practical sources appear realistically bright. The twilight period is brief and so the actors and crew must be well rehearsed.

Checking the brightness of the sky with the spot meter indicates the light adjustment necessary to keep the relationship between the sky and the foreground illumination (on faces) in constant balance. You should have a good assortment of scrims to cut down lamp intensity as the daylight fades away. On the other hand, if only one master shot of the scene is all that is needed and you intend to do close-ups later on with the help of artificial lights, then every subsequent take of this master does not have to match the previous one. Under these circumstances, as the sky light fades away, more fill is necessary to maintain the required exposure on the actor's face.

In such a situation, start with several scrims on the lamps, and then remove them as it gets darker to keep a constant light level on the faces.

In order to secure a number of takes in this short period, start shooting before perfect dusk. The first take should be shot when the sky reads on the spot meter the same value as the actor's face. In the second take, the sky may be already one stop darker than the face, and in the third take two stops darker. One of these three takes should yield the desired look.

In the dusk-for-night effect the attenuator filter can successfully darken the sky if the camera remains static.

The techniques for obtaining a blue color tone with dusk-for-night footage are the same ones used for day-for-night shooting.

Day-for-Dusk

Another variation on a theme, this approach can be necessary in order to complete all the shots required for a scene set at magic hour, which is too brief to allow more than one or two setups before it is too dark to shoot.

If you are lucky, the daytime weather will be overcast; the soft overhead light is similar in quality to the light at dusk, only much brighter. This means that practical illumination won't expose as brightly. Therefore, wide shots where these lights are visible should be shot in true dusk, and then close-ups where they can be framed out may be accomplished in the daytime, using ND filters to reduce depth of field.

If the weather doesn't cooperate and the sun is shining, you can use large overhead diffusion frames to soften the light on the actors. Try and find a background that is shaded; no direct sunlight should be visible in the shot.

SHOOTING SUNSETS

When exposing for a sunset, we have to make judgments based on the understanding that a reflected light meter is calibrated for medium gray. We do not want the hot sky, and particularly the sun, to be represented as medium gray. We want it hotter, but not to the point that it will lose its color.

Exposure decisions will be based on how prominent the sun ball is in the frame. In wideangle shots where the sky is dominant and the sun is a small object, the exposure will be based more on the sky and clouds. In telephoto shots where the sun ball is very large, the exposure will be based on how hot we want the sun ball to appear. When shooting on color negative, overexposing the sun ball by two stops will also preserve some of the orange hue.

When the sun is small in the frame, the sky density becomes more important. We now want the sky to be hot, but not to the point of blending with the sun. Certainly not more than three stops over medium gray.

Much of sunset exposure decisions will also depend on such atmospheric conditions as clouds and smog. On a smoggy day the large orange sun ball may be only two stops hotter than the sky. If there is a stratum of clouds, the cinematography may be able to decide which part of the sky has medium gray density, measure this area with a spot meter, and expose the sky accordingly. Then the brighter areas will be naturally hotter in relation to the chosen spot.

When there is no smog or clouds and the blazing sun is far from pleasing, we can bring this brightness ratio down with a graduated filter. A two-stop grad (ND.60) with a soft blend in the middle, or an attenuator, will be typical choices. Sometimes an orange-toned graduated filter (Coral, Tobacco, etc.) may be used.

To fill 50 percent of the frame with the sun ball, use a long lens (such as a 300mm lens for 16mm film). There would be no point in using a grad filter on such a long lens. In trying to preserve the sun's color, you may stop down to f/22 and still have to put on a heavy neutral density filter (such as ND.60 or ND.90).

A word of caution here: Gelatin filters positioned behind the lens may occasionally burn up when a long lens is focused on the sun. Also, if the lens is heavily stopped down to preserve the color of the setting sun, any figures in the foreground will be rendered as silhouettes.

A spot meter is an obvious choice for the exact measurement of sunsets, but it is not the only one. After all, cinematographers were exposing sunsets long before the modern spot meters were invented. With an experienced eye and a regular reflected meter, fairly accurate exposures can be achieved. Some camerapeople use their incident meter for this purpose. The rule of thumb is to turn your meter toward the part of the sky away from the sun, and this reading should give you a correct sunset exposure. However, it is recommended that you use a reflected meter if possible.

VEHICLE CINEMATOGRAPHY

We are living in such a mobile society that a good portion of screen time is devoted to scenes taking place inside cars, planes, trains, and other moving vehicles. When you plan such scenes, an important decision is whether to shoot with the vehicle actually moving outdoors or fake the action with a parked car, perhaps on a soundstage in front of a chroma-key screen. Shooting inside a moving car offers more authenticity but can severely limit the lighting, camera angles, and sound quality.

Moving Vehicles

Many creative techniques were developed to achieve the best quality under these circumstances. Unfortunately, the most sophisticated equipment is quite expensive. The top of the line in vehicle-shooting techniques is the *insert car* (also called a "camera car") setup. This is a specially designed vehicle with outrigger brackets to tow the "picture" car alongside or

CINEMATOGRAPHY

8.4 The Shotmaker Classic Camera Car. (Courtesy of Shotmaker Classic Camera Car)

behind it. It is also possible to tow a low flatbed trailer (a process trailer) with the picture car sitting on top. Insert cars have platforms for lights and cameras, and they have a silent crystal-sync generator on board to provide enough power for the larger lights. A trained driver usually comes with the car and has to be paid separately. Also, many cities require that you get a driving permit plus pay at least two traffic officers to guide the rig through traffic. The basic permit allows ITC (intermittent traffic control) but does not allow you to stop or redirect traffic; this requires a different permit and possibly more police. You also have to file a plan that shows the entire route to be driven. When you get on location with the insert car and driver, it's a good idea to check out the route and look for places to turn the car and trailer around. There should be a safety meeting before the whole rig pulls out into traffic. Walkie-talkie communication with all drivers, police, the AD, (assistant director) and actors is necessary.

The advantage of the process trailer is that nothing has to be rigged to the picture car itself, so it can quickly be driven on and off the trailer for shots where it is driving freely or when you have a couple of cars to shoot in one day. Also,

8.5 A hood mount. (Courtesy of James Kwiatkowski)

8.6 A hostess tray. (Courtesy of James Kwiatkowski)

the camera does not have to be attached to the car; you can secure a tripod to the deck of the trailer with a safety chain. There is even room to put a small dolly on the deck and make a tracking shot alongside the car during the take. The disadvantage is that the picture car sits a foot or more higher than normal, which can look odd when other (lower) cars drive past. The whole trailer is also rather large and needs more space to drive down the road and to turn around. It may also be limited in terms of driving speed.

If you don't use a process trailer, the picture car will have to be towed behind the insert car and any lights and cameras rigged to the car itself. A platform can be rigged on the hood (a *hood mount*), or hung off the door (a *hostess tray*). Or a *limpet mount* with suction cups can be attached directly to the hood, door, or any other part of the car body. Safety cables, ratchet straps, and ropes are essential and should be rigorously tested and checked, because filming on a moving vehicle always presents serious hazards to crew safety and equipment. Scraps of rubber matting and duvetine cloth should be used to protect the car from being scratched at the points of contact with the rigging.

Why tow the car at all? It's true that there are many circumstances in which the car will have to be driven freely, untowed, but it should only be done when other methods are not possible. For one thing, it is not a particularly good idea to have an actor try to drive safely while delivering a performance, especially if he or she also has other actors and crew people in the car. There may also be lights shining into the actor's eyes from the hood, obscuring some of the view. And you have to consider that the director, sound person, and cinematographer will all have to fit inside the car and not be seen by the camera.

When lighting inside the car, there is often a tendency to use too much light. In daylight our

main problem is to balance the background, visible outside the car, with the light level of the inside. A neutral density gel, stretched on the windows visible in the frame, will usually take care of this problem if it can be mounted in a way that it won't rattle and ripple in the wind. A white card rigged on the hood or outside the side window may sometimes be sufficient to fill in the interior. It depends, of course, on the weather, the location, and the angle of the sun. Quite often FAY clusters or small HMI lights are mounted on the hood. If you are not using an insert car with a generator, you may have to use batteries or an inverter to power the lights, which is limiting and often unreliable.

A big advantage of using an insert car with sufficient power is that you can use more powerful HMIs through diffusion frames to create a realistic soft light coming through the windows. If the camera is looking through the side window and the front windshield is off camera, it can be covered with tracing paper to allow an extremely soft light.

Reflections of the sky on the windshield can represent a problem. Most people try to just use a polarizer on the camera to reduce the reflections to a less distracting level. You can also build a black awning over the windshield and hood and use lights rigged under this black "tent" on the hood. There is also a more imaginative way to handle it. If the scripted scene allows, choose a road with tree branches stretching over it. Such a location allows for a picturesque play of light and shadow on the front glass and on people inside the car.

Usually the car ceiling is not visible in the frame. It can be covered with white or silver plastic to bring up the general light level. Bouncing light off it from a lamp hidden behind the seat is sometimes done, but this doesn't create a very realistic light direction. Bouncing off a white card positioned on one side would pro-

vide a better angle. Battery-operated small HMI units ("sun guns") are often used as light sources for bouncing. If the car has a sunroof, it can be covered with diffusion gel or tracing paper (tightly to reduce rattling) to create a soft top light.

Night shooting inside the car requires more elaborate lighting schemes. It all depends on where the light source on the faces is supposed to be coming from. The traditional "dashboard light" effect makes more sense when the car is driving down an unlit road. The light shining up under the actor's chin may not be very realistic or attractive unless kept to a low intensity, which means that other lights may still be added to play across the face. It is helpful to soften the dashboard light to keep it from looking too harsh.

Particularly useful for lighting car interiors are incandescent tubes originally developed for display cabinets. These Lumiline lamps come in 12- and 18-inch lengths and are 1 inch in diameter. They come in 40-watt and 60-watt tubes, respectively, and can be run from a 120-volt battery pack. A small rheostat can be used to control their intensity. These lightweight lamps can be attached to visors, or any other place in the car, with tape or Velcro ribbons.

Small light domes used for lighting recreational vehicles can also be used. Small 12-volt bulbs can be plugged (via cable) into the cigarette lighter circuit. Catalogs of such major lamp manufacturers as General Electric and Sylvania, as well as the supply lists of the motor home trade, have information about the availability of various useful bulbs. To run regular 120-volt lamps from a 120-volt battery, inverters made for mobile homes are available. They can usually handle up to 700 watts.

Probably the most popular technique is to use the Kino Flo Mini Flo "car kit" containing two miniature fluorescents that can be powered through the cigarette lighter. Their small ballast units also allow you to dim the lights. The tubes come balanced for either 3,200°K or 5,500°K.

To be able to balance a car interior with the light levels of city streets at night, keep your additional lighting quite low. Use faster film and faster lenses so that street lighting exposes brightly enough in comparison. Use more backcross lighting than frontal lighting to create separation and mood. Remember: car scenes at night that are overlit stick out like a sore thumb.

Faking a Moving Vehicle

A process shot usually refers to the use of a rearscreen projection rig behind a parked car to simulate motion, but the term can apply to the use of a chroma key screen (green or blue) to create a composite effect in postproduction. Rear projection has become less and less common over the years as digital compositing using a chroma key has become cheaper and betterlooking. Rear projection requires that the background plates be shot, color-timed, and printed before the car scene can be photographed. Special projection equipment is rented and enough stage space is required so that there is sufficient distance between the back of the screen and the projector. A cheaper variation used for some night driving scenes involves using rearprojected video; the poorer resolution and the visible TV scan lines can be hidden by keeping the projected background out of focus.

The least expensive of all is the *poor-man's process*. In this case, the background is black and the shots are framed fairly tight.

You can simulate moonlight, car headlights, or streetlamps moving past or over the car. A small lamp like a Tweenie can be swung handheld, creating moving shadows inside the car. Lights can be panned across the car, or panned across a bounce card for a softer effect. You can also use dimmers to bring the lighting up or down.

These moving shadow patterns help sell the feeling of driving. The process tends to be more believable if the setting is dark, like a moonlit country road, versus a well-lit city street. When looking through the front windshield at the actor, some depth can be created by placing two small lights side by side in the far background to suggest a distant car on the same road.

Rain falling onto the car windows, obscuring some of the background, can do a lot to reduce some of the fake quality of rear projection and poor-man's process shots. Remember, in order for rain to show up on film it must be backlit. A wind machine can help blow the water onto the windshield and the windows.

UNDERWATER CINEMATOGRAPHY

The underwater cinematographer must be an experienced diver, and so must the entire film crew. When using actors or when filming under hazardous conditions, a safety diver should also be employed.

Underwater, the cameraperson is faced with a different optical medium than above the surface. Water absorbs and diffuses the light. The intensity of sunlight decreases as it travels farther through the water. It penetrates deepest when it comes from straight above, because the more acute the angle of penetration, the greater the effective distance the light must travel, and so the light level falls off rapidly. Therefore, the best shooting time is the four to six hours in midday.

Locations must be chosen that provide shallow areas, clear water, and a high sun. Generally, uncloudy weather is also a must.

Artificial light is used as a last resort. It looks unrealistic. In addition, it fades away rap-

idly as it travels farther from the source, making it impossible to light large areas evenly. In some cases, where the actors have practical lights, you can logically justify uneven lighting.

Underwater lighting should be done from the sides, because frontal lighting is reflected back into the camera, creating a foggy effect. This "back scatter" is similar to what happens when you try to use your high beams while driving in a thick fog.

Power problems also add to the argument against using artificial lights underwater. Battery-powered underwater lights are hopeless, as they run down after a very short period. A small DC generator on the boat, with cables running to the lights, is a clumsy answer. The best solution is to avoid underwater lights whenever possible and try to depend exclusively on the sun.

If lights have to be used, they must have a closed reflector, a piece of glass that keeps the water away from the bulb and reflector.

Measuring light levels underwater is difficult. There are differences of opinion as to the best measuring techniques. Incident readings do not account for the light that is lost on its way from the subject to the camera. (The light is absorbed by the water.) Reflected readings, taken from the camera position, are perhaps better in this respect, but they are easily influenced by bright bottoms or dark backgrounds, common factors in underwater photography. The best tool is probably a narrow-angle reflective light meter, such as the Sekonic L-164 Marine II, which features a comparatively narrow acceptance angle and has a waterproof case. There is also a digital underwater meter made by Ikelite. Ordinary light meters can be used if a waterproof housing is provided.

Another important consideration is color. Underwater, the daylight color changes with increased depth, gradually becoming bluish-

green. At ten feet there are no reds. By about thirty feet orange vanishes, and sixty feet down there is nothing left but green with a bit of blue.

You can use daylight-balanced stock or tungsten-balanced shot with the #85B filter. Since the light levels become quite low underwater, higher-speed stocks are the norm. To counteract these color deficiencies, additional warming filters may be used to improve skin tones. For example, red and magenta CC filters of various strengths can be useful, depending on the depth. When filming at fifteen feet, CC40R (red) is sufficient for *partial* correction. Partial correction will leave it more realistic; full correction may remove the underwater appearance. Aquacolor is another color-correction filtering system that is very effective for obtaining more natural color rendition underwater.

In black-and-white, the concern is the contrast range. The water scatters and diffuses the light, thus decreasing contrast with added depth. A yellow or orange filter will improve the contrast.

The camera lens in an underwater housing usually has either a flat port or a dome port in front of it. The *flat port* is a simple glass window that the lens looks through. It does not correct for *refraction*, the effect of light passing through two mediums of optical density (the water and then the air in front of the lens), which causes magnification. Therefore, distances appear onequarter closer underwater. An object forty feet away appears to be thirty. This effect applies to both the eye and the lens. Therefore, if we guess the distance to the subject, estimating by eye that it is thirty feet, and we set the focus accordingly, it will be in focus. However, if we focus by measuring the distance and use the marks on the lens, we will be off. Reflex focusing can be an accurate method, but it is physically difficult to get your eye very close to the eyepiece because of the underwater camera housing and the face mask.

A *dome port* uses a lens instead of flat glass to reduce refraction and other optical distortions underwater. The camera lens actually focuses on a "virtual image" created by the dome port a few inches in front of the lens; a closerfocusing lens is therefore needed. Distance marks on the lens have to be recalibrated while underwater.

Wide-angle lenses are most commonly used underwater, especially if a flat port is used. This allows the cameraperson to come closer to the subject. There is less water between the subject and camera and the picture is therefore clearer.

Underwater cameras can be either selfcontained or housed. A popular 16mm selfhoused underwater camera is the Teledyne DBM 9-1 with a 200-foot magazine and speeds ranging from 16 to 48 fps.

Housings have been designed by companies like Hydroflex, Inc. for many popular cameras. They can be rented or bought from

8.7 The Teledyne DBM 9-1 self-housed underwater camera with a 400-foot magazine and speeds ranging from 16 to 48 fps. *(Courtesy of Teledyne Camera Systems)*

dealers. Some underwater cinematographers build their own.

It is important in these situations to maintain the watertight integrity of the housing. After the housing has been opened for reloading or changing a lens, it must be carefully resealed.

Humidity can be a major concern, which may cause fungus growth or emulsion softening. After shooting, the outside of the housing should be rinsed off with *fresh* water; the camera should then be taken out of the housing (or opened, in the case of self-housed cameras) and allowed to air. During shooting, a humidityabsorbing substance is sometimes placed inside the housing as an added precaution.

The most important consideration in selecting an underwater camera is its maneuverability, which depends on the unit's buoyancy. If buoyancy can be adjusted, it gives the operator many advantages. An operator's buoyancy can be adjusted with the amount of air in his or her inflatable vest and with the weighted belt. Maneuvering underwater is the opposite to maneuvering on dry land in one respect: moving shots are smooth and the cameraperson can glide in any direction, but steady shots are difficult because of water movement. One solution is to increase the weight of the camera. In other cases a weighted tripod may be necessary.

Remember that everything is more difficult underwater. Communication is limited to hand signals and buzzers. There are many cumbersome problems and delays, such as air running out or crew members or actors getting cold. Therefore, when planning underwater work, allow extra time. Much time can be saved if the locations are all in shallow water, no deeper than thirty feet. Factors favoring shallow water include expediency of shooting, more light, better color and contrast, comfort (warmer water and less pressure), and less danger, especially if you are using actors who are not experienced divers.

For more detailed information, read the article on underwater cinematography by Pete Romano in the *American Cinematographer Manual*.

9 Production

Unfortunately, film is a very expensive medium, and therefore the scope of any film project must depend heavily on the amount of available money. There are various ways of financing a film. You can start with an idea and shape it to the limits of your funds, or search for sufficient backing to accommodate your concept. Sometimes, with limited funds, it is better to complete a small part of the total project and use it in the search for additional money. In situations where small budgets are allocated annually (such as in some film schools), it is possible to produce one or two small films each year, for a few years, planning them so that later they can all be edited together to make a feature.

On the other hand, there is a good argument for making a feature project in a concentrated period of a few weeks. You can get better deals on equipment rentals that way and it's easier to bring a cast and crew together *once* rather than over and over again on scattered weekends stretching throughout the year. In particular, it can be hard to keep bringing back the same actors over a long period and keep them from wanting to cut their hair or grow a beard, or in some other way change their appearance.

Budgeting

Whatever way a film is financed, it must be thoroughly budgeted if you expect to finish what you started. Otherwise, unforeseen and wasted expenditures may leave the production out of money before it is completed.

The following is a broad and rather general list of expenses to be reckoned with in filmmaking. The list is long and includes some expenses that will not always be encountered. Small productions could start with this list and scale it down to meet their needs.

- 1. Story
 - a. Rights to the original material
 - b. Screenwriter(s)
 - c. Photocopying
- 2. Producer and personal assistant(s)
- 3. Production department
 - a. Line producer
 - b. Unit production manager
 - c. Location manager
 - d. Accountant
 - e. Assistants
- 4. Director and personal assistant(s)
- 5. AD department
 - a. Assistant director
 - b. Second assistant
 - c. Second second assistant
 - d. Key set PA
 - e. Set PAs
- 6. Cast
 - a. Featured players
 - b. Day players
 - c. Extras and stand-ins

- d. Other costs, including a nurse or teacher for juvenile actors
- 7. Camera crew
 - a. Director of photography
 - b. Camera operator
 - c. First assistant cameraperson
 - d. Second assistant cameraperson
 - e. Loader
- f. Still photographer
- 8. Grip department
 - a. Key grip
 - b. Best boy grip
 - c. Grips
- 9. Electrical department
 - a. Gaffer
 - b. Best boy electric
 - c. Electricians
- 10. Sound department
 - a. Production mixer
 - b. Boom operator
 - c. Cable person
- 11. Script supervisor
- 12. Art department
 - a. Production designer
 - b. Art directors
 - c. Set decorators
 - d. Coordinators
 - e. On-set dressers
 - f. Construction crew
 - g. Swing crew
 - h. Strike crew
- 13. Property department
 - a. Prop master
 - b. Assistants
 - c. Prop makers
- 14. Wardrobe department
 - a. Costume designer
 - b. Costumers
- 15. Makeup and hair departments
 - a. Key makeup
 - b. Key hair
 - c. Assistants

- 16. Stunts
 - a. Stunt coordinator
 - b. Stunt people
- 17. Transportation department
 - a. Transportation captain
 - b. Drivers
- 18. Trucks and trailers rental
- 19. Animal(s) and handler(s)
- 20. On-set special effects
- 21. Equipment rentals
 - a. Camera equipment
 - b. Sound equipment
 - c. Lighting equipment
 - d. Grip equipment
 - e. Generators
 - f. Art department
 - g. Property department
 - h. Special effects
- 22. Expendables (tape, rope, gels, etc.)
- 23. Makeup and hair supplies
- 24. Wardrobe rental and cleaning
- 25. Set construction costs
- 26. Soundstage rental
- 27. Feeding the cast and crew
 - a. Caterer(s)
 - b. Craft service person
 - c. Food supplies
 - d. Equipment rental (tables, tents, etc.)
- 28. Preproduction tests
- 29. Losses and damage ("L&D") of borrowed or rented materials
- 30. Location
 - a. Costs
 - b. Rentals
- 31. Accommodations
- 32. Location scouting and advance arrangements
- 33. Miscellaneous costs
 - a. Dealing with electrical supply
 - b. Local permits
 - c. Police
 - d. Fire department personnel
 - e. Fuel (for generator, trucks, etc.)

- 34. Tape stock for sound
- 35. Editorial
 - a. Editor
 - b. Assistant(s)
 - c. Equipment and room rental
 - d. Supplies
- 36. Film costs
 - a. Raw stock
 - b. Development
 - c. Transfer to video for dailies
 - d. Work printing
 - e. Negative cutting
 - f. Answer printing
 - g. Masters and dupes
 - h. Optical printing
- 37. Sound roll transfers
- 38. Optical negative track
- 39. Miscellaneous smaller costs, such as printing corresponding edge numbers
- 40. Projection room rental
- 41. Music
 - a. Composer
 - b. Music rights
 - c. Performance rights
 - d. Conductor and musicians
 - e. Recording stage, music photocopying, sound recordists, rental and transportation of instruments, etc.
- 42. Postproduction sound department
 - a. Sound supervisor / designer
 - b. Sound editors
 - c. Mixers
 - d. Foley artists
 - e. Loop groups
- 43. Postproduction Sound
 - a. Editing costs (supplies, transfers, etc.)
 - b. Mixing
 - c. Dialogue replacement
 - d. Sound effects
- 44. Mastering for home video
 - a. Telecine transfer to HDTV
 - i. Color-correction

- ii. Layback to tape
- iii. Digital dust and dirt removal
- b. Down conversion of HDTV master(s) to NTSC and PAL submasters
 - i. VHS dubs
 - ii. DVD copies
- 45. General
 - a. Legal
 - b. Taxes (payroll, sales, property)
 - c. Office rental
 - d. Telephone bills
 - e. Insurance
 - f. Miscellaneous
- 46. Contingency: In order to ensure that the film will have funds to finish, about 10 to 15 percent of the budget should be a contingency fund for dealing with unexpected expenses. With more production experience, this percentage can be decreased.

A well-developed script is essential in planning the budget. If the film idea is not your own, the first consideration is copyright. If the written material is more than seventy-five years old, it probably is in the public domain and is no longer protected by copyright. For further information on researching the copyright status of a work in the United States, write to:

Library of Congress Copyright Office Reference and Bibliography Section, LM-451 101 Independence Avenue, SE Washington, DC 20559-6000

EARLY PREPRODUCTION

The final shooting script will evolve gradually. Step by step, the directorial approach is determined and the script is adjusted to reflect that. The casting is completed and again the script may be adjusted to reflect the actors' needs and

ideas. The cinematographer and production designer are hired around this time, as well as the assistant director (AD).

In the shooting script, the characters appearing in a given scene will be typed in capitals, to indicate clearly which actors will be needed particular days of shooting.

Very rarely will a film be shot in consecutive order. For this reason a production will need a breakdown showing what scenes will be shot on what day. An initial schedule will be prepared by the line producer, but the final work will be done by the assistant director. A typical breakdown sheet for a scene shows its location and the set, the time of day and the season, the cast and the extras, props and animals, special effects, and finally the number of script pages and one-sentence descriptions of shots.

Logistics

All out-of-town locations must be scouted on a reconnaissance trip. The choice of a location will depend on the accessibility of the area, the availability of power, the topography, the sound conditions (check air-traffic routing charts and road-traffic noise), the average weather conditions, what permits are required, the availability of local help (such as police to redirect traffic, electricians, and catering services), and the local accommodations for the cast and crew. Travel arrangements will have to be made for the cast and crew. When filming out of the country, passports and sometimes visas will have to be secured; they should be applied for well in advance in case of delays.

All foreign-made equipment has to be listed with serial numbers and declared to the customs authorities when you leave. This is absolutely necessary in order to bring the equipment back without having to pay customs duties. Familiarize yourself in advance with the customs regulations of your destination countries.

Naturally, all the equipment used on a production should be insured. Liability insurance may also be necessary if there is any risk involved in the filming. Sometimes property owners will demand that you have such insurance before using their premises.

Hiring the Crew

While the breakdown is being made, the crew is also being organized. There is a tendency on low-budget student productions to assign too many functions to one person. This may be unavoidable on certain documentary projects, but on larger productions each key crew member should be able to concentrate on one job. An inexperienced director would be wise to concentrate on the actors and not try to be the cinematographer as well. For a first-time director, a more experienced cinematographer can be a most valuable ally. And an inexperienced cinematographer would be wise to surround himor herself with experienced people.

The cinematographer is also called the *di*rector of photography (*DP*) and is supported by three important departments: electric, grip, and camera. Each department has its own head. The *gaffer* runs the electrical department, assisted by the best boy electric. The *key grip* runs the grip department, assisted by the best boy grip. And the *first assistant cameraperson* (*first AC*) is in charge of all the camera equipment and the other camera assistants and film loaders.

Camera assistants need to be truly reliable. A cinematographer must be confident of being alerted immediately if any mistakes happen for example, if the loader exposes a roll of film to light, or if the focus-puller misjudges the distance during the take. All crew members are always expected to be on time and to concentrate on their jobs.

The production has an equal responsibility to the crew to provide regular meals and keep the working day to a reasonable length, with enough turnaround before the next day's call time. If the workday goes beyond fourteen hours, the production should offer either transportation home or nearby hotel accommodations.

It is *everyone's* responsibility to help promote and maintain a safe working environment.

As soon as there is enough information to determine what equipment will be required, the cinematographer, the sound recordist, and the other department heads will provide the producer with their equipment request lists.

As for the amount of film stock to be ordered, that depends on the planned shooting ratio. A 10:1 ratio is a good starting point, as it is easy to calculate. For example, if the final project will be ten minutes long, you should plan on shooting a hundred minutes of film stock (3,600 feet of 16mm running at 24 fps.) Of course, for financial reasons, you can shoot at even lower ratios than 10:1, but it becomes more difficult. These figures relate to shooting narrative fiction projects; documentaries generally have much higher shooting ratios.

How a Cinematographer Prepares

All creative discussions between the cinematographer and the director during preparation are based on the needs of the story. The ideal situation is to have a final script to work from early in the preproduction process.

The cinematographer's ongoing job is to understand the director's artistic intent for the production so that it may be effectively realized. Of course, the director hopes that the cinematographer will provide creative input that will complement the director's vision. Early discussions are generally vague as both director and cinematographer get to know each other's visual sensibilities and tastes in movies.

Since film is a visual art, describing ideas only in words can sometimes be problematic. So the director and cinematographer will show various visual references to each other: film clips, paintings, photographs, and so on. Over time, a visual plan to tell that particular story will emerge that both can agree on. The production designer should be brought into these discussions as well so that everyone ends up on the same track.

The director and the cinematographer should find the time to go through every scene in the script in great detail so that an accurate shot list can be written describing the camera setup needed for each scene. If preproduction is short, the scenes might have to be discussed in schedule order instead of page order, so that the scenes to be shot earlier are definitely covered.

It is absolutely vital that the first few days of the film shoot be so thoroughly planned that the shooting goes smoothly. Also make sure that the first day on the schedule is not overly ambitious. The crew will respond better and work harder if they see that the director and cinematographer have really done their homework and have realistic expectations of what can be done each day. If the first few days of the shoot are disorganized, causing the crew to either work long hours or find out that they didn't "make their day" (complete all the work listed on the call sheet), then morale will be lowered.

The director and the cinematographer set the tone for the entire working environment. So be professional, be pleasant, and be organized.

LATE PREPRODUCTION

The director, producer, cinematographer, and AD will make numerous trips to the location to study it and plan their shots. Then there is a final *tech scout* to the location, where all the department heads and their assistants are invited. The placement of equipment trucks, trailers, and the generator will be discussed at that time. Parking arrangements will be made. A tech scout is usually an all-day affair, especially if there are multiple locations spread throughout the city. It may even spill over into another day.

After the tech scout, there is a final *production meeting* with the same department heads, possibly another all-day affair. Each scene will be discussed in detail. Afterward, the department heads usually meet individually with the line producer or production manager with revised equipment package lists. They will also negotiate for extra "man days" when additional crew people are needed. Any prerig or wrap crews needed will also be discussed.

When working on a tight budget, the challenge is to spend your money wisely. Therefore, if paying a prerig crew to come to the location the day before to lay out the power and rig some lights in advance will end up saving you time on the day of the shoot, it can be money worth spending. Especially if the alternative is the likelihood of adding a day at that location in order to get all the shots needed.

Tests

To ensure high photographic quality, the budget should include the costs of shooting some tests. Tests may include emulsion characteristics, lens and camera performance, filters, color schemes of sets and costumes, lighting, makeup, and unusual camera movements or special effects. These tests may be shot at the camera rental facility in order to avoid incurring the costs of renting the camera for the day. Luckily, many of the larger camera rental houses have a room or small soundstage for shooting tests.

The sound recordist may also want to test certain things, such as performance of the recorder, the mics, and cables; sound interferences, such as a radio station being picked up; and acoustics of the sets and locations.

PRODUCTION BEGINS

Scheduling the Day

Before shooting, the script is broken down and an overall schedule drawn up showing the exact scenes to be shot each day and listing the actors, props, and sets that will be needed.

Then, a daily *call sheet* is created a day in advance of shooting by the AD. This shows the order in which the scenes will probably be shot, with times listed for different actors and crew people for when they should arrive and when they should be on set ready to shoot. Such scheduling is necessary for efficient operation and reduces wasted time. When time is especially limited, it is wise for the director and cinematographer to study each scene to determine the quickest shooting order for the various shots. This plan is then discussed with the AD and changes are made to the "preliminary" call sheet if necessary. Then copies of the final call sheet are distributed to everyone.

During production, the crew and cast must be kept well informed about all times, dates, and locations. Lists of phone numbers are mandatory in case crew people have to be called the night before about changes in location or call times for the next day.

The Production Day

If makeup is required, the makeup person and the actors are the first to arrive before the rest of the crew.

After the crew is called to set, the AD calls the actors out of makeup or their trailers and brings them to the set. The director holds a *blocking rehearsal* of the scene; the camera and actor positions are marked. The lighting and microphones are then set up while the actors return to complete their makeup.

When the cinematographer gives the AD a five-minute warning that the lighting will soon be ready, the actors are brought back to set and the first full *camera rehearsal* follows. Any necessary adjustments are made.

When the actual shot is taken, the sound recorder and camera are started, the scene is slated, and then the actors begin. In coordinating this procedure, there is usually a dialogue that goes something like this:

AD (when everyone is ready): Quiet on the set.

- DIRECTOR or AD: Roll sound.
- SOUND MIXER (starts recorder and when it is up to speed): Speed.
- DIRECTOR or AD: Roll camera.
- CAMERA OPERATOR (starts camera and when it is up to speed): Speed.
- CLAPPER (holding up slate in front of camera): Scene one, take one. Mark! (claps slate and quickly exits).
- DIRECTOR: Action.

Now the scene takes place. When it is over the director will call "Cut" and the camera operator and recordist will switch off their machines. What is important here is not the specific words or who says them, but the fact that a systematized procedure is followed to get the recorder and camera started, slated, and stopped with a minimum of wasted film.

After each take, the director will usually ask the camera operator and sound recordist if there were any problems or mistakes. When the director is satisfied with the setup and wants to move on, the AD will ask the first AC to check the camera gate for anything that might have ruined the take. After checking, the AC will usually say "Gate is good" and the AD will announce that they are moving on to the next setup.

The script supervisor constantly makes notes during each take on every possible detail that, if changed, might spoil the continuity and make the coverage difficult to edit together later. The notes cover the relative positions of all the fixtures, actors, and props, and the actions of the actors, such as how they picked up an object—for example, in their right or left hand—and on what line of dialogue. The screen direction is noted as well as the lens focal length and the camera position. The takes that the director wants printed ("P") are identified. Takes that are completely no good ("NG") are also noted and the reasons why.

The script supervisor sometimes takes *continuity photos* after the take with a Polaroid or digital still camera. Some productions will attach a video printer to the video tap monitor to capture and print out select frames. Other departments may also need to take photos as well for continuity reasons. For example, if food is spilled onto a costume deliberately during the scene, the wardrobe person will take a photo after the take in case the stain on the costume has to be re-created for other setups, some perhaps scheduled for weeks later.

Professional camera crews also fill out camera reports during the shooting. They partially duplicate the script supervisor's notes, indicating footage of each take, effects, the "P" or "NG" indication, and so on. This information is later transferred to a negative report sheet that accompanies the film to the lab.

The End of the Production Day

When the magazines are unloaded and prepared for the film lab, it is important to note what magazine each roll of film was shot with, in case that magazine is defective and, for example, is scratching the film or has a light leak. If possible, it is convenient to have one person doing all the paperwork involved, including the negative report sheets.

A log sheet is also kept for the sound. It accompanies the original quarter-inch tape or DATs when they are sent to the post house, usually for syncing with the camera rolls during the transfer to video for dailies.

At the end of the shooting day, the script supervisor collects and checks the camera reports and the sound reports to make sure that the information matches the script notes.

INVASION OF PRIVACY

When shooting on location, you should know something about the laws concerning invasion of privacy that might apply to persons not under contract who appear in the film. Such participants might willingly help you while filming but then sue you later. However, if they can be persuaded to sign a simple release, the chance of a suit is reduced. The following is one type of release.

AUTHORIZATION TO REPRODUCE PHYSICAL LIKENESS AND VOICE

For \$_____ and good and valuable consideration from_____

Productions, the adequacy and receipt of which is hereby acknowledged, I hereby expressly grant to said

Productions, or any third party it may authorize, and to its and their employees, agents, and assigns, the right to photograph me and/or make recordings of my voice, and the right to use and to license others to use pictures, silhouettes, and other reproductions of my physical likeness (as the same may appear in any still-camera photograph and/or motion picture film) and/or recordings of my voice in any manner or media whatsoever, including theatrical, nontheatrical, television (free, pay, cable and/or pay-per-view), home video (whether cassettes or disks), audio cassette tapes, CD, reel-to-reel, CD-ROM, interactive media, electronic media as well as any and all other media throughout the entire universe, whether now known or hereafter discovered or invented, in which my physical likeness and/or voice may be used or incorporated, and in connection with the publication in magazines, newspapers, or otherwise of any articles in which my physical likeness may be printed, used, or incorporated, and in the advertising, exploiting, and publicizing of any such motion pictures, television programs, radio programs, magazines, and newspapers.

I certify and represent that I have read the foregoing and fully understand the meaning and effect thereof and, intending to be legally bound, I have hereunto set my hand this ____ day of _____, 20 ___.

(Signature)

I hereby consent and agree to the above as the Parent/Guardian of _____

(Signature) Witness:

Date:

This is a long and very thorough version. Sometimes it is easier to get people to sign this simplified but still binding short form:

RELEASE FORM

For \$_____ and for consideration received, I give permission without restrictions to _____ Productions, its successors and assigns, to distribute and sell still and sound motion pictures, video, and audio tape recordings taken of me for a motion picture tentatively titled _____

Signed

Date _____

Signature of Parent or Guardian

Witness Date

Whichever release is used, after signing, the person should be given a token payment such as one dollar in cash (not check) to make the arrangement binding.

In some situations a similar release might be necessary from the owner of the premises to allow you to photograph the property. If the actors are not under contract, it is often a very good idea to have them sign a release also. This will prevent them from suing you later if the film unexpectedly makes money.

These are only *examples* of possible consent forms; research current practices in the state or country you are shooting in, where certain legal requirements not mentioned here may apply.

POSTPRODUCTION

Postproduction expenses will primarily involve editing, sound mixing, music scoring and recording, optical effects, titles, negative cutting, and all the lab expenses along the way to the release print.

It is preferable to score a picture rather than "lift" the music from a record. Many excellent student and amateur films are not able to be distributed because the producer cannot pay the price demanded for the right to license the music. Music libraries will sell the rights to "stock music" at fairly reasonable prices. However, stock music is never original and is often overused and dull. Having a picture specially scored is usually better. When music is composed for the picture, an additional tape copy of the edited version is provided for the composer to study and to use during the scoring and rerecording.

COPYRIGHT

To copyright a film, the first thing you have to do is to print the copyright symbol, ©, followed by your name and the year on the title credit of the film. For example "© 2004, William Shakespeare." This first step to copyright should always be taken. It signifies a claim to the right to the material.

According to the Copyright Office of the Library of Congress, your work is under copyright protection the moment it is created and fixed in a tangible form that it is perceptible either directly or with the aid of a machine or device. Copyright registration is voluntary; copyright exists from the moment the work is created. You will have to register, however, if you wish to bring a lawsuit for infringement for a work created in the United States.

As a general rule, for works created after January 1, 1978, copyright protection lasts for the life of the author plus an additional seventy years. Having your film copyrighted makes it illegal for someone to make copies of all or part of it. It unfortunately cannot prevent someone from taking the same idea and applying his or her own interpretation.

To receive a certificate of copyright registration, put into one package:

leluxe D	ELU)		BOR						
P: :	323.462.6171	F: 323.960.	lywood, CA 90 7016	027-3023					
CAMERA REPORT NO. 93701									
COMPANY 74	RNAW	A FIL	.ms						
DIRECTOR P. DUNNSI CAMERAMAN J. PLEWA									
PRODUCTION NUMBER OR TITLE "ACADEMIA Nots "									
	105	CUSTO	MER ORDER N	JMBER					
AMERA TYPE	AATON	KTR							
MAGAZINE NUMBER 2 ROLL NUMBER 422									
YPE OR FILM / EMULSIO		8 # 7	12-181	1-3-5					
DEVELOP NORMAL PUSHSTOP(S) PULLSTOP(S) FILM PULLSTOP(S) FILM PULLSTOP(S) PULLSTOP(S) </td									
VIDEO PREP & TR	RANSFER		CIRCLED TAK						
				ANSFER AT 24 FPS					
SCENE NO.	TAKE	DIAL	PRINT/ FEET	REMARKS					
GRAY SCALE	$\widehat{\mathbf{D}}$	10	10						
42	1	100	90	12mm T4					
	Q	150	50						
	(3)	210	60						
42A	0	260	50	25mm 74					
	2	310	50						
42B	Ø	330	20	SOMM TH					
117	1	350	20	9.8 mm T 5.					
	0	370	20	Pola + .3 grad					
	3	380	10						
			1						
	OUTO	0 39	0						
		-							
TIME	FOR	GRAY	SCALE						
			GOOD	220					
			N/G	160					
			WASTE	20					
2			TOTAL	400					
			SHORT	400					
contracts with this c	omnany are a	ccented with th		ng that all film delivered ery necessary sibility for its loss.					

9.1 Camera report sheet.

SOUND REPORT - DAT

	PAGE# / OF /			
PRODUCTION Dog Trouble	DATE 23 June 05 TAPE # 40F			
DIRECTOR Jackson	SOUND MEXER Molly Smith			
LOCATION Jumbos Clown Room	BOOM OPERATOR Jesse Becker			
⊠PD-4#4 □DA-P1# □OTH				
SAMPLE RATE 🗆 44.1 kHz 🛛 48 kHz 🖾 48.04	8 kHz REF. TONE /000hz@-20dbFS=0W			
MIC(S): Senn 416 Lectro wirele	55 TC: 30 fps □DF & ND			

SCENE	TAKE	□ ABS ⊠ TC in nuin sec	CN.1	CH.2	NOTES
17	1	04:01:23	416 Boom	-	INC- NG Action
	2	: :52	и		Good
	3	:03:17	11		Good - mic hit
17A	1	04:05:02	o	Ambiance	CU-BOB- good
	2	:05:48		0	good
17B	1	04:06:30	Įŧ	15	CU-Sue - car noise
	2	:08:23	u		false start
	3	:10:12	11	- 11	good
19	1	04:12:15	wireless	wireless SUE	Parking Lot-Wide
	2	:16 :23	11	л	Horn Honk - NG-
	3	:20:52	11	10	Good- clothing noise
	4	:24:14	11	17	Good
19A		04:29:03	14	11	2-540+
	2	:33:09	Both Wireless	416	Better sand
	3	:37:19	ų	"	NG-Action
	4	:41:23	h	11	Good !
20	Í	04:44:49	416		Funny drunk - Gasd!
	2	:46 :33	11		Good
ZOW		04:49:14	416		wild Ambiance
		: :			
		04:55:47	EL	100	FROLL
		: :			

9.2 Sound recording report sheet.

- a completed application Form PA or Short Form PA
- a \$30 payment to "Register of Copyrights"
- a description of the nature and content of the work (shooting script, synopsis, or press book)
- a copy of the movie (nonreturnable)

Send the package to:

234

Library of Congress Copyright Office 101 Independence Avenue, SE Washington, DC 20559-6000 Your registration becomes effective on the day that the Copyright Office receives your application, payment, and copy(ies) in acceptable form. If your submission is in order, you will receive a certificate of registration in four to five months.

You can find out more about copyright issues at the Web site of the Copyright Office: http://www.copyright.gov/.

GLOSSARY

- **A-B rolls.** A method of preparing the original footage for printing from two rolls (A and B) onto a single print. Roll A may contain shots 1, 3, 5, . . . and roll B shots 2, 4, 6, . . . The process requires two printer runs. This method prevents the splices from showing on the print and permits dissolves and other common optical effects without the use of an optical printer. There may be additional printing rolls: Roll C, Roll D, etc.
- Academy aperture. A frame area enclosed by an Academy projection mask, giving screen proportions of approximately 4×3 (1.37:1). The image is offset on the 35mm print to allow for an optical sound track to one side.
- acceptance angle. A characteristic of an exposure meter describing the angle of the light cone reaching the photocell. Applies also to the camera-lens angle.
- ACE. A variable silver retention printing process used by Deluxe Labs.
- acetate base. Also called safety base. A film base made of cellulose triacetate with slow-burning characteristics.
- ADR. Automatic dialogue replacement. See dialogue replacement.
- aerial perspective. Perspective augmented by water and dirt particles in the air, which gradually obscure the view of distant objects.
- A-frame. When 24 fps film is transferred to NTSC video with a 3:2

pulldown, this is the first film frame in the cycle that corresponds to two fields of the same video frame.

- **ambient light.** The general light surrounding the subject, filling in the shadows, generally of a soft, lowcontrast quality and often from sources of light reflecting off objects in the space.
- analog sound. A continuously variable signal.
- anamorphic lens. A lens used to produce a wide-screen image. A cylindrical lens element optically "squeezes" the picture, allowing a wider horizontal angle of acceptance; the image is "unsqueezed" during the projection by another anamorphic lens. See Cinema-Scope.
- answer print. Print made from the edited negative that's used to determine printing light corrections needed for following print; it may take a number of answer prints to determine final printing lights needed. Usually first answer print is silent; later ones will be composite prints. See composite print and first trial composite.
- antihalation backing or layer. An opaque layer on the back of the film base to prevent internal light reflections in the film base. It prevents or minimizes the halo effect around the images of strong lights such as car headlamps or streetlights.
- aperture, lens. The opening through which light passes within the

lens. Its diameter is adjustable by means of a lens iris (diaphragm).

- **aperture plate.** In camera: a plate with a rectangular opening that limits the area of a film frame being exposed. In projector: a plate that defines the frame being projected. See **mask** or **matte**.
- apple boxes. Wooden boxes in four basic sizes (full, half, quarter, and "pancake") used on the set in a variety of ways to raise actors, furniture, lights, and so on.
- arc light. A powerful lamp in which the electric current flows between two electrodes. A carbon arc operates in the normal atmospheric pressure, while a mercury arc works with the current flowing through an enclosed mercury vapor. This pressure can sometimes be very high.
- **ArriCode**. A machine-readable time code that an Arri camera can expose on the edge of the film.
- Arrilaser. A laser recorder made by ARRI, used to transfer a digital image onto film.

ASA speed. See exposure index.

- ASC. American Society of Cinematographers.
- **aspect ratio.** The ratio of height to width of a film picture frame and of the projected image.
- **assembly**. The first stage of editing, when all the shots are arranged in script order.
- attenuator. A filter with a continuous gradual change from a specific density to clear glass, or from heavier to lighter density. Some-

times used to designate a graduated filter.

- **A-wind, B-wind.** Terms designating the position of sprocket holes and emulsion on rolls of a raw stock perforated along one edge only. In popular usage the terms could apply to single- or double-perf film generations in the lab as well.
- Baby. 1. A tungsten studio lamp made by Mole-Richardson with a Fresnel lens and a 1,000-watt bulb.
 2. A product line by Mole-Richardson of smaller, more portable versions of their stage lamps. The 1,000-watt version is therefore called a Baby Baby. 3. A type of spud used to mount Baby lamps.
- baby tripod, baby legs. Very short tripod used when shooting low camera angles.
- **backdrop.** Painted or photographed background used behind the set windows and doors.
- back focus. See depth of focus.
- back projection. Also called rear projection. See process projection.
- **barn doors.** Two or four metal shields hinged in front of a lamp to limit and shape the pattern of light.
- barney. A soft, padded camera cover, shaped to allow camera operation. It reduces mechanical noise and sometimes contains electric heating elements.

base, film. See acetate base.

- batch, emulsion. A quantity of raw stock with emulsion made at the same time and under the same conditions, therefore maintaining identical sensitometric and color characteristics.
- **BCU**. big close-up. A single feature such as eyes, mouth, or hand filling the screen. Also known as XCU or ECU (extreme close-up).
- **belly board**. A board for mounting a camera as low as possible.
- **bin.** A boxlike or barrel-like container with a frame from which to hang lengths of film during editing. It is usually lined with a disposable linen bag to prevent scratching.

- **bipack printing.** 1. Printing in contact with printing stock, using a contact printer. 2. Printing two film strips, sandwiched together, onto a third film, using an optical printer.
- **bleach-bypass.** Also called skipbleach. The technique of bypassing the bleach step in color film processing and thus leaving metallic silver in the film.
- **bleach step.** The step in color film processing when the metallic silver that forms during development is converted into silver halide, which is later removed during fixing and washing.
- **bleeding.** A phenomenon in the developing process appearing on the border between high- and low-density areas, when vigorous development action spreads from the highlights into the shadows and degrades the sharp cutoff line between these areas. It is often noticeable around a figure silhouetted against the sky.
- blimp. Rigid soundproof camera housing to prevent mechanical noise from being picked up by the microphones. Many modern cameras are self-blimped, that is, built to operate noiselessly.
- **blocking rehearsal.** Used to establish the positions and movements of actors and/or camera in the scene.
- **bloop.** 1. A noise caused by the splice in an optical sound track passing in front of the exciter lamp. 2. A patch or fogging mark covering the splice line to eliminate this noise. 3. A sound signal recorded on tape simultaneously with a light exposing a few frames of film to establish the synchronization between the two. Also called clap. See **slate**, **electronic**. 4. Colloquial for **sync pop**.
- **blue coating.** Magnesium fluorite deposit on the glass-air surfaces of a lens. This antireflective coating greatly improves the lighttransmitting power of the lens and therefore prevents reflected

and scattered light from flaring the image.

- **boom, microphone.** A sound dolly with a long extendible arm enabling the operator to position the microphone and move it silently around the set, following the actors.
- **booster light.** Usually an arc lamp or cluster-type tungsten quartz lamps used on exterior locations for boosting the daylight, especially when filling the shadows.
- **breaking down.** Separating individual shots from a roll of rushes in the early stage of editing.
- **brightness.** Ability of a surface to reflect or emit light in the direction of the viewer.
- **broad.** A single or double lamp designed to provide even illumination over a relatively wide area. Used as a general fill light.
- brute. 1. A type of carbon arc lamp that draws 225 amps. 2. Mini-Brute and Maxi-Brute are trade names of cluster-type tungsten quartz lighting instruments produced by Berkey-Colortran, Inc.
- **buckle-trip** or **buckle switch**. A circuit breaker in the film path of many modern cameras that acts as a safety device in case of a camera jam, to stop the camera motor.
- **butterfly.** A net (scrim) or diffusing material sometimes stretched over an outdoor scene to darken or soften the sunlight.

b&w. Black-and-white.

- **candela.** A unit of light intensity. The luminance of a light source is often expressed in candelas per square meter.
- **capstan.** A spindle that drives the tape in a sound recorder at a constant speed.
- **CC filters.** Color-compensating filters. A series of filters in yellow, cyan, magenta, blue, green, and red, growing in density by small steps. Used for precise color correction at the printing stage, but sometimes also when filming, especially in scientific cinematography.

- CCD. Charge-coupled device. A light-sensitive sensor used to capture images in digital cameras and some telecines.
- **cement**, **film**. An acetone-based solution used for splicing films by partially dissolving the base and thus welding them together.
- **characteristic curve**. The curve that results on a chart when you plot the change in density on a piece of film for a rise in exposure.
- chroma key. A method of separating a subject against a background of a solid primary color for the purpose of compositing that subject against a new background.
- cinch marks. Scratch marks on film, chiefly caused by pressing on the edges of an unevenly wound roll of film, or by pulling on the end of a loosely wound roll.
- CinemaScope. 1. A wide-screen system utilizing an anamorphic lens.2. The anamorphic process introduced by Twentieth Century Fox in 1953. Anamorphic lenses and prints are called scope for short.
- cinema verité. Style of documentary filming in which maximum authenticity of the photographed real action and dialogue is preserved, without narration, optical effects, or added music.
- **cinex printer.** An instrument for printing a strip of adjacent frames using a series of standard printer lights.
- **cinex strip.** A strip of positive film printed on the cinex printer, which allows the cameraperson to judge the original as printed at different printer lights. Used to determine printing lights needed to create a color-corrected interpositive from a piece of original negative, which is then used in an optical printer for creating an optical effect. Sometimes referred to as a wedge test.
- **circle of confusion.** A circle representing on film an image point formed by a lens; 0.001 inch is the

largest acceptable circle of confusion in 16mm cinematography.

- clapper board. Also called clapstick or clapper. Two short boards hinged together and painted in a matching design. When sharply closed, they provide an audible and visible clue that is recorded on film and sound tape simultaneously. This helps to synchronize the picture film with the magnetic film in the editing process. Usually attached to a slate with relevant information, like scene and take number. Modern cameras are often equipped with an electronic slate. See slate and slate, electronic.
- **claw.** Part of the camera pull-down mechanism; a metal tooth that engages film perforations and moves the film down one frame at a time.
- **code numbers.** Progressing ink numbers printed usually at half-foot intervals on the edges of both picture and sound dailies to help the syncing-up process in editing.
- coding machine. A machine used for printing code numbers.
- color-blind film. Black-and-white emulsion sensitive to only one color, usually blue. See also orthochromatic film.
- color chart. A test chart representing the colors of the spectrum. Sometimes the color steps are parallel with the fields of gray that have the same visual luminosities as the corresponding steps of the colored half, as on the Illford Test Chart. Other test charts may have gray steps from white to black, blackening in logarithmic progression and independent of the color fields. Sometimes the colors are in square patches, as with the MacBeth Color Chart.
- **color sensitivity.** Corresponding photochemical reaction of film emulsion to different wavelengths, representing colors in the visible spectrum.

color temperature. A system of evalu-

ating the color of a light source by comparing it to a theoretically perfect temperature radiator called a black body. At lower temperatures a black body emits reddish light, and when heated to high temperatures its light changes to bluish. Color temperature is measured in degrees Kelvin. A degree Kelvin is the same as a degree Centigrade, but the two scales have different starting points; 0° K = -273° C.

- complementary colors. Colors obtained by removing the primary colors from the visible spectrum. Minus-blue (yellow), minus-red (cyan), minus-green (magenta).
- composite print (married print). Positive projection print with picture and a sound track.
- **conforming.** Cutting the original camera rolls (reversal or negative) to match the finished work print or edited video made using a telecine-transfer (video dailies).
- contact printer. A printing machine in which the printing stock and the film being printed are in contact, emulsion to emulsion.
- contrast. Scene contrast refers to the brightness range of a scene. Lighting contrast refers to the light intensity differences between the sources. Emulsion and/or development contrast refers to the density range of the developed original and/or any subsequent generations, as compared with the scene contrast.
- cookie. Also called kukaloris or cucaloris. An irregularly perforated shadow-forming flag, opaque or translucent, made of plywood or plastic, for example.
- **core.** A centerpiece around which a film is wound. Made of plastic, metal, or wood.
- **covering power.** A lens characteristic denoting the capacity to produce a sharp image over a film frame of a given size.
- crab dolly. A camera-mounting device with wheels that can be

GLOSSARY

steered in any direction. Usually fitted with an adjustable-height column.

- **cradle.** A lens support for heavy lenses, used to improve steadiness and protect the lens mount from damage.
- crane. A large camera-mounting vehicle with a rotating and high-rising arm, operated electrically or manually.
- cross-processing. Processing a reversal film stock in a negative processor to produce a negative instead of a positive.

CRT. cathode ray tube.

- **CRT recorder.** Used to transfer digital images onto film.
- crystal motor. Also called crystalcontrolled or crystal-sync motor. A motor operating at a precise synchronous speed, regulated by reference to an accurate crystal frequency source.
- crystal-sync system. A double system of synchronous filming not requiring connecting cables between the camera and the recorder. Both mechanisms are regulated by very precise crystal-control systems.
- **CS.** close shot. Head and torso down to the waistline filling the frame.
- **C-stand.** Century stand. A metal stand for positioning a lighting accessory such as a flag, cookie, or scrim.
- **CU.** Close-up. Head and shoulders filling the frame.

cucaloris, kukaloris. See cookie.

- **cue sheets.** A sheet that plots the changes in multiple sound tracks as a guide for the mixer during the sound mix.
- **cut.** The point of joining two shots by splicing, thus creating an immediate transition, as opposed to fade or dissolve.
- cutter. 1. Term used either interchangeably with "editor" or to define a person who is responsible for the mechanical rather than the creative elements of editing. 2. Shadow-forming device, usually rectangular in shape; a type of flag.

cutting copy. See work print.

- cyclorama (cyc). Stage background, usually white with rounded corners, that is used to create a limbo or sky effect. Made of plaster or stretched plastic. Sometimes painted green or blue for shooting foreground elements to be composited using a chroma key process.
- **cye strip.** Lighting instrument shaped like a trough with up to twelve bulbs for even illumination of a cyclorama.
- D log E curve. Also called sensitometric curve, characteristic curve, H&D curve, or gamma curve. The curve on a graph representing a relationship between the film density and the logarithm of exposure. Its shape changes depending on the time and temperature of development. It enables the cameraperson and the lab technicians to evaluate the photographic characteristics of a given film emulsion.
- dailies. Also called rushes. (1) The first print from original footage, with or without synchronous sound tracks, delivered from the lab daily during the shooting period, for viewing by the director, camerapeople, etc. (2) Dailies can also be seen on videotape if the original camera rolls on a telecine are transferred to a video format for electronic editing.
- DAT. digital audio tape.
- daylight loading spool. Metal spool with full flanges to protect the film stock from exposure to light during the loading and unloading of camera or magazines.
- **definition.** Ability of an emulsion to separate fine detail, depending on several factors, such as graininess and subject contrast.
- **degausser.** An instrument used for the process of demagnetizing. See also **erasing**.
- **densitometer.** An instrument for measuring the density of a processed photographic emulsion.

- **density.** The light-stopping power of the silver or color dye that results in processing a photographic emulsion.
- **depth of field.** The range of distances in front of and behind the point at which the camera is focused through which objects will appear sharp.
- **depth of focus.** The distance behind the lens through which the film can be moved backward and forward and still produce a sharp image of a flat object. Motion picture cameras hold the film at a fixed distance from the lens by the gate, so depth of focus is not normally adjusted. Sometimes referred to as back focus.

DI. See digital intermediate.

- dialogue replacement. Technique of recording dialogue under the acoustically perfect conditions of the dubbing studio, to replace the poor dialogue of scenes already shot on location. Actors time the delivery of their lines in order to match their lip movement as viewed on the screen.
- **diaphragm, lens.** Also called iris. An adjustable opening that controls the amount of light reaching the film through the lens. Calibrated in f-stops or T-stops.
- dichroic filter. A filter used on tungsten lamps to convert their color temperature to that of daylight. A coating on the glass reflects excessive red and transmits light that is bluer than original.
- differential focus. Also called split focus. Focusing at a point between two subjects in depth, to accommodate them both in the depth of field range (i.e., both in sharp focus).
- **diffused light.** Light originating from a physically large source. It is either reflected (bounced) off a surface or directed through a diffusing medium.
- diffusers. For lenses: Fine stretched nets, gauze, panty hose, or glass with light-scattering particles or a

pattern of "lenslets" all designed to soften definition. For lamps: Cellular diffusing materials such as silk or spun glass, or frosted semiopaque plastic placed in front of the lamp designed to spread and defocus the beam and turn a point source into a broad source.

- digital intermediate. A method of shooting on film, converting the image into digital data for various postproduction purposes, and recording the final digital master back to film.
- digital sound. A signal made up of numerical digits that represent a sound.
- dimmer. An instrument used to change the voltage of lights on the set, regulating in this way their intensity. Color temperature of the lights will lower when dimmed.
- dirty dupe. A black-and-white reversal print made from a spliced work print for screening during a sound mix.
- discontinuous spectrum. Characteristic of light sources, such as fluorescent tubes, which emit energy only in a few wavelength bands of the spectrum. Some colors are not represented in the discontinuous spectrum.
- dissolve. Also called lap dissolve. An optical effect representing a transition through a superimposed disappearance of one scene and appearance of the next.
- dolly. A wheeled vehicle for mounting a camera and accommodating a camera operator and assistant. Often equipped with a boom on which the camera is mounted.
- dot. Shadow-forming device in the form of a small round scrim or flag.
- double exposure. Two pictures exposed on the same frame of film in two passes, resulting in superimposition.
- double-headed projection. A synchronous projection of separate picture and sound tracks, which

are run in interlock. Done on a double-system projector.

- double-system sound recording. Synchronous shooting system in which the sound is recorded on a tape separate from the film in the camera. See also single-system sound recording.
- dubbing. 1. See dialogue replacement. 2. Another term for rerecording.
- dupe negative. Short for duplicate negative. See internegative.
- dynamic range. The difference in decibels between the noise level and the overload level of a sound system.
- edge fogging. Unwanted exposure on the film edges caused by light leaks in the camera, film magazines, or film cans if faulty or misused.
- edge numbers. Also called key numbers, or negative numbers. Numbers and key lettering exposed every half foot on the edge of the raw stock and consequently reprinted on the printing stock. These numbers make it possible to synchronize the original footage and the work print at the conforming stage.
- editing machine. Vertical or horizontal viewing machine for running separate picture films and sound tracks in sync or independently. Modern designs achieve high levels of sophistication in the range of available operations.
- editorial synchronism (edit sync). Picture and sound track on separate films arranged and marked in synchronous relationship for editing purposes in parallel alignment; that is, corresponding frames of picture and sound are opposite each other in the editing equipment. See also projection synchronism.
- EDL. Edit decision list. A list of every cut made for a movie when edited on video; the list is by time code and by key code / edge code numbers.

- effects track. A sound track containing sound effects as opposed to dialogue, narration, and music tracks.
- EI. See exposure index.
- electronic clapper. See slate, electronic.
- emulsion. A light-sensitive coating composed of silver halides suspended in gelatin, which is spread over a film base.
- ENR. A variable silver retention printing process at Technicolor Labs.
- erasing. Removing of the magnetic pattern from a tape or film by passing the tape through a magnetic field that is alternating at a high frequency.
- establishing shot. A shot usually close to the beginning of a scene defining the place, time, and other important elements of the action.
- Estar. A strong plastic (polyester) base used by Kodak for some products instead of an acetate base.
- exciter lamp. Part of the optical sound recording and reading system; it excites a current in a phototube. This current is modulated by an optical sound track moving between the lamp and the phototube, resulting in sound reproduction through amplifiers and loudspeakers.
- exposure. A process of subjecting a photographic film to any light intensity for a given time, resulting in a latent image.
- exposure index. EI for short. A number representing the sensitivity of the film emulsion that enables you to determine the correct exposure when using a light meter, exposure tables, or even experience. This same number was formerly called an ASA or ISO rating.
- exposure meter. An instrument for measuring the light intensity, either incident upon or reflected from a photographic subject.
- fade-out, fade-in. An optical effect consisting of the picture's gradual disappearance into blackness

GLOSSARY

(fade-out), or appearance from blackness (fade-in).

- **fall-off.** 1. A gradual diminishing of light falling on the set obtained by the use of, for example, barn doors or flags. 2. Weakening of light intensity when the distance from the light source increases.
- fast lens. A lens with a wide aperture for low-light photography. See speed.
- fill leader. Film leader, usually white or yellow, used to fill those parts of a sound roll where sound does not occur, when preparing separate rolls bearing different sounds such as dialogue, music, or effects for a sound mixing session.
- fill light. Light coming from the camera direction and illuminating the shadows caused by the key light.
- film chain. Also called telecine. Technical process of showing film materials on the television screen. Also used for video transfer. "Film chain" often refers to using an older transfer device that projects a print in real time and rephotographing the print with a video camera for TV broadcast.
- film plane. Plane in which film is held during exposure. It is often marked on the outside of camera body to facilitate the tape measurement to the photographed subject for focusing purposes.
- film recorder. A device for transferring digital images onto film.
- film scanner. A device for converting film images into a digital format.
- filter factor. A number by which the exposure must be multiplied to allow for the light absorption of an optical filter.
- final trial composite. A composite print with all required corrections accomplished and therefore ready for release. Also referred to as the final answer print.
- fine cut. The work print at an advanced stage of editing.
- finger. Narrow rectangular shadowcasting device.
- first trial composite. First composite

print (one with a sound track) off the edited negative; it is usually the second answer print (the first being silent). Used to show the necessity for further corrections in color, density, sound quality, etc.

- fish pole. A long, lightweight handheld rod on which a microphone can be mounted in situations where the large stage boom is not practical. Sometimes also called a boom.
- fixing. Film-processing stage after development, when the unexposed silver halides are converted into soluble silver salts, to be removed by rinsing in water. Fixing terminates the film's sensitivity to light.
- flag. Shadow-casting device made of plywood or black cloth stretched on a metal frame. Specific types of flag include the cutter, finger, gobo, and target.
- flange. A disk used on a rewinder, against which the film is wound on a core.
- flare. 1. Spots and streaks on film caused by strong directional light reflected off the lens components or filters. Also caused by leaks in the magazines and camera body. 2. Uniform, overall fog caused by reflections in some lenses.
- flashing. Exposing undeveloped film to an even but weak amount of light in order to lower contrast. Will lighten blacks and lift shadows when done to a negative or reversal original; will dull whites and darken bright details when done to a positive (print or interpositive).
- flat. A section of a studio set, usually modular, eight to ten feet high and six inches to twelve feet wide. Constructed on a wooden frame covered with a variety of materials like plywood and fireproof hessian. Surface treatments vary from paints to wallpapers, papiermâché, fabrics, metals, etc.
- flat light. Shadowless frontal light, usually from soft-light sources.

FlexFile. Computer file containing

keycode, time code, and edge code number information about film footage transferred to video using a telecine.

- **flip-over.** An optical effect of the picture on the screen turning over on the horizontal or vertical axis and revealing another image.
- fluid head. A type of tripod head in which the slowing effect of a fluid being pushed through narrow channels is employed to cushion any jerky movements and smooth out horizontal and vertical rotations.
- flutter, picture. Also called breathing. Picture unsteadiness caused by an unwanted film movement in the gate of the camera, printer, or projector.
- flutter, sound. See wow and flutter.
- flying spot scanner. A film-to-video tape transferring machine. Scans the film frame line by line with a white light projected through the film. A series of color photocell receptors positioned behind the film react to changes in color and density encountered by the scanning light.
- **focal length.** The distance between the principal point (effective optical center) of the lens and the focal point (film plane), when the lens is focused at infinity.
- **focal plane**. A plane in which the image of a distant object is sharply formed by a lens focused on infinity. It should coincide with the film plane.
- **focal point, principal.** Point at the intersection of the lens's optical axis and the focal plane.
- focus. 1. See focal point, principal.2. Colloquially, the position of an object at the exact distance at which the lens is focused.
- **fog density.** The density of a developed piece of film caused by factors other than light, such as age and temperature. Also called base fog density.
- fogging, chemical. Film density caused during processing by cer-

tain chemicals in the developer or by excessive exposure to air during development.

- **fogging**, **light**. Film density caused by unwanted exposure to light.
- **follow-focus.** A technique of continuous refocusing of a lens during the shot in which the distance between the camera and the subject changes more than can be accommodated by the depth of field.
- follow shot. Shot in which the camera is moved to follow the action.
- **foot-candle.** International unit of illumination. The intensity of light falling on a sphere placed one foot away from a point source of light of one candlepower, that is, one candela.
- **footlambert.** International unit of brightness. Equal to the uniform brightness of a perfectly diffusing surface emitting or reflecting light at the rate of one lumen per square foot.
- frame. One individual picture on a strip of film.
- freeze-frame. An optical effect of arresting the film action by printing one frame several consecutive times.
- frequency. The rate of vibration, measured by the number of complete cycles executed in one second. The unit of frequency is a cycle per second, called a Hertz (Hz).
- **Fresnel lens.** A type of lens used on spotlights. The convex surface is reduced to concentric ridges to avoid overheating and to reduce weight. Lamps equipped with this lens are called Fresnels in popular usage.
- friction head. A type of tripod head in which a smoothly sliding friction mechanism regulates the camera pan and tilt movements. The amount of friction required can be adjusted.
- front projection. See process projection.
- **f-stop.** A number obtained by dividing the focal length of the lens by its effective aperture. F-stop num-

bers represent the speed of the lens at any given diaphragm setting.

- **full aperture.** The largest picture area that can potentially be exposed on a film frame.
- FX. Abbreviation for "effects," such as sound effects or special effects.
- gaffer. The chief electrician on the film crew.
- gaffer's tape. Wide and strong adhesive tape used for securing the lighting instruments, stands, cables, and other equipment on the set.
- **gamma.** A degree of photographic contrast arrived at by measuring a slope of the straight-line portion of the D log E curve of a photographic emulsion.
- gang, synchronizer. A term describing the accommodation of each film in a synchronizer. Synchronizers are rated as two-gang, three-gang, four-gang, etc.
- gate. The aperture and pressure-plate unit in cameras and projectors.
- gator grip. An alligator-type grip used to attach lightweight lamps to sets, furniture, and pipes, for example, mainly on location. A stronger variety is called a gaffer grip.
- gear head. A type of tripod head in which the pan and tilt movements are operated by crank handles through a gear system. These gears can be regulated.
- **generation.** A term used in describing how many duplicating stages separate a given film from the original.
- geometry, film. The print emulsion position (wind) in relation to the left-right picture orientation. Geometry changes in successive printing generations.

ghost. See halation.

- **gobo.** A flag is sometimes called a gobo, particularly when it is used to protect the lens from direct light.
- **gobo head.** The gripping section of a C-stand and arm.

grading. See timing.

- graduated filter. A filter with neutral density or color covering only a certain portion of the glass. There is a graduated transition (a bleed line) between the dense and the clear part of the filter.
- grain. 1. Fine silver halide particles embedded in the gelatin of a film emulsion exposed to light and developed. 2. The resulting particles of metallic silver or color dye left after processing.
- graininess. Impression of nonuniformity in the photographic image caused by silver or color dye particles (grains) suspended in random fashion in many layers. The depth of these layers depends on the density of the image.
- **gray scale.** Chart representing a series of gray fields from white to black in definite steps.
- green print. A print that, because of improper lab handling during hardening or drying, does not go smoothly through the projector gate.
- grip. A member of a film crew responsible for, among other things, laying camera tracks and setting flags.
- **ground glass.** A finely ground glass on which an image is formed in the camera viewfinder system.
- guide track. A sound track recorded synchronously with the picture in acoustically poor conditions to be used as a guide during the postsynchronizing session.
- H&D curve. See D log E curve.
- halation. 1. Also called ghost image; a halolike, blurred flare surrounding the outlines of bright objects caused by light reflected from the film base. Almost eliminated in modern emulsions. 2. The glow surrounding a bright object from a diffusion filter on the camera.
- halogen. Elements such as iodine, chlorine, bromine, fluorine, and astatine are classified as halogens. They are used in manufacturing tungsten halogen lamps, such as quartz-iodine bulbs.

- handles. Extra frames at each end of a cut necessary for some types of printing.
- hazeltine. A device used by labs to determine the first set of printing lights needed to color-correct a print; usually the first answer print is made using this machine by the Hazeltine timer. Later corrections will be determined by using a Comparator, which matches a print to the printing lights for the timer so he or she can input changes.
- HDTV. See high-definition television.
- head, camera. Also called tripod head. A device for mounting the camera on a tripod or other supports. It allows for vertical and horizontal camera movements, called tilting and panning respectively. See also friction head, gear head, and fluid head.
- Hertz (Hz). Unit of frequency. One Hertz equals one cycle per second; 1,000 Hz equals 1 kHz (kiloHertz).
- high-definition television. HDTV for short. A video system that has more lines of resolution than current standard-definition television (NTSC, PAL, SECAM, etc.). Currently either 720 or 1,080 lines of vertical picture information. The native aspect ratio of HDTV is 16 \times 9.
- high hat. Low camera support of fixed height.
- high-key. A lighting style in which the majority of the scene is composed of highlights. Usually enhanced by bright costumes and sets. Low key-to-fill lighting ratio lowers the contrast, helping to obtain this effect.
- **Highlights.** The brightest parts of a photographed subject, represented as the heaviest densities on the negative and as the lightest on the positive.
- HMI. See hydrargyrum medium arclength iodide.
- Horse. A simple cutting-room device

for dispensing film. Often used for supplying the leader.

- **hot spot.** A very bright area in the scene, caused by excessive light or a strong reflection.
- hue. A scientific term for color.
- hydrargyrum medium arc-length iodide. HMI for short. A metal halide discharge lamp constituting, in effect, a mercury arc enclosed in a glass envelope. Gives off color temperature equivalent to daylight.
- hyperfocal distance. Distance at which a lens must be focused to give the greatest depth of field. Then all objects from infinity down to half the hyperfocal distance will be in acceptable focus.
- incandescent light. Electric light produced by the glowing of a metallic filament such as tungsten. Modern quartz-type lamps, better called tungsten-halogen lamps, are incandescent.
- incident light. Light coming directly from the source toward the object and the light meter, as opposed to light reflected from the photographed subject toward the light meter. See also **exposure meter**.
- **infrared.** A range of wavelengths slightly longer than those in the visible spectrum.
- inky-dink. A very small studio lamp made by Mole-Richardson with a Fresnel lens and a bulb up to 200 watts.
- **insert.** A shot inserted to explain the action, for example, a close-up of a letter, newspaper headline, calendar, or gun.
- interlock system. Electrical or mechanical system in which two mechanisms will start, stop, and run in synchronization. Used for cameras, sound systems, and projectors.
- intermittent movement. The stopand-go movement of the filmtransport mechanism in the projector or camera, making it

possible for each individual frame to be stationary during the moment of exposure or projection.

- intermittent pressure. Pressure applied on film in the camera gate during the periods of rest in the intermittent-movement cycle.
- internegative (IN). Also known as a dupe negative. Made on a lowcontrast lab intermediate stock designed to minimize any increase in contrast and graininess that occurs with duplication. The original negative will produce a positive image when printed onto this stock, called an interpositive, and when this positive image is copied onto the same stock, a negative image results. These intermediates serve as: (1) protection masters for archiving; (2) lowcontrast copies suitable for transfer to video; and (3) duplication masters to allow large numbers of prints to be made without risking the original negative. An internegative can also be made from a color reversal original.
- interpositive (IP). See above. A lowcontrast master positive copy made from a negative or internegative using lab intermediate stock. The IP and IN both have the same orange color mask of color negative film, unlike a projection print.

iris. See diaphragm, lens.

- jam, camera. Also called salad. A camera trouble when film piles up inside the camera body, sometimes caught up between the sprocket wheels and the guide rollers.
- junior. A studio lamp made by Mole-Richardson, with Fresnel lens and 2,000-watt bulb. A smaller version of this light is called a Baby Junior.
- Kelvin scale. A temperature scale used in expressing the color temperature. Kelvin degrees have the same intervals as the Centigrade scale, but 0° K = -273° C.
- keycode. A machine-readable bar code printed along the edge of

camera negative stock outside the perforations. It gives key (edge) numbers, film type, and film stock manufacturer code.

key light. The main source used to light the subject. Its direction and amount relative to fill light establishes the mood of the illumination.

key numbers. See edge numbers.

- **kinescope recording.** A simple process of filming a video image off a monitor onto motion picture film as a means of transferring video to film.
- **LAD.** Lab aim density. The optimal negative densities for each color layer of a film stock, according to the manufacturer.
- **lamp.** A term basically used for the lightbulbs of various designs, but also employed to describe the lighting instrument as a whole.

lap dissolve. See dissolve.

- laser recorder. A method of transferring a digital image onto film using lasers.
- latent image. An invisible image formed in the photographic emulsion when it is exposed to light. Latent image becomes visible after the development.
- **latitude, exposure.** An emulsion's ability to accommodate a certain range of exposures and produce satisfactory pictures.
- **leader.** Uniformly black, white, colored, or transparent film used in editing processes, such as preparing sound tracks or A-B rolls, or for head and tail protection of film rolls. See also **SMPTE universal leader.**
- Leko. An ellipsoidal spotlight with pattern-forming capability manufactured by Century Strand, Inc. Very popular in theater lighting but also used in film and TV as effect light.
- **letterbox.** A method of using black borders on the top and bottom of the TV screen image in order to show a wide-screen image with-

out cropping it to fit the less-wide TV set. See **Pan and Scan**.

- **lighting instruments.** The proper term in the film industry for lighting sources (luminaries) of different designs. Sometimes they are popularly called lamps, but strictly speaking, a lamp is just the electric bulb in the lighting instrument.
- **logging, film.** Entering in a logbook all the printed shots itemized by scene and take number, length in feet and frames, and edge numbers. A description of the action is also included.
- **long pitch.** Specific distance between film perforations designed for original camera stocks, which could also be used in projection (such as some reversal stocks), and for films used in high-speed cameras.
- **loop, film.** Slack loop formed before and after the gate in cameras and projectors to accommodate the transition from continuous to intermittent movement.
- **low-con print.** A print made onto a low-contrast stock designed for telecine transfer to video; normal print stock has too much contrast for a good transfer to video.
- **low-key.** Lighting style in which the majority of a frame is composed of dark areas. Usually enhanced by dark costumes and sets. High keyto-fill lighting ratio is employed for this effect.
- **LS.** Long shot. Full figure filling the frame.
- **lumen.** The light emitted by a source of power of one candela that falls on one square unit of surface at one unit of distance from the source.
- **luminance key.** A method of pulling a "key" off an image by using areas above or below a certain brightness. Once an area has been "keyed out" it can be filled in by another image.
- lux. An international unit of light in-

tensity. One lux equals an illumination of a surface, all points of which are one meter distant from a point source of one candela. One foot-candle = 10.764 lux.

- macrocinematography. Filming of small objects, often requiring lens extension with bellows or extension rings, but not so small as to necessitate filming through a microscope.
- magnetic film. Magnetic recording materials in one of the standard film gauges, with sprocket holes on one side in 16mm or on both sides for 35mm and wider gauges.
- **magnetic head.** Electromagnet containing a coil or coils of wire wound over an iron ring broken to create an air gap. Used to record electromagnetic variations on recording materials.
- magnetic master. A final edited or rerecorded magnetic track used for transfer to magnetic or optical release prints or to produce another master.
- magnetic recording. Recording sound or picture by introducing magnetic changes in a ferromagnetic medium, such as the coating on magnetic tapes and films.
- magnetic tape. Thin plastic base, like PVC or polyester, coated with magnetic iron oxide dispersed in a binder.
- married print. See composite print.
- mask. An opaque shape, often in contact with film, preventing the exposure of certain parts of the frame. The shape can be on a film strip traveling in contact with the film stock to be exposed, sometimes called a holdout matte, or as a plate in a camera, projector, or printer aperture to regulate the size and shape of the picture frame, sometimes called a hard matte. Sometimes means a lightobstructing device of desired shape in front of the lens.
- mask, color. Also known as an integral dye mask. The orange color of

film negatives and intermediates, used to improve color reproduction when printing by reducing unwanted excess dye formation in certain colors.

matte. See mask.

- **matte box.** A combination of filter and/or matte holder and sunshade mounted in front of the camera lens.
- microcinematography. Cinematography through the microscope.
- mixing. Creatively combining the sound signals coming from several microphones, or several tapes, and recording them onto a single track.
- Molefays. Lighting instruments manufactured by Mole-Richardson in one- to twelve-bulb clusters, employing usually the FAY type (650watt) bulbs. Used for an even illumination of large areas, often to provide a fill light in outdoor filming. FAY bulb has a color temperature of 5,000°K but can be replaced by bulbs of other color temperatures.
- Molepars. Lighting instruments manufactured by Mole-Richardson in one- to thirty-six-bulb clusters, employing the 1,000-watt PAR lamps.
- MOS. Filming without sound (silent). A coinage from the early days of sound cinema; one possible origin is that immigrant German technicians spoke of shooting scenes without recording the sound as being recorded "mit out sound." Another explanation is that it means "minus optical sound," since early sound films, before the invention of magnetic tape recording, put the sound directly to film emulsion in the form of an optical track.
- **Moviola.** A trade name of an editing machine that allows viewing picture film or films synchronously, with one or more sound films. Often used as a generic term in referring to editing machines in general.

- **MS.** Medium shot. Frame composition in which a three-quarterlength figure fills the screen.
- **negative image.** A photographic picture with reversed brightnesses of the photographed scene. What was bright in the scene is dark (dense) in negative and vice versa.
- negative numbers. See edge numbers.
- Neutral density (ND) filters. Colorless filters in a range of densities, used to cut down the amount of light entering the lens. Employed on the camera or on the windows. ND filters do not affect the color rendition of the lens. Used when the light is too intense for a given film, or a required f-stop.
- Newton rings. Ring patterns on film print caused by optical interference when light passes through two film surfaces slightly separated by the imperfect contact in a contact printer.
- NG. Short for "no good." A notation for picture and sound takes that will not be used in the final edited film.
- nitrate base. Film base made of cellulose nitrate, highly inflammable and self-igniting under certain conditions. Used until the 1950s in 35mm, when it was superseded by the triacetate safety base. Since its introduction in the 1920s as an amateur filmmaking format, 16mm has always used the safer acetate base.
- **noise.** An unwanted sound or signal generated in the sound or video system or transferred by these systems from other sources, such as the power supply.
- NTSC. National Television Standards Committee. A television broadcasting standard in North America for standard-definition video.
- **opacity.** A ratio of the light incident upon the measured portion of film frame to the light transmitted. The logarithm of the opacity equals the density.

optical effects. Special effects such as

fades, dissolves, superimpositions, freeze-frames, split screens, and wipes, usually created at the printing stage.

- **optical negative.** A negative of the optical sound track. Used to print the image of the sound onto the edge of the print.
- **optical sound recording.** Process of converting electrical sound signals into light-beam intensity or width, in order to record these signals on light-sensitive emulsion, creating in this fashion an optical sound track of variable density or variable area, respectively. Today used mainly in the preparation of release prints.
- original (negative or reversal). Film stock that was exposed in a camera and processed to produce either a negative or a positive picture.
- orthochromatic film. Black-andwhite film emulsion sensitive only to blue and green wavelengths.
- **outtakes.** Shots or takes that will not be used in the final version of the film.
- **overload.** An amplitude distortion in sound recording when the system receives a signal of higher amplitude than it can carry.
- **PAL.** Phase alternating line. A television broadcasting standard in the UK and much of Europe.
- **Pan and Scan.** The method of cropping a wide-screen image to fill a less-wide TV screen; the image often has to be electronically reframed or artificial pans have to be added in order to show the most important action in the wide-screen image.
- panchromatic film. Black-and-white film with an emulsion sensitive to all colors of the visible spectrum.
- **pan, panning.** Camera pivotal movement in a horizontal plane. Sometimes used when describing pivotal camera movements in other planes.
- parallax. A displacement of an image as seen by the independent view-

finder in relation to the image as seen through the lens. Especially evident when the subject is close to the camera. Independent viewfinders are usually adjustable to match the view area of the lens but not the lens's perspective.

parallel. A wheeled scaffolding with raised platform to accommodate the camera crew for high-angle shots, or the lamps and electricians.

perf. Short for perforation.

- **perforations, film.** Accurately spaced holes along one or both edges of the film, used to position and move the film through various mechanisms, such as cameras, printers, and projectors. Also called sprocket holes.
- **persistence of vision.** The phenomenon of the eye retaining for a short period of time the image just seen. Therefore, a stream of images of short duration (such as projected frames of film) are seen as a continuous picture without flicker.
- **photoflood.** Type of lightbulb in which voltage overcharges the filament, boosting the light output and color temperature but shortening the life of the bulb itself.
- **picture duplicate negative (dupe).** Negative printed from a master positive, or a reversal printed straight from the picture negative. See **internegative**.
- **picture master positive.** Special print made as an intermediate step in producing a picture duplicate negative. See **interpositive**.
- **picture print.** Film print bearing positive images. Also called a projection print. It has a higher contrast than lab intermediate duplicating stock in order to reproduce solid blacks on the theater screen.
- **picture release negative.** Edited picture negative from which the picture part of release prints will be printed.

pilot pin. See registration pin.

pitch. The distance between the lead-

ing edge of one perforation and the leading edge of the next along the length of the film.

- **plate; process plate.** Background materials (still or motion picture) shot to be used in back or front projection.
- playback. Instant playback of recorded materials to check the quality of recording. Playback also means a reproduction of previously recorded music, vocals, etc., when filming the performers in acoustically adverse conditions. In this technique the sound is recorded (prescored) in the sound studio and the picture is filmed on a visually desirable location while the previously recorded sound is played back.
- **polarity.** Correct polarity in connecting the batteries or other power sources means that the plus terminal on the power source is connected to the plus terminal on the equipment, and the minus terminals are connected accordingly. Plus is usually marked red.
- **polecats.** Extensible metal tubes to erect a lamp support in the form of a pipe wedged between the walls, or floor and ceiling, of a room, or used in conjunction with other tubes to form a more elaborate scaffolding for holding lamps. Pole Kings manufactured by Berkey Colortran, Inc. are a good example of this equipment.
- **postflashing.** When flashing is done after the image is exposed onto the film but before it is developed. See **flashing.**
- postsynchronization. See dialogue replacement.
- **practical.** A lamp or other prop on the set that is rigged to be operational during the scene action.

preflashing. When flashing is done before the actual image is exposed onto the film. See flashing.

prescoring. Recording of sound track to accompany the action, which is shot to the playback of this sound track. Used often when filming singers or musicians performing in acoustically inferior locations.

- **pressure plate.** A part of film gate in the camera, optical printer, or projector that presses the film, keeping it flat against the aperture plate during the exposure.
- primary colors. Blue, green, and red. By mixing these three colors of light, all other hues can be obtained.
- print, picture. See picture print.
- print, reversal. See reversal print.
- printer. Machine for printing from one strip of film (exposed and processed) to another strip of film (raw stock), by moving both these films in front of an aperture with regulated illumination. There are continuous and step printers, depending on the mode in which the film moves. Another division, mainly among step printers, distinguishes the contact printer, in which two strips of film touch each other emulsion to emulsion, and the optical printer, in which the picture is exposed on the raw stock via an optical system. This allows for picture modifications such as change in frame size and shape, zoom effect, freeze-frame, flip-over, wipe, and rotation.
- printer light scale. A scale of variations in printing light intensity, allowing you to print the original images brighter or darker, to obtain an evenly exposed print from an original with uneven exposures. The light scale is also used when executing optical effects such as fades and dissolves.
- print master. The final recording master that results from the sound mix, containing the final tracks of sound for the finished movie. Used to make the optical negative.
- **print-through.** A condition where the signals recorded on tightly wound magnetic tape affect the coating of adjacent layers, causing an echo effect when the tape is played. High recording levels and

GLOSSARY

high temperature in storage will augment the print-through effect.

- **processing.** All the chemical and physical operations necessary to convert a latent image into a satisfactory picture on film.
- **process projection.** A technique of filming live action staged in front of the screen on which the background view is projected. This background plate can be projected either from behind the translucent screen (back or rear projection), or from the front on a highly reflective screen (front projection).
- **process shot.** A shot of live action in front of a process projection.
- **projection synchronism (projection sync).** A twenty-six-frame displacement between the optical sound track and the 16mm picture on the composite print, to accommodate the distance between a film gate and an exciter lamp on the 16mm projectors.
- proof print. Some labs create a "slide show" of one frame from each cut in the conformed negative as a step before making an answer print, to determine basic printing lights to be used.
- **props.** Short for properties, movable objects used on the set in the filmed scenes.
- protection master. 1. A master positive (interpositive) made from the assembled negative (A-B rolls) and kept as a protection in case the original is damaged or lost. 2. Any archived version of the film of high enough quality to be used for reproduction.
- **pull-down.** The action of moving the film one frame at a time for exposure or projection by the intermittent mechanism of the camera, printer, or projector. See also **intermittent movement.**

pup light. See Baby.

- **PVC base.** Tape or film base made of polyvinyl chloride.
- quartz lights. Popular name for tungsten-halogen lamps. Tungsten fila-

ment and halogen gas are sealed in an envelope made of quartz or other materials that permit bulb temperature up to 600°C. The particles evaporating from the filament combine with the halogen gas and are redeposited back on the filament. This recycling process prevents the darkening of the bulb so that the color temperature stays fairly constant during the lamp's life.

- radio microphone. A microphone with a miniature transmitter and a piece of wire as an aerial. The receiving station can amplify the signal and transmit it to a recorder located even farther away.
- raw stock. A film that has not yet been exposed and/or processed.
- rectifier. An instrument to convert alternating current into direct current.
- **reduction printing.** Optical printing of a film onto a raw stock of a smaller gauge.
- reflector. A board with a lightreflecting surface, hard or soft depending on the texture of the surface, used mainly for redirecting the sunlight to add fill light into the shadows in the scene.
- **registration.** The positioning of film in the aperture gate of a camera, printer, or projector in precisely the same place for each consecutive frame.
- **registration pin.** A part of the intermittent mechanism in more elaborate cameras. It secures the steadiness of the film by engaging the perforation during the period of exposure.
- **release print.** A composite print made for general theatrical distribution, after an approval of the final trial composite print. Often made from a dupe negative in order to allow a large number of prints to be made.
- rerecording. Transferring several sound tracks, such as dialogue, music, and effects, onto a single track, creatively mixing sounds by

controlling levels and other characteristics.

- reticulation. A phenomenon of emulsion cracking in a leather-grain pattern, caused by too high a temperature in processing.
- **retrofocal lens.** Inverted telephoto lens. A lens of a special optical design that allows a longer physical distance between the rear end of the lens and the film plane. Convenient in the design of lenses with extremely short focal length; the retrofocal design increases physical size and facilitates mounting and operating.
- reversal print. A print made on a reversal material.
- rewinds. Geared devices for rewinding film. Manual rewinds are usually used in editing rooms, and electric ones in projection rooms and libraries.
- rigging. Positioning lamps in the studio according to the preliminary lighting plot.
- **riser.** 1. A low platform to raise an actor, camera, or furniture a few inches off the ground. 2. A part of a dolly used to mount a camera or a seat higher.
- **rough cut.** Roughly edited film at the work-print stage with finer changes to be made before the fine cut.
- rushes. See dailies.
- safe action area. The area within a frame that will be seen in a TV broadcast. Titles usually have to be photographed so that they fall within the safe action area. Sometimes called TV-safe area.
- safety base. See acetate base.

sample print. See final trial composite print.

- saturation. The criterion of the purity of a color. It indicates the distinctness and vividness of hue. Color is most saturated when it appears the strongest and most brilliant, least saturated when a color is approaching a neutral gray.
- **scoop.** A studio lamp of a soft, wide, round pattern; 500 to 2,000 watts.

scratch print (slash print). A print made from an assembled original (A-B rolls), but without the printer light corrections. Used for music or narration recording and similar applications where the visual quality is of little importance.

scratch track. See guide track.

- **scribe.** Sharp, pointed instrument to scratch the emulsion when marking film edges in preparation for conforming original footage for splicing.
- scrim. Lighting accessory made of wire mesh, or a flag or frame covered by a cloth mesh, positioned in front of a light source when reducing the intensity of the light is required.
- script. A written screenplay that undergoes several phases, from an outline and rough treatment to the final shooting script, where all the scenes are described in detail.
- secondary colors. See complementary colors.
- senior. A tungsten studio lamp made by Mole-Richardson with a Fresnel lens and 5,000-watt bulb. The smaller version is called a Baby Senior.
- sensitometer. An instrument in which a strip of film is exposed to a series of light intensities in logarithmic steps, which will produce corresponding densities when the film strip is developed.
- sensitometric strip. Film strip exposed to a series of logarithmically growing light intensities in a sensitometer, developed and measured for densities to establish a proper developing time for the given emulsion.
- **sensitometry.** The science of measuring a film emulsion's sensitivity to light and of evaluating the development.

shooting script. See script.

- shot. A homogeneous element of the film structure between two cuts or two optical transitions.
- show print. A theatrical release print

struck from the original negative instead of a dupe negative.

- **shutter.** 1. A mechanism for covering the aperture of a camera during the period in which the film is moved between exposures. 2. A mechanism for covering the gate of the projector while the frame is being advanced.
- silver halide. Light-sensitive silver compound such as silver bromide, silver chloride, silver fluoride, or silver iodide, used in photographic emulsions.
- single-system sound recording. A technique of recording synchronous sound simultaneously with the picture on the magnetic track adhering to the edge of a picture film.
- **skip-printing.** A method of speeding up the action in a shot by skipping (eliminating) frames when copying that footage onto another piece of film.
- sky light (sky pan). A nonfocusable tungsten studio lamp with a 5,000-watt to 10,000-watt bulb providing illumination over a broad area, such as set backdrops.
- slate. A board with written information such as production title and number, scene and take number, and director's and cameraperson's names, photographed at the beginning or end of each take as identification. See also clapper board and slate, electronic.
- **slate**, **electronic**. An electrical device synchronously exposing a few frames in the camera and providing an electric signal that is recorded on the magnetic tape, so that the two can later be matched in editing.

slip focus. See differential focus.

smart slate. A clapper board/slate with a large LED display showing the time code being used by the sound recorder.

SMPTE. Society of Motion Picture and Television Engineers.

SMPTE universal leader (society leader). Film leader introduced in

1965 with numbers from eight to two, each printed over twentyfour frames, that is, for one second at standard projection speed. A rotating line covers a full circle in each second.

snoot. A funnel-shaped lightcontrolling device used on lamps in place of barn doors for more exact light-beam pattern.

sound boom. See boom.

- sound displacement. See projection sync.
- **sound master positive.** Special sound print made from a sound-release negative in order to produce sound duplicate negatives used for making release prints.
- sound print. A positive print with sound only, made (1) from a sound negative; (2) from a sound positive through reversal process; (3) direct from magnetic tape, as positive recording.
- **sound-release negative.** An optical sound negative from which final sound printing onto the release print will be made.
- **sound speed.** Standardized speed of filming and projecting at 24 fps, when picture is synchronized with a sound track. Applies to films of all gauges.
- **sound track.** An optical or magnetic band carrying the sound record alongside the picture frames on a motion picture film. Also any magnetic or optical sound film at the stage of editing and mixing.
- spectrum, visible. A narrow band of electromagnetic waves from approximately 400 to about 700 millimicrons, which produce in the human brain a sensation of light.
- **speed.** 1. Camera speed is the rate of film advancement, expressed in frames per second (fps). 2 Lens speed is the full amount of light a lens is capable of transmitting, expressed as a lowest f-stop (purely geometrical computation), or as a lowest T-stop (real-light transmission as measured individually for the given lens). 3. Emulsion speed

GLOSSARY

is the emulsion sensitivity to light, expressed as an index of exposure.

- **splicer.** A machine for joining pieces of film together. Depending on the method used, there are tape splicers and cement splicers. Cement splicers can be cold or hot (heated for faster splices), negative or positive (making narrower or wider splices respectively), and hand- or foot-operated, the latter being much faster in operation.
- **splicing.** Technique of joining separate film pieces into a continuous film strip. At the work-print stage, transparent tape splices are the most common, as the tape can easily be removed for changes in editing. Originals or damaged release prints are joined with a cement splice, which welds together the two pieces of film in a more permanent way. A negative splice, used for joining original footage, is narrow and therefore less visible, and the positive splice, used to repair broken prints, is wider.
- **split reel**. A reel with a removable side, so that the film on a core can be placed in or removed from the reel without rewinding.
- spotlamp. A general name for many studio lamps of similar design but different in size, such as the Baby, Junior, and Senior. Equipped with Fresnel lens and focusable from spot to flood-beam pattern.
- spreader. A metal or plastic base used under a tripod to keep the legs from spreading out.
- static marks. Unwanted exposures in the form of random lines caused by discharges of static electricity. They occur when unexposed film stock is rewound, especially at an uneven speed, or when the rewinds are not grounded. They may also happen in the camera through too much friction, particularly in low temperatures and low humidity.

step printer. See printer.

still. A static photograph, as opposed to the motion picture.

- stock footage. Film-library footage of famous or typical places and situations, historical events, and the like, which can be used more than once in different film productions.
- story board. A series of drawings as visual representation of the shooting script. Sketches represent the key situations (shots) in the scripted scenes. Dialogue or indication of music or effects appears below the pictures.
- **stretch printing.** A method of slowing down the action of a shot by repeating frames when copying that footage onto a new piece of film.
- **superimposition (super).** Two scenes exposed on the same piece of raw film stock, one on top of the other. Superimposition is usually done in the printer but can be performed in the camera, although this offers less control of the operation.
- **Super-16.** A variation of the 16mm format that uses single-perf film to allow the extension of the usable picture area out to the extreme edge of the film. This creates a wide-screen aspect ratio of approx. 1.69:1.
- Super-35. A method of exposing an image across the full aperture of the 35mm frame, usually in order to create a wide-screen image. Super-35 is used for TV production and composed for 16×9 for transfer to HDTV. For theatrical production, it is often composed for 2.39:1 for transfer to 35mm anamorphic.
- **swish pan.** A very fast panoramic movement of the camera, resulting in a blurred image. Used sometimes as a transition between sequences or scenes.
- synchronism. Coordination of picture and sound. See editorial synchronism, projection synchronism.
- **synchronous speed**. Camera speed of exactly 24 fps synchronized with the sound recording.

- sync motor (synchronous motor). Constant-speed motor for camera or projector that can be electrically or mechanically synchronized, meaning it will run at the same speed along with the soundrecording and/or sound-reproducing machines.
- **sync pop.** One-frame sound signal placed near the heads of the edited sound tracks to confirm proper synchronization during mixing operation.
- sync tone oscillator. Small oscillator in the camera producing electrical signals that indicate exactly the speed of the camera motor. These signals are transmitted to the sound recorder and recorded on magnetic tape as a guide enabling precise synchronization of sound and picture at the later stage. Sync pulses are inaudible on normal playback and do not interfere with the sound recording on tape.
- tachometer. A meter indicating the camera speed in frames per second.
- take. A scene or part of a scene recorded on film and/or sound tape from each start to each stop of a camera and/or recorder. Each shot may be repeated in several takes, until a satisfactory result is achieved.
- **target.** A black or translucent disk up to ten inches in diameter that is used to control the lamp beam and create desirable shadows. A type of flag.
- telecine. See film chain.
- **Tener.** A tungsten studio lamp made by Mole-Richardson with Fresnel lens and 10,000-watt bulb. The smaller version is called a Baby Tener.
- **test strip.** Several feet of film left at the beginning or end of the roll for lab tests before the rest of the roll is developed. Test strip can be of unexposed footage to be used as a sensitometric strip, or of footage of a gray scale exposed in the same manner as the rest of the roll

to be tested for the optimal development time necessary to obtain the most pleasing picture. This second method may be used when the cameraperson has some doubts about the correctness of his or her exposure calculations.

- threading. Also called lacing. Placing film in a proper way for correct passage through all the film transport mechanisms of camera, printer, projector, or other filmhandling machine.
- 3:2 pull-down. A method of converting 24 fps to 60 fields per second (NTSC). The first frame is represented by two fields but the second frame is represented by three fields.
- tilt, tilting. Camera pivotal movement in a vertical plane. Sometimes called vertical panning.
- time code. A system of synchronizing picture and sound by way of generators installed in cameras and recorders that provide time signals registering on film and sound track as year, month, day, hour, minute, and second.
- timing. A lab operation in the early printing stages to select printer lights and color filters to improve the densities and color rendition of the original footage and thus obtain a visually more satisfactory print. Also called grading. The technician in charge is called a timer or grader.
- timing card. Listing of printer lights to be used for printing from the given original. This card is then kept for future reference.

tracking. See dolly.

- transfer, sound. Process of duplicating sound recording, for example, from quarter-inch magnetic tape to 16mm magnetic film for editing, or from 16mm or 35mm magnetic master to 16mm optical track in the preparation of a composite print.
- treatment. A literary presentation of an idea for a future film before a proper script is developed.

- trial composite print. See first trial composite print.
- triangle. A triangular device made of metal or wood and used as a tripod base to prevent the tripod legs from slipping. See spreader. trim bin. See bin.
- trims. Leftover pieces of film from the shots that were incorporated into the work print and the final composite print. These unused trims are filed in case the editor changes his or her mind.
- trombone. A tubular device for hanging small studio lamps from the top of set walls.
- T-stop. Calibration of the lens lighttransmitting power arrived at by an actual measurement of the transmitted light for each lens and each stop individually. T-stops are considered more accurate than f-stops.
- tungsten light. Light generated by an incandescent lamp with a tungsten filament.
- turret, lens. A revolving lens mount for two to four lenses, enabling the cameraperson to make a fast choice of lens for the next shot.
- 24P. 24 fps progressive-scan video. Normal NTSC video cameras capture sixty fields per second, every two fields interlaced to create a frame of video; 24P means that twenty-four whole frames of video are captured per second, similar to a film camera running at 24 fps. Though 24P is usually associated with high definition (HD) video, there are now NTSC video cameras that can capture at 24P.
- ultraviolet. A range of wavelengths shorter than those in the visible spectrum but detected by film emulsions. An ultraviolet (UV) filter is used to stop this radiation.
- universal leader. See SMPTE universal leader.
- variable-area track. An optical sound track on which the electrical signals are recorded as the varying width of a constant-density image.

- variable-density track. An optical sound track on which the electrical signals are recorded as the varying density of the image.
- variable focal-length lens. Also called varifocal lens. See zoom lens.
- variable-speed motor. See wild motor.
- video dailies. Instead of work print (film dailies), the camera original is transferred to video for viewing on a TV monitor and for electronic editing.
- vignetting. Blurring or darkening of the photographic image on the sides of the frame, caused by close-range objects obscuring the view. Unintentional vignetting is sometimes caused by a sunshade extended too far in front of the lens or a badly positioned flag to protect the lens from flare. In some camera designs a long lens mounted in an adjacent turret socket can cause vignetting.
- VO (voice-over). Indication in the script that the shot or scene will be accompanied by a voice not visibly originating in the picture. Voice-over can be in forms such as narration, inner monologue, or "voice from the past."
- VU meter. Volume-unit meter, indicating the recording level on sound-recording equipment.
- walk-through. First rehearsal on the set, for camera positions, lighting, and sound when the director describes the scene in detail to the crew and the actors. Sometimes stand-ins are used instead of actors for this operation. Also called a blocking rehearsal.
- waxing. Applying wax to the edges of film to improve the film passage through the projector and prevent the piling up of emulsion, which is likely if the film has been incorrectly dried during processing.
- weave. Undesirable sideways movement of film in the camera or projector.
- wild motor. Camera motor that does

GLOSSARY

not run at an exact synchronous speed. Usually adjustable for different speeds.

- wild recording. Sound recording not synchronized with the picture. This recording results in a "wild track."
- wind. Film wind refers to the emulsion position on the roll of a single-sprocket film. See A-wind, B-wind.
- work print. A print built up from dailies. It undergoes editorial improvements from the assembly stage through rough cut to a fine

250

cut. Finally it is used to guide the negative cutter when conforming the original.

- **wow and flutter.** Sound distortions in recording or playback caused by speed variations in the tape movement.
- **XLS. Extreme long shot.** Distant landscape or vast interior shot in which the human figures appear relatively small.
- **zero cutting.** A method of cutting an original with extra picture frames on each end of a cut for special printing techniques.
- **zoom, zooming.** The magnification of a certain area of the frame by bringing it optically to the full screen size and excluding the rest of the frame in the process.
- **zoom lens.** A lens with a continuously variable focal length over a certain range, allowing the change of subject magnification during the shot. On many modern cameras zoom lenses substitute for the standard complement of primary lenses.

BIBLIOGRAPHY

GENERAL BOOKS ON FILM TECHNIQUES AND PRODUCTION

- Arijon, Daniel. Grammar of the Film Language. Boston: Focal Press, 1976.
- Baddely, W. Hugh. The Focal Encyclopedia of Film and Television Production Techniques. Boston: Focal Press, 1981.
- ———. The Technique of Documentary Film Production. 4th ed. Boston: Focal Press, 1981.
- Boyle, Geoff. The Cinematography Mailing List Web site. http://www.cinematography.net.
- Brown, Blain. *Cinematography: Theory and Practice*. Boston: Focal Press, 2002.
- Happe, L. Bernard. Basic Motion Picture Technology. New York: Hastings House, 1978.
- Lipton, Lenny. *Independent Filmmaking*. Rev. ed. New York: Simon & Schuster, 1983.
- Pincus, Edward, and Steven Ascher. *The Filmmaker's* Handbook. Rev. ed. New York: Penguin Group, 1999.
- Roberts, Kenneth H., and Win Sharples, Jr. A Primer for Film-Making: A Complete Guide to 16mm and 35mm Film Production. New York: Pegasus, 1971.

CAMERA AND LIGHTING TECHNIQUES

- Almendros, Nestor. *A Man with a Camera*. New York: Farrar, Straus & Giroux, 1986.
- Bergery, Benjamin. *Reflections: Twenty-one Cinematog*raphers at Work. Hollywood: ASC Press, 2002.
- Box, Harry C. Set Lighting Technician's Handbook. Boston: Focal Press, 1993.
- Brown, Blain. *Motion Picture and Video Lighting*. Boston: Focal Press, 1992.

- Burum, Stephen H., ed. *American Cinematographer Manual.* 9th ed. Hollywood, CA: ASC Holding Corp., 2004.
- Campbell, Russell. Photographic Theory for the Motion Picture Cameraman. New York: A. S. Barnes, 1974.
- ———. Practical Motion Picture Photography. New York: A. S. Barnes, 1970.

Carlson, Verne, and Sylvia Carlson. Professional Cameraman's Handbook. Boston: Focal Press, 1986.

- ———. Professional Lighting Handbook. Boston: Focal Press, 1985.
- Eastman Kodak Company. *Kodak Motion Picture Film*. 5th ed. Rochester, NY: Eastman Kodak Company, 1999.
 - ——. Kodak Motion Picture Web site. http:// www.kodak.com/US/en/motion.
- Fauer, Jon. Arriflex 16SR Book. 3rd ed. Boston: Focal Press, 1999.
- GTE Products Corporation. *Lighting Handbook for Television, Theatre, and Professional Photography.* 7th ed. Danvers, MA: GTE Products Corporation, Sylvania Lighting Center, 1984.
- Hirschfeld, Gerald. *Image Control.* Boston: Focal Press, 1993.
- Lowell, Ross. *Matters of Light and Depth.* Philadelphia: Broad Street Books Publishing, 1994.
- Malkiewicz, Kris J. Film Lighting: Talks with Hollywood's Cinematographers and Gaffers. New York: Prentice-Hall Press, 1986.
- Millerson, Gerald. The Technique of Lighting for Television and Motion Pictures. Boston: Focal Press, 1982.
- Ray, Sidney F. *The Lens in Action*. Boston: Focal Press, 1976.

- Ritsko, Alan J. Lighting for Location Motion Pictures. New York: Van Nostrand Reinhold, 1979.
- Samuelson, David W. Motion Picture Camera and Lighting Equipment. Boston: Focal Press, 1986.
 - ——. *Motion Picture Camera Data.* Boston: Focal Press, 1979.
- ———. Motion Picture Camera Techniques. Boston: Focal Press, 1984.
- Schaefer, Dennis, and Larry Salvato. Masters of Light: Conversations with Contemporary Cinematographers. Berkeley: University of California Press, 1984.
- Underdahl, Douglas. *The 16mm Camera Book*. 2nd ed. Long Valley, NJ: Long Valley Equipment, 1996.
- Wilson, Anton. Cinema Workshop. Rev. ed. Hollywood, CA: ASC Holding Corp., 1983.

POSTPRODUCTION TECHNIQUES

- ACVL Handbook. 5th ed. Los Angeles, CA: Association of Cinema and Video Laboratory Services, 1994.
- Burder, John. The Technique of Editing 16mm Films. 4th ed. Boston: Focal Press, 1981.
- Case, Dominic. *Film Technology in Post Production*. 2nd ed. Boston: Focal Press, 2001.
- Churchill, Hugh B. *Film Editing Handbook: Technique* of 16mm Film Cutting. Belmont, CA: Wadsworth Publishing Company, 1972.
- Happe, L. Bernard. *Your Film and the Lab.* 2nd ed. Boston: Focal Press, 1983.
- Hollyn, Norman. *The Film Editing Room Handbook*. New York: Arco Pub., 1984.
- Reisz, Karel, and Gavin Millar. *The Technique of Film Editing*. 2nd ed. Boston: Focal Press, 1982.
- Walter, Ernst. *The Technique of the Film Cutting Room*. 2nd ed. Boston: Focal Press, 1982.

SOUND TECHNIQUES

- Aikin, E.G.M. Sound Recording and Reproduction. Boston: Focal Press, 1987.
- Alten, Stanley R. *Audio in Media*. Belmont, CA: Wadsworth Publishing Company, 1986.
- Clifford, Martin. *Microphones*. 3rd ed. Blue Ridge Summit, PA: Tab Books, 1986.
- Eargle, John. *The Microphone Handbook*. Plainview, NY: Elar Publishing Co., 1982.
- Frater, Charles B. Sound Recording for Motion Pictures. New York: A. S. Barnes, 1979.
- Nisbett, Alec. *The Technique of the Sound Studio: For Radio, Recording Studio, Television, and Film.* 4th ed. Boston: Focal Press, 1987.
- ——. The Use of Microphones. 2nd ed. Boston: Focal Press, 1984.

PRODUCTION PLANNING AND BUDGETING

- Chamness, Danford. *The Hollywood Guide to Film Budgeting and Script Breakdown*. Rev. ed. Los Angeles:S. J. Brooks Co., 1986.
- Garvy, Helen. Before You Shoot: A Guide to Low Budget Film Production. Santa Cruz, CA: Shire, 1985.
- Honthaner, Eve. The Complete Film Production Handbook. 3rd ed. Boston: Focal Press, 2001.
- Hurst, Walter E. Copyright: How to Register Your Copyright and Introduction to New and Historical Copyright Law. Hollywood, CA: Seven Arts Press, 1977.
- Library of Congress Copyright Office Web site. http://www.copyright.gov.
- Squire, Jason E., ed. *The Movie Business Book*. New York: Simon & Schuster, 1986.
- Wiese, Michael. *Film and Video Budgets*. Westport, CT: Michael Wiese Film Productions, 1984.

INDEX

Assembly of scenes, 181, 183

Audio-Technica Corporation, 161

A-B rolls, 155, 185, 199 assembling, 192–98 and optical printer blowups, 205 and postproduction activities, 200-207 and preparing originals, 189, 191 - 92and printing effects, 186, 189 storage of, 192 and submitting materials to lab, 201 and titles, 189 Aaton cameras, 9, 10, 44, 160 AatonCode, 160 Aaton mounts, 18 Acoustics, 168-70, 229 Acutance test, 59 American Cinematographer (magazine), 59-60 American Cinematographer Manual, 16, 20, 46, 62, 63, 71, 223 American National Standards Institution (ANSI), 54 American Standards Association (ASA), 54 Angenieux cameras, 15, 28 Answer printing/prints, 174, 180, 199, 200-201 Apocalypse Now (film), 150 Aquacolor, 222 Arc lights, 106–8 ARRI plastic "skewer," 2 ArriCode, 160 Arriflex cameras, 9, 10, 11, 27, 44, 170 Arriflex lighting kits, 117 Arriflex mounts, 18 Arriflex Varicon device, 156 ASA values, 54–55

Avid Film Composer, 185 Backdrop lights, 97 Backlights, 95, 98, 132, 153 and close-ups, 130 and measuring light, 102, 104 and planning and executing lighting, 133 and shooting on location, 146, 148 and simulating natural lighting effects, 133, 135 and special shooting techniques, 214, 220, 221 Ballasts, 108, 115, 116, 220 Barco, 210 Barn doors, 125, 126, 135, 139, 140, 141 Barry Lyndon (film), 139 Batteries, 9, 10, 44, 47, 165 Beaulieu cameras, 44 Bell & Howell cameras, 44 Black-and-white photography color versus, 60 and definition, 58 and depth, 98 and film structure, 49, 52, 55, 57 filters for, 70, 71–73 and image manipulation, 152, 153, 157 and measuring light, 101, 102, 105 and postproduction activities, 178, 180, 204 and special shooting techniques, 214, 215, 222 Bleach-bypass process, 50, 154 - 55

"Blooming," 85, 103 Blurs, 5-6, 37, 45 Bolex cameras, 2, 6, 44, 45 Booms, 83, 140, 164-65, 168 Bouncing light, 112, 113, 128, 134, 145, 219-20 Brightness and balancing light levels, 102 - 3and image manipulation, 151, 152, 153 and postproduction activities, 180, 201, 209 and practical light meter use, 104 - 5projection, 180 and shooting on location, 146 and special shooting techniques, 216, 217 and video transfers, 173 Budgeting, 224-27, 229 Burton, Tim, 151 Butch Cassidy and the Sundance Kid (film), 152 C-rolls, 155, 198 The Cabinet of Dr. Caligari (film), 98 Cables, 123, 143-44, 165, 219, 221, 229 Camelot (film), 156 Camera rehearsal, 230 Camera reports, 172, 230-31 Cameras backward running, 40–41 choosing, 41, 44, 223 cost of, 1 digital, 105, 212, 230 maneuverability of, 37 noise of, 170

operation and care of, 45-47

Cameras (cont.) renting, 41, 44, 229 supports for, 30-37 troubles and tests for, 44-45 underwater, 221-23 See also specific part of camera Candle flames, 134-35, 139 Canon cameras, 2, 15, 44 Cast Away (film), 215 Changing bags, 10, 11, 47 Characteristic curve, exposure, 50-53, 54, 56 Cheating, 131–32 Checkerboard technique, 186, 202 Chimera Corporation, 129 Chretien, Henri, 17 Cinema Products, 18 CinemaScope movies, 65 Cinematographer as director of photography, 227 and how a cinematographer prepares, 228 and production, 227, 228, 229 and production activities, 230 Cinerama, 65 Circles of confusion, 19 City of God (film), 209 Clapper board. See Slates Close-ups, 16-17, 85, 104, 130-32, 146, 160, 170, 183, 215, 216 Color and accessories for controlling light, 123 and assembling A-B rolls, 197 and balancing light levels, 102, 103 black-and white versus, 60 and characteristics of light, 92, 93 and controlling the light, 128 and definition, 58 and depth, 97, 98 and desaturation, 153-54 as film stock, 61 and film structure, 53, 55 and film technology, 49-50 filters for, 70, 73–77, 87, 89, 151, 157, 212, 222 and fluorescent lighting, 116 and image manipulation, 150 - 58

and postproduction activities, 180, 201, 203, 204, 206, 210, 211 and practical light meter use, 104 and print stocks, 62 and reasons to shoot film, 211 and shooting on location, 145, 146 and simulating natural lighting effects, 135 and special shooting techniques, 213, 214, 215, 216, 217, 221-22, 223 and speed and graininess, 61 storage and handling of, 62 and studio lighting, 141 temperature of, 73, 74, 75-77, 82, 114, 120, 128, 141, 145, 151, 156, 213 testing, 229 and texture, 98 and tungsten versus daylight, 61 and types of fixtures, 113, 115, 116 and video transfers, 173 Color-correction, 74, 173, 201, 207, 209, 212, 213, 215, 222 digital, 153–54, 155, 156, 157, 173 Color enhancer, 75, 87, 89 Color gels, 76, 98, 104, 146, 151 Color rendering index (CRI), 77 Colortran, 115 Compositing, 201, 205, 209–10, 220 Computer screens, filming, 213-14 Conforming, 186, 191, 192, 197, 199, 207 Contact printer/printing, 202, 203, 205 Contrast and cheating, 131 controlling, 152 and definition, 58, 59 and depth, 98 and film stock, 61 and film structure, 56, 57 filters for, 71, 73, 83–86, 102, 152 and image manipulation, 150-54, 155, 156

low-, 85, 152, 153, 173, 174, 202 and postproduction activities, 202-3, 205, 206 and practical light meter use, 105 and shooting on location, 149 and special shooting techniques, 222, 223 and video transfers, 173 Contrast-viewing glasses, 101–2, 105 Cooke cameras, 15 Cooper portable mixers, 165 Copyrights, 226, 232-34 CP cameras, 44 Cranes, 8, 36-37 Crew, hiring the, 227–28 Cross lights, 148, 153, 214, 220 Cross-processing, 155–56 Crystal sync, 9, 44, 108, 115, 116, 159 Crystal-sync generators, 144, 218 Crystal-sync motors, 9, 44, 108, 115, 116, 159 Cue marks, 198 Cue sheets, 189, 197, 198, 200 Cutting. See Editing Cycloramas, 140-41 Dailies (rushes), 160, 171, 172, 173, 178, 180-81, 184, 201, 231 Daylight, 55, 102, 152, 180, 219 and day-for-dusk filming, 216 and day-for-night filming, 146-47, 214-16 and exterior shooting, 147–48 and filters and light, 73-74, 75, 77 - 82and interior shooting, 145 and mixed light sources, 77-82 and shooting on location, 145 Daylight-balanced arc lighting, 61, 106, 108, 116, 120, 222 Daylight spools, 9–10, 40 Deakins, Roger, 157 Dedolight lighting kits, 117, 120Dedolights, 144

Definition, 58-59, 84, 153 Deluxe Labs, 155 Depth, 97-98, 104, 115, 130, 135, 149, 211, 221 See also Depth of field; Depth of focus Depth of field, 14, 19-20, 85, 98, 139, 148, 212, 214, 216 Depth of focus, 19, 20 Desaturation/saturation, 151, 152-54, 155, 157, 204 Deschanel, Caleb, 157 Dialogue replacement, 170 Dietrich, Marlene, 130 Diffusion, 132, 141, 173, 220 and accessories for controlling light, 123, 125 and close-ups, 130 and creating soft light, 128, 129 filters, 83-86, 130, 153 frames, 131, 139, 216, 219 materials for, 129, 148 and shooting on location, 146, 148 and special shooting techniques, 220, 221, 222 Digital cameras, 105, 212, 230 Digital intermediate (DI) technology, 61, 154, 157, 206 - 10Digital technologies, 152, 157, 185, 205, 215 See also Digital intermediate (DI) technology Diopters, 16, 17, 28 Director of photography (DP) See Cinematographer Dirty dupes, 178, 199 Disney animation films, 98 Dissolves, 183, 185, 186, 189, 193, 197, 201, 203, 207 Ditty bag, 46-47 DLP Cinema technology, 210 Dollies, 8, 22, 29, 35-36, 93, 219 Dubbing, 170, 183, 184, 199 Dupes, 178, 185, 199, 201-3, 205, 206-7,209 See also Dirty dupes Duro-Test Corporation, 77 Dusk-for-night filming, 173, 215 - 16DVDs, 174, 175, 184

Eastman Kodak, 59, 61, 62, 63, 65, 68, 102, 139, 155-56, 174, 202, 209 Eclair cameras, 44 Eclair mounts, 18 Editing concerns about, 184-85 digital, 185, 199 on film, 175–83 linear, 183 machines for, 178, 181 nonlinear, 183-98, 207 and postproduction activities, 171, 172, 175-83, 207, 232 and production activities, 230 rough and fine, 183 and sound mix, 199 See also Editing rooms; Mixing Editing rooms, 175–78, 184, 192 EI. See Exposure index 8mm cameras, 2 Elaine cameras. See Panaflex cameras Electromagnetic spectrum, 68 Elipsoidals, 110-11, 134, 141 Expenses, production, 224–27, 229 Exposure, 29, 39, 85, 104, 108, 129, 153, 211 and balancing light levels, 102 - 3characteristic curve, 50-53, 54, 56 and image manipulation, 151, 152, 153, 154, 156 and intermittent movement principle, 1 and lenses, 12, 14 and optical attachments and close-up work, 16, 17 and postproduction activities, 180, 201, 205, 209, 211 and shooting on location, 146, 148 and shutter, 4, 5-6 and special shooting techniques, 214, 215, 216, 217 Exposure index (EI), 54–55, 56-57, 61, 103, 189 Exposure values. See F-stops Exterior shooting, 147-48 Eye light, 95, 97 Eyeglasses, reflections from, 132 - 33

F-stop (exposure value), 5, 29, 39, 99, 103 and balancing light levels, 102, 103 and camera operation and care, 45, 46 and filters and light, 70–71, 85 and lenses, 12-13, 14, 15-16, 27 and optics, 19, 20 overview about, 53-55 and special shooting techniques, 215 Fader device, 89 Fades, 5, 183, 185, 186-87, 189, 197, 198, 201, 203, 207 FAY bulbs, 114–15 Field of view, 20, 22 Fill lights, 95, 102, 104, 130, 133, 141, 145, 148, 151, 152, 216 Film cost of, 63 editing on, 175-83 fogged, 45 reasons to shoot, 211-12 scratched, 45, 210, 231 start of, 198 storage of, 176, 181, 212 and transferring film to video, 172 - 75transporting on airlines of, 63 See also Film stock; type of film Film bins, 176, 181 Film formats, 54–56, 64–67, 204 Film gate, 1–2, 10, 11, 45, 46, 90, 103, 156 Film stock, 48, 59–64, 151, 153, 156, 209, 228 *See also type of film stock* Film structure, 48-49, 53-55 Filter factors, 70–71, 75, 89 Filter tray, 83 Filters acrylic plastic, 90 all-purpose, 82-89 attenuator, 214, 216, 217 for black-and-white photography, 71-73 and camera operation and care, 46, 47 and close-ups, 16, 130 for color, 70, 73-77, 87, 89, 151, 157, 212, 222 for contrast, 71, 73, 83-86, 102, 152

Filters (cont.) and day-for-night filming, 214 - 15and desaturation, 153 diffusion, 83-86, 130, 153 and electromagnetic spectrum, 68 and filter theory, 68, 70-71 fog, 84-85, 86, 150, 153, 156 frost, 85 functions of, 92 gel, 89-91, 128, 217 glass, 89, 90, 91 graduated, 83, 85, 152, 214-15, 217 heat-removing, 128 and image manipulation, 150, 151, 152, 153, 156, 157, 158 light-balancing, 75–76 low-contrast filters, 85 maintenance of, 89-91 and mixed light sources, 77-82 neutral density (ND), 82-83, 147, 148, 214, 216, 217 and optical attachments, 16 optical flat, 90 physical characteristics of, 89-91 polarizing, 86–89, 91, 152, 214-15, 219 and postproduction activities, 209 quality of, 90 and shooting on location, 147, 148sizes of, 91 and special shooting techniques, 213, 214-15, 216, 217, 222 testing, 229 ultraviolet, 82 "warming," 75, 222 Final Cut Pro, 185 First trial prints. See Answer printing/prints Fisher Corporation, 165 Flagging, 125, 126, 128, 135, 139, 140, 141, 148 Flaring, 13–14, 16, 85 FlexFile, 185 Flicker, 4, 108, 115, 116, 135, 139 Flood, 110, 111, 113, 114

Fluorescent lights, 75, 77-82, 106, 115-16, 128, 144, 145, 158, 167, 220 Focal length, 20, 22, 30, 85, 91 See also F-stops; T-stops Focal range, 45 Focus back, 20 and camera operation and care, 45-46 and close-ups, 16, 17 and depth, 98 by eye, 14-15 and film stock, 60 and filters and light, 85 "fixed," 14 and image manipulation, 157 and lenses, 12–13, 14–16, 17, 19, 27, 28, 29, 30 and optical attachments, 16, 17 and optics, 20 and postproduction activities, 212 and reasons to shoot film, 212 reflex, 222 and special shooting techniques, 220, 222 "splitting" the, 20 tape, 16 and time manipulations, 41 and video assist, 8 See also Depth of focus Fogging, 84–85, 86, 150, 153, 156 Format, 91 Fostex recorders, 161 Freeze frames, 203, 206, 207 Fresnels, 108–10, 111, 115, 125, 128, 134, 135, 139, 141, 144, 145 Frontal lighting, 98, 130, 153, 158, 220, 221 Fuji, 59, 61, 62, 63, 155-56, 209 Gamma, 57 Gel filters, 77, 89-91, 128, 217 Gels behind-the-lens, 20, 217 color, 76, 98, 104, 146, 151 and controlling the light, 128 density, 134 diffusion, 220 and image manipulation, 151, 158 and MIRED shift value, 77

and mixed lighting sources, 78, 82 neutral density (ND), 134, 146, 147,219 and practical light meter use, 104 and shooting on location, 143, 146, 147, 148 and simulating natural lighting effects, 134, 135, 139 and special shooting techniques, 213, 217, 219, 220 General Electric, 77, 220 Graduated tonality lighting, 93, 94 Graininess, 61, 62, 67, 102, 173 and film structure, 56, 58 and image manipulation, 153, 154, 155 overview about, 58-59 and postproduction activities, 203, 204, 206, 209, 211-12 and reasons to shoot film, 211 - 12Gray scale/gray card, 101, 156, 157 - 58The Great Train Robbery (film), 212 Hall, Conrad, 152 Handheld work, 37-39, 156 Harrison & Harrison, 85, 91 HDTV, 64-65, 174, 175, 207, 209, 210, 211, 212 Heads sound, 165, 167, 168, 178, 180-81, 183, 192 for tripods, 33–34, 37 Heat, 123, 128 HMI light, 76, 78, 120, 148 and shooting on location, 142-43, 147, 148 and special shooting techniques, 214, 219, 220 as type of lighting equipment, 106 - 7and types of fixtures, 108, 110, 111, 113–15, 116 Huston, John, 150 Hydroflex, Inc., 222 Hyperfocal distance, 20

Ianiro Corporation, 112 ICG (magazine), 60

Ikelite Corporation, 221 Image manipulation, 150–58 Incandescent light, 108, 134, 220 Incident light meters, 99-100, 101, 103, 104, 133, 217, 221 Intermittent movement, 1–2, 39 International Standards Organization (ISO), 54 Internegatives (IN), 153, 155, 156, 173, 201–2, 204, 206–7, 209 Interpositives (IP), 153, 155, 156, 157, 173, 174, 201, 202, 203, 204, 206-7, 209 Invasion of privacy, 231–32 Jamming, 11–12, 44 Jib arms, 36–37 Key grip, 120, 227 Key lights, 130, 131, 133, 148 and functions of light, 94–95 high-, 93-94 and image manipulation, 150, 151 and light meter use, 103-4 low-, 93, 94, 95 and measuring light, 102, 104 and simulating natural lighting effects, 134, 135, 139-40 Keys, 173, 180, 209-10 Kicker lights, 95, 102, 104, 130, 133 Kino Flo Corporation, 77, 116, 117, 120 Kodak. See Eastman Kodak Laboratory and production activities, 231 submitting materials to, 171-72, 200-203 Lee Corporation, 77, 78, 82, 91, 146 Lenser, 126 Lenses anamorphic/nonanamorphic, 65,67 and camera noise, 170 and camera operation and care, 45, 46 care of, 27-30 changeable, 18 and characteristics of light, 92 and circles of confusion, 19

and close-ups, 16-17, 130-31 coatings on, 13-14, 30 and controlling the light, 125, 126 and definition, 59 and depth, 97, 98 and depth of field, 19-20 and film formats, 65, 67 and focus, 12-13, 14-16, 17, 19, 27, 28, 29, 30 fresnel, 108, 110 function of, 12 and functions of light, 95 heavy, 27–28 and image manipulation, 151 and light meters, 101, 104 long, 27-28 macro, 8, 16 and matte boxes, 28-29 mounts for, 18, 20, 27-28, 30 nonremovable, 27 optical attachments for, 16–17 optimal range for, 14 overview about, 12-18 and postproduction activities, 203 and practical lens use, 27-30 prime, 15, 16, 20, 91 retrofocal, 17, 30 sharpness of, 45 short, 22 and simulating natural lighting effects, 139 and special shooting techniques, 214, 217, 220, 222, 223 speed of, 13, 14 spherical, 67 stop pulls for, 29 support systems for, 27–28 testing, 229 tilt-focus, 17 and types of fixtures, 108, 110, 111, 113, 114 and viewing systems, 8 wide-screen, 65 zoom, 15-17, 20, 28, 29, 30, 45, 91 See also Filters; Optics Light accessories for controlling, 123 - 28color of, 92

controlling the, 120-28 and electromagnetic spectrum, 68 and filter theory, 68, 70-71 functions of, 94-97 hardness or softness of, 92-93 measurement of, 54, 98-105, 221 and mixed light sources, 77-82 quality of, 105 temperature of, 73, 74 and time manipulations, 39 type of source of, 105–8 See also specific topic Light levels, 50, 102–3, 145–46 Light meters, 47, 98-101, 102, 103-5, 156, 221 Lightbulbs, 116–17, 120, 129, 134, 220 Lighting, 92-149 characteristics of, 92-93 concepts about, 92–98 controlling the, 120–28 equipment for, 105-8 and functions of a light, 94-97 as heart of cinematography, 92 and image manipulation, 150-51, 153, 156, 158 "improving," 131-32 placement of, 130 planning and executing, 133 and postproduction activities, 201, 210 simulating natural, 133–40 source of, 92–93 studio, 140-41 styles of, 93–94 testing, 229 and types of fixtures, 108–16 See also specific topic Lighting kits, 116–20 Lindley, John, 157 Location, shooting on, 62-63, 112, 121, 140, 141–48, 161, 170, 227, 229 Logging of footage, 181, 189, 192 Lowel-Light Manufacturing, 116-17, 129 Lowell, Ross, 116 LTM lighting kits, 117 Lumiline lamps, 220

INDEX

Mackie portable mixers, 165 Magazines, 9-12, 44, 45, 46, 47, 156,231 Master shots, 131, 171, 173, 198, 199, 200, 201-3, 216 Matte boxes, 28–29, 46, 83, 85, 91, 156 Microphones, 161-64, 165, 168-70, 229, 230 Minolta light meters, 99 MIRED (micro reciprocal degrees) system, 76–77, 78, 82 Mitchell flat-bases, 32, 34 Mixing, 165, 170, 183, 198–200, 232 Mole-Richardson Company, 110, 112, 115, 165 Monitors, 6, 8, 213–14 Morris, Oswald, 150 Motion rendition, 211 Motors/generators, 8-9, 10, 15, 28, 44, 46, 108, 115, 116, 144, 159, 218, 221 Moulin Rouge (film), 150 Mounting accessories, 120–21 Mounts, 18, 20, 27–28, 30, 31–32, 33, 34-35, 37, 120-21, 144, 165, 219 Movement, intermittent, 1-2, 39 Moviola editing machines, 178, 181 Music, 183, 232 Nagra recorders, 161, 165, 167, 168 The Natural (film), 157 Night scenes, shooting, 145, 146, 148-49, 173, 174, 180, 214-16, 220 Noise, 144 O Brother, Where Art Thou? (film), 157 One-third-distance principle, 20 Open lights, 111–13, 144 Optical frequency meter, 213 Optical printers/printing and creating titles, 189 and definition, 59 and desaturation, 153 and editing, 185 and image manipulation, 152, 153, 156-57

and postproduction activities, 202-7,209 and time manipulations, 40 Optics, 19–20, 22, 221 See also Optical printers/printing PAL system, 174, 207, 213 Panaflasher, 156 Panaflex cameras, 10, 44, 156 Panavision cameras, 44, 91 Panning, 4, 8, 16, 22, 33, 34, 40, 83, 220 Parallax, 6, 8 Parliament Guillotine splicer, 176 PARs (parabolic aluminized reflectors), 113–15 Perspective, 20, 22, 97, 98, 169-70 Photoflex corporation, 129 Photosonics Actionmaster cameras, 44 Picnic (film), 156 Pixilation, 40 Pleasantville (film), 157 Polarizers, 86–89, 91, 152, 214–15, 219 Polaroid cameras, 104, 105, 230 Polecats, 121, 144 Poor-man's process, 220–21 Poster, Steven, 62 Postproduction activities and image manipulation, 150, 151, 157 and reasons for shooting film, 211 - 12and special shooting techniques, 220 See also specific activity Practical lights and functions of light, 97 and measuring light, 105 and planning and executing lighting, 133 and shooting on location, 145, 146, 147, 148 and simulating natural lighting effects, 133, 134, 139 and special shooting techniques, 214, 215, 216, 221 and underwater cinematography, 221 Preproduction activities, 226–29 Printer lights, 155, 201, 203

Printers/printing answer, 200-201 and assembling A-B rolls, 198 and balancing light levels, 103 and basic printing effects, 186-89 contact, 202, 203, 205 and filters and light, 74 and image manipulation, 153, 156 one-light, 103 and postproduction activities, 180, 200-206, 207 and "printing up/down," 201 reverse-motion, 204 skip, 203 step, 207 stretch, 203, 207 submitting materials to lab for, 200-203 video, 230 See also Optical printers; Prints Prints and balancing light levels, 103 damage to, 210-11 and film structure, 57 and image manipulation, 154, 155, 156 low-con, 173, 174 master, 198, 199, 200 and postproduction activities, 171, 172, 198, 199, 200, 201, 203, 210-11 projection, 173-74 and sound mix, 198, 199 sound on release, 200 and type of film stock, 62 and video transfers, 172–75 See also type of print Processing, 151 See also type of processing Production activities, 224–34. See also specific activity Production day, 229-31 Production design, 150–51 Production meeting, 229 Projection/projectors, 2, 103, 173-74, 178, 180, 203, 210, 211-12, 220 Proof prints, 201 Pull-processing, 57–58, 152, 153 Push-processing, 56–57, 152

Quality control importance of, 48 See also Color; Contrast; Exposure; Lenses; Lighting Quartz lights, 108, 125, 144 Range, optimal, 14, 50, 51 Rank Cintel, 173 Rear projection, 220 Reciprocity failure, 39–40 Recorders, 9, 47, 161, 165, 167-68, 181, 207, 209, 229, 232 Reels, 175, 176 Reference chart, shooting a, 157 - 58Reflected light meters, 100, 101, 102, 103, 104, 216, 217, 221 Reflex cameras, 85, 86, 90, 156 Reflex viewing system, 6, 8, 14, 15, 27, 44, 45 Release form, sample, 231–32 Release prints, 178, 200, 201, 232 Renting cameras, 41, 44, 229 Resolving power, 58, 59 Reverse action, 40–41 **Revisquick Tapesplicer**, 176 Rewinds, 175, 176 Rifa-Light, 129 Rigging, 37, 120, 121, 123, 131, 133, 144-46, 219, 229 Romano, Pete, 223 Rosco Corporation, 77, 78, 82, 146, 151 Rushes. See Film dailies Saturation/desaturation, 151, 152-54, 155, 157, 204 Saving Private Ryan (film), 6 Scanning, 173, 207, 209, 220 Scatter, 14, 84, 85, 86, 153, 221, 222 Scheduling the day, 228, 229–30 Schneider Corporation, 84, 85, 91 Scoops, 111 Scrims, 123, 125, 134, 135, 139-40, 146, 147, 216 Sealed-beam lights, 113–15 Sekonic Corporation, 99, 221 Sennheiser Corporation, 161, 163 Sensitometer, 50 Sensitometry, 49–58 Set designers, 133 Set lights, 97 Shapes, 98. See also Textures

Sharpness, 58, 59, 62 Shooting. See Location, shooting on; Production activities Shure portable mixers, 165 Shutter, 4-6, 8-9, 45, 90, 99, 110, 213 Silver-retention process, 152, 153, 154 - 55Skip-bleach process. See Bleachbypass process Sky, filming, 111, 152, 214, 215, 216, 217, 219 Slates, 103, 160-61, 181, 230 Sleepy Hollow (film), 151 Slow-motion photography, 9, 39 Snow White and the Seven Dwarfs (film), 98 Soft lighting and accessories for controlling light, 125 and balancing light levels, 102 and characteristics of lighting, 92-93 and cheating, 131 and close-ups, 130 creating, 128-30 and fluorescent lighting, 116 and functions of lighting, 95 and lighting styles, 94 and open lighting, 111, 112-13 and reflection, 132, 133 and shooting on location, 148 and simulating natural lighting effects, 134 and special shooting techniques, 216, 219, 220 and studio lighting, 141 and textures and shapes, 98 Sony, 163, 173 Sound recording and acoustics, 168-70 and care of tapes, 212 crystal sync, 159 and dialogue replacement, 170 editing, 183 and editing room equipment, 176 and location, 161 and maintenance of equipment, 165, 167-68 and microphones, 161-64, 165, 168 - 70mixing of, 198–200, 232 non-sync, 44

and other equipment, 164-65 and perspective and presence, 169-70 and postproduction activities, 159-61, 176, 198-200, 201 presence, 169-70 and recorders, 9, 47, 161, 165, 167-68, 181, 207, 209, 229, 232 on release prints, 200 and slates, 160-61 and special shooting techniques, 217 and speed of camera, 4 and synchronous sound, 159-61 and syncing up dailies, 180-81 time code, 159-61 Sound-release negatives, 200 Sound reports, 168, 231 Soundstage, creating small, 141 Spectra light meters, 99, 101 Speed and choosing cameras, 44 and editing, 185 and film stock, 61 and fluorescent lighting, 116 of intermittent movement, 2 of lenses, 13, 14, 15 and magazines, 10 of motors, 9, 15 of projector, 2 and shutter, 4-5 of tapes, 167–68 and time manipulations, 4, 39 - 40variable, 2, 4, 15 Splicing, 49, 175, 176-77, 178, 181, 183, 186, 189, 191, 192, 198, 202 Spot light meters, 89, 100, 102, 104, 105, 133, 141, 216, 217 Spotlights, 110, 111, 113, 114, 115, 139, 141 Stabilizing equipment, 37, 39 Stands, 120–21, 123, 126, 139, 144 Steadicam shooting, 8, 37, 39, 156 Steady shooting, 45, 223 Sternberg, Josef von, 130 Storaro, Vittorio, 150 Streaks 'N Tips, 134 Studio lighting, 140–41 Sun guns, 120 Sunsets, shooting, 216–17

INDEX

Sunshade. See Matte boxes Super-8 cameras, 2, 9, 12, 20, 30, 34 Super-16 cameras, 15, 40, 63, 65-67, 91, 174, 184, 211-12 Super-35 cameras, 64 Superimpositions, 186, 189, 193, 197, 201, 203 Supports, for cameras, 30–37 Surefire Corporation, 134 Sylvania Corporation, 220 Synchronizers/synchronization, 159-61, 171, 175, 176, 180-81, 192, 197, 199 T-stops, 12-13 Tapes beginning new, 168 care of, 167 identification of, 168 magnetic, 63 repair of, 211 speed of, 167-68 Telecines, 160, 171, 172, 173, 174, 184, 185, 202 Teledyne Corporation, 222 Telephoto lenses, 8, 13, 16-17, 22, 98, 217 Television, 6, 59, 95, 141, 154, 155, 211, 212, 213-14 Tests, 59, 62, 102–3, 156, 180, 203, 229 Texas Instruments, 210 Texture, 98, 130, 149, 151, 153 Thomson Corporation, 173, 207, 209 Three-point lighting, 95 3:2 pull-down method, 185 Tiffen Corporation, 76–77, 78, 82, 84, 85, 91, 156 Time code, 159–61, 181, 185 Time-lapse photography, 4, 9, 39, 40

Time manipulations, 39–41 See also Slow-motion photography; Time-lapse photography Titanic (film), 41 Titles, 189, 207, 232 Traveling matte composites, 207, 209 Triple light measuring technique, 104 Tripods, 30–35, 46, 219, 223 Tungsten lighting, 102, 120, 151, 201 daylight versus, 55, 61 and film stock, 61 and film structure, 55 and filters and light, 73-74, 77-82 and mixed light sources, 77-82 and shooting on location, 142-43, 145, 147, 148 and special shooting techniques, 213, 215, 222 as type of lighting equipment, 106, 108 and types of fixtures, 108, 110, 111, 113, 114, 116 2001: A Space Odyssey (film), 157 Underwater cinematography, 221 - 23Upside-down reverse motion, 41

Vehicle cinematography, 217–21 Video transfers and cuts, 183 and editing, 184, 185 and image manipulation, 154, 155, 158

and operation of tape recorders, 167 overview about, 172-75 and postproduction activities, 172-75, 183, 184, 185, 202, 207, 212 and production activities, 231 Viewing systems, 6, 8, 14–15, 27, 37, 44, 45–46, 156, 175, 176, 180 Vita-Lite, 77 Weather conditions, 44–45, 62-63, 148, 216, 217, 219, 221 Wedge tests, 203 Wide-angle lenses and camera troubles and tests, 45 care of, 30 and close-ups, 16, 17, 131 and depth, 98 and dollies, 35-36 and filters and light, 85, 90, 91 and focusing, 14, 17, 20, 22 and handheld work, 37 and optical attachments, 16, 17 and optics, 20 optimal range of, 14 and special shooting techniques, 214, 215, 216, 217, 222 speed of, 13 and underwater shooting, 222 Wilson Corporation, 85 Windows, 133–34, 135, 146, 147, 219 Xenon lights, 108, 134, 201

Zeiss cameras, 15, 16, 139 Zeiss viewers, 176 Zooming, 15–17, 20, 22, 28, 29, 30, 45, 91

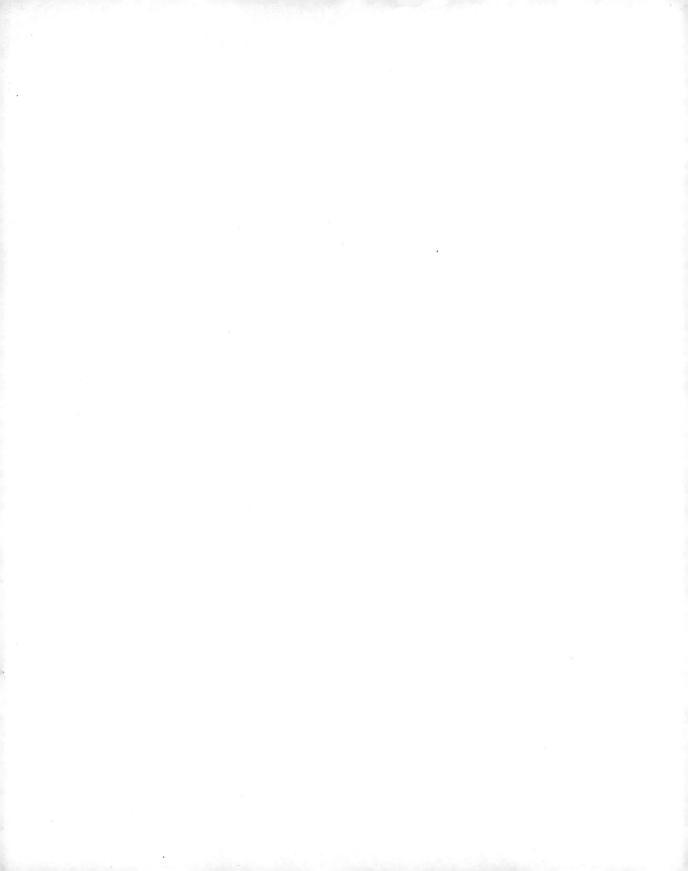